THE CONCEPT OF THE 'MASTER' IN ART EDUCATION IN BRITAIN AND IRELAND, 1770 TO THE PRESENT

A novel investigation into art pedagogy and constructions of national identities in Britain and Ireland, this collection explores the student-master relationship in case studies ranging chronologically from 1770 to 2013, and geographically over the national art schools of England, Ireland, Scotland and Wales. Essays explore the manner in which the Old Masters were deployed in education; fuelled the individual creativity of art teachers and students; were used as a rhetorical tool for promoting cultural projects in the core and periphery of the British Isles; and both united as well as divided opinions in response to changing expectations in discourse on art and education.

Case studies examined in this book include the sophisticated tradition of 'academic' inquiry of establishment figures, like Joshua Reynolds and Frederic Leighton, as well as examples of radical reform undertaken by key individuals in the history of art education, such as Edward Poynter and William Coldstream. The role of 'Modern Masters' (like William Orpen, Augustus John, Gwen John and Jeff Wall) is also discussed along with the need for students and teachers to master the realm of art theory in their studio-based learning environments, and the ultimate pedagogical repercussions of postmodern assaults on the academic bastions of the Old Masters.

Matthew C. Potter is a Senior Lecturer in Art and Design History at Northumbria University, UK. His research interests include national identity in British art, and the history of art education.

To the memory of Katerina Reed-Tsocha

The Concept of the 'Master' in Art Education in Britain and Ireland, 1770 to the Present

Edited by
Matthew C. Potter

Routledge
Taylor & Francis Group

LONDON AND NEW YORK

First Published 2013 by Ashgate Publisher

Published 2016 by Routledge
2 Park Square, Milton Park, Abingdon, Oxon OX14 4RN
711 Third Avenue, New York, NY 10017, USA

Routledge is an imprint of the Taylor & Francis Group, an informa business

British Library Cataloguing in Publication Data
A catalogue record for this book is available from the British Library

The Library of Congress has cataloged the printed edition as follows:
The concept of the 'master' in art education in Britain and Ireland, 1770 to the present / [edited] by Matthew Potter.
 pages cm
 Includes bibliographical references and index.
 ISBN 978-1-4094-3555-6 (hbk) 1. Art--Study and teaching--Great Britain
--History. 2. Art--Study and teaching--Ireland--History. 3. Teacher-student relationships--Great Britain--History. 4. Teacher-student relationships--Ireland
--History. I. Potter, Matthew C. (Matthew Charles), editor of compilation.
 N88.5.G7C66 2013
 707.1'041--dc23

 2013003635

ISBN 978 1 4094 3555 6 (hbk)

Contents

List of Illustrations

**Learning from the Masters:
An Introduction**

0.1 Nicolas Poussin, *Eliezer et Rebecca*
(*Eliezer and Rebecca at the Well*) (1648),
oil on canvas, 118 × 199 cm, Musée du
Louvre, Paris (C) RMN-GP (Musée du
Louvre)/Droits réservés.

0.2 Sir Joshua Reynolds, *Self-portrait*
(c.1779–80), oil on panel, 127 × 101.6 cm/
Royal Academy of Arts, London, UK/
Bridgeman Art Library.

**3 The John Frederick Lewis
Collection at the Royal Scottish
Academy: Watercolour Copies of
Old Masters as Teaching Aids**

3.1 John Frederick Lewis, *SS Peter
and Paul Restoring the King's Son to
Sight, after Fra Filippo Lippi* (undated)
watercolour with gouache, Royal
Scottish Academy.

3.2 John Frederick Lewis, *Study of
a Portion of the Picture of the Adoration
of the Shepherds, after Velazquez* (now
reattributed to Neapolitan School) (1833),
pencil, watercolour and gouache, Royal
Scottish Academy.

**4 British Art Students and German
Masters: W.B. Spence and the Reform
of German Art Academies**

4.1 Peter von Cornelius, *Last
Judgement* (detail) (completed in
1880), fresco, Munich, Ludwigskirche,
author's photo.

**5 Standing in Reynolds' Shadow:
The Academic Discourses of Frederic
Leighton and the Legacy of the First
President of the Royal Academy**

5.1 Frederic Leighton, *Fatidica* (c.1893–
4), oil on canvas, 153 × 111 cm/© Lady
Lever Art Gallery, National Museums
Liverpool/Bridgeman Art Library.

5.2 Sir Joshua Reynolds, *Mrs. Siddons as
the Tragic Muse* (1789), oil on canvas, 239.7
× 147.6 cm/© Dulwich Picture Gallery,
London, UK/Bridgeman Art Library.

5.3 Michelangelo, *Sistine Chapel Ceiling:
The Prophet Isaiah* (1508–12), fresco/Vatican
Museums and Galleries, Vatican City/
Bridgeman Art Library.

**7 Struggling with the Welsh
Masters, 1880–1914**

7.1 David Cox, *The Welsh Funeral,
Betwys-y-Coed* (1847–50), oil on paper,

540 × 749 mm, purchased 1936. Tate/ Digital Image © Tate, London 2011.

7.2 Richard Wilson, *A White Monk* (undated), oil on canvas, 94 × 133.3 cm; 1946; gift; F.J. Nettlefold; NMW A 5192 © Amgueddfa Cymru – National Museum Wales, 2012.

8 Emulation and Legacy: The Master-Pupil Relationship between William Orpen and Seán Keating

8.1 Seán Keating, *The Reconciliation* (1914), oil on canvas, 110 × 90 cm. Private collection. Photograph © and courtesy of John Searle. Painting © The Keating Estate.

8.2 Seán Keating, *Men of the West* (1915, exhibited 1917), oil on canvas, 125 × 95 cm. Courtesy of Collection of the Dublin City Gallery The Hugh Lane. Painting © The Keating Estate.

8.3 Seán Keating, *Economic Pressure, or A Bold Peasant Being Destroyed* (1949–50), oil on canvas, 122 × 122 cm. Courtesy of Collection of the Crawford Art Gallery, Cork. Painting © The Keating Estate.

9 Prototype and Perception: Art History and Observation at the Slade in the 1950s

9.1 Henry Tonks, *Demonstration Drawing* (c.1908), pencil and red chalk on paper, 40.6 × 28 cm, UCL Art Museum, University College London.

9.2 Michelangelo, *Studies for the Last Judgement* (1534), black chalk on paper, 40.4 × 27 cm © The Trustees of the British Museum.

9.3 Front View of Lower Limb, figures 77–8 from Eugene Wolff, *Anatomy*

for Artists (1925), UCL Art Museum, University College London.

9.4 Rex Whistler, *Trial Scene from 'The Merchant of Venice'* (1925), oil on canvas, 91.4 × 122 cm, UCL Art Museum, University College London © Estate of Rex Whistler. All rights reserved, DACS 2012.

9.5 Euan Uglow, *Female Figure Standing by a Heater* (1952), oil on canvas, 101.6 × 76.2 cm, UCL Art Museum, University College London © the artist's estate.

9.6 Martin Froy, *Seated Nude* (1950), pencil with white heightening on paper, 37.8 × 25.5 cm, UCL Art Museum, University College London © the artist.

9.7 Harold Cohen, *The Raising of Lazarus* (1950), oil on fibreboard, 122 × 150.2 cm, UCL Art Museum, University College London © the artist.

9.8 Michael Andrews, *August for the People* (1951), oil on board, 143.5 × 121.5 cm, UCL Art Museum, University College London © the Estate of Michael Andrews, courtesy of James Hyman, London.

9.9 Victor Willing, *Fighting Men (The Wasteland)* (1952), oil on board, 149.9 × 180.4 cm, UCL Art Museum, University College London © the artist's estate.

9.10 Mario Dubsky, *The Lament of Orpheus* (1960), oil on canvas, 157.5 × 231.2 cm, UCL Art Museum, University College London © the artist's estate.

9.11 Euan Uglow, *Musicians* (1953), oil on canvas, 101.7 × 127.0 cm, Amgueddfa Genedlaethol Cymru – National Museum of Wales © the artist's estate.

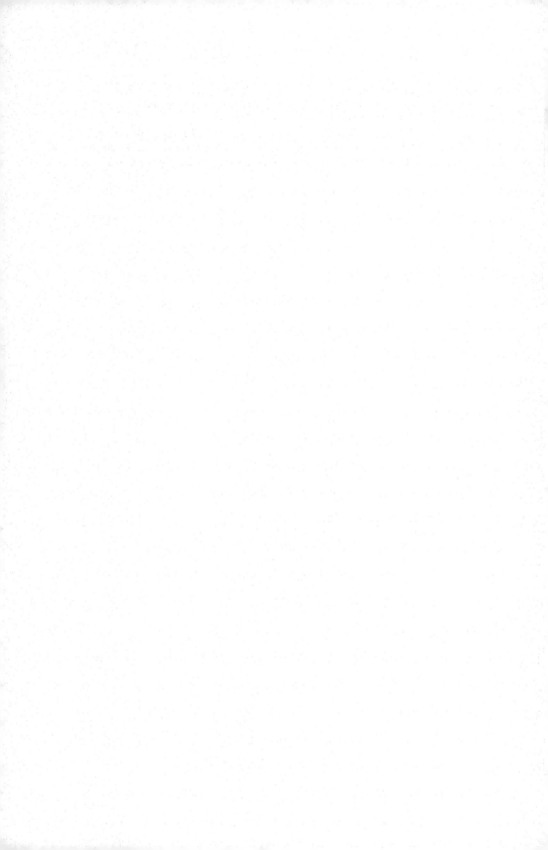

Notes on Contributors

Paul Barlow is a senior lecturer in Art and Design History at Northumbria University. His research focuses on aspects of Victorian artistic culture. His publications on this subject relevant to issues of art education include 'Fear and Loathing of the Academic, or Just What is it that Makes the Avant-Garde So Different, So Appealing?', in R. Denis and C. Trodd (eds), *Art and the Academy in the Nineteenth Century* (2000), as well as '"Fire, Flatulence and Fog": The Decoration of Westminster Palace and the Aesthetics of Prudence' and (co-authored with Shelagh Wilson) 'Consuming Empire?: The South Kensington Museum and its Spectacles', in *Governing Cultures: Art Institutions in Victorian London* (2000).

Emma Chambers is Curator of Modern British Art at Tate Britain. Her research interests in twentieth-century British art include art and medicine, art education, war art and émigré artists. Her publications connected to art education include a complete catalogue of the Slade School of Art's painting collection (2005) and the article 'Redefining History Painting in the Academy', in *Visual Culture in Britain* (2005). Her publications on art and medicine include an article on Henry Tonks' plastic surgery portraits in *Art History* in June 2009 and an essay on the *Saving Faces* exhibition at the National Portrait Gallery in R. Sandell, R. Garland-Thomson and J. Dodd (eds) *Re-Presenting Disability* in January 2010. At Tate Britain, her research has focused on émigré artists in Britain; she was co-curator of the *Migrations: Journeys Through British Art* exhibition (2012) and was curator of the *Schwitters and Britain* exhibition (January 2013).

Joanne Lee is an artist, writer and senior lecturer in Fine Art at Nottingham Trent University, where she teaches across the interdisciplinary programme from undergraduate to postgraduate and doctoral level. Her research, pursued through writing and photography, investigates questions of attention, curiosity, imagination and resourcefulness, and frequently has an explicit link to issues of pedagogy in Fine Art. Her current work is focused through

an independent serial, the Pam Flett Press, the first two editions of which appeared in 2011. Previous publications include *Drafts/Draughts*, co-authored with Julie Westerman (2006) and 'Languages for Learning to Delight in Art', in G. Beer, M. Bowie and B. Perrey (eds), *In(ter)discipline: New Languages for Criticism* (2007). She writes regularly for publications and websites, including *a-n* and *The Wire: Adventures in Modern Music*, as well as producing catalogue texts for contemporary art exhibitions and projects.

Éimear O'Connor is a research associate with TRIARC-Irish Art Research Centre at Trinity College Dublin. She is predominantly concerned with the complex national and international contexts pertaining to the construction of Irish visual identity in the late nineteenth and twentieth centuries. She lectures on courses about Irish, European and American art in several academic and cultural institutions in Ireland. The subject of her PhD research was Irish artist Seán Keating (1889–1977). She is also the author of *Seán Keating: Responses to Culture and Politics in Post-Civil War Ireland* (2009), and of two recent catalogues on the artist's work, 'Seán Keating: Contemporary Contexts' and 'Seán Keating and the ESB: Enlightenment and Legacy', both of which were written to accompany the eponymous exhibitions for the Crawford Art Gallery Cork and the Royal Hibernian Academy respectively (2012). She is the author of a monograph on the artist, *Seán Keating: Art, Politics and Building the Irish Nation* (2013) and editor of *Irish Women Artists 1800–2009: Familiar But Unknown* (2010). Her next book will address socio-historical issues concerning Irish art and the American expatriate market in the early twentieth century.

Matthew C. Potter is a senior lecturer in art and design history at Northumbria University. In the past decade, he has taught numerous forms of art and design history to undergraduates studying studio-based and art history degrees in universities around the UK. He researches issues of international exchange and imperialism in visual culture between 1850 and 1939, with special focus on Anglo-German transfers and the British world. His publications include 'British Art and Empire: Holman Hunt's *The Light of the World* Reflected in the Mirror of the Colonial Press' in *Media History* (2007) and 'Orientalism and its Visual Regimes: Lovis Corinth and Imperialism in the Art of the Kaiserreich', in J. Kromm and S. Bakewell (eds), *A History of Visual Culture* (2010). He is also author of a monograph on *The Inspirational Genius of Germany: British Art and Germanism, 1850–1939* (2012).

Saskia Pütz is a lecturer and scientific collaborator in art history at Hamburg University, Germany. Her area of research interest is European art from the eighteenth to the twentieth centuries with special focus on prints, religious and orientalist art, artistic self-representation and art historiography. Her recent list of publications includes articles on 'Künstlerschaft als Differenz:

künstlerische Identität und Alterität in den Autobiographien von Louise Seidler und Ludwig Richter', in *Fremdbilder, Feindbilder, Künstlerbilder: Sichtweisen auf die Malerei zwischen 1800 und 1850* (2013), 'Philipp Otto Runge zwischen Aufklärungstheologie und Erweckungsbewegung', in M. Bertsch, *et al.* (eds), *Kosmos Runge. Das Hamburger Symposium* (2013) and 'Als Protestantin in der Papststadt: Louise Seidler in Rom', in *Hinaus ins Weite. Thüringer Reisende* (2010), as well as the monograph *Künstlerautobiographie. Die Konstruktion von Künstlerschaft am Beispiel Ludwig Richters* (2011).

Malcolm Quinn is Associate Dean of Research at the CCW Graduate School, University of the Arts London. His current research focuses on the development of government-funded art education in early nineteenth-century Britain, focusing on utilitarian criticisms of the academy and the relation of public utility to public taste. He is the author of *Utilitarianism and the Art School in Nineteenth-Century Britain* (2012), 'The Disambiguation of the Royal Academy of Arts', *History of European Ideas* (2011) and 'The Political Economic Necessity of the Art School 1835–1852', *International Journal of Art and Design Education* (2011).

Katerina Reed-Tsocha was Head of the Graduate Programme at the Ruskin School of Drawing and Fine Art, University of Oxford and formerly Research Fellow at Trinity College, Oxford. She held college lectureships at Christ Church and St Hilda's College, Oxford, and taught at the Department of History of Art, Oxford, and at the Open University. Her research interests were at the intersection of the history of art and philosophy. Her recent publications include articles and book chapters on art historiography, including the historiography of twentieth-century art, contemporary theoretical frameworks for artistic practices, artistic collaboration, the role of art-historical narratives, art and research, and the academicisation of art practice.

Joanna Soden, HRSA, is an independent art historian. Until 2013, she was Collections Curator of the Royal Scottish Academy of Art and Architecture. Prior to this, she served as a curator for three Scottish local authority museum services based in Dundee, Perth and Edinburgh. A specialist in Scottish art since 1800, her publications include J. Soden and V. Keller, *William Gillies* (1998), M. Macdonald, J. Soden, L. Lindsay and W. Maclean (eds), *Highland Art from the Collections of the Royal Scottish Academy. A Window to the West* (2008) and numerous articles relating to Scottish art. She has a particular interest in the history of the training of artists in Scotland. In 2006 she was awarded a PhD from the University of Aberdeen, the title of her thesis being 'Tradition, Evolution, Opportunism: The Role of the Royal Scottish Academy in Art Education 1826–1910'.

Alice Strickland is Assistant Curator at Imperial College Healthcare Charity who in the past has taught on the subject of twentieth-century British art and women artists. She read History at the University of Exeter and holds a PhD in History of Art on women war artists. Most recently, she has given papers at the Malvern Festival, Tate Britain and the Dame Laura Knight Society. She is currently conducting research on women artists practising in Cornwall during the early twentieth century. Her publications include 'Ethel Gabain, Evelyn Gibbs and Evelyn Dunbar: Three Approaches to Professional Art Practice in Interwar Britain', in Karen E. Brown (ed.), *Women's Contributions to Visual Culture, 1918–1939* (2008).

Iris Wien is currently Marie Curie Fellow of the Gerda Henkel Foundation at the Courtauld Institute of Art, London. Her research interests include British art and visual theory, the history of drawing, reflections on the relationship between word and image, and contemporary painting and photography. She has taught many courses on the eighteenth- and nineteenth-century history of British art theory and painting, perspective and early photography at the Department of Art History of the Goethe Universität Frankfurt. Her PhD thesis (from the Freie Universität Berlin) was published as *Joshua Reynolds. Mythos und Metapher* (Munich, 2005). Her other publications include 'Ein Pop-Künstler als Medusa? Begegnung mit zwei Selbstbildnissen von Andy Warhol', in *Wiener Jahrbuch für Kunstgeschichte* (2011) and 'The Transparency of Innocence: A Look at English Children's Portraits of the Eighteenth Century', in Mirjam Neumeister (ed.), *The Changing Face of Childhood: British Children's Portraits and their Influence in Europe* (2007).

Preface

This volume has its origins in the discussions for a research project entitled *Vision and Experience: Artists and Designers as Teachers*. In 2006/7 and 2007/8, I led planning for this initiative at the University of Plymouth, with a team which included Professors David Jeremiah, Sam Smiles and Jeremy Diggle, as well as Katy Macleod and Chris Cook. Reflecting upon developments in the teaching of art history at the former Exeter School of Art (subsequently amalgamated into the University of Plymouth), we wanted to trace the pedagogical ideals and practices of teachers and students in British schools of art and design since the Coldstream era. Using interviews and thematic workshops, we sought to explore the influential texts, models of good practice, and the role of competitions within art schools. Although we were unable to fully realise our initial ambitions, the success of similar projects, such as Tate's *Art School Educated: Curriculum Development and Institutional Change in UK Art Schools 1960–2000* (2009–14), confirms the importance of such a field of study within the history of art education and the timeliness of new investigations like these. This is especially so as the subject area of art and design comes to terms with new challenges related to funding and vocational expectations that are presented by higher education in twenty-first-century Britain.

As planning for the project drew to a close, David Jeremiah and I decided to convene an event that would allow us to share some of our ideas and interests with other scholars. I would like to thank Sam Smiles particularly for providing funding from the History of Art departmental research budget to support this event. The *Learning from the Masters: The Use of Art History by Artist-Teachers* conference, held on 9 and 10 May 2008 at the Sherwell Centre of the University of Plymouth, became both a natural progression and a fitting finale. The call for papers allowed us to cast our net wider both geographically – to include scholars and subjects beyond the UK – and historically – taking the subject back beyond the confines of the 1960s. Following a series of interesting and diverse papers, it was clear to me that a publication was desirable to capture the research energies that had been generated by the occasion. The

influence of past 'Masters' on successive teachers and students quickly offered itself up as a natural focus for an edited collection. With the kind and helpful encouragement of the Ashgate readers and the commissioning editors with whom I worked, Meredith Norwich and Margaret Michniewicz, the venture expanded so that new contributors who did not take part in the original conference joined us in order to bring additional perspectives. My thanks also go to Adam Guppy at Ashgate for his exemplary management of the production process for the book.

It has been a great pleasure to work on this volume over several years and I would like to thank everybody for their efforts in realising this ambitious project. Finding myself once more in an educational institution where the mission to provide historical content for studio-based students continues, I hope *The Concept of the 'Master'* will not only provide some perspective on this problem to both staff and students everywhere, but will also help them to formulate their own views on these matters. Hopefully it will demonstrate that, for better or for worse, the relationship of art history and art education carries on, even if in some quarters the marriage has given way to a trial separation.

Matthew C. Potter
Northumbria University

Learning from the Masters: An Introduction

Matthew C. Potter

> I would chiefly recommend that an implicit obedience to the *Rules of Art*, as established by the great MASTERS, should be exacted from the *young* Students – that those models, which have passed through the approbation of ages, should be considered by them as perfect and infallible guides as subjects for their imitation, not their criticism.[1]

In this brief section from his inaugural address to the Royal Academy of Arts on 2 January 1769, the first President, Sir Joshua Reynolds, revealed his personal belief in the important role that artists from the past could play in the education of modern students. The central argument of this book is that a complex discourse evolved in Britain and Ireland between the late eighteenth century and the present day in which art history and the Old Masters have occupied positions of great influence upon the theory and practice of art education.

Two relative peaks in the status of the Old Masters within educational discourses during this time have been recorded in key published texts. The first, Joshua Reynolds' *Discourses on Art* (1769–90), captured the spirit of the Enlightenment and the second, William Coldstream's parliamentary reports (1960 and 1970), captured the realism of the post-Second World War era. From the very beginning of academic art debates, two separate pedagogical relationships jockeyed for position: between the art master and the pupil on the one hand, and the art student and the Old Master on the other. In both Reynolds' and Coldstream's visions, the art tutor was attributed a synthetic function and became an important conduit for the distribution of the ideas and forms of the Old Master. Additionally, as will become clear, the apotheosis of the studio 'master' to 'Old Master' was far from automatic and the histories traced in this book demonstrate how contentious such associations were.

The Concept of the 'Master' presents a collection of essays engaged with changing discourses on the Old Masters and art history in the art education

of Britain and Ireland. The spectrum of academic and avant-garde attitudes is represented in a range of case studies that include institutions like the Royal Academy (Potter and Wien), the Royal Scottish Academy (Soden), the Royal Cambrian Academy (Potter), the Dublin Metropolitan School of Art (O'Connor), the National Art Training School (Quinn), the Slade (Strickland and Chambers), the Ruskin School of Art (Reed-Tsocha) and Nottingham Trent University (Lee) over the last three centuries. Some of the art-historical interventions highlighted in these essays follow the 'models of excellence' principles of the various teaching institutions, for example, in Soden's discussion of the watercolour copies of Old Master paintings at the Royal Scottish Academy. An important issue that arises from such work is the question of authenticity. As with the 'book-learning' of today, where art students have access to high-quality reproductions in catalogues or Internet images, the importance of seeing works of art in the flesh remains in contemporary art schools.[2] John Frederick Lewis' copies of works by the great masters potentially produced as many semantic problems as they solved. The dubious quality of studying from engravings, for example, has been explored by such theorists as Walter Benjamin and André Malraux, who have focused on the loss of context and 'aura'.[3] In debating the nature of art history, some theorists have argued that it is fundamentally different from the wider discipline of history due to its materiality: unlike the abstract or absentee objects of history (the Bastille, the weather conditions on a battlefield, or some other ephemeral agency), drawings, paintings and sculptures from the past are mostly still present to impact upon the contemporary teacher and student even if their exact form or context may have changed since their point of creation (through damage or placement in a different location).[4] Such a conclusion, however, privileges the pedagogical potency of the 'present' art work above the 'abstract' idea in art. As these essays demonstrate, other historical artefacts such as lectures and books played equally significant roles in transmitting ideas about the art of the Old Masters and provided palpable, if arguably less evocative, physical reminders of the past. There was more than *ekphrasis* at work in these instances: these texts were not simply repositories of data about the physical and formal aspects of art objects; rather, they contained important value judgments through their commentaries. The abstract principles of philosophy or historical agency that they contained constituted the intellectual mortar for binding together the art-historical building blocks for artistic canons. This is true for seminal texts like the 'modernist' encyclopaedic textbook *Art since 1900: Modernism, Antimodernism, Postmodernism* (2004) as much as it is for Reynolds' *Discourses*.

While the history of the symbiotic relationship between art education and art history is truly international and chronologically wide-ranging, the present volume focuses on case studies affecting Britain and Ireland in the period after 1770 in order to form a better understanding of how abstract ideas

contributed to a particular set of national, geographical, socio-economic and political circumstances to create the traditions that exist today in England, Ireland, Scotland and Wales. This book does not seek to provide biographical surveys of the great artists of these countries as art teachers: Reynolds' role as an educator is, for example, addressed in this book tangentially by looking at his discussions of the ornamental and his role as a model for a later President of the Royal Academy. Instead, each chapter focuses on a problem that existed within the history of art education in the British Isles – moments when art history was used or abused to promote a certain agenda or perspective (be it technical or political) and in so doing brings up many neglected issues rather than repeating the conventional stories where art history and art education meet.

The history of modern art education in the British Isles has been largely defined by the institution of art academies. In the mid-eighteenth century, artists followed the artisanal tradition of apprenticeship whereby a young talent would be placed under the supervision of an established practitioner. Such was the case with the generation of artists who formed the bedrock of the modern British national art school: Allan Ramsay (1713–84), Richard Wilson (1714–82), Sir Joshua Reynolds (1723–92) and James Barry (1741–1806) apprenticed respectively to Hans Hysing, Thomas Wright, Thomas Hudson and possibly Jacob Ennis.[5] Such a system was felt wanting by artists who saw the potential benefits of a more professionalised art world in the quickly expanding British commercial and imperial system. Early attempts to remedy the situation occurred when Sir Godfrey Kneller (1711), Sir James Thornhill (1716), Louis Chéron and John Vanderbank (at the first St Martin's Lane Academy: 1720) and ultimately William Hogarth (at the second St Martin's Lane Academy: 1735) established master-class drawing academies, in which copying had no place.[6] Hogarth (1697–1764) had been apprenticed to an engraver Ellis Gamble in London and his desire to establish drawing classes was part of a strategy for establishing not only his professional credentials but also his upwardly mobile social standing. These enterprises were short-lived, dependent as they were on the individuals who led them, but nevertheless they demonstrated the need for such art institutions. Over the next century and a half, more permanent versions of these establishments blossomed with the foundation of the Royal Academy of Arts (London, 1768), the Royal Hibernian Academy (Dublin, 1823), the Royal Scottish Academy (Edinburgh, 1826) and finally the Royal Cambrian Academy (Conwy, 1881).

Without embarking on full institutional histories for these institutions, the role of art education and the provision of 'models of excellence' for the rival 'national' schools of English, Irish, Scottish and Welsh art were singularly important in wider cultural debates. Art was an important index for many of the idiosyncratic cultural identities of constituent national groups within the larger corporate identity of the United Kingdom of Great Britain and Ireland

(1801–1927). The Royal Academy of Arts was established 'in a self-professedly patriotic bid to forge an English School' uniting 'the functions of a public art school, exhibiting society, and a prestigious, genteel platform for native artists'.[7] The role of the Old Masters within this institution was immense, and the clearest evidence of this exists in the hagiographic conclusion to Reynolds' final *Discourse* when he exclaimed: 'THE great Artist ... did not possess his art from nature, but by long study' and that 'these Discourses bear testimony of my admiration of that truly divine man, and I should desire that the last words which I should pronounce in this Academy, and from this place, might be the name of – MICHAEL ANGELO'.[8] Despite its narrowly patriotic rhetoric, the Royal Academy did not establish itself exclusively for English artists. A great many of its members came from Ireland, Scotland, Wales and beyond, and occupied positions of importance within this institution in its first 50 years. Wilson was one of the founding Royal Academicians, for example, and Barry became an RA in 1772 and the Professor of Painting in 1782 before ultimately being expelled in 1798 for his attacks on the Academy's maladministration and failure to support the establishment of a permanent national collection of art.[9]

Much of the motivation for these new academies can be found in the civic humanist ambitions of the mid-eighteenth century onwards. Despite the parochial bent of nationalist movements, historians have often found that better understandings of the mechanics of nation-building can be found by looking to regional and international contexts rather than the hermetically sealed unit of the nation-state itself.[10] Musings on the origins of nationalism arguably began with Ernest Renan's 1882 essay 'What is a nation?', in which he provided the rather imprecise definition of it as an 'expression of a great solidarity'.[11] Since that time, more thorough categorisation formulated by historians has enabled the recognition of two different possible foundations for modern nations: one based on civic or political expediencies and the other formed around ethnic or historical connections (the reality for most nations being a mix of components from both models).[12] Others, like Mikuláš Teich and Roy Porter, have sought to stress the ephemeral and flexible nature of nations – incessantly exchangeable to suit the political contingencies of the moment – whilst dating the origins of patriotic sentiment proper to the Napoleonic Wars.[13]

Benedict Anderson's concept of 'imagined communities' and Eric Hobsbawn and Terence Ranger's associated notion of 'invented traditions' work collaboratively to describe the identity-forming activities of national groups during the fast-transforming and alienating conditions of the Industrial Revolution.[14] As Michael Jeismann has described, the changing social connections entailed in this revolutionary age necessitated the development of dynamic traditions, and state-sponsored institutions (like museums or art schools) provided a crucial role in defining regional identities within a national hierarchy with their subsequent histories being defined

by initiatives for and resistance to centralisation.[15] Oliver Zimmer asks 'is nationalism primarily an ideology or political religion, a political movement seeking state power, a cultural formation allowing industrial societies to function, a modern cognitive framework, a movement of cultural and historical revival, or a combination of these factors?'.[16] Whatever the historical debates about the exact motivation or form of nation-building, the importance of culture within all such exercises is a matter upon which there is unanimous agreement. In artistic terms, whilst national themes emerged in Britain during times of heightened diplomatic tension, for example, in the political cartoons of the Revolutionary and Napoleonic eras or during the Westminster fresco competitions (1843–6), this was in a far from programmatic manner. It was only as the economic repercussions of industrialisation spread to Europe and the national movements of the same period (e.g. Italian unification (1866) and unification of Germany (1870–1871)) that cultural nationalism developed properly. According to Michelle Facos and Sharon L. Hirsh, by the *fin de siècle*, 'in all circumstances, nation-builders relied on visual codes to establish, support, and disseminate their claims'.[17] In the marginalised areas of Europe, artistic developments of regional nationalism (such as those of Slavonic nations on the periphery of the Austro-Hungarian Empire) manifested themselves in movements whose paintings rejected 'outmoded' and 'irrelevant' academic styles of history painting in favour of vernacular mythological manners and subjects.[18]

If nation-building was the key issue for the political and artistic cultures of Europe during the century and a half following the Industrial Revolution, it is important within the contexts of this book to consider how these debates impacted on Britain and Ireland specifically. The eighteenth century was crucial, for political initiatives coincided clearly with socio-economic changes: Great Britain was inaugurated in 1707 with the Act of Union between England and Wales, and Scotland, and 1801 saw the incorporation of Ireland. The extension of British power over the globe through empire changed the scope but not the essential nature of the problem involved in reconciling multiple 'national' groups within one centralising identity.[19] While many histories of the British nation focus straightforwardly on the central and centralising activities of the metropole, even these take stock of the impact of the peripheries on the process of forging the nation.[20] Victor Kiernan, for example, traced the cultural politics of rival Celtic and Anglo-Saxon forces in the definition of the British national question.[21] These ethnic tectonic fault lines are also to be seen running through the histories of art institutions in Britain and Ireland.

Whilst the Celtic fringes generally failed to combine against English inroads (resulting in the widely perceived success of the English 'divide and rule' policy of Anglicisation), Celticism lived on and was often able to develop beyond its original 'narrow' remit to become a significant internationalist force.[22] At home the potential cultural achievements of such nationalist drives

were often defused by the installation of an English or Anglicised elite who were less likely to lend their support. Such divisions were institutionalised by the creation of Anglo-Irish or Anglo-Welsh dynasties, Scottish involvement in the imperial enterprise, and the fracture of Wales along Agrarian North and Industrial South lines. The pace of nationalist debates also followed an undulating rhythm. Whilst home rule was only granted to Ireland in 1914, it had originally been intended to extend it to Wales and Scotland. Presumably the plans were derailed not only by the First and Second World Wars but also the demonstrable failures of the policy to placate Ireland: British bonds were ultimately cut seven years later with the foundation of the Irish Free State (1921), the creation of Eire (1937) and Ireland's departure from the Commonwealth (1939).[23] These cultural and political contexts are crucial for understanding the trials and tribulations of art educational establishments with a national remit, such as the RA, the Royal Hibernian Academy, the Royal Scottish Academy and the Royal Cambrian Academy.

In order to understand why art educational institutions held the Old Masters in such high esteem, it is necessary to turn to the earlier European institutional structures which provided frameworks not only for the organisation of the academies in the British Isles but also academic discourses on art history which were informed by their teaching practice. The key institutions on the continent were the *Accademia delle Arti del Disegno*, established in Florence in 1563, and the *Académie Royale des Beaux Arts*, founded in Paris in 1648. These early academies were forged in the flames of early modern intellectual culture. Expectations regarding the function of education were fundamentally altered by the end of medieval Scholasticism and the rise of more secularised attitudes to learning in the Renaissance. The advent of Humanism in universities like Padua triggered a new paradigm where classical history, rhetoric and the study of jurisprudence replaced theology as the purpose of university training. Attempts to establish art educational institutions at this point thus occurred within the contexts of complex debates centring upon political economy and utility. To establish their right to exist, art academies needed to explain how they provided a service so far unfulfilled by existing institutions. Writers on educational philosophy during this age relied either upon practical (technical) or idealistic (moral) defences for the academies and thus established a traditional divide between the applied and liberal arts with which theorists have had to grapple ever since. Art history offered a supremely suitable tool for proponents of both schools of thought, for not only was art history a bona fide intellectual pursuit, but it also furnished the student with examples of successful practice. As objects of study, the Old Masters had many useful lessons for those who wished to emulate them: in the sixteenth century, artists such as Borghini, Bronzino, Franco, Parmigianino, Raphael, Salviati, Vasari and Venusti drew upon the work and career of Michelangelo for inspiration.[24]

Whether employed for the ends of political economy or technical instruction, the use of art history in such debates was affected by agency and interest. In many cases the process involved a large degree of ventriloquism: posthumously the acquiescent Old Masters were used to articulate the ideas of the later academic theorists and teachers. The new academics were dependent upon the intellectual reputation of the Old Masters as bedrocks on which to establish their own professional credibility. There were, of course, practical reasons for this course of action. Corporate identity was an important concept for artists to cultivate ideologically, for it helped them to break free from the restraints of medieval guilds, such as the guild of Saint Luke in Antwerp, the *Maîtrise* in Paris or the Worshipful Company of Painter-Stainers in London.[25] Old Masters were an effective rhetorical tool for the promotion of the status of artists. These corporate strategies were contextually crucial in providing stepping stones towards the foundational art educational principles of the academies. As Carl Goldstein notes:

> To write the history of art in academies, then, was to sing the praises of the works of Michelangelo, Raphael, Annibale Carracci, and Poussin – as well as the ancients. In the histories themselves, this was done by means of verbal *ekphrasis*, the translation of an image into words, whether by a Vasari or a [Giovan Pietro] Bellori, whose *Lives* consist largely of such detailed descriptions of seminal works.[26]

The dependence upon student-teacher relationships for authority had been a feature of cultural discourse since records began. These traditions emerged in Pliny the Elder's *Natural History* (*Naturalis Historia*) in the first century AD. Pliny painstakingly listed Greek artistic pedagogical networks (recording, for example, those between Aristides and Euxinidas or Pamphilus and Eupompus). Even when Nature served as an artist's only tutor, the master's inspirational role was still normative, as demonstrated by Pliny's account of the model offered to Lysippis of Sicyon by Eupompus' turn to natural forms.[27]

The history of the Old Masters was disrupted by the infamous 'Dark Ages', when anonymity veiled the identity of artists.[28] With the Renaissance came a renewed obsession with individualism in art, identified by Jacob Burckhardt as the defining feature of this epoch, which can be seen in its imperative to record (or invent) details of the lives of artists.[29] It was no accident that Giorgio Vasari's art-historical enterprise, the *Lives of the most eminent Painters, Sculptors and Architects* (1550), was roughly coincident with the foundation of the *Accademia delle Arti del Disegno*. The ability to teach was believed to require a foundation in knowledge about past artistic practice. Likewise, institutionally the shift from the workshop system of the fifteenth century to the *Accademia* model of the sixteenth century was predicated upon facilitating individual enterprise. While workshops provided stability (protecting guild interests, controlling the movement of artists and producing a fixed number of artists as craftsmen), the *Accademia* was by contrast designed as a manufactory of great Masters.[30]

In the account of early interactions between Masters and pedagogy, the issue of Mannerism deserves special attention. The effect of Mannerism (a term Vasari reinvented with his concept of *la maniera moderna* or the 'modern style') on the physical composition of art works in Rome and Florence between 1520 and 1590 was to prescribe complex historical compositions using the nude figure forms promoted by Raphael's late work and Michelangelo's *Last Judgement* (1536–41).[31] According to German commentators like Walter Friedlaender, the defining characteristic of the *maniera* group was their combination of theory with their assiduous emulation of the Masters who preceded them – for Friedlaender, the next generation struggled to break with both theory and the Old Masters, 'for after all, they had all studied under the masters of the past generation, and been brought up on their works'.[32] Yet the geopolitics of rivalry between national schools here entered the fray. Giuliano Briganti suggested that the obsession of German scholars with the anti-naturalistic nature of Mannerism began with Max Dvorak's Expressionist interests and developed into Walter Friedlaender's academic construction of the concept of the 'eternal Gothic spirit'.[33] Writing in 1940, the émigré Nikolaus Pevsner rallied against such a nationalistic view when he saw the Renaissance as producing a great cultural unity around 1500, but that 'as soon as Mannerism had defeated and annihilated Renaissance, that great harmony was torn asunder'.[34] Regardless of the judgment of twentieth-century scholars, the impact of the Old Masters on teaching methods was arguably their most important legacy. Ironically Michelangelo's preference to remain aloof from the *Accademia del Disegnio* during his lifetime was ignored when his state funeral in 1564 was seized upon as an opportunity for enshrining him as its spiritual head. As Elizabeth Pilliod writes:

> the 'unstudied' became the hero of the pedantic Academy. What was studied there did not recapitulate the perceived source of Michelangelo's excellence – genius – as it was understood by most of his contemporaries, or by Vasari himself. Rather, it reflected Vasari's own concept of improvement and perfection through industry. For Vasari, disciplined study was the precondition for a transition from the artisanal culture of the *botteghe* to the realm of the professional.[35]

The French *Académie Royale des Beaux Arts* took this further with its creation of a clearly defined set of academic champions and masterpieces. The process by which the academic canon was fixed is visible in the debates that took place over Nicolas Poussin's *Eliezer and Rebecca at the Well* (Figure 0.1: 1648), for example. In this composition Poussin demonstrated the academic ideals of order and balance in both use of forms and colours (most notably in the evenly distributed blue, green and red dresses and skirts worn by the female characters in the foreground), along with the placement of figures within a landscape setting, and the use of an uplifting historical narrative. However even a painting as grandiose as this and an artist as esteemed as Poussin

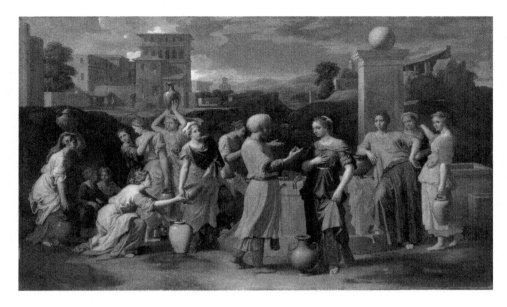

0.1 Nicolas Poussin, *Eliezer et Rebecca* (*Eliezer and Rebecca at the Well*) (1648), oil on canvas, 118 × 199 cm, Musée du Louvre, Paris (C) RMN-GP (Musée du Louvre)/Droits réservés.

were not above questioning. In 1668 Philippe de Champaigne criticised Poussin's decision to omit camels from the scene in contravention of his biblical sources. Yet the internal orthodoxy of academic strictures ultimately triumphed, with Charles Le Brun's defence of Poussin's design – the artist's decision being seen as correct in excluding 'ignoble creatures' in order to maintain both the aesthetic integrity and the uplifting moral narrative of the painting.[36] According to Quentin Bell, the international influence of the *Académie Royale des Beaux Arts* was immense as it was 'the model upon which all other academies were built throughout Europe'.[37] The early history of the *Académie* nevertheless illustrates a fundamental departure from its original principles. The antagonistic components of 'genius' and 'schooling' in Italian Mannerism, identified by Pilliod, were initially reconciled by Charles Le Brun and his colleagues in Paris. They hoped the Old Masters could be used to free, rather than shackle, the minds of artists through emulation rather than copying. Goldstein argues that 'academies aimed to liberate images from the tyranny of texts' so that the institution of academic laws was anathema to the original academics.[38] Likewise, recent scholarship has suggested that the *Académie*'s adoption of conservative and neo-classical principles was more a result of accident than intention.[39] Le Brun's role in establishing a canon of academic artists is well established, with Titian, Veronese and Nicolas Poussin each forming a 'paragon of academic art'.[40] Early attempts to

impose antique artistic canons were, however, resisted by 'modernists' who fought additionally over the issue of line and colour, most notably within the *conférences* of the *Académie*.[41] The ways in which such debates impacted upon the precise relationship between art history and education in Britain can be seen in the professed ideals of Reynolds. That his *Discourses* were free of mimetic prescriptions is reinforced by his personal decision to paint in the modern style of portraiture rather than history painting. Reynolds' promotion of the Carracci provides further evidence of his relativist beliefs as applied to theory. The traditional and apocryphal association of the Carracci school with the theory of eclectic selection (taking the best parts from the Old Masters who preceded them) provided an ideal type for numerous art historians, from Giovanni Pietro Bellori through Johann Joachim Winckelmann to Franz Theodor Kugler.[42] Helpfully this selective method could be traced back even further to the legendary practice of Zeuxis, who took the most perfect parts from multiple models for his depiction of Helen of Troy.

Despite the eclectic beliefs of many early academic artists, there was an inexorable and seemingly irreversible slide in academies towards the encoding of proscriptive rules for art training and practice. The imperative in academies to collect the works of the Old Masters arguably contributed to this process of ossification. For Goldstein, the adoption of 'the functions of a modern museum' by the academies was a conscious decision motivated by controlling desires, for 'in using this collection [of pictures] for purposes of instruction in the history of art', this history became 'the property of the academy'.[43] Such uses for academic collections underline the importance of power-relationships: in a manner analogous to a national bank and its bullion, the academies were seeking to collect masterpieces by which to set the gold standard for taste. This provided them with the authority not only to teach but also to take part in public debates about art.

Nevertheless, the creation of an academic collection did provide the solution to the problem of accessibility faced by artists in the British Isles. Unlike their colleagues in Italy and France who could access works by the great Renaissance artists with relative ease in churches and other public buildings, English artists during the time of Reynolds' presidency faced greater difficulties.[44] The Royal Academy collection was an important foundational act of the original Academicians and it engaged simultaneously with their conception of the interrelationship between art history and education.[45] As Reynolds observed in 1769:

> The principal advantage of an academy is that, besides furnishing able men to direct the student, it will be a repository for the great examples of the Art. These are the materials on which Genius is to work, and without which the strongest intellect may be fruitlessly or deviously employed. By studying these authentick models, that idea of excellence which is the result of the accumulated experience of past ages, may be at once acquired; and the tardy and obstructed progress of our predecessors may teach us a shorter and easier way.[46]

Reynolds' *Self-portrait* (Figure 0.2: c.1779–80) was the founding stone on which the collection rested – with the display of the Diploma Work Collection (since 1810) and further donations, most famously Sir George Beaumont's 1830

0.2 Sir Joshua Reynolds, *Self-portrait* (c.1779–80), oil on panel, 127 × 101.6 cm/Royal Academy of Arts, London, UK/Bridgeman Art Library.

bequest of Michelangelo's *Taddei Tondo* (1504–6).[47] The double importance of the Old Masters was represented by Daniele da Volterra's bust of Michelangelo (1564) that seemingly hovers in the shadows as a haunting presence in the mind of the President. What is more, the submission of Diploma Work followed the example of the *tableau de réception* which the French Academy had imposed since its inception in 1648. With choice donations and a growing collection of masterpieces by Royal Academicians, the Royal Academy hoped to solve the persistent problem faced by artists in Britain of access to great works. In the eighteenth century, artists were dependent upon the patronage or friendship of aristocrats who owned masterpieces or institutions like the Academy. The dual agency of artworks and texts can be seen in J.M.W. Turner's life. His friendship with the Earl of Egremont enabled access to the art collection at Petworth House and, interestingly, Turner's engagement with Old Masters, art theory and pedagogical ideas was indirectly evident in his *Watteau Study by Fresnoy's Rules* (exh. R.A., 1831), which filtered his personal experience of such works through reading a great academic text.[48] Whilst the Grand Tour was the major mode of art education for aristocrats, connoisseurs and dilettantes at this time, it was a luxury from which artists were largely excluded. Reynolds himself was exceptional in travelling to Italy in the two years after his apprenticeship to Thomas Hudson from 1779–c.1780 in order to study the Old Masters and develop an understanding of the 'Grand Style'.[49] For others, there were a few scholarships to Rome, although artists studying in the academies of the British Isles lacked an equivalent to the French *Prix de Rome* and most had to fund their own trips as speculative investments in their careers.[50]

The political contexts in which academies functioned must also be recognised in order to understand their impact upon teaching practices. As historians like Elizabeth Mansfield have noted, the framework of each institution imposed specific ideological parameters on the use of art history within educational practices.[51] In the case of the *Accademia delle Arti del Disegno*, this meant using art education as a form of propaganda: Cosimo I de' Medici's patronage was crucial in the *Accademia*'s foundation and one of its remits was to produce artists to glorify the Florentine city-state.[52] In France, ideology and state power may be implicated in the corruption of the early liberal intellectual ideals of the *l'Académie Royale*. This institution before all others has been seen as demonstrating the politically contingent nature of public art teaching practices. Against the backdrop of the Second World War, Pevsner poignantly drew the links between academicism and absolutism, for 'What had been conceived in absolutist Florence during the age of Mannerism was achieved in absolutist France during the age of Descartes and Richelieu'.[53] This perspective has been revised somewhat, but the relationship that existed between artists and the state in Bourbon France are still seen to have been predicated on political negotiation rather than ideal principles.[54] Whilst Paul Duro discounts the primacy of royal agency in these developments, it is easy

to see the royal ministerial support for the *Académie* as an extension of Cardinal Mazarin's absolutist agenda, actively alienating and disenfranchising the aristocrats and *parlementarians* to the point of open rebellion in the *Fronde* (1648–53).[55] Under Mazarin's successors, this situation continued and Charles Le Brun, as founder of the *Académie*, ultimately benefited from the centralising policies of Louis XIV's *Contrôleur général des finances*, Jean-Baptiste Colbert.

As suggested above, the Old Masters were used as a rhetorical device. Furthermore, the political contingency of such discourse meant that the status of the Old Masters could develop in response to changing requirements. Initially, treatises in defence of the new *Académie* were necessarily innovative, regarding history as providing blueprints for future artists. Such a position was remote from the later practice of 'collecting' artists and metaphorically archiving them in the inner sanctum of the institution. The *Académie* was forced to negotiate for political capital using the growing discourse of civic humanism, selling itself on the benefits it could render to the community at large rather than the privileges and advantages it could give to its private members.[56] The employment of such an argument in the 1640s and 1650s did not prohibit the future subtle shift in attitudes towards the Old Masters. Even the language of civic humanism could be redeployed in support of an academy's interests, shifting focus from outward-looking accountability to introspective self-reliance. The ideas of civic utility could be used to indoctrinate students and preserve the hold of the Old Masters (and their present successors as custodians of the *Académie*) over future generations.

The rather constrained role that art history eventually occupied within the academic educational system was another byproduct of accidental development.[57] In the later part of the seventeenth century academic debates in print and at the *conférences* (held at the *Académie Royale des Beaux Artes* during the late seventeenth century) departed from the relatively free theoretical grounds of previous years in favour of documentary biographies and hagiographical celebrations of past masters, which in turn influenced teaching practices. The initial forward-looking use of the Old Masters in the seventeenth century was replaced by the conservative cast of the *Académie* in the eighteenth century, with a concomitant loss of forward momentum.[58] This is amply demonstrated by the rhetoric employed in Henri van Hulst's *Histoire de l'Académie Royale* from the mid-eighteenth century:

> Let us offer up for a moment our eternal gratitude to the shades of these men [the founders]. What praise have they not earned? We are going to follow in their footsteps, see them at the head of the [French] school, discuss their individual actions. In a word we are going to see the Golden Age of the Academy.[59]

For Hulst, leadership of the contemporary school was to be entrusted to the dead. Such an evolution in the use of art history by the academies may partly

be explained, if not excused, by the *Académie*'s transition from the insecurity of its foundational epoch to the complacency of its later position once it was fully established. This change within the attitude of theorists and academics towards the Old Masters also had an inevitable impact upon the student–Old Master relationship, with the shift in the role of the Old Master from being permanently the object of emulation to instead assuming a secondary role as the creator of objects for students to copy: the common associations of the adjective 'academic' with unoriginal practice dates from such developments.[60]

The language of civic humanism did not fall out of currency despite such developments. Its versatility helped combat such moves, for after all it had been employed both by revolutionaries like Tom Paine as well as by Tories like Edmund Burke to either undermine or support traditions of privilege, property and parliamentary representation under the banner of liberty. When defending himself and his institution against rationalist calls for Enlightenment interventions in the Royal Academy's business, Reynolds declared in 1769 that commercial training was a waste of time and effort for students, and that the more sensible route for reform was via the improvement of the tastes of the general public through the promotion of High Art activities at the Academy. Manufacturers would be forced to up their game by seeking to address the 'polite' elite:

> An Institution like this has often been recommended upon considerations merely mercantile; but an Academy, founded upon such principles, can never effect even its own narrow purposes. If it has an origin no higher, no taste can ever be formed in manufactures; but if the higher Arts of Design flourish, these inferior ends will be answered of course.[61]

Reynolds' principles relied upon an engagement with the political economy of subsistence put forward by such a key Enlightenment thinker as Adam Smith, who argued that Europe's commercial power was a means to the end of moral and cultural improvement.[62] Under Benjamin West's Presidency of the Royal Academy during the Napoleonic Wars, there was a further dalliance with commercialist rhetoric, but the Royal Academy ultimately resorted to self-interest and Tory alliances.[63] It was no mistake that the Royal Academy 'dinners endorsed notions of virtual representation of culture and, in reaction against the emerging egalitarian notions of taste, excluded those whom the Academy did not consider qualified to judge, or likely to patronise, art'.[64] Once again, the Royal Academicians deployed the Old Masters in the way they wished to be viewed themselves as a virtual aristocracy and custodians of cultural continuity. This was demonstrated in the active role the Academicians played as governmental advisers on various occasions – pushing for the reduction in custom levies that had been imposed since 1695 on the importation of art works from Europe, for example.[65] The persistence of these ideals carried through not only into the beginning of the nineteenth

century (as demonstrated by Sir Martin Archer Shee's defence of the Royal Academy's privileges as owing 'much to their Sovereign, but nothing to their country') but also to the present day.[66]

The way in which these debates impacted on art education in Britain and Ireland is evident in the activities of the various national academies mentioned above. In 1823 the Royal Hibernian Academy (RHA) was the first art educational institution to be established as distinct from the RA in London. The degree to which this was motivated by devolutionary sentiment is arguable, but its intention to better serve its locality was evident in its attempt to engage a wider public through exhibitions and art lotteries. This was a clear adoption of the model of the German *Kunstvereine* that had also inspired the London-based Art Union in 1836.[67] Such exhibitions excluded the Old Masters, presumably due to financial considerations, but their role in the history of the RHA has been nevertheless extensive and problematic. The emergence of the National Gallery of Ireland (NGI) near the end of the 1860s offered opportunities for change. The work of Hugh Lane was important in this respect, and in addition to his benefactions to the NGI, he organised an important exhibition of Old Master works at the RHA.[68] The correspondence that appeared in the *All Ireland Review* in November 1902 in response to this exhibition is revealing. Whilst Lane made it known that 'the object of the Exhibition is to encourage the study and appreciation of hitherto unseen works of Art, and it is hoped that it will greatly benefit the Student', the response from Standish O'Grady was perhaps a more accurate representation of Irish attitudes to the Old Masters:

> In spite of my very Irish proclivities, and a certain disrespect, which I can't help, for Old Masters, and Raths, and Ruins, even for Tara, I think that your movement is on [the] right lines, and that we all ought to stand by it. You have addressed your letter to me to Castle Bamford, Co. Kilkenny, which I left more than two years since. You imagined, doubtless, that with such a high-sounding address I was sure to have there a grand supply of 'Old Masters', but in fact the only Old Master there was myself; and done by Mr. Yeats, standing on an easel in the dining-room scowling against Fate.[69]

The National Gallery of Ireland has since taken up wholeheartedly the duty of arranging Old Master shows, leaving the RHA to concentrate on contemporary work. In terms of its teaching remit, Arthur Gibney, former President of the RHA, made observations in 2002 upon its future pedagogical role and how important a sense of art history was in this with the return to drawing in the life class:

> One of the big problems in most art schools in Ireland is the lack of fundamental historical knowledge of painting from life. The life class hasn't the importance it had in traditional art schools. We're not really involved in any stylistic expression: Impressionism, Expressionism, Abstract. The thing

that holds us together is the belief in the central aspect of the art division: drawing. Drawing is the central skill and discipline that we believe in.[70]

By contrast, the establishment of a national provision of art education was a relatively drawn-out process in Scotland. The Honourable Board of Trustees for Fisheries and Manufactures in Scotland founded the Trustees' Academy in Edinburgh in 1760 as a drawing school to improve design skills in support of Scottish industries. Over the decades, it developed into an academy for aspiring fine artists – for example, in 1798, during John Graham's tenure as master, a cast gallery was instigated and teaching facilities were improved under subsequent masters such as Andrew Wilson. However, it was only in 1826 that the vision for a national fine art academy emerged with the foundation of the (Royal) Scottish Academy 'on the principles of that of London' and the Schools of the Royal Academy of Arts based on the Old Masters, contemporary painting and life drawing.[71] Primarily the RSA was a professional association rather than a teaching institution. Nevertheless, educational provision was included in its founding aims, the second of which advertised the intention 'To open an Academy where … the Students in the Arts may find that instruction so long wanted and wished for in this Country, free of expense', and once sufficient funding was available, the RSA opened a much longed-for Life Class in 1840.[72] This functioned on and off until 1911 when it was superseded by the recently established Edinburgh College of Art.[73] Thereafter, the RSA has moved from being an art teaching provider to an art teaching enabler through scholarships, awards and competitions.

The RSA also appointed Professors of Antiquities and Ancient History, although little actual teaching was done by incumbents. For example, the antiquarian David Laing was elected Honorary Professor of Antiquities (1854) and Honorary Professor of Ancient History (1861), and in 1861 delivered a short series of public lectures.[74] The RSA's aspirations here were initially strongly influenced by the RA, and these can be seen in the draft constitution printed in its First Annual Report (1828), which proclaimed that 'There shall be a Professor of Painting who shall annually read six lectures in the Scottish Academy to instruct Artists in the principles of composition, to form their taste of Design and colouring and to point out the beauties and imperfections in celebrated works of Art' and that 'no comments or criticisms or opinions on the productions of living Artists in this country shall be introduced into any lectures delivered in the Scottish Academy'.[75] The role of art history was thus limited within such teaching strategies, focused as it was on practical affairs. Nevertheless, emulating London, the RSA's educational principle was to teach through the example of exhibited works, the institution having been established 'to encourage the practice of the Fine Arts in Scotland by showing to the Public representative Collections of Works mainly by Scottish Artists of the time'.[76] Frank Rinder called in 1917 for the public support of all academies

'to preserve the continuity of the arts' as 'the duty of an enlightened and patriotic people'.[77] He believed that the course of a century had discredited Reynolds' plan for learning from Old Masters who were from 'an alien time and a different race', and that the Royal Academy was not the best model to follow; according to Rinder, the RSA's 'differentiating characteristics have onward from its very inception – as in the stimulating purchase of Etty's "Judith" pictures … – betokened a truer apprehension of an Academy's functions and educative influence' by engaging with contemporary artistic affairs.[78] Such activity was far from uncomplicated, for at the time the council was criticised for over-stepping its remit in making such a purchase, although in the long term this investment paid dividends in offering inspiration and direction to a generation of Scottish artists.[79]

The pedagogical role of historic art was long established in Edinburgh. Study at the Trustees' Academy was based on antique casts rather than Old Master paintings. Robert Scott Lauder, who took over from William Allan at the Trustees' Academy in 1829 and was elected to the RSA in 1830, introduced the importance of life drawing in connection with subject painting as 'Director of the Antique'.[80] The status of the Old Masters at the RSA itself features prominently in William Darling McKay's 'Historical Narrative', which states explicitly that the collection was intended to provide objects for study. The third aim of the RSA on its foundation was: 'To form a Library of Books of Painting, Sculpture and Architecture and all other objects relating thereto, and also of Painting, Prints, Casts and Models and all things useful to the Students in their Art'.[81] Scottish artists who had moved to London, and many of whom were Royal Academicians themselves, expressed a desire 'to assist in the formation of a Scottish School of Painting by contributing works which, along with the Diploma works of Academicians, would lay the foundation of such a school'.[82] In practice, apart from the Diploma Collection of significant representative works by its Scottish academician members, the RSA's art collection was a piecemeal affair dependent on benefactors and erratic funding. However, it played a significant role in the cultural landscape of Edinburgh and when the National Gallery of Scotland (NGS; rebranded as the Scottish National Gallery in 2012) opened, the RSA's collection was hung alongside the nascent national collection and incorporated into its published catalogues throughout the nineteenth century. The relationship that developed between the RSA and the NGS was similar to that which existed between the Royal Academy and the National Gallery in London. Academicians played an important advisory role in acquisition policies for the National Galleries. Like Charles Lock Eastlake and Edward John Poynter, the RSA's members were central in decision making at the NGS and academicians were appointed as curators of the NGS. This institutional coordination was helped by the academies and galleries often sharing the same physical space, as was the case in London between 1837 and 1868 at Trafalgar Square, and in Edinburgh

between 1850 and 1911 on the Mound.[83] In addition, some significant works were gifted to the RSA on the basis that they would eventually be passed on to the NGS, such as David Robert's presentation of *Rome from the Convent on San Onofrio on Mount Janiculum* (c.1853–5) and the RSA purchase of the *Adoration of the Magi* attributed then to Titian but now to Bassano.[84]

Compared to the RHA and the RSA, the Royal Cambrian Academy has suffered relative neglect, with few modern historians taking an interest in it. As the history of the foundation of this institution falls squarely within the remit of one of the chapters contained in this book, little space will be given here to the subject. Nevertheless it is worth emphasising that the same issues of art-historical stimuli, cultural nationalism and divided loyalties apply to Welsh art education as they do to the other regions of Britain and Ireland.

For idealists, Pevsner included, there existed a fundamental tension between liberal artistic traditions and the prospect of state intervention in education. The history of art education, and the limited role of the Old Masters within this, spoke to the evolving discourse in Britain during the nineteenth century with the establishment of the Government Schools of Design in 1837. However, perhaps reflecting the utilitarian and oligarchic, if not truly democratic, nature of English governance at this time, there were arguably no petty social or political ulterior motives behind the scheme for the Schools of Design. The government wanted to promote good workmanship to make sure that the nation's products would continue to be competitive in the global markets of the day: when the Schools were rebranded as the Department of Practical Art in 1852 and then again as the Department of Science and Art in 1853 under the auspices of the Board of Trade, the idea of the vocational art school blended straightforwardly into the plans for making a permanent legacy for the Great Exhibition of 1851.[85]

The curriculum for the Schools of Design was significant as it avoided the 'Old Masters' model of the academies, instead taking on a rather formalist nature through the study of outline drawing and examples of good designs to be emulated rather than the artists or designers themselves.[86] Shunning the lofty moral associations of the nude (promoted by the allied traditions of life study and history painting) which had been an important foundation for both the RA Schools and its closest rival, the Slade School, the Schools of Design turned instead to the useful study of beautiful objects and the pillorying of grotesque ornaments that populated Henry Cole's celebrated 'Chambers of Horrors'.[87] At this point it is easy to suggest an overly simplified division between the academic and practical aims of the rival British art educational institutions. Indeed, Benjamin Robert Haydon's attacks on the Academy represented a third way for reform, one which never happened but suggested a course in which the aristocracy of the Old Masters and supremacy of the Grand Manner could be divided from the tyranny and privileges extended automatically to modern academies.[88] Nevertheless, the vocational demands

of practical training for artists created disruptive tensions in art schools across Britain in the nineteenth century and in so doing provided an alternative to the academic system that equated the Old Master–student and tutor–student relationships. There were ambitions to address 'Art proper, or Industrial Art' in such establishments as the Manchester School of Art Museum in the late nineteenth century, resulting in one-man shows of work by William Morris, Edward Burne-Jones and Walter Crane, but the haphazard process of acquisition by donation prohibited any systematic approach comparable to the academic ethos.[89] Nevertheless, at that time Manchester promoted 'an art and design training which chose to emphasise the importance of studying the history of the fine and decorative arts through subject analysis, with past and present set side by side', as opposed to a study of the Romantic creative genius of artist-designers or the effects of grand historical motors.[90] The small amount of time devoted to the education of taste in the Schools of Design, whilst forming an analogy to Coldstream's later provision of art-historical courses for art students, provided a questionable grounding, and was certainly far less ambitious than the liberal education ideals of the Academy. Bell notes that the Academy was 'intended to give artists a new and improved social status, to make them the equal of the poets and philosophers', but by contrast the industrial student's subject 'was not a liberal art, he had no muse, he was a manual labourer who aspired to become a shopkeeper'.[91] The Schools of Design represented a conscious decision by the government to foster art education free from art-historical intervention and the Old Masters, taking material artefacts and studying them 'out of context' for their utilitarian lessons.

Regardless of the intentions of the academies to reinvent versions of the Old Masters through art-historical teaching alongside their collecting and exhibiting practices, in reality the mercurial spirits of these deceased great artists were hard to pin down. An important result of postmodern thought has been to undermine former monopolies of authorship and authority, so that both Old Masters and the institutions reliant upon their influence have been destabilised. Infinite variety has been generated by the realisation that a new version of a 'text' is created on every subsequent reading to which it is subjected. Amongst critical discourses on art history and education, there is therefore no authoritative reading of any artist: there is no longer one Reynolds, for example, but multiple versions, and at no point can a definitive reading of Reynolds occur that will prevent subsequent new versions from being created. Despite the 'absolute' idealist foundations of many academies, the rhetorical framework for education and art history thus carries an inherent instability within its structure. 'Models of excellence', be they art works or literature, have therefore been able to develop intriguing multiple lives, allowing for their continual reinterpretation and deployment to alternatively support or subvert academic principles and the varied institutions which employed them.

Modern theory has not only made the relationship between Old Masters and art teaching problematic through such multiplicity, but the modernist mindset has also openly challenged many of the principles upon which the esteem of the Old Masters was based. An important characteristic of the process of learning from Old Masters is its inertial nature: cultivating a habitual crick in the neck from looking to the past that will forever resist straightening. Since the 1960s and the attempts of the Coldstream reports to impose contextual studies upon art students, a tension has developed between art teaching practice emphasising historical study and that involved in contemporary art-making techniques. Student rebellions against conservative teaching practice in the 1960s spread across the British Isles. That at the Hornsey College of Art and Crafts in 1968 has arguably attracted most interest due to the experimental student administration that was installed during the demonstration. At Hornsey, part of the problem was the institutional tension created by Coldstream's reforms, which saw art school teachers becoming resentful of the invasion of university academics to teach art history, which as a discipline was often seen as 'remote in practice from the interests of the studio, and its emphasis on painting and sculpture had little or nothing to offer design students'.[92] Similar revolts against the continuation or imposition of 'conservative' values occurred across Britain. In Ireland, student unrest in the late 1960s brought an end to the academic hold the RHA had over the teaching practices of the National College of Art.[93] By the 1970s, educational theorists were able to talk of art history as 'discredited' as an aid to teaching art due to the dual problems of its assumed 'objectivity' and the anti-art ethos generated in the contemporary institutions of learning.[94] From such a perspective, the use of art history also implied a subscription to the values of the past, threatening a revival of the *ancien régime* with the teaching of art history serving to reinforce conservative imperatives such as the academic aristocracy and the gender bias of mastery. In the arena of art history, assaults have been made most effectively on these prejudices by scholars cross-examining modernism in art and its historiography. Griselda Pollock's writings on this subject, for example, can be taken as symptomatic of the discourse, in which modern art history is described in imperialistic terms with colonising male 'painter-heroes' determining the course of art history and art historians conspiring to help perpetuate these fantasies of power and control through the 'uncritical acceptance of the authority of masculinity, whiteness and Europeanness'.[95] As representatives of the old order, the role of the Masters might now represent models of 'bad' or 'old-fashioned' practice just as easily as 'excellence'. As Pollock herself notes, this was a feature encouraged by the agencies of modernism and the avant-garde. An important aspect of postmodern criticism has also been the exposure of hegemonic agencies. Roland Barthes' famous exclamation of the death of the author has a natural counterpart in the 'death of the Old Master'. Ultimately implicated in

the creation of the field of authority, Barthes employed a pre-eminent master-artist in his list of cultural figures involved in the production of the malicious cult of individuality and authority:

> criticism still consists for the most part in saying that Baudelaire's work is the failure of Baudelaire the man, Van Gogh's his madness, Tchaikovsky's his vice. The *explanation* of a work is always sought in the man or woman who produced it, as if it were always in the end, through the more or less transparent allegory of the fiction, the voice of a single person, the *author* 'confiding' in us.[96]

The Old Master type could just as easily be used to create anti-academic canons and support principles alternative to the Academy. In addition to Vincent Van Gogh's function as a type of author (the mad genius), invoked by Barthes, there is the hagiographical function evident in André Malraux's form-creator (from Peter Paul Rubens to Paul Gauguin) or Clement Greenberg's action painter (Jackson Pollock) whose individualities challenged conventions.[97] In 1973, writing in favour of the reform of art history teaching, though not specifically about its use in art education, Sonia Rouve suggested the abandonment of myopic art-historical research disciplines and the embrace of subjectivity and generalisation, most notably through the empathic use of formal analogies to replace the cold scientific stratification of chronological art histories.[98]

Whatever the changeable features of this discourse, the self-conscious invocation of art-historical models has become *de rigueur* for modern artists. Art historians have frequently traced how artists have addressed the Old Masters in their practice.[99] It has become a leitmotif of referential modernism in a hereditary line passing from Paul Gauguin's gambit of 'reference, deference, and difference', through Marcel Duchamp's *L.H.O.O.Q.* (1919) to contemporary works like Jake and Dinos Chapman's *Great Deeds Against the Dead* (1997) and *Insult to Injury* (2003), or Julian Opie's *Eat Dirt Art History – A Pile of Old Masters (J.O.)* (2004).[100] Though not perhaps intentionally pedagogical in their address, these works have nevertheless entered classrooms through reproduction and discussion between tutors and students.

Yet if the relativism of interdisciplinarity and multiple perspectives has successfully displaced the universalism of past intellectual and philosophical paradigms, what place is left for the Old Masters and art history in modern art education? Postmodernist discourse may in fact be more forgiving in its attitude to the past. As André Malraux noted: 'Artists do not stem from their childhood, but from their conflict with the achievements of their predecessors; not from their own formless world, but from their struggle with the forms which others have imposed on life'.[101] Additionally, instead of providing one set of Old Masters to contend with, the multiplicity of interpretation has in fact led to a repopulation of the constellation of great artists, furnishing infinite versions of each Old Master for students to study and interpret and for tutors

to 'teach'. With the revival of painting celebrated in Charles Saatchi's *Triumph of Painting* (2005), there has even been a recent effort to relocate indexes of authority and authenticity in the phenomenal experience of the artist and his or her brush – placing such individuals as Marlene Dumas and Luc Tuymans within a revised art-historical canon. Under such circumstances, the demise of the author and the Old Master had perhaps been announced too soon. Against such a backdrop, it is possible to talk to some degree of a return of the author/master within art education.[102]

Allied to the above discussion of the intellectual culture and historical conditions under which the academies of Europe and those in Britain and Ireland were formed is the issue of contextuality and rhetoric. As has been noted above in relation to Pliny, Vasari and Bellori, the literature of art history and art education was tied to a public discourse of civic utility. It became an important tool in a war of words waged between competing institutions and powers. Discourse theory and the work of Quentin Skinner and J.G.A. Pocock perhaps provide the most appropriate theoretical grounding for such discussions, and a concern with rhetoric is a characteristic that links the chapters in this book. Those by Potter, Quinn, Reed-Tsocha and Wien engage explicitly with these issues through the analysis of the language used by art educators and essayists in their discussion of art history and how this was defined by contemporary conventions. Whether it be the Humanist defence of the Academy by Reynolds against the pragmatic demands of the Enlightenment, Poynter's use of Ruskinian political economy to support the spiritual wellbeing and ennoblement of the worker, Leighton's adoption of Hegelian notions of historical agency, or the insertion of the October group's operative framework within modern art school curricula, all these examples speak of the idiosyncrasies of changing pedagogical and wider political economic contexts. Throughout these chapters, the conservative or progressive spirit of the age was mirrored in its pedagogical systems. Ideological and philosophical issues are also recurring. Strickland's investigation of the impact of gender on the experiences of art students reflects socio-economic and political changes that occurred in Britain in the twentieth century. Whilst the effect of the Enlightenment and Romantic movements is evident in the discussions of Potter, Pütz and Wien, the final chapters of Reed-Tsocha and Lee demonstrate the shifts that have led to the dominant influence of postmodern discourse in the practice of art school teaching today. Furthermore, issues of nationalism and cultural identity arise in the chapters that cover the core–periphery tensions within art education in Britain and Ireland (O'Connor, Potter, Pütz and Soden).

Another major theme presents itself in the form of contests over authority and the struggle for autonomy. The practice of art education through art history has never been conducted in a vacuum and several of the accounts included in this book trace how individuals were restricted in their activities

by the political constraints of the environments in which they worked. Barlow traces an alternative to the academic perspective on the masters and art education offered by a market-orientated standpoint. This was available to artists in Britain during the eighteenth and nineteenth centuries and was arguably better suited to the national character of a 'polite and commercial' people. Quinn's study of the National Art Training School gives a critical account of how government intervention skewed the intention of art trainers in their use of art history and the Old Masters. Under such conditions, art educational institutions developed pedagogical philosophies that often propagated and perpetuated such tensions. The implication of such pressures is also evident in the foundational principles that were rejected at the Slade in the 1950s, when tutors like Coldstream attempted to bypass academic traditions through alternative empirical models.

The final issue to consider here is one of chronological linkage. The overall impact of these studies is far from teleological. While identifying the developmental nature of numerous pedagogies (be they academic or avant-garde, traditionalist or modernist), what is clear from these examples is that free-form relationships were spawned by the accidental nature of personal contacts and educational environments. The art history certain artists experienced when they were students subsequently informed their own choice of pedagogical strategy when embarking upon the task of teaching art through or against (old or new) masters. What is clear is that surprising connections form in the flexible realm of artistic inspiration, defying both theoretical expectations and easy categorisation. Chronological slippage thus occurs between the eighteenth and nineteenth centuries when Leighton borrowed from Reynolds, just as much as in the twentieth century when Orpen turned to the nineteenth-century French masters in teaching Keating or when Lynton engaged with themes raised by Poynter. The extent to which art teachers were constrained in their use of art-historical examples was limited only by their creative ambitions. The chapters by Lee and Reed-Tsocha demonstrate the importance of the Old Masters within contemporary debates on art history's role in art education. Should the fact that artists like Jeff Wall hold the Old Masters in esteem be seen as a form of useless nostalgia? Does the customer-oriented turn of higher education in the twenty-first century mean that teachers should follow the apathetic attitude to art history of some of their studio-based students? Is it even desirable to resolve such a debate once and for all, for is not the continually evolving and repeated discursive process a positive end in itself for tutors and students alike?

The intention of this book is ultimately to offer students of art and art history insights into the debates and contexts which were formative at key moments when these disciplines interacted in art education in Britain and Ireland. By taking this wider chronological and geographical perspective, it is hoped that readers will be encouraged to forge links of their own between

the 'live questions' that trouble students and teachers in the present and those that exercised their colleagues in days gone by. Returning to the imperative issued by Reynolds in 1769, these chapters help us to appreciate not only the intellectual and technical lessons artist-teachers drew from the practice of their predecessors but also the ways in which the use of art history in art teaching has altered in response to the changing conditions of the time. Learning from the Masters has become a problematic strategy for those involved in the business of art education, and the masters themselves have been variously subjected to praise, ridicule and postmodern assassination.

Notes

1 Sir Joshua Reynolds, 'Discourse I, January 2, 1769', in Robert R. Wark (ed.), *Sir Joshua Reynolds, Discourses on Art* (New Haven, CT: Yale University Press, 1997), p. 17.

2 Penny McKeon, 'The Sense of Art History in Art Education', *Journal of Aesthetic Education*, 36(2) (Summer 2002), pp. 98–9: 'The autonomy of art and the intrinsic value of art history are respected by looking to the structure and particularity of art-historical knowing rather than pursuing the pedagogical tactic of shackling the value of art history to notions of visual culture, visual literacy, or other instrumental interpretations. By providing students with systematic concepts and practical strategies for active participation, the individual knower is capable of moving in an informed, even shrewd way from passive to active art world player beyond the school years'.

3 Carl Goldstein, *Teaching Art: Academies and Schools from Vasari to Albers* (Cambridge: Cambridge University Press, 1996), p. 81. However, as Goldstein points out, 'academies blurred the distinction between original and copy, going so far as to encourage their artists to regard virtual copies as originals' (p. 7).

4 Sonia Rouve, 'Teaching Art History: A Methodological Reappraisal', in Dick Field and John Newick (eds), *The Study of Education and Art* (London: Routledge & Kegan Paul, 1973), p. 194.

5 Alastair Smart, *Allan Ramsay, 1713–1784* (Edinburgh: Trustees of the National Galleries of Scotland, 1992), p. 5; David H. Solkin, *Richard Wilson: The Landscape of Reaction* (London: Tate Gallery Publications, 1982), p. 12; James Northcote, *The Life of Sir Joshua Reynolds* (London: Henry Colburn, 1819, 2 volumes), Vol. I, pp. 16–17; William L. Pressly, *The Life and Art of James Barry* (New Haven, CT: Yale University Press, 1981), p. 4; Fionnuala McManamon, 'James Barry: A History Painter in Paris in the 1760s', in Tom Dunne and William L. Pressly (eds), *James Barry, 1741–1806: History Painter* (Aldershot: Ashgate, 2010), p. 43.

6 Rica Jones, 'The Artist's Training and Techniques', in Tate Gallery, *Manners & Morals: Hogarth and British Painting 1700–1760* (London: Tate Gallery Publications, 1987), pp. 19–22.

7 Holger Hoock, *The King's Artists: The Royal Academy of Arts and the Politics of British Culture, 1760–1840* (Oxford: Oxford University Press, 2003), p. 7.

8 Reynolds, 'Discourse XV, December 10, 1790', in Wark (ed.), *Discourses*, pp. 281–2.

9 Solkin, *Richard Wilson*, p. 16; Pressly, *The Life and Art of James Barry*, pp. 37, 133, 139–41.

10 Oliver Zimmer, *Nationalism in Europe, 1890–1940* (Basingstoke: Palgrave Macmillan, 2003), pp. 45–6.

11 Quoted in Timothy Baycroft and Mark Hewitson, 'Introduction', in Timothy Baycroft and Mark Hewitson (eds), *What is a Nation? Europe 1789–1914* (Oxford: Oxford University Press, 2006), p. 1.

12 Ibid., pp. 2–7.

13 Mikuláš Teich and Roy Porter, 'Introduction', in Mikuláš Teich and Roy Porter (eds), *The National Question in Europe in Historical Context* (Cambridge: Cambridge University Press, 1993), pp. xvi–xvii, xix.

14 Benedict Anderson, *Imagined Communities: Reflections on the Origin and Spread of Nationalism* (London: Verso, 1983); Eric Hobsbawn and Terence Ranger (eds), *The Invention of Tradition* (Cambridge: Cambridge University Press, 1983).

15 Michael Jeismann, 'Nation, Identity, and Enmity: Towards a Theory of Political Identification', in Baycroft and Hewitson (eds), *What is a Nation?*, pp. 25–6.

16 Zimmer, *Nationalism in Europe, 1890–1940*, p. 5.

17 Michelle Facos and Sharon L. Hirsh, 'Introduction', in Michelle Facos and Sharon L. Hirsh (eds), *Art Culture and National Identity in Fin-de-Siecle Europe* (Cambridge: Cambridge University Press, 2003), p. 3.

18 Ibid., p. 6.

19 Chris Williams, 'The United Kingdom: British Nationalisms During the Long Nineteenth Century', in Baycroft and Hewitson (eds), *What is a Nation?*, pp. 272–4.

20 See Linda Colley, *Britons: Forging the Nation, 1707–1837* (New Haven, CT: Yale University Press [1992], 1994), Chapter 3, 'Peripheries'.

21 Victor Kiernan, 'The British Isles: Celt and Saxon', in Teich and Porter (eds), *The National Question in Europe in Historical Context*, pp. 1–3.

22 Murdo Macdonald, 'Celticism and Internationalism in the Circle of Patrick Geddes', *Visual Culture in Britain*, 6(2) (2005), pp. 69–83.

23 Kiernan, 'The British Isles: Celt and Saxon', pp. 4, 6, 10, 14–15, 27.

24 Frances Ames-Lewis and Paul Joannides (eds), *Reactions to the Master: Michelangelo's Effect on Art and Artists in the Sixteenth Century* (Aldershot: Ashgate, 2003).

25 Nikolaus Pevsner, *Academies of Art, Past and Present* (Cambridge: Cambridge University Press, 1940), p. 152.

26 Goldstein, *Teaching Art*, p. 79.

27 Pliny, *Natural History Books XXXIII–XXXVI with an English translation by H. Rackham* (Cambridge, MA: Harvard University Press, 1952), Book XXXIV, Section 61, p. 173.

28 Andrew Martindale, *The Rise of the Artist in the Middle Ages and Early Renaissance* (London: Thames & Hudson, 1972), pp. 97–9: Discussions of this age-old art-historical problem are legion, but Martindale explains how rather than seeing the fame of artists as a glorious invention of the Renaissance, a more accurate explanation of earlier anonymity (as accidental rather than purposeful) is to be found in the absence of documentation or the lack of interest in the arts during the medieval period. More recent discussion of the issue of the fame or anonymity of artists occur in, for example, Janetta Rebold Benton, *Art of the Middle Ages* (London: Thames & Hudson, 2002), pp. 7, 17–18; Neil MacGregor, *A Victim of Anonymity: The Master of the Saint Bartholomew Altarpiece* (London: Thames & Hudson, 1993); and Emma Barker, Nick Webb and Kim Woods (eds), *The Changing Status of the Artist* (New Haven, CT: Yale University Press, 1999).

29 Ernst Kris and Otto Kurz, *Legend, Myth and Magic in the Image of the Artist: A Historical Experiment* (New Haven, CT: Yale University Press, 1979), pp. 9, 24. The tale of Cimabue's discovery of his precocious ward Giotto is part of the primordial myths of art history. However, the accounts of Vasari, Ghiberti and that in the Anonimo Fiorentino commentary on Dante were pure fabrications.

30 Evelyn Welch, *Art and Society in Italy* (Oxford: Oxford University Press, 1997), pp. 83–6.

31 Giuliano Briganti, *Italian Mannerism* (London: Thames & Hudson, 1961), p. 44; Linda Murray, *The High Renaissance and Mannerism: Italy, the North and Spain 1500–1600* (London: Thames & Hudson, 1967 [1977]), pp. 124–6.

32 Walter Friedlaender, *Mannerism and Anti-Mannerism in Italian Painting*; introduction by Donald Posner (New York: Schocken Books, [1965]), p. 52. See also Arnold Hauser, *Mannerism: The Crisis of the Renaissance and the Origin of Modern Art* (Cambridge, MA: Belknap Press of Harvard University Press, 1986; London: Routledge & Kegan Paul, 1965).

33 Briganti, *Italian Mannerism*, pp. 8–9.

34 Pevsner, *Academies of Art*, p. 12.

35 Elizabeth Pilliod, 'The Influence of Michelangelo: Pontormo, Bronzino and Allori', in Ames-Lewis and Joannides (eds), *Reactions to the Master*, p. 33.

36 Paul Duro, *The Academy and the Limits of Painting in Seventeenth-Century France* (Cambridge: Cambridge University Press, 1997), pp. 1, 128–30.

37 Quentin Bell, *The Schools of Design* (London: Routledge & Kegan Paul, 1963), p. 18.

38 Goldstein, *Teaching Art*, p. 7.

39 June E. Hargrove, 'Introduction', in June E. Hargrove (ed.), *The French Academy: Classicism and its Antagonists* (Newark, NJ: University of Delaware Press, 1990), p. 11.

40 Linda Walsh, 'Charles Lebrun, "Art Dictator of France"', in Gill Perry and Colin Cunningham (eds), *Academies, Museums and Canons of Art* (New Haven, CT: Yale University Press, 1999), p. 117; Bell, *The Schools of Design*, pp. 7, 8, 285.

41 Hargrove, 'Introduction', p. 13.

42 Denis Mahon, *Studies in Seicento Art and Theory* (Westport, CT: Greenwood Press, 1971), pp. 198–9, 205–8, 213, 219, 222. Mahon argues that Annibale Carracci was in fact a naturalistic 'reformer' rather than a hagiographic classicist and that historians were misled by Malvasia who attributed a dubious sonnet to the artist in 1678. It was not until Jacob Burckhardt that the cliché of Carraccian eclecticism was seriously re-examined.

43 Goldstein, *Teaching Art*, p. 75.

44 Ibid., pp. 78–9.

45 The power of such a work is amply demonstrated by the various sketches of Michelangelo's marble sculptures that exist in the Royal Academy's drawing collection. Sir David Wilkie RA made the *Sketch of Michelangelo's Taddei tondo* (c.1823?) shortly after Beaumont acquired the piece for his Grosvenor Square residence and John Constable's *Sketch of Michelangelo's Taddei Tondo, 1st July 1830* marks the excitement on the occasion when it was transferred on Beaumont's death to the Royal Academy.

46 Reynolds, 'Discourse I (1769)', in Wark (ed.), *Discourses*, p. 15.

47 Hoock, *The King's Artists*, p. 73: see also Holger Hoock, 'Old Masters and the English School: The Royal Academy of Arts and the Notion of a National Gallery at the Turn of the Nineteenth Century', *Journal of the History of Collections*, 16(1) (2004), pp. 1–18.

48 James Hamilton, *Turner: A Life* (London: Hodder & Stoughton, 1996), pp. 113–15; David Solkin (ed.), *Turner and the Masters* (London: Tate Publishing, 2009), pp. 43, 67, 125, 128, 174–7.

49 Northcote, *The Life of Sir Joshua Reynolds*, Vol. I, pp. 26–8. According to Northcote, after parting company with Thomas Hudson, who was jealous of his student's abilities, Reynolds returned to Plymouth and secured the patronage of the Mount Edgcumbe family. Their introduction of Reynolds to Commodore Augustus Keppel led to an invitation by the latter for the artist to join him in sailing to Italy: 'the friendship of the Commodore, as well as his own merit, soon introduced him to notice, and he was employed busily in painting the portraits of almost all the officers in the garrison and on the station [of Port Mahon], greatly to the improvement of his skill and fortune'. Northcote also related details of Reynolds' activities in Italy (see pp. 31–43). See Richard Wendorf, *Sir Joshua Reynolds: The Painter in Society* (Cambridge, MA: Harvard University Press, 1996), pp. 161–2 for a brief discussion of Keppel's importance to Reynolds' rise.

50 Andrew Wilton (ed.), *Grand Tour: The Lure of Italy in the Eighteenth Century* (London: Tate Gallery Publishing, 1996), pp. 85–7, 134–5, 138, 143, 149, 156, 159–60, 162–3, 197, 290. Artists who followed this practice included John Robert Cozens, William Marlow, Thomas Patch, Jonathan Skelton, Francis Towne, Joseph Wright of Derby and Richard Wilson.

51 Elizabeth Mansfield, *Art History and its Institutions: Foundations of a Discipline* (London: Routledge, 2002), pp. 2–3.

52 D.V. Kent, *Cosimo de' Medici and the Florentine Renaissance: The Patron's Oeuvre* (New Haven, CT: Yale University Press, 2000).

53 Pevsner, *Academies of Art*, p. 17.

54 Hargrove, 'Introduction', p. 13. Historians like Antoine Schnapper and Gail Davidson have argued instead that royal protection was a necessary evil to allow modernisation by professional artists breaking away from the constraints of the feudal guilds and the malign effects of mannerism.

55 Duro, *The Academy and the Limits of Painting*, pp. 11, 18, 31.

56 Ibid., p. 42.

57 Ibid., p. 127.

58 Ibid., pp. 152–3.

59 Ibid., p. 153; Archives de l'École Nationale Supérieure des Beaux-Arts, Paris. Ms. 14, Henri van Hulst, 'Histoire de l'Académie Royale de Peinture et de la Sculpture de 1648 à 1653', p. 25.

60 Jo Alice Leeds, 'Copying and Invention as Sources of Form in Art', *Art Education*, 37(2) (March 1984), pp. 41–6; Paul Barlow, 'Fear and Loathing of the Academic, or Just What is it that Makes the Avant-Garde So Different, So Appealing?', in R. Denis and C. Trodd (eds), *Art and the Academy in the Nineteenth Century* (Manchester: Manchester University Press, 2000), pp. 15, 21.

61 Reynolds, 'Discourse I (1769)', p. 13.

62 David Bindman, *Ape to Apollo: Aesthetics and the Idea of Race in the 18th Century* (Ithaca, NY: Cornell University Press, 2002), p. 60.

63 Hoock, *The King's Artists*, pp. 129, 132, 231.

64 Ibid., pp. 218–21.

65 Ibid., pp. 240–45.

66 Matthew C. Potter, 'A Glorious Revolution in British Art?', in C. Keeley and K. Boardman (eds), *1848: The Year the World Turned?* (Newcastle: Cambridge Scholars Press, 2007), pp. 251–2.

67 Robin Lenman, *Artists and Society in Germany 1850–1914* (Manchester: Manchester University Press, 1997), pp. 66–7; William Vaughan, *German Romanticism and English Art* (New Haven, CT: Yale University Press, 1979), p. 8.

68 Robert O'Byrne, *Hugh Lane 1875–1915* (Dublin: Lilliput Press, 2000), pp. 42–3.

69 Hugh P. Lane and Standish O'Grady, 'Royal Hibernian Academy of Arts, Lower Abbey Street, Dublin. Winter Exhibition – Old Masters', *All Ireland Review* (15 November 1902), p. 607.

70 John Mulcahy and Arthur Gibney, 'Arthur Gibney on the Future of the RHA', *Irish Arts Review*, 19(1) (Summer 2002), p. 47.

71 In 1838 the Scottish Academy received a Royal Charter and has subsequently been known as the Royal Scottish Academy. Since 2005 its official full title has been the Royal Scottish Academy of Art and Architecture. See also W.D. McKay, 'The Royal Scottish Academy: A Historical Narrative', in W.D. McKay and Frank Rinder, *The Royal Scottish Academy, 1826–1916* (Glasgow: James Maclehose & Sons, 1917), pp. xxxi, lxiii.

72 Copy of letter, J. Elder to Lord Advocate of Scotland, 6 January 1826, *Minute Book 1826–1830*, pp. 39–43, RSA Archives. For more on the establishment of the RSA, see Joanna Soden, 'Tradition, Evolution, Opportunism. The Role of the Royal Scottish Academy in Art Education 1826–1910' (unpublished PhD thesis, University of Aberdeen, 2006), pp. 4–37, 38–75.

73 In 1858 the Trustees' Academy was renamed the Trustees' School of Art and from this date operated under the auspices of the Science and Art Department in South Kensington. It was taken over by the Scottish Education Department in 1907.

74 Murray C.T. Simpson, 'Laing, David (1793–1878)', in H.C.G. Matthew and Brian Harrison (eds), *Oxford Dictionary of National Biography* (Oxford: Oxford University Press, 2004), Vol. XXXII, pp. 219–22.

75 Quoted in Esme Gordon, *The Royal Scottish Academy of Painting, Sculpture and Architecture: 1826–1976* (Edinburgh: Skilton, 1976), pp. 23, 34–5.

76 Anon., *Centenary Exhibition of the Royal Scottish Academy of Paintings, Sculpture, and Architecture 1826–1926* (Edinburgh: Royal Scottish Academy, [1926]), p. 11.

77 Frank Rinder, 'Academies and Art', in McKay and Rinder, *The Royal Scottish Academy*, p. xi.

78 Ibid., pp. xxiii, xxviii; see also Soden, 'Tradition, Evolution, Opportunism', pp. 81–9.

79 Gordon, *The Royal Scottish Academy*, pp. 56–7.

80 Ibid., p. 69; Lindsay Errington, *Master Class: Robert Scott Lauder and his Pupils* ([Aberdeen]: National Galleries of Scotland, 1983), pp. 10, 16, 33; Duncan Macmillan, 'Lauder, Robert Scott (1803–1869)', in Matthew and Harrison (eds), *Oxford Dictionary of National Biography*, Vol. XXXII, pp. 675–6.

81 RSA Archives: copy of letter, J. Elder to Lord Advocate of Scotland, 6 January 1826, *Minute Book 1826–1830*, pp. 39–43; quoted in Soden, 'Tradition, Evolution, Opportunism', p. 6.

82 McKay, 'The Royal Scottish Academy: A Historical Narrative', p. lxi.

83 Academicians and Honorary Academicians who were on the staff of the National Galleries of Scotland included amongst its Principal Curators William Borthwick Johnstone RSA (1858–68), James Drummond RSA (1868–77), Sir William Fettes Douglas RSA (1877–82), Gourlay Steel

RSA (1882–94) and Robert Gibb RSA (1895–1907), and as its Directors, Sir James Caw HRSA (1907–30) and Sir Stanley Cursiter RSA (1930–1948): my thanks to Joanna Soden for sourcing this information. See also Gordon, *The Royal Scottish Academy*, p. 118.

84 Ibid., pp. 109, 117, 125, 128.

85 Hermione Hobhouse, *The Crystal Palace and the Great Exhibition: Art Science and Productive Industry: A History of the Royal Commission for the Exhibition of 1851* (London: Continuum, 2002), pp. 85–9, 112.

86 Bell, *The Schools of Design*, pp. 1–3, 25–8, 67–73.

87 Bruce Laughton, 'Introduction', in *A Centenary Exhibition: The Slade, 1871–1971* (London: Royal Academy of Arts, 1971), p. 9; Christopher Frayling, *Henry Cole and the Chamber of Horrors: The Curious Origins of the V&A* (London: V&A Publishing, 2010).

88 Hoock, *The King's Artists*, pp. 132, 304.

89 David Jeremiah, 'Lessons from Objects', *Journal of Art & Design Education*, 3(2) (1984), pp. 217–18, 222.

90 Ibid., p. 215.

91 Bell, *The Schools of Design*, pp. 9–10.

92 Lisa Tickner, *Hornsey 1968: The Art School Revolution* (London: Frances Lincoln, 2008), pp. 47–8.

93 Brian Fallon, *Irish Art 1830–1990* (Belfast: Appletree Press, 1994), p. 183.

94 Rouve, 'Teaching Art History', pp. 187–8.

95 Griselda Pollock, 'Beholding Art History: Vision, Place and Power', in Stephen Melville and Bill Readings (eds), *Vision and Textuality* (Basingstoke: Macmillan, 1995), pp. 39–40.

96 Roland Barthes, 'The Death of the Author', in *Image Music Text* (London: Fontana Press, 1977), p. 143 (emphasis in original).

97 André Malraux, *Psychologie de l'art: la création artistique* (Geneva: Skira, 1947–8), p. 128.

98 Rouve, 'Teaching Art History', pp. 191–201, 205–6.

99 Elizabeth Cowling, 'Competition and Collaboration: Picasso and the Old Masters', in Elizabeth Cowling (ed.), *Picasso: Challenging the Past* (New Haven, CT: Yale University Press, 2009), pp. 11–23; David Solkin (ed.), *Turner and the Masters* (London: Tate Publishing, 2009).

100 Griselda Pollock, *Avant-Garde Gambits 1888–1893: Gender and the Colour of Art History* (London: Pandora Books, 1992), pp. 12–14.

101 André Malraux, *The Voices of Silence* (trans. Stuart Gilbert) (Princeton, NJ: Princeton University Press, 1953 [1978]), p. 281.

102 Séan Burke, *The Death and Return of the Author: Criticism and Subjectivity in Barthes, Foucault, and Derrida* (Edinburgh: Edinburgh University Press, 1998).

Naturalising Tradition: Why Learn from the Masters?

Iris Wien

'THEORY is the knowledge of what is truly NATURE' is written on a scroll held by Joshua Reynolds' lofty personification of the *Theory of Art* (1779).[1] In his 1781 guide to the premises of the Royal Academy (RA) which had recently opened in the new Somerset House, Giuseppe Baretti described this female figure as 'an elegant and majestick female, seated in the clouds, and looking upwards, as contemplating the Heavens'.[2] In the context of the ceiling of the Royal Academy library, the statement on Theory's label not only explains the meaning of the image, but, moreover, represents the Academy's artistic doctrine.[3] These tenets were formulated more substantially in the 15 *Discourses* Reynolds delivered annually and later biannually on the occasion of the RA's award ceremony singling out the best student works to academy members, students and a selected public. This purpose affected the form and content of the lectures, which at times reflected current events of the contemporary artistic world or ongoing aesthetic discussions. Whereas the early discourses are more didactic and develop a curriculum for the student in three stages, the later ones were more expansive in their aesthetic engagements.[4] Given the fact that the Academy lectures were composed and delivered over a course of 21 years, Reynolds' *Discourses* nevertheless developed a remarkable coherence in their theoretical observations, despite not evolving into a fully-fledged aesthetic system.[5] One important conceptual thread that emerged in the *Discourses* centres on the question of how theory mediates between diverse natural and socio-historical stimuli in the production of artworks. According to academic principles of reason, theory ought to guide the artist in developing exemplary works of art, which transcend the individual, the local and all that is merely ephemeral. But in Reynolds' lectures, theory has to cope with difficulties besides these, such as the practical reconciliation of natural observation with academic ideals of general beauty and the juxtaposition of static traditions with dynamic concepts of historical change. Such a debate was

of major importance to a President of the Royal Academy seeking to educate both assembled students and the public at large. This chapter examines how Reynolds tackled these problems by exploring his attempts to resolve these difficulties through the rhetorical device of a 'naturalising tradition' which he advocated most prominently in his seventh *Discourse*, which explored the use of 'ornaments of art'.

In order to elucidate his concepts and hierarchies of artists, schools, styles and genres as well as sporadically illustrating general rules of colour, chiaroscuro or composition, Reynolds discussed various works of the Old Masters, continually pondering on the individual merits and defects of their works. However, the discourses were not intended to develop art students technically, but rather intellectually. Moreover, the lectures were also semi-public events that formed part of the official image of the RA. As president of a royal institution, Reynolds could lay claim to setting a standard of taste in the arts and to defining its criteria in his lectures not only for the benefit of his students but also for the sake of the nation.[6] In its intellectual orientation the Academy had a distinctive continental profile and in its hierarchical structure it was, according to Holger Hoock, 'more similar to the hierarchical and rigid Parisian model, than the more democratic and informal Italian one'.[7] Whereas the students of the contemporary rival academy of the Society of Artists of Great Britain could attend lectures on the chemistry of pigments, in the RA, the practical tuition in painting techniques and the knowledge of pigments was relegated to the studio apprenticeship every student had to complete before commencing compositional training.[8] Similar to the Académie des Beaux-Arts in Paris, further instruction at the RA took place in special lectures on anatomy, architecture and painting, as well as on geometry and perspective, alongside the Antique and Life Schools.[9]

The difficulty of tracing the pedagogical impact of Reynolds' *Discourses* and theories was flagged up clearly by one of his pupils, James Northcote.[10] In Reynolds' studio the dominant method of teaching and learning was by reference to the works of the Old Masters. As Northcote's letters to his brother show, he had fully absorbed his master's theory of imitation and Reynolds' warning to confine the study of the art of painting to only one favourite master.[11] Northcote complained that Reynolds was not a very communicative teacher, instead giving paintings from his own collection to his pupils for copying and providing them with access to his personal library for their studies.[12] Nevertheless, as Northcote explained to his reluctant family, it was absolutely necessary to travel to Italy in order to become acquainted first hand with the works of antiquity and of the Modern Masters to complete his education.[13]

According to Reynolds, studying the Old Masters meant more than merely distinguishing the different manner of each artist and school; in fact, the aspiring artist had to adopt a forensic approach in order to understand the

working process as much as 'the contrivance in the composition' and the way pictorial concepts were developed.[14] Only through such an approach could an artist appropriate models effectively and then transform them into integral parts of his or her own work. Furthermore, a broad and sound knowledge of the Old Masters was of paramount importance in terms of conceiving ideal beauty. For Reynolds, the pursuit of ideal beauty was the main objective of art, and this became a recurrent theme in the discourses. By objectifying the entirely intellectual nature of the idea of general or ideal beauty, the painter can, as Reynolds wrote, 'raise the thoughts, and extend the views of the spectator'.[15] Thus, the artist could contribute to the necessary gradual refinement of taste, eventually leading not only the individual beholder but also entire nations to virtue.[16] Notwithstanding the ideal nature of beauty, Reynolds emphasised that this ideal is 'not to be sought in the heavens, but upon earth'.[17] He conceived of ideal perfection and beauty not as *a priori* forms, but insisted that these must be achieved by experience.[18] The *Discourses* refer to two different but complementary procedures by which the artist can come closer to the concept of ideal beauty: first, studying nature in a specific way and, second, studying the works of the Old Masters.

Nature in her concrete individual forms was inherently deficient for Reynolds; hence, to know what is truly natural meant to abstract 'from all singular forms, local customs, particularities, and details of every kind'.[19] This process of abstraction was to be conducted according to an idea of perfect nature, which the artist gains by 'contemplation and comparison of these forms; and which, by a long habit of observing what any set of objects of the same kind have in common, has acquired the power of discerning what each wants in particular'.[20] The improvement of nature via selection is a classical topos, revived by Renaissance art theory, but in previous forms usually the most beautiful detail was selected from a model and synthesised into a new form of the artist's invention.[21] In contrast, Reynolds' process eliminated all that was particular and transitory in order to depict the 'central forms' of 'general nature' following John Locke's empirical epistemology.[22] According to Reynolds, the painter of the great style, 'like the philosopher, will consider nature in the abstract, and represent in every one of his figures the character of its species'.[23]

Unlike Horace Walpole and Edmund Burke, who understood painting as a transparent mimetic and therefore a natural medium of communication, Reynolds emphasised its artificiality. He was somewhat closer to the transformative view of the Earl of Shaftesbury who had declared in *Sensus Communis, an Essay on the Freedom of wit and humour* (1709) that if artists were to imitate nature in its original peculiar character, they 'will make the subject appear unlike to anything extant in the world besides'.[24] Painting thus resembled the capacity of language to form general concepts. One could say that Reynolds understood representation in painting as an artificial construction, which had to transcend the particularity of individual perceptions, and thus

students wanting to understand naturalism in art had to look to the artistic process, not nature itself. In the fourteenth *Discourse* (1788) Reynolds presented an encomium on his recently deceased former rival Thomas Gainsborough in which he discussed the imitation of nature as an elementary part of painting or the 'language of art'.[25] But even at this very basic level, where invention and originality were not yet at stake, Reynolds insisted that mimesis was a complex undertaking and that artists could only learn from nature with the help of the Old Masters. From them the art student had to learn 'the true art of seeing nature'.[26] In his notes on Charles-Alfonse Dufresnoy's didactic poem *The Art of Painting* (1783), Reynolds pointed out that the rules teaching the artist to see nature in an aesthetic way were 'formed on the various works of those who have studied Nature the most successfully'.[27] For him, nature was an enormous conglomerate of minutae, an 'accumulation of particulars' which lacked intrinsic meaning for 'The mind is distracted with the variety of accidents, for so they ought to be called rather than forms' so that 'by generalizing his ideas, the painter has acquired the only true criterion of judgment'.[28]

Rejecting inductive methods vehemently in his theoretical writings was all the more important to Reynolds since there was a voice at the RA prompting students to exact empirical observation, minute scrutiny and systematic description in words and images. This voice belonged to Dr William Hunter, anatomist and physician, who delivered anatomy lectures at the RA and thought the 'simple portrait' superior to a more synthetic method of representation because it reflected the 'mark of truth'.[29]

As becomes apparent in Reynolds' insistence on studying the Old Masters, the process of abstraction towards the expression of general ideas was not solely the individual task of each painter. It had to take place in the mediated context of collective experience, and only in this abstraction from subjective perception could it lay claim to be meaningful to others.[30] In contrast to Hunter and Gainsborough, Reynolds believed that general aesthetic ideas of nature could only be deduced from the efforts of the Old Masters, for the modern artist 'sets out with an ample inheritance, and avails himself of the selection of ages'.[31] From the Old Masters one could learn the 'characteristick distinctions' of objects, which 'press strongly on the senses, and therefore fix the imagination'.[32] In the eleventh *Discourse* Reynolds emphasised that the artist could never hope to express these characteristic traits by the mere diligent accumulation of particulars.[33]

The exceptional role of the Old Masters in Reynolds' art theory can be explained by his understanding of painting as a language which was universally accepted as a non-natural medium based on conventional signs. Due to the artificial nature of painting, only the works of the Old Masters could provide models of ideal beauty in art.[34]

Like John Locke, Reynolds seemed to have understood beauty as a complex idea of a mixed mode, which did not directly correspond to anything existing

in reality.[35] Functioning in a similar way to abstract ideas in Locke's philosophy of mind, for Reynolds, ideal beauty had its foundation in the similarity of things. As such, ideal beauty was a mental construct of the understanding. It did not have a physical precedence in nature and therefore could only be positively defined by reference to beautiful art works.[36] The school of casts at the RA furnished the students with the main examples of antique sculpture. Studying these was considered to be the only 'method of shortening the road to perfect nature' by Reynolds.[37] Thus, ancient sculptures gained the same status as *genus* in Locke's classification where definition by *genus* is described as a shortcut avoiding the troublesome enumeration of simple ideas.[38] In addition, Reynolds regarded the ancient sculptors as especially privileged in being free of all the artifice of fashion: 'They had, probably, little or nothing to unlearn, as their manners were naturally approaching to this desirable simplicity; while the modern artist, before he can see the truth of things, is obliged to remove a veil, with which the fashion of the times has thought proper to cover her'.[39] Holding the ancient masters in high esteem, Reynolds judged the modern Masters, with the exceptions of Michelangelo and Raphael, less leniently.[40] Nevertheless, he believed they also needed to be studied carefully, since only then could the arts improve. His belief in historical progress applied primarily to the 'mechanical part' of the arts. He thought that this part of artistic production was guided more and more by means of fixed and ascertained principles.[41] Whereas investigating nature scientifically was irrelevant to his notion of art, he nevertheless conceived of the technical improvement of painting as analogous to the continually increasing fund of scientific knowledge.[42]

However, the imitation of the Old Masters was not only absolutely necessary at the elementary level of mimetic techniques in painting but also in the higher reaches of artistic practice. Pertinent to his views on education, in his sixth *Discourse* Reynolds wrote that even genius 'is the child of imitation', since invention is reliant on it.[43] A rich 'assemblage of all the treasures of ancient and modern art' in the mind of the artist was seen as the most important resource of a painter and 'the greatest means of invention'.[44] Reynolds' concept of imitation ought to be understood as a selective and highly creative process that aimed at the emulation of one's predecessors. Repetition of certain figures, attitudes or actions attested originality to the artist as long as it was performed ingeniously and in order to demonstrate that the artist was a judicious arbiter. Reynolds called creative or demonstrative repetition 'borrowing'.[45] This kind of pictorial quotation not only allowed artists to demonstrate their learning but also exercised the intellect of the audience. In learning common visual codes and references through the history of art, viewers could distinguish different referential layers and understand borrowing as a competitive trope.[46]

The central place where necessary knowledge of the history of art could be acquired and the eye trained in comparative seeing was the library. Studying

the Old Masters in the library was all the more important to English artists because they had no easy access to art collections in their own country, as Northcote recognised.[47] The RA did not possess its own collection of Old Master paintings from which the students could have benefited and it was not until the beginning of the nineteenth century that Old Master exhibitions became a regular feature of the London art world thanks to the efforts of the British Institution.[48] At the same time, theoretical discussion and graphic reproduction of more and more artworks complicated the formation of one authoritative canon of art and the relationships between the included works.

Reynolds defined the canon in terms of tradition. This did not mean that it was a fixed entity to be passed on from one generation to the next, but a slowly growing body of works which could evolve with learned taste. Individual artists might re-evaluate certain works from the past, but it was the test of time that determined whether claims for modifying the canon were justified.[49] If the formation of the canon via tradition was a collective undertaking, tradition itself now became a critical value and had to be understood.[50]

In his last lecture Reynolds, emphasised that with his theoretical observations, he had aimed at critically reassessing the inherited canon of art with the help of rationally demonstrable principles:

> I have pursued a plain and honest method; I have taken up the art simply as I found it exemplified in the practice of the most approved Painters. That approbation, which the world has uniformly given I have endeavoured to justify by such proofs as questions of this kind will admit; by the analogy which Painting holds with the sister Arts, and consequently by the common congeniality which they all bear to our nature … I have succeeded in establishing the rules and principles of our Art on a more firm and lasting foundation than that on which they had formerly been placed.[51]

What is clear from this statement is Reynolds' recognition that tradition was itself unstable. What is also apparent is that a critical re-evaluation of the Old Masters was of paramount importance for a successful continuation of tradition. Even though the Italian followers of Michelangelo possessed the great model of a 'true, genuine, noble, and elevated mind', having only possessed it 'as by inheritance', they could not make successful use of it according to Reynolds.[52] Thus, in order to characterise the immediate dissemination of Michelangelo's grand style all over Europe, the President of the RA used a metaphor of contagion: 'Some caught it by living at the time, and coming into contact with the author, whilst others received it at a second hand'.[53] Paradoxically it seems to be exactly this unconscious absorption and indiscriminate proliferation over a succession of several generations of artists that Reynolds thought to have resulted in the deterioration of the arts during his own time, when artists proceeded 'without thought, and with as little trouble, working as by receipt'.[54]

Given the non-systematic nature of the *Discourses*, it comes as no surprise that this complex of problems was never straightforwardly set down by Reynolds. Nevertheless, in his subtle analysis of single artworks, he frequently referred to this ideal and the elusive canon by allocating a position for each artist and work in a hierarchy of artistic styles and schools. One reason for only tacitly referring to the canon may be found in his sceptical attitude towards absolute standards in aesthetic judgments. In his famous 'Balance des Peintres' in the *Cours de Peinture par principes*, published in 1708, Roger de Piles had opted for analytical evaluation, quantifying the quality of composition, drawing, colouring and expression separately.[55] William Hogarth had already lampooned this approach, and Reynolds would have agreed with this assessment due to his belief that aesthetic rules could not be established *a priori* and that artworks possessed a degree of aesthetic autonomy, for 'the art is better learned from the works themselves than from the precepts which are formed upon those works'.[56]

Perhaps surprisingly, the vital role of tradition in Reynolds' art theory becomes most apparent in the argument he put forward for the 'ornaments of art'. Whilst academic rules restricted the use of ornament, for example, prohibiting its use in works of the highest academic category of the sublime, the potentially destabilising nature of ornaments attracted Reynolds. In looking at ornament, he was interested in it as a means of expression, thus further exploring the analogous character of painting and language by considering the formation of figurative meaning in both media.[57] Reynolds argued for a thoroughly linguistic conception of painting. In stressing its artificiality throughout his art-theoretical writings, he revived the principle of *ut pictura poesis*, which had come under attack in the late eighteenth century.[58] In analysing Reynolds' language, it becomes obvious that he not only knew all the main positions and arguments of contemporary intellectual discourse, but also that his own writings were innovative contributions to this field.[59] Based on the standards of poetics, Reynolds distinguished between two different kinds of pictorial ornaments: first, ornaments appealing merely to the senses of the beholder, such as the pattern of chiaroscuro or the colour scheme of a painting, which he compared to the formal poetic means of rhyme, rhythm and verse, describing them as a 'vehicle of sentiment'; and, secondly, pictorial tropes, like allegory and personification, which appealed to the intellect of the recipient and could be compared to the figurative use of language in poetry.[60] But in the same manner as rhetorical tropes were vilified as unnecessary ornaments that veiled truth in early Enlightenment poetics, pictorial allegory was increasingly criticised as an artificial obfuscation of meaning. The perceptual and aesthetic unity of the image was jeopardised by such forms, according to Horace Walpole in his invective against the 'hieroglyphic cattle' of attributes that usually accompanied artistic personification.[61]

In Reynolds' seventh *Discourse*, which provides a rationale of genius and taste, one finds a revealing apology for the ornaments of art. In view of Reynolds' depreciation of the ornamental style, one is puzzled to read: 'We may add likewise to the credit of ornaments, that it is by their means that art itself accomplishes its purpose'.[62] It is true that Reynolds' apology for the ornaments of art primarily concerns art works whose main task was decorative. However, his appreciation of such works as were displayed in the *Galerie de Rubens* in the Luxembourg Palace is itself remarkable, especially if one bears in mind the widespread rejection Rubens' mingling of historical and fictitious personages encountered in the contemporary art theory of figures like the Abbé du Bos and Horace Walpole.[63] For Reynolds, allegory ranked among the indispensable means of the artist because he understood it as expressive ornament which transcended the mere imitation of nature. For him, the mythological personages in the *Galerie de Rubens* constituted an important component of a valuable language or *lingua franca* of ornamental painting handed down as antiquarian custom and fable.[64] In vindicating Rubens' use of allegory, Roger de Piles had already stressed that allegorical painting as a kind of language must be firmly rooted in tradition in order to be easily understood.[65]

The prevalent argument against allegory – also brought forward by Walpole – that it depended on conventions and therefore was purely arbitrary did not convince Reynolds. Even though the ornaments of art needed to be based on mutual consent and established conventions, their dependence on opinion instead of proven knowledge did not prevent their use in painting.[66] For Reynolds, it was much more important to find out if the opinions and prejudices these ornaments followed were of permanent validity and could therefore serve as a kind of 'secondary truth'.[67] Customs and habits, such as the manner of greeting, constituted for him the 'ornaments of life' which in turn were established by general principles of 'urbanity, politeness, or civility' held as the foundation of politeness by all civilised nations.[68] To a certain degree, they thus represented an anthropological universal and as such the very foundation of culture.

This correlation becomes clear at the end of the seventh *Discourse*, where Reynolds connects the 'secondary truth' of 'general prejudices' and 'opinions' to the association of ideas. He illustrated this by reminding his audience how the costumes used by Van Dyck remained popular in portrait painting for a long time after the artist had died. Ornamentation thus served an associational function. In the later portraits, 'very ordinary pictures acquired something of the works of Van Dyck' by their use of Stuart couture and thus also bathed themselves in the reflected status of the Old Master to whom they alluded.[69] Even though the connections established by association seemed to be completely arbitrary at first, it was possible to show that they followed rules and could be explained with reference to tradition.[70] Such observations

display Reynolds' awareness of the complexity of the human imagination, which once again could benefit the artist as long as he or she was attendant to learning not only from personal experience but also from the example of past artists. Embedding individual experience within the broader framework of cultural tradition prevented the artist from developing a merely idiosyncratic artistic language which did not reach the public, for, as Reynolds argued: 'It is from knowing what are the general feelings and passions of mankind, that we acquire a true idea of what imagination is'.[71]

For Reynolds, the inherited language and tradition of art played an important role in establishing the value of cultural activity in the present. These beliefs had important repercussions for the kind of pedagogical conclusions he reached. The history of the arts represented a kind of treasure chest for the accumulated experience of mankind. According to Reynolds, art works that had been cherished by many generations reflected the 'history of the mind of man'. Thus, studying their history was equivalent to studying the history of the mind of man. The foundations for such a premise also explain his advocacy of the analogies between the sister arts and the universal principle of association that governed the human imagination and passions when involved in creative affairs.[72] Furthermore, a thorough historical knowledge of the arts was desirable for developing a shared pictorial language between artists and their audiences. The *Discourses* served a vital educational function in fixing the terms of engagement for the learned artist and student with the polite and educated public.

In Reynolds' opinion, the inventive use of allegory was a token of artistic excellence allowing the artist to generate figurative meaning in painting, thus augmenting pictorial tradition. In contrast to superficial ornaments which appealed directly to 'the sensuality of our taste', allegory ranked high in Reynolds' hierarchy of artistic means because it addressed itself to the mind of the beholder.[73] It was a visual means that depended on 'the organization of the soul', which meant for Reynolds the imagination and the passions.[74] He defended allegorical painting by stressing that it enabled the painter not only to attract but also to fix the attention of the beholder. This was achieved because allegory produced 'a greater variety of ideal beauty, a richer, a more various and delightful composition' and gave greater opportunity of exhibiting artistic skill.[75]

Reynolds' seventh *Discourse* forms a defence of the kind of early mythological character portraits he produced himself, for example, *Elizabeth Montagu, Duchess of Manchester, as Diana Disarming Cupid*. When Reynolds showed this painting at the RA exhibition of 1769, it was much criticised since people did not know what to make of the analogy it made between Lady Montagu and the chaste goddess of Diana.[76] In his Academy lecture of 1776, Reynolds argued that allegory was nevertheless an important means of artistic expression:

> The variety which portraits and modern dresses, mixed with allegorical
> figures, produce, is not to be slightly given up upon a punctilio of reason,
> when that reason deprives the art in a manner of its very existence. It must
> always be remembered that the business of a great Painter, is to produce
> a great picture, he must therefore take especial care not to be cajoled by
> specious arguments out of his materials.[77]

This rarely quoted statement functions as more than self-defence; rather,
Reynolds' in-depth analysis of the relation of the ornaments of art to custom,
habits and tradition, and hence to the association of ideas in the seventh
Discourse, demonstrates how important the creation of figurative meaning
was to his theoretical conception of art.

The canon of art that Reynolds was trying to establish in his *Discourses*
by dint of a sophisticated hierarchy of genres and painterly styles is in a
way naturalised through its link with the various cognitive faculties. The
ornamental style was closely linked to the lower faculties of the senses. This
legitimised Reynolds' devaluation of this style and the schools of painting
employing it. By contrast, the 'grand style', with its use of abstractions,
appealed to the imagination directly and could hence lay claim to the top
rank in Reynolds' hierarchy. The creation of figurative meaning seems to have
had an exceptional position in this system of norms and values. On the one
hand, it was part of ornament in painting, while on the other hand, it directly
appealed to the mind of the beholder and therefore exceeded mere formal
means in painting.

Reynolds' linking of the ornaments of art to the association of ideas in a way
naturalised such ornaments that were based on fixed principles of association.[78]
While 'merely arbitrary ... ornaments and modes of address' ought strictly
to be avoided, ornaments could also contribute to the aesthetic value of an
artwork when 'founded in the nature of our passions and affections'.[79] Thus,
the artificiality of the associational link generated by ornaments did not bar
Reynolds from valuing it highly as long as this link was deeply embedded in
cultural reference and tradition. As such, it actually was an indication of the
poetry of art, as he set out in the thirteenth *Discourse*:

> there is another principle in the human mind, to which the work must be
> referred, which still renders it more artificial, carries it still further from
> common nature, and deviates only to render it more perfect. That principle
> is the sense of congruity, coherence, and consistency, which is a real existing
> principle in man; and it must be gratified.[80]

This appreciation of artificiality can be further explained by Reynolds'
continuous analogising of poetry and painting, despite contemporary
tendencies in poetic and aesthetic discourse to emphasise their medial
differences.[81] He absorbed Edmund Burke's concept of poetry, which was
developed in Burke's 1759 treatise, *A Philosophical Enquiry into the Origin of*

Our Ideas of the Sublime and Beautiful.[82] But whereas Burke, like du Bos and Walpole, considered painting a natural medium and therefore incapable of creating sublime figurative meaning, Reynolds emphasised that sublime art had to be highly artificial as well, even though he had to confess that painting was more limited in its use of figurative tropes.[83] Thus, Reynolds countered Burke's devaluation of painting as merely imitative art by appropriating and at the same time modifying Burke's own argumentation.

By insisting on the *ut pictura poesis* doctrine, Reynolds was still adhering to a thoroughly rhetorical conception of art.[84] Nevertheless, the definition of rhetoric was changing in the late eighteenth century, as the title of George Campbell's highly influential book *The Philosophy of Rhetoric* (1778) indicates. Rhetoric ceased to be a compendium of rules, which imparted practical knowledge about ethics and the art of eloquence, but rather laid claim to being a universal theory of communication. Reynolds was familiar with this rhetorical and epistemological discourse through such writers as Hugh Blair and James Beattie.[85] His distinction between fluctuating and fixed principles of association determining both the ornaments of art and – on a more basic level – pictorial composition seems to originate in this discourse. Like him, George Campbell wanted to separate merely ornamental figures of speech from tropes and figures which represented fundamental activities of the human mind. Informed by these epistemological ties, figurative language was no longer seen as mere adornment, but instead became a general mode of human expression and thought.[86] In Reynolds' theory, pictorial devices such as allegory profited from this re-evaluation of figurative tropes.

In Reynolds' theoretical considerations about the ornaments of art, one main difficulty becomes manifest in the relationship between historical change and tradition. Through its ornaments, the historically contingent nature of art becomes most apparent. Yet this aspect of historical change threatens the universality of Reynolds' idealised concept of art and taste. Nevertheless, universality may be retained by firmly embedding the ornaments of art in tradition, especially as their legibility was dependent upon their currency. Whilst an undisrupted tradition might have been lost in Reynolds' opinion, an alternative constant was established by principles of association: the fact that mankind could be relied upon to react in the same way to different yet similar circumstances allowed Reynolds to square the historical and the ideal. His complex train of thought in the seventh *Discourse* forms the framework for establishing a valid taxonomy of the historical phenomena of art. Such an argument not only provided a rational justification of the canon of art but also established an anthropological foundation for art and culture at large.

Thus, the role of art history was crucial in order to teach art students and the general public the language of art. A sound knowledge of the tradition of art was particularly important for artists wanting to transcend conventional practice and innovate. Only then could the painter master invention,

extend the scope of painting and open up new intellectual prospects for the arts without losing the crucial frame of reference that linked the artist to his or her audience. Reynolds not only recommended the inventive use of tradition in relation to the creation of meaning in his Academy lectures, but also demonstrated it in his artistic practice. Looking at his own art-historical borrowings, it becomes apparent that his recourse to past models usually transcended mere pragmatic appropriation and involved pictorial reflections on the production of aesthetic meaning itself. Nevertheless, the interpreter of Reynolds' paintings ought to be aware that all quotations of artistic traditions are semantically meaningful in a very tangible way. They not only serve to demonstrate Reynolds' detailed acquaintance with these traditions and illustrate his art theory, but they can also be used as agents in the construction of specific pictorial meaning. However, we should keep in mind that due to the parameters of Reynolds' own theoretical position, none of these semantic references can be understood as producing fixed meanings; rather, these references open up a field of possible associations, which depend on the context in which they appear, in much the same way as words do in a text. Reynolds' mentor Samuel Johnson had called attention to the fact that language is not a static entity but has developed through usage and various accidents in his *Plan of a Dictionary* (1747).[87] For Johnson, in contrast to mathematics, language was not uniform and her signs were not fixed, but words gained their meanings through association and experience.[88]

In accordance with these developments, Reynolds forged innovative modern forms to create figurative meanings that were based upon association, and thereby intentionally incorporated ambiguity within his paintings. His pictures therefore often became invested with double meanings, sometimes referring self-consciously to the artificiality of painting and the autonomy of its aesthetic tradition, and on other occasions hinting at a concealed character trait of a sitter through a classical allusion. Such rebuses presented perpetual challenges to the audience. Reynolds' strategy of using borrowings to invest his pictorial inventions with layers of meaning should be understood precisely like rhetorical ornament, since it worked as an addition to the main message of a painting. Part of the strategy was to present an image which had a straightforward meaning at first glance, ostensibly requiring no search for further meanings. But if the polysemy of Reynolds' paintings is discovered, it elicits a special kind of intellectual pleasure for the beholder, adding 'wit' and further beauty to the painting.[89] At the same time, the strategy of borrowing introduces a more philosophical subtext to Reynolds' paintings as it provokes reflections both on the relationship between present and past art and manners, and on the aesthetic relation of content and form, or the question as to how pictorial meaning can transcend mere imitation and repetition of the natural world.

Reynolds' practice of borrowing is most evident in his fancy pictures and character portraits. As Edgar Wind has already shown in the portrait *Mrs*

Hartley as Nymph with Young Bacchus (1771), Reynolds utilised the attitude of the Madonna reaching towards her child in Michelangelo's *Doni Madonna* (1503–4).[90] With this quotation, Reynolds did more than serve homage to the Italian genius of painting; he used Michelangelo's invention in order to demonstrate that he had found out how his predecessor had proceeded artistically. His use of Michelangelo's motive for an image of a nymph with a young Bacchus not only refers in its formal composition to Michelangelo's *Doni Madonna* but also with regard to content to Michelangelo's own model: the relief of a faun with a young Bacchus, which was made by the workshop of Donatello. Together with other tondi, it embellished the relief frieze of the Palazzo Medici-Riccardi in Florence.[91] With this quotation, Reynolds could express his veneration for Michelangelo and at the same time present himself as a distinguished arbiter of art.

Another example in this mode is Reynolds' portrait of *Miss Meyer as Hebe* (1772). As is well known, Reynolds used Ugo da Carpis' colour woodcut of *Circe after Parmigianino* (1542–7) as a compositional model for his painting. Even though Horace Walpole did not recognise Reynolds' source in this case, the patron of the portrait, the miniature painter and Royal Academician Jeremiah Meyer, would surely have done so. Furthermore, the meaning of the portrait depends on the identification of the source. Ugo da Carpis' woodcut depicts Circe, who demonstrates to the assembled crew of Odysseus' ship that her elixir is not dangerous at all. Yet the following events are invoked for the viewer through their knowledge of the classical narrative even though they are not depicted: Circe's deceit results in the transformation of her admirers into beasts. As Geffrey Whitney's *A Choice of Emblems* shows, the tale could be used to illustrate the negative example of 'wicked love'.[92] With his discreet allusion to Circe, Reynolds could hint at the fact that it was not decided yet if Miss Meyer would become a Hebe or a Circe. If Miss Meyer was to be a Hebe, the eagle in the picture would be Jupiter or, alternatively, as Circe, it would represent one of the male victims of her enchantment. Reynolds' pictorial strategy to employ the same formula for different contents can be compared to wordplay, and more exactly to paronomasia, where two words sound similar but have different meanings. Hebe and Circe form an exact opposition. Whereas Hebe can be seen as an image of a girl who will become a devoted wife obeying her marital duties, the mythological figure of Circe was employed metaphorically to express all-consuming passion. Reynolds also used the character of Circe in his portrait of the career mistress *Mrs Mary Nesbitt* (1781).

As is evident from these examples, Reynolds' associative hints could be so intricate that their meaning must have been intentionally accessible to only an elite circle of connoisseurs. Nevertheless, those who were well versed in the history of art could delight in the wit of Reynolds' inventions and glimpse the unpredictable double entendres in many of his paintings. Such

an audience would have understood that borrowing was a critical strategy which commented on the works of the past.[93] In expressing such ideas in his *Discourses*, Reynolds was providing a model for his students on how to engage with their polite patrons in the present. Once again, he expressed his belief that modern artists were at a disadvantage compared to their forebears for:

> In pursuing this great Art, it must be acknowledged that we labour under greater difficulties than those who were born in the age of its discovery, and whose minds from their infancy were habituated to this style; who learnt it as a language, as their mother tongue. They had no mean taste to unlearn; they needed no persuasive discourse to allure them to a favourable reception of it, no abstruse investigation of the great latent truths on which it is founded. We are constrained, in these later days, to have recourse to a sort of Grammar and Dictionary, as the only means of recovering a dead language. It was by them learned by rote, and perhaps better learned that way than by precept.[94]

Reynolds felt distanced from the traditions of art which he so highly prized. His many exhortations to the art student to go back to the sources, to study and imitate the Old Masters and to borrow from them has to be seen against this background of a disrupted tradition. But at the same time it becomes evident that an artist could no longer bridge this divide intuitively, but needed to proceed by intellectual reflection. These theoretical statements thus represent an important pedagogical imperative which Reynolds was passing on to his students at the RA as valuable wisdom to ensure both their commercial and intellectual success in the present and their legacy in the future.

Acknowledgement

I would very much like to thank Matthew C. Potter for his essential editorial and linguistic support for this chapter.

Notes

1 David Mannings, *Sir Joshua Reynolds: A Complete Catalogue of his Paintings. The Subject Pictures Catalogued by Martin Postle* (New Haven, CT: Yale University Press, 2000, 2 volumes), Vol. I (Text), cat. no. 2168, p. 567; Nicholas Penny (ed.), *Reynolds* (London: Royal Academy of Arts, 1986), cat. no. 112, p. 284.

2 Giuseppe Marco Antonio Baretti, *A Guide Through the Royal Academy* (London: Cadell, 1781), p. 17.

3 Charles Mitchell, 'Three Phases of Reynolds' Method', *The Burlington Magazine for Connoisseurs*, 80(467) (1942), p. 39.

4 Joshua Reynolds, 'Discourse II, December 11, 1769', in Robert R. Wark (ed.), *Sir Joshua Reynolds, Discourses on Art* (New Haven, CT: Yale University Press, 1988), pp. 26, 31.

5 David Mannings, 'An Art-Historical Approach to Reynolds' Discourses', *British Journal of Aesthetics*, 16(4) (1976), p. 354; John L. Mahoney, 'Reynolds' Discourses on Art: The Delicate Balance of Neoclassic Aesthetics', *British Journal for Aesthetics*, 18 (1978), pp. 126 f.; Renate Prochno,

Joshua Reynolds (Weinheim: VCH, Acta Humaniora, 1990); and Günter Leypoldt, 'A Neoclassical Dilemma in Sir Joshua Reynolds' Reflections on Art', *British Journal of Aesthetics*, 39(4) (1999), pp. 330–32.

6 Cf. Holger Hoock, *The King's Artists: The Royal Academy of Arts and the Politics of British Culture 1760–1840* (Oxford: Clarendon Press, 2003), pp. 25, 83.

7 Ibid., p. 27. See also Nikolaus Pevsner, *Academies of Art: Past and Present* (New York: DaCapo Press, 1973), pp. 183 f; Ilaria Bignamini, 'George Vertue, Art Historian and Art Institutions in London, 1689–1768: A Study of Clubs and Academies', *Volume of the Walpole Society*, 54 (1988), pp. 1–18; Matthew Hargraves, *Candidates for Fame. The Society of Artists of Great Britain 1760–1791* (New Haven, CT: Yale University Press, 2005), p. 90 f.

8 Ibid., pp. 102 ff.

9 Sidney C. Hutchison, 'The Royal Academy Schools, 1768–1830', *Volume of the Walpole Society*, 38 (1962), pp. 123–91; H. Cliff Morgan, 'The Schools of the Royal Academy', *British Journal of Educational Studies*, 21(1) (1973), pp. 88–103; and Hoock, *The King's Artists*, pp. 52–62.

10 James Northcote, R.A., *Memoirs of Sir Joshua Reynolds* (London: Colburn, 1813), p. 410.

11 Reynolds, 'Discourse VII, December 10, 1776', p. 103.

12 William Hazlitt, *Conversations of James Northcote, Esq., RA.* (London: Colburn & Bentley, 1830), p. 32.

13 Northcote correspondence: Royal Academy of Arts archives (London): letters NOR/17 and NOR/3.

14 Reynolds, 'Discourse VI, December 10, 1774', p. 103.

15 Reynolds, 'Discourse IX, October 16, 1780', p. 171.

16 Ibid.

17 Reynolds, 'Discourse III, December 14, 1770', p. 44.

18 Mahoney, 'Reynolds' Discourses on Art', p. 128.

19 Reynolds, 'Discourse III' (1770), p. 44.

20 Ibid.

21 Erwin Panofsky, *Idea: ein Beitrag zur Begriffsgeschichte der älteren Kunsttheorie* (Berlin: Wiss.-Verl. Spiess, 1993), p. 24 ff.

22 John Locke, *An Essay Concerning Human Understanding* (London: Penguin, 1997), Book II, Chap. 12 § 1, p. 159; Michael Alexander Stewart, 'Abstraction and Representation in Locke, Berkeley and Hume', in G.A.J. Rogers and Sylvana Tomaselli (eds), *The Philosophical Canon in the 17th and 18th Centuries: Essays in Honour of John W. Yolton* (Rochester, NY: University of Rochester Press, 1996), pp. 123–47.

23 Reynolds, 'Discourse III' (1770), p. 50.

24 Anthony Ashley Cooper Shaftesbury, *Characteristics of Men, Manners, Opinions and Times* (ed.), Lawrence E. Klein (Cambridge: Cambridge University Press, 1999), p. 66.

25 Reynolds, 'Discourse II' (1769), p. 26; Reynolds, 'Discourse IV, December 10, 1771', p. 64; Reynolds, 'Discourse XIV, December 10, 1788', p. 253.

26 Reynolds, 'Discourse XI, December 10, 1782', p. 204.

27 Joshua Reynolds, *The Works of Sir Joshua Reynolds, Knight: Late President of the Royal Academy […] in Three Volumes*, ed. by Edmund Malone, Esq. (London: Cadell & Davies, 1809), Vol. II, p. 267.

28 Ibid., Vol. II, p. 213.

29 Martin Kemp, 'True to Their Natures: Sir Joshua Reynolds and Dr. William Hunter at the Royal Academy of Arts', *Notes and Records of the Royal Society of London*, 46(1) (1992), pp. 77–88, at p. 82.

30 Cf. Reynolds, 'Discourse VII' (1776), p. 132.

31 Reynolds, *The Works of Sir Joshua Reynolds*, Vol. II, p. 213.

32 Reynolds, 'Discourse XI' (1782), p. 192.

33 Ibid.

34 Reynolds, 'Discourse III' (1770), pp. 44–5.

35 Locke, *An Essay Concerning Human Understanding*, Book II, Chapter 12, §5. It has to be acknowleged that Locke was quite indifferent to aesthetic questions; nevertheless, he refers briefly to the idea of beauty in his *Essay*. Cf. Dabney Townsend, 'Lockean Aesthetics', *Journal of Aesthetics and Art Criticism*, 49(4) (1991), pp. 349–61.

36 Locke, *An Essay Concerning Human Understanding*, Book III, Chapter III, §§ 11–13.

37 Reynolds, 'Discourse III' (1770), p. 45.

38 Locke, *An Essay Concerning Human Understanding*, Book III, Chapter III, § 10.

39 Ibid., p. 49. Already Rubens linked the issue of artistic imitation to history. He thought of his own time as degenerate in its custom and manners, in contrast to antiquity, when mankind was seen as unspoiled and close to nature. Cf. Jeffrey M. Muller, 'Rubens's Theory and Practice on the Imitation of Art', *Art Bulletin*, 64(2) (1982), pp. 231 f.

40 Reynolds, 'Discourse XV, December 10, 1790', pp. 271 f.

41 Reynolds, 'Discourse VI' (1774), pp. 95, 97, 102; Reynolds does not yet use the word 'progress' meaning a linear concept of history, but talks about 'perfection', 'improvement' or 'advancement' of the arts. Like the French modernists Fontenelle and Perrault in the 'Querelle des anciens et des modernes', Reynolds transfers the 'progrès des sciences' to the arts. For Fontenelle and Perrault, cf. Reinhart Koselleck, 'Fortschritt', in *Geschichtliche Grundbegriffe* (Stuttgart: Klett-Cotta, 1975, 8 volumes), Vol. II, pp. 351–423.

42 Cf. Francis Bacon, *The Advancement of Learning and New Atlantis* (Oxford: Clarendon Press, 1974).

43 Reynolds VI, 'Discourse VI' (1774), pp. 96, 99.

44 Ibid., p. 99.

45 Ibid., p. 106; Edgar Wind, 'Humanitätsidee und heroisiertes Porträt in der englischen Kultur des 18. Jahrhunderts', *Vorträge der Bibliothek Warburg* (1930/1931), p. 183; Werner Busch, *Nachahmung als bürgerliches Kunstprinzip, Ikonographische Zitate bei Hogarth und in seiner Nachfolge* (Hildesheim: Olms, 1977), pp. 20, 29; Dawna Schuld, 'Conspicious Imitation: Reproductive Prints and Artistic Literacy in Eighteenth-Century England', in Rebecca Zorach and Elizabeth Rodini (eds), *Paper Museums: The Reproductive Print in Europe, 1500–1800* (Chicago, IL: The David and Alfred Smart Museum of Art, University of Chicago, 2005), pp. 101–13.

46 Rudolf Wittkover, 'Imitation, Eclecticism, and Genius', in Earl. R. Wasserman (ed.), *Aspects of the Eighteenth Century* (Baltimore, MD: Johns Hopkins University Press, 1965), pp. 143 ff.; Busch, *Nachahmung als bürgerliches Kunstprinzip*, pp. 14–30; Maria H. Loh, 'New and Improved: Repetition as Originality in Italian Baroque Practice and Theory', *Art Bulletin*, 86(3) (2004), pp. 477–504; Ulrich Pfisterer, 'Kampf der Malerschulen – Guido Renis *Lotta dei Putti* und die "Caravaggisten"', in *Pluralisierung und Autorität in der Frühen Neuzeit. 15.–17. Jahrhundert* (Mitteilungen des Sonderforschungsbereiches 573, Vol. II, Munich: LMU, 2008), pp. 16–26.

47 Holger Hoock, 'Old Masters and the English School: The Royal Academy and the Notion of a National Gallery at the Turn of the Nineteenth Century', *Journal of the History of Collections*, 16(1) (2004), pp. 1–18.

48 The lack of a painting collection and the incompleteness of the existing cast, print and book collections of the Royal Academy were often complained about. After being promoted to Professor of Sculpture, it was John Flaxman in particular who committed himself to the expansion and improvement of the RA's collections. Rhodri Windsor Liscombe, '"The Diffusion of Knowledge and Taste": John Flaxman and the Improvement of the Study Facilities at the Royal Academy', *Walpole Society*, 53 (1987), pp. 226–38.

49 Reynolds, 'Discourse VI' (1774), p. 100; Reynolds, 'Discourse VII' (1776), p. 133.

50 V. Steenblock, 'Tradition', in Joachim Ritter and Rudolf Eisler (eds), *Historisches Wörterbuch der Philosophie* (Darmstadt: Wiss. Buchges., 1995, 13 volumes), Vol. XI, pp. 1315–18; Hans Robert Jauss, 'Tradition, Innovation, and Aesthetic Experience', *Journal of Aesthetics and Art Criticism*, 46(3) (1988), pp. 375–8.

51 Reynolds, 'Discourse XV' (1790), p. 269, emphasis in original.

52 Ibid., p. 272.

53 Ibid., p. 275.

54 Ibid., p. 280.

55 Victor Ginsburgh and Sheila Weyers, 'De Piles, Drawing and Color: An Essay in Quantitative Art History', *Artibus et Historiae*, 23(45) (2002), pp. 191–203.

56 Bernd Krysmanski, 'William Hogarths Kritik an der Balance des Peintres: Roger de Piles, Jonathan Richardson, Mark Akenside und Joseph Spence im Fadenkreuz der englischen Satire', in Joachim Möller (ed.), *Sister Arts: Englische Literatur im Grenzland der Kunstgebiete* (Marburg: Jonas, 2001), pp. 51–75; Reynolds, 'Discourse VI' (1774), p. 102.

57 Cf. Reynolds, 'Discourse VII' (1776), pp. 135 f.

58 Simon Alderson, 'Ut Pictura Poesis and its Discontents in Late Seventeenth- and Early Eighteenth-Century England and France', *Word and Image*, 11(3) (1995), pp. 258–63.

59 Iris Wien, *Joshua Reynolds: Mythos und Metapher* (Munich: Fink, 2009), pp. 169–237.

60 Reynolds, 'Discourse XIII, December 11, 1786', p. 234; Reynolds, 'Discourse VII' (1776), p. 129.

61 Horace Walpole, *Anecdotes of Painting in England*, 4th edn with additions (London: Dodsley, Pall Mall, 1786, 4 volumes), Vol. II, p. 80.

62 Reynolds, 'Discourse VII' (1776), p. 135.

63 Joachim Rees, 'Die unerwünschten Nereiden. Rubens' Medici-Zyklus und die Allegoriekritik im 18. Jahrhundert', *Wallraf-Richartz-Jahrbuch*, 54 (1993), pp. 205–32; Abbé du Bos, *Critical Reflections on Poetry, Painting and Music. With an Inquiry of the Rise and Progress of the Theatrical Entertainment of the Ancients*, transl. by Thomas Nugent (London: Nourse, 1748, 3 volumes), Vol. I, pp. 154 ff; Walpole, *Anecdotes of Painting in England*, Vol. I, p. 80.

64 Jean Starobinski, 'Fabel und Mythologie im 17. und 18. Jahrhundert', in *Das Rettende in der Gefahr, Kunstgriffe der Aufklärung* (Frankfurt: Fischer Wissenschaft, 1992), p. 320; and Wien, *Joshua Reynolds*, Chapter 1.3.

65 Roger De Piles, *The Principles of Painting* (London: Osborne, 1743), p. 35 f.

66 Reynolds, 'Discourse VII' (1776), p. 135.

67 Ibid., p. 122 f.

68 Ibid., p. 134 f.

69 Ibid., p. 139; Aileen Ribeiro, *Dress Worn at Masquerades in England, 1730 to 1790, and its Relation to Fancy Dress in Portraiture* (New York: Garland, 1984).

70 Reynolds, 'Discourse VII' (1776), p 139: 'But this association is nature, and refers to that secondary truth that comes from conformity to general prejudice and opinion; it is therefore not merely fantastical'.

71 Ibid., p. 132.

72 Ibid., p. 133.

73 Ibid., p. 129.

74 Ibid., p. 131.

75 Ibid., p. 129.

76 Mannings, *Sir Joshua Reynolds*, Cat. No. 1271, p. 338. The inconsistencies that existed between the chosen mythological role and the status of the sitter in this portrait were criticised by Allan Cunningham in *The Lives of the Most Eminent British Painters, Sculptors, and Architects* (London: J. Murray, 1829, 6 volumes), Vol. III, pp. 260 f.

77 Reynolds, 'Discourse VII' (1776), p. 129.

78 Martin Kallich, *The Association of Ideas and Critical Theory in Eighteenth-Century England: A History of a Psychological Method in English Criticism* (The Hague: Mouton, 1970); James Engell, *The Creative Imagination: Enlightenment to Romanticism* (Cambridge, MA: Harvard University Press, 1981); Locke, *An Essay Concerning Human Understanding*, Book II, Chapter XXXIII, pp. 354–60.

79 Reynolds, 'Discourse VII' (1776), p. 136.

80 Reynolds, 'Discourse XIII' (1786), pp. 234 f.

81 Cf. Edmund Burke *A Philosophical Enquiry into the Origin of Our Ideas of the Sublime and Beautiful* (Oxford: Oxford University Press, 1990); and Daniel Webb, *Remarks on the Beauties of Poetry* (London: Dodsley, 1762), pp. 91, 102.

82 Burke, *A Philosophical Enquiry*, pp. 149–59; cf. Jean H. Hagstrum, *The Sister Arts: The Tradition of Literary Pictorialism and English Poetry from Dryden to Gray* (Chicago, IL: Chicago University Press, 1958), pp. 152 f; Frederick P. Lock, *Edmund Burke* (Oxford: Clarendon Press, 1998, 2 volumes), Vol. I, pp. 93, 105.

83 Burke, *A Philosophical Enquiry*, p. 159; For a more detailed discussion of this issue, see Wien, *Joshua Reynolds*, Chapter 4.10.

84 Contrary to John Barrell, who thinks that Reynolds abandoned the rhetorical aesthetic of humanism in favour of a more philosophical view of painting, I would like to make the point that rhetoric itself changed towards a philosophical theory of painting. As such, rhetoric could still function as a model for Reynolds' thoughts. Cf. John Barrell, *The Political Theory of Painting from Reynolds to Hazlitt: 'The Body of the Public'* (New Haven, CT: Yale University Press, 1986), p. 71.

85 Wien, *Joshua Reynolds*, Chapters 3 and 4.

86 Lloyd F. Bitzer, 'Introduction', in George Campbell, *The Philosophy of Rhetoric* (Carbondale: Southern Illinois University Press, 1988), p. x; James Engell, *The Creative Imagination. Enlightenment to Romanticism* (Cambridge, MA: Harvard University Press, 1981), pp. 144 f.

87 A.D. Horgan, *Johnson on Language* (Basingstoke: Macmillan, 1994), p. 53; cf. Samuel Johnson, 'Progress of Arts and Language', *The Idler*, 63 (June 1759), in Samuel Johnson, *The Idler* (London: Newberry, 1761, 2 volumes), Vol. II, p. 48.

88 Samuel Johnson, *Lives of the Most Eminent English Poets* (London: Bathurst, 1781, 4 volumes), Vol. I, p. 92: '[W]ords being arbitrary must owe their power to association, and have the influence, and that only, which custom has given them'.

89 Reynolds, 'Discourse XII, December 10, 1784', pp. 216–21; Wind, 'Humanitätsidee und heroisiertes Porträt', pp. 156–229; Edgar Wind, 'The Mænad under the Cross. Comments on an Observation by Reynolds', *Journal of the Warburg and Courtauld Institutes*, I (1937/38), pp. 70–71; Edgar Wind, 'Borrowed Attitudes in Reynolds and Hogarth', *Journal of the Warburg and Courtauld Institutes*, II (1938/39), pp. 182–5; Busch, *Nachahmung als bürgerliches Kunstprinzip*, pp. 42 ff.; Werner Busch, *Das sentimentalische Bild: die Krise der Kunst im 18. Jahrhundert und die Geburt der Moderne* (Munich: Beck, 1993), p. 395; Prochno, *Joshua Reynolds*, pp. 46 ff; John Sitter, *Arguments of Augustan Wit* (Cambridge: Cambridge University Press, 2007).

90 Wind, 'Humanitätsidee und heroisiertes Porträt', pp. 156–229; Mannings, *Sir Joshua Reynolds*, Cat. No. 854, pp. 245 f.

91 Graham Smith, 'A Medici Source for Michelangelo's Doni Tondo', *Zeitschrift für Kunstgeschichte*, 38 (1975), pp. 84 f; Konrad Hoffmann, 'Antikenrezeption und Zivilisationsprozeß im erotischen Bilderkreis der frühen Neuzeit', *Antike und Abendland*, 24 (1978), pp. 146–58.

92 Geffrey Whitney, *A Choice of Emblems* (Leyden: Plantyn, 1586), No. 82 'Homines voluptatibus transformantur'.

93 Horace Walpole, *Anecdotes of painting in England; with some account of the principal artists; and incidental notes on other arts; collected by the late Mr. George Vertue* (Strawberry Hill/Twickenham: 1765–71 [1765–80], 4 volumes), here Vol. IV, pp. vi f.

94 Reynolds, 'Discourse XV' (1790), p. 278.

A Free Market in Mastery: Re-imagining Rembrandt and Raphael from Hogarth to Millais

Paul Barlow

In accounts of art education in the nineteenth century, it is rare to find much discussion of the fact that art is a profession and that art education is training for a job dependent on a market. Indeed, the academies are typically identified with the view that art should maintain professional standards that exist independently of the market. As one of the founders of the Royal Academy (RA), Joshua Reynolds was certainly clear that *compromises* needed to be made to satisfy the market in which the artist was required to work. But of course the very concept of compromise implies the existence of a professional or moral ideal that transcends it.

The alternative to the academic ideal is usually coded through models of personal vision, based on the romantic concept of creative freedom, one that later mutates into that of the 'avant-garde', in which the personal creative perspective is later recognised and accepted by a (slowly expanding) community of aficionados. This model, like the alleged academic valorisation of universal ideals, implies that commercial requirements are, at best, to be tolerated as a regrettable necessity of creative life. But what about artists, teachings and traditions that positively embraced the market: ones that took the old adage 'vox populi, vox deii' seriously as a model for the future of art practice? How does such a model impact upon our understanding of creativity and what does it tell us about the ways in which the twin concepts of tradition and innovation are understood in practice?

I will seek to examine this problem by posing a question. When is an Old Master sufficiently old: a 'past' master from whom modern artists can learn? This issue is central to the debate about whether art education is a form of training in technical skills or whether it should be dedicated to developing an aesthetic sensibility. Clearly, the concept of such an 'old' master is distinct from the educational model of the artist's workshop, in which students learn

techniques from a living master. For example, Rembrandt is perhaps the best-known example of an artist who established a workshop in which students were taught to paint in a style similar to the Master himself. So close was the relationship between Rembrandt and his pupils that it is often so hard to tell the work of one from the other that a massive scholarly project has been established in an attempt to do so.[1] However, Rembrandt's practice is merely an unusually good example of the standard workshop model. It did not depend on a student's scholarly study of the compositional methods, poses and draughtsmanship of 'Old' Masters, but on the imitation of a living one who incarnated the lessons of the past and the skills of the present.

At some point, though, Rembrandt himself became an 'Old Master'. His techniques – especially lighting and brushwork – became models to imitate. It is difficult to be precise about when this happened, but in the late eighteenth century, Joshua Reynolds self-consciously adopts Rembrandt's lighting in his academic self-portrait, an assertion of his status as first President of the RA. By the mid-nineteenth century, Rembrandt is definitively established as an 'Old Master'. In John Everett Millais' 1874 painting *The North-West Passage*, a grizzled old sailor contemplates the history of failed British attempts to navigate the passage between Canada and the Arctic ice. He glares out from the image, his face depicted with the characteristic Rembrandtian impastoed layers of agitated pigment, modelling the signs of age and pathos. Millais adopts Rembrandt as a model for a humanist realism, epitomised by the famous portraits of the Old Master's own age-ravaged and saddened face.

My point is that Rembrandt, in becoming an 'Old Master', begins to have a different *meaning* within art education. For his pupils, he is the possessor of skills to be learned. For later artists, he is a distinct creative personality – markedly different from other 'Old Masters' such as Rubens or Raphael – whose style can be adopted to represent values: typically the pathos of human vulnerability. These values come to exist in a system of oppositions constituted by the canon of the Old Masters as a whole. The chaotic and broken paintwork representing Rembrandt's rumpled human bodies counterpoises the smooth, sharply outlined and sculpted surfaces defining Michelangelo's ideal athletes.

However, such antitheses can and do change. Many eighteenth-century artists were unimpressed by Rembrandt's possibilities as an 'Old Master'. William Hogarth's attempts to demonstrate his abilities as a history painter assumed that Raphael was the master to respect and rival, though his Raphaelism was inflected by the Baroque. His famous 'modern moral' paintings had pointedly ignored such precedents. In order to demonstrate his rejection of the vulgar realism for which his earlier work had been regularly criticised, he created an alternative version of his own Raphaeleque biblical painting *Paul Before Felix* (1752–62), an engraving of the same composition in the 'ridiculous manner of Rembrandt'. This parodied Rembrandt's religious

etchings, in which Jesus rubs shoulders with Dutch burghers and peasants. For Hogarth, Rembrandt could never be an 'Old Master'.

Hogarth's and Millais' attitudes towards Rembrandt represent a radical divergence of view about the nature of 'Old Master' identity. Hogarth assumes that there is a mode of painting proper to high art and that Rembrandt violates the proprieties of genre. In this respect, his view derives from the well-established model of the hierarchy of the genres, according to which composition and style are determined by content. In the century before Hogarth, the emergence of independently marketable genres of painting – notably tavern scenes and landscapes – had been accompanied by an expansion of printed images of all kinds. Academic writers had created the hierarchy to place this uncontrolled proliferation of art practices into a structure in which style came to be related to subject. In accordance with this view, 'photographic' documentation in subjects such as still lives represented the lowest form of artistic skill – mere mechanical duplication of material fact. This was typically linked to the base appetites of the body, especially those of the lower social orders, as represented in abundant food or crude physical gratifications. As human action became abstracted from the body, art entered into this 'generalising' process in which beauty of form and colour shone through the materiality of bodily experience, revealing a spiritual and moral order structuring merely material facts. This was the province of history painting, the highest form of which was to be found in the work of Raphael.

This, of course, is why the conception of the Old Masters used by Hogarth is linked to art education of the kind associated with the academies. Old Masters are there to teach us how art *should* be undertaken, to free it from the fickle demands of the market and the idiosyncratic interests of individual workshop masters. Rembrandt's pupils were in thrall to him. They had no choice but to mimic his work. An academically trained artist has the power to discriminate by identifying and absorbing the relevant skills of a range of precursors.

This attempt to order art in a hierarchy was never quite stable or uncontested. There was a long dispute about which styles represented the highest ideals. Roger de Piles, one of the principal scholars dedicated to the topic, insisted that Rubens, not Raphael, was the greatest artist because his use of colour was more powerful and his compositional creativity was greater. The debate was still unresolved in the mid-eighteenth century when Hogarth published his own contribution to the theory of aesthetic hierarchy, *The Analysis of Beauty* (1753). It continued to assert itself well into the nineteenth century – in William Blake's attacks on the 'blotted and blurred' style of colourists such as Rubens and, as we shall see, in the debates surrounding the revival of fresco painting in the 1840s.

Hogarth's own role in the debate was always paradoxical and problematic. His fame rested on his satirical paintings and engravings. These grew from the very commercial and popular traditions that the academic 'hierarchy' of

genres sought to contain. Though these were certainly not without precedents, they were proclaimed by Hogarth and his admirers to be a new form of art – assertively 'modern' in character. In this respect, Hogarth has a claim to be the earliest artist of the avant-garde, self-consciously rejecting the precedent of the Old Masters and proclaiming an art freed from stultifying dependence on the past. This position is linked to a critical attitude to both artistic convention and social norms – again, a point of view associated with an anti-academic identity typical of the late nineteenth and early twentieth centuries.

For Hogarth, however, this position was strongly associated with the embrace of the market, in contrast to the avant-garde of the nineteenth century, which typically claimed to represent an emotional sincerity or aesthetic authenticity which bypassed market forces.[2] In this regard, Hogarth's position implies at least a possible acceptance of the precedents of the Old Masters, since their achievements may provide useful lessons to modern artists. This is not very far from the opinion of Joshua Reynolds, founder of the RA and admirer of Rembrandt. Reynolds had become Hogarth's chief rival and antagonist, since Hogarth strongly resisted Reynolds' view that Britain could only achieve international recognition as an artistic nation if it established an academy in which international norms were recognised and disseminated. For Hogarth, this was no more than submission to the values of oppressive autocracies. Britain stood against such state-sanctioned cultures, affirming the freedom of the creative mind to produce art that commented on the paradoxes of modern life. An academy was a tool of state control in art. For Hogarth, it epitomised attempts to restrict the freedom to make stylistic choices without requiring permission from one's betters.

How these attitudes impacted on Hogarth's pedagogical priorities is not straightforwardly clear. As a teacher, Hogarth was renowned foremost as a moralist rather than a practitioner providing 'useful lessons of morality ... calculated to improve the man, as well as the artist'.[3] As later commentators noted, he was 'Without a school, and without a precedent (for he is no imitator of the Dutchman)'.[4] Little evidence remains of Hogarth's work at the St Martin's Lane Academy; nevertheless, his diploma work for the RA shows the life drawing practice used there with approximately 25 students assembled before the model working with chalk on blue or white paper.[5] Hogarth was opposed to all programmatic teaching and in around 1755, when 'the Academy in St. Martin's Lane began to form themselves into a more important body [i.e. the RA], and to teach the Arts under regular professors', Hogarth rebelled for 'extraordinary as it may appear, this scheme was so far from being welcomed by Hogarth as indicative of a brighter æra in the Fine Arts, that he absolutely discouraged it, as tending to allure many young men into a profession in which they would not be able to support themselves, and at the same time to degrade what ought to be a liberal profession into a merely mechanical one'.[6] The assemblage of professors proposed at the RA

was deemed by Hogarth to be 'a ridiculous imitation of the foolish parade of the French Academy' which had produced no benefit to the arts and referred to Voltaire's judgement that 'after its establishment, no one work of genius appeared in the country', and that 'the whole band, adds the same lively and sensible writer, became mannerists and imitators'.[7]

Hogarth's legacy for students was arguably not to be found in the schoolroom. Despite 'Being ill-qualified by his education for any literary performance', it was his *The Analysis of Beauty* that held the greatest potential lessons to future artists.[8] It was ambitious in its aims and was advertised as aimed at 'fixing the fluctuating ideas of Taste'.[9] Writing at the end of the nineteenth century, Austin Dobson found the book a 'desultory essay having for a pretext the not very definite precept attributed to Michael Angelo, that a figure should be always "Pyramidall, Serpent-like, and multiplied by one two and three"'.[10] Nevertheless, theory and teaching were not always so problematically linked for Hogarth, for as Gerard Baldwin Brown later observed:

> Hogarth, it seems, had no idea of the need for any special preparation for 'historical' painting other than the study of the figure; but to Reynolds, and through Reynolds to his successors, this 'grand' or 'historical' style became a mystery that was to be approached in the spirit of a candidate for initiation. There is really no mystery about the style. It is simply figure painting on a monumental scale applied to subjects of a religious, or classical, or allegorical order.[11]

Interestingly, Hogarth had intended to write a history of art to accompany *The Analysis of Beauty*, but as this never materialised, it is impossible to know what lessons it might have contained for students.

In contrast, Reynolds sought to affirm international and common ideals in art represented by the achievements of the Old Masters. In notes for one of his lectures to students, he emphasises the need to subject oneself to the judgement of one's predecessors by telling an anecdote about his visit to the Vatican in order to see the works of Raphael. He was deeply disappointed by the paintings, thinking them banal and derivative. But rather than blame Raphael, he blamed himself:

> disappointed and mortified at this great master, I did not for a moment conceive or suppose that the name of Raphael, and those admirable paintings in particular, owed their reputation to the ignorance and the prejudice of mankind; on the contrary, my not relishing them as I was conscious I ought to have done was one of the most humiliating things that ever happened to me. I found myself in the midst of works executed upon principles with which I was unacquainted.[12]

Returning to study them, Reynolds finally came to appreciate these 'famous compositions' and to accept the discrimination of the connoisseurs who had

asserted their value. His acceptance of his own failings is itself paradoxical. He submits to what he calls 'the opinion of mankind' while also narrating his own scepticism about it. He is both humble in the face of tradition and conscious of his own potential independence from it.

Reynolds' view raises many questions about what it means to be an 'Old Master'. Raphael, by this time, was increasingly established as the model of an eternal ideal of art, one which transcended mere mechanical skill, a point repeatedly made in the academic critical tradition. For Reynolds, the Raphaelesque tradition justified his view that art should articulate what he called 'central form', the normative condition of any object, one which visualised the mental image of its proper shape, rather than any 'accidental' deviations from its typical incarnation. Even the proper components of art itself should conform to this model. Composition, colour, pictorial space: all should articulate the norm. This totality of 'centrality' represented both a philosophical and a political view. The pictorial norm was a sign of the consensus of educated humanity as much as the mechanics of biology and physics themselves.

This view that an 'Old Master' is defined by the accumulated wisdom of critical commentary and practice excluded or marginalised practice which did not represent this ideal. Unsurprisingly, Hogarth's comic prints about harlots, rakes and low-life were typically identified with the crude appetites associated with the low genres of art in the hierarchy. Hogarth had attempted to demonstrate that he could rise above such things, painting several biblical and mythological subjects in a style influenced by the international Baroque. His *Sigismunda* (1759) owes a debt to the work of Guido Reni and other Bolognese masters. His other historical works drew on these models while retaining idiosyncratic qualities that were unique to him. Famously, they did not win the approval for which he had hoped. His critics ridiculed *Sigismunda* as a portrait of 'Mrs Hogarth in an agony of passion', implying that the artist had failed to 'generalise' in the way a true master of the higher genres should, but was unable to rise beyond the absurd depiction of his own domestic circumstances. It was *Sigismunda* in the 'ridiculous manner of Hogarth'.

Hogarth's activities as a 'serious' artist in higher genres were closely related to his personal political ideals, which were linked to the emergence of civic culture based on the model of independent entrepreneurs and tradesmen developing social networks linked to charitable activities. Hogarth was strongly opposed to the 'gentlemen' connoisseurs who sought to create a national academy, preferably sanctioned by royal patronage. He associated such an approach with foreign despotism. For him, his own essays in high art formed part of an attempt to create civic networks of patronage. Most important among these was the Foundling Hospital, established by his friend, Captain Thomas Coram. Hogarth was a trustee of the hospital, which was established to look after abandoned children. He used the building

as an exhibition space, both by creating works to be shown as part of the fixtures of the space and by setting up temporary exhibitions of the work of contemporary artists. He donated his painting *Moses Brought to Pharaoh's Daughter* (1752–62) to the building, a subject intended to express the values of the hospital by reference to biblical precedent. The painting is constructed as a simple Raphaelesque frieze-like composition, though it unusually centres on the intimate emotions of the Princess and of Moses' mother, who is giving up the child. The young Moses himself is at the centre, shown as a frightened and vulnerable toddler, clinging to his mother's clothes as he looks towards the welcoming Princess.

Hogarth's approach suggests the so-called cult of sentiment that was developing in the period, though in its very early stages. This was in marked contrast to his more avowedly populist works. His own business strategy was intentionally inclusive; he sought to encompass as wide a range of consumers as possible. He sold his paintings to an elite clientele, while marketing his engravings to a wider middle-class audience. With his *Stages of Cruelty* series (1751), he even aimed at a lower-class market, though he did not pursue his one experiment in creating cheap woodcuts. His methods are analogous to the creation, promotion and marketing of a brand, attempting to achieve maximum market penetration while maintaining the identity and values associated with his brand-image. He abandoned the attempt to use woodcuts precisely because the crudity of the technique undermined his image as a trustworthy provider of high-quality products.

Nevertheless, there is a clear distinction between styles of the *Stages of Cruelty* prints and the genteel sentiment of *Moses Brought to Pharaoh's Daughter*. The latter imitates earlier lurid popular prints. This aspiration to aesthetic inclusivity is largely consistent with the methods outlined in *The Analysis of Beauty*. Here an aesthetic model is created which runs parallel to the political vision of independent mercantile and civic culture implied by the charitable institution for which Hogarth created it. It was to provide a transition to the forms of pro-commerce discourse which were to define debates in the early nineteenth century.

In *The Analysis of Beauty*, Hogarth creates a system of thought about beauty which seems to be designed to complement the modern intellectual trends of his day epitomised by the science of Sir Isaac Newton and the political model of the Social Contract. In one respect, Hogarth aspires to be the Newton of art, creating mathematical laws of beauty that will explain the movement of art's heaven and earth. His political and aesthetic vision combine in his comic print *The Battle of the Pictures* (1743), which combines an attack on despotism and his belief that an art culture governed by academic ideals would be stultifying and oppressive. This depicts his own 'modern moral' pictures being attacked by phalanxes of similar paintings of violent biblical and classical subjects, implicitly linking high art to the coercive powers of an over-mighty state.[13]

The print was part of a ticket-design in Hogarth's innovative – if unsuccessful – scheme to sell paintings by lottery, thereby both increasing sale prices and expanding public interest in his work. Thus, modernity and originality of design are linked directly to a populist model of sales in which uninhibited modes of marketing correspond to the proliferation of creativity. As we shall see, this position comes to be openly articulated as a 'laissez-faire' ideal of free-market creativity once the utilitarian economics promoted by the so-called philosophical radicals came to be applied to art. In Hogarth, however, it forms part of a much less clear-cut belief system, one which was to have an influence on writers and artists whose views could not be reduced to simple free-market ideology. This drew on the 'gentlemanly' ideal, which is still markedly present in Hogarth's conception of art.

The Analysis of Beauty articulates an aesthetic theory that seeks to both accept and transcend classicism by allying art to modern science. It includes high and low within a system defined by the famous 'line of beauty', a gently curving wave, which moves in three dimensions. This constantly varying arc is supposed to define classical norms, such as the graceful movement of drapery and the ideal human body and face. It also explains natural beauty: the beauty of good design and pictorial composition. Hogarth's theory is in essence a defence of Rococo style in the face of the emergence of what came to be known as neoclassicism, a style strongly associated with the institutional power of academies.[14] The stylistic characteristics of Baroque and Rococo are essentially *independent* of the claims of authoritative tradition. They correspond to the *Rubeniste* affirmation of variety and innovation, but also draw on the unconstrained innovations created by the marketplace of images in the same period. The *Analysis* seeks to cut through this aesthetic Gordian knot with its mathematical model. This allows Hogarth to create a quasi-scientific explanation for the effortless superiority of classical and Raphaelesque art, while also justifying his use of popular styles and his more typical manner adapted from the *fêtes galante* tradition initiated by Watteau. The ideal curvature of the line of beauty is evidenced in flowing drapery, in the bodily curves of the classical nude and in the most beautiful facial features. It can also be found in the design of elegant furniture and in the natural world. It involves continual movement while creating a satisfying sense of order. Moreover, it can be found in art of many different types. Caricature can obey the principles of the line, while exaggerating and distorting it. Thus, beauty resides, as it were, within ugliness, and even the crudest forms of art, whether childhood scrawls or grotesques, take their place within an evolutionary model of dynamic forms. Hogarth replaces a hierarchy of genres with a hierarchy of forms.

This is, of course, epitomised by Hogarth's famous print of the dance, which takes centre stage in the book. In this we see an elegant couple dancing at one end of a line, while obese, scrawny, dumpy, clumsy and mismatched

couples extend across the rest of the space. Here the 'ideal' and the 'caricature' form part of one inclusive whole. Around this dance of unity in diversity, Hogarth places a frame, beyond which are depicted fragments of illustrations: bits of human musculature, naive graffiti-like drawings, examples of shading. At one end is a copy of a detail from one of Raphael's cartoons and at the other is a peasant, imitating the style of Dutch painters such as Teniers.

This inclusiveness is, I want to suggest, central to the emergent commercial discourse of aesthetics to which Hogarth contributes. It re-emerges in later appropriations of the Baroque as a form of corrective to the High Renaissance. What is important is that Hogarth allows as part of his model Old Masters who do not depend on the imitation of classical and Cinquecento models. His model involves a dynamic construction of colour and form related to both the 'decorative' and 'realist' aspects of the post-Cinquecento tradition. Both of these are of course present in Hogarth's art, including the proto-Impressionist aspects of his work, most prominent in paintings such as *The Shrimp Girl* (1740–1745). These draw on the Baroque tradition of rapid sketches of genre subjects, dating back to Annibale Carracci and Franz Hals, but can likewise look forward to the styles of the nineteenth century that defined themselves in opposition to reliance on tradition.

To sum up, Hogarth provides a model for what I have called 'pro-commerce' discourse that involves a paradoxical attitude to the Old Masters, a paradox that will be evident in the works of artists, art teachers and critics who adopted this position in the decades to come. On one side of the paradox is the idea that a pure *principle* of art can be created. For Hogarth, this principle confirms the social and aesthetic perfection of the greatest masters, and thus stabilises the critical tradition. On the other side is the fact that the very abstraction of the principle opens up the possibility that other artistic practices may represent aspects of it, perhaps even some aspects more effectively than great masters. The principle itself also justifies innovation. Like science, art should not be based on blind respect for tradition, but should judge even the greatest masters according to a proper methodology, one capable of including all known observations into the interpretative model.

This argument was to become central to the debates of the early nineteenth century about the reform of art education and the role of the RA. At this time, a political reform agenda was clearly articulated in terms of an attack on the entrenched power of the aristocracy and an opening up of social institutions to public scrutiny. This was also linked to a liberal economic ideology promoting free competition. Hints of such ideas can be found earlier, such as in the circle of William Blake, whose political radicalism was, like Hogarth's, allied to an ideology of freedom of imagination and a promiscuous attitude to Old Master precedents. Blake too was an independent artisan-trader with an entrepreneurial attitude to art production as a business, albeit an idiosyncratic one. While Blake never taught other artists, his personal experience of the RA

schools as a student would have affected his radical viewpoint regarding the legacy of the Old Masters and how this should be used in art education.[15]

Blake, of course, affirms the power of 'imagination' in the context of religious values derived from radical Protestant non-conformism, which affirm the ultimate freedom of conscience receiving direct inspiration from the divine, while insisting that there is a pure community to be realised in the Millennium – the thousand-year rule of Jesus after the Second Coming. While this millennial view may be idiosyncratic, though far from unique, Blake's conflation of individualism and civic ideals was not unusual. Its relation to the pro-commerce position is complex. In one respect, it is related to an ideology that affirms both taste and market values. This dates back to the debates of the mid-eighteenth century in which the unleashing of the market was linked to the persona of the 'educated gentleman'. According to David Hume, the expansion of production and choice will also lead to the expansion of taste as consumers learn to discriminate in the very act of choice. This market ideology of gentility continues to be expounded well into the Victorian era by the followers of the Philosophical Radicals. Blake essentially replaces the concept of 'taste' with 'inspiration', condemning 'Reynolds's Opinion … that Genius May be Taught & that all Pretence to Inspiration is a Lie & a Deceit … The Enquiry in England is not whether a Man has Talents & Genius, But whether he is Passive & Polite & a Virtuous Ass & obedient to Noblemen's Opinions in Art & Science. If he is, he is a Good Man. If Not, he must be Starved'.[16] The possible repercussion of such views for art students is immense, for despite Blake's continued admiration for Michelangelo and Raphael, it implied that breeding was the gold standard for acceptance and that nothing could really be learned by artists from the Old Masters.

While the millennial vision in Blake links to an ideal society of the 'new age', a more modest liberal-civic ideal of social order was coming into being during the same period. A model combining free-competition and public scrutiny of government came to fruition after the Great Reform Art of 1832 and was epitomised in art a decade later by the open competition for fresco paintings to decorate the new Houses of Parliament. It is perhaps most clearly articulated by the fairly obscure artist George Foggo, a painter who produced collaborative works with his brother James. James appears to have been the dominant brother in the painting studio, but George was clearly the more powerful presence in the public world. Both brothers were involved in a variety of organisations designed to secure public access to historic buildings and art collections.

The brothers were also allies of Benjamin Robert Haydon, an artist who, like Hogarth, sought to prove his skills as a history painter and as a commentator on the modern social scene. Also like Hogarth, both the Foggos and Haydon demanded reform of the RA, which they believed had been corrupted by its quasi-aristocratic independence from full public scrutiny. As George Foggo

asserted, either its doings should be fully opened to public scrutiny via Parliament or it should be a wholly private, self-funding organisation. This claim concerning the organisation of the RA was closely related to Foggo's belief that a truly civic form of history painting had been destroyed by the 'luxury' of aristocratic taste. The attitude of the Foggo brothers to the role of the Old Masters in art education is difficult to frame precisely. George Foggo did write an article in *Arnold's Library of the Fine Arts* which dealt with art teaching. In this he complained not of the deficiency of the RA's anatomy lecturers, but rather of its students taking up what was on offer: 'I can only say that it would be well if our artists, to say nothing of our students, would prove that they possess as much anatomical knowledge as Sir Anthony [Carlile] placed before them'.[17] Yet the mechanical instruction of Charles Bell's studies of wounded French soldiers at Waterloo were quickly linked in wider relevance, first as forms of noble expression and then as connected to the qualities of the Old Masters:

> The study of nature in all its intricacies is evidently the way to excellence; but if it be thought that a school is requisite to form the taste of the students, what collection could supply equal opportunities to our own, if government were to place within their reach the studies of Leonardo for his picture of the Last Supper, Sir Charles Bell's heads of expression, and the noble compositions of Raphael at Hampton Court; the youth who had already imbibed from the antique the grace and purity of form, so conspicuous in those precious objects, could require nothing else, besides nature, than the dignity and elegance of Da Vinci, the intensity and science of our great anatomist, and the variety and combinations of the prince of painters.[18]

George Foggo was a firm advocate of the revival of fresco painting, though he appears to have been dismissive of the 'severe' revivalist style of the German Nazarene artists. In practice, surviving examples of their work suggest that the Foggos adopted models derived from recent French practice, ones which drew on the Baroque as a model of modernity. Their painting of the *Conversion of St Paul* closely resembles aspects of Delacroix's style, with its dramatic colourism.

The new model is very directly related to innovative exhibiting practices, though again these can be traced to the precedent of Hogarth. By the early years of the nineteenth century, the advertising of both new and Old Master works in privately funded exhibitions had become commonplace, often interlinked with current events. For example, after the death of Nelson in October 1805, the news officially reached Britain on 4 November. Three days later, *The Times* published Lord Collingwood's dispatches on its front page. Alongside was a strip of classified advertisements. At the top, the manager of the 'European Museum' invited the nobility and gentry to become 'subscribers for the ensuing season', 'as the books will soon be closed'. Their current exhibit, 'Gerrard Dow's very celebrated PICTURE of the DOUBLE SURPRISE', had

just arrived at the museum.[19] Below this was an advertisement for a newly published portrait of Nelson, after John Hoppner.

As these examples indicate, this marketplace of public imagery links displays of celebrated works by established masters with imagery related to current events. The expansion of the press, polemical commentary on art and, by the 1840s, the emergence of the illustrated press produced an environment in which Old Master art and modern illustration were conjoined. The European Museum itself was essentially a commercial venture run by John Wilson, in which 'the choicest specimens of the Italian, Dutch, Flemish, French and Spanish schools' were offered for sale along with modern British masters. Despite being essentially a sale room, the venture was marketed as a 'museum' designed for 'the promotion of the fine arts and the encouragement of British artists'.[20]

Haydon's position is close to that of the Foggos. He epitomises the claims on civic culture linked to the ideal of heroic history painting. It is well known that Haydon continuously defined himself in relation to the High Renaissance and classical art typically identified as the ultimate model of 'Old Master' identity. Like his contemporary William Hazlitt, Haydon affirms the overarching value of truth to nature, which both trumps and confirms the Old Masters. His autobiographical account of his life as an artist emphasises a quasi-Wordsworthian dedication to obsessive drawing informed by the full variety of his social experiences. The confrontation with Old Masters is initially intense – looking at copies of ancient sculptors until 'I made my eyes ill'. Reading Reynolds convinces him of the value of work and of a civic ideal 'that all men were equal'.[21] He ridicules the minor artist Prince Hoare, who later turned to play writing. His father had sent him to Italy 'to get what nature had denied him in the *Capella Sistina* … [he] went through the whole routine of labouring for natural talents, by copying Raphael, copying Micheal Angelo, copying Titian'.[22] Here, once more, the scientific study of anatomy is seen as central to the valorisation of those true masters whose work can be both copied and transcended by the true artists. Most remarkably, he asserts that the ancient Greeks achieved aesthetic perfection by imitating nature to such an extent that the works of Phidias are virtually the equivalent of plaster-casts from the human body, such is their anatomical precision. If Phidias' greatness is defined by his approximation to a plaster-cast, why not just forget Phidias? We only really need the cast. This position has the paradoxical character that it both affirms and negates the art it valorises.

This view is comparable to that of William Hazlitt, who adapted it to the cult of sensibility, taking the view that art criticism formed part of a process of educating sensibility in a cultured environment. While art exhibitions were expanding across the capital, Hazlitt's Romantic ideas about art emphasised a 'Shakespearean' ideal of inclusive experience against the classical model of formal clarity and discipline. The wild profusion of experiences in the streets

of London finds its way into Hazlitt's essays, along with attempts to describe the unfolding and flowing nature of the thoughts and feelings that accompany them.

Hazlitt's conception of art was, like Blake's and Hogarth's, set up against the hapless Reynolds. However, he did not lay claim to a Newtonian line of beauty that explained the abundant variety of nature, nor, like Blake, a transcendent 'imagination' that constituted it. Rather, he repeatedly falls back on 'nature' as an explanatory tool. Hazlitt's view of nature was quite distinct from Hogarth's and Blake's; it stressed the idea of living presence, or rather of fantasy, of the feeling that one could enter into the world of the painting, or that, Pygmalion-like, the sculpture could warm into life and breath. This idea of psychological dissolution into the work of art creates a distinct preoccupation with the unique qualities of the Old Masters. No longer are they examples of the techniques to copy, but rather of integrated world views, or examples to *enter into.* To look at an Old Master is to begin an adventure into a rich world of encoded thoughts, feeling and insights. In Hazlitt's rhetoric, this complex dialogue between art and nature is always resolved in favour of nature. As he says, to have the real Samuel Johnson before us would be far better than to have a portrait, however powerfully it captured the qualities of the man. In this respect, Hazlitt's view would seem to negate the traditional respect for the Old Masters clearly articulated by Reynolds. But, of course, 'nature' is in practice nothing more than an abstraction itself – like 'truth'. Hazlitt's view allows for a multiplicity of masterly qualities – each exploring or expressing an aspect of experience. It also allows for a radical rejection of a canon of taste, as artists can be judged and rejected for failing to adequately express nature.

This, of course, frees up potential for an utterly open approach to Old Master identity, one which paves the way for the 'ridiculous' manner of Rembrandt to be freed from the hierarchy into which Hogarth himself had confined him. Hazlitt essentially creates the notion that Old Masters create forms of living in art, that they allow us to see the world in distinct and mutually exclusive ways that involve the totality of the style that they create. This new model, I want to suggest, creates a very distinctive view of Old Master art that leads us into the cultural world occupied by Millais and other mid-Victorian painters – one in which the imitation of Old Masters goes well beyond the extraction of skills or the proper ordering of types of visual pleasure. Instead, it involves the appropriation of style to create forms of experience. This clearly occurs in the painting I referred to at the beginning of this chapter: the art of Rembrandt is used by Millais in *The North-West Passage* to represent the pathos of age, but also to portray the idea of struggle. The dynamics of the paint itself, derived from the master's famous dynamic impasto, emphasises the ways in which the old man feels the burning resentment of his failure to navigate the empty spaces of the north. Behind him, seen through a window, is a seascape. Millais here appropriates the style of his contemporary Whistler – showing us a flat,

blank blue-grey field: a thin calm in opposition to the knotted pigment of the central figure.

This new approach to Old Master identity is, I want to suggest, a logical consequence of the pro-commerce position, with its links to the idea of the unleashing of imagination and the power of choice. What is perhaps most striking about this process is the way in which it allows artists to enter into the condition of 'Old Masters'. In a sense, both Rembrandt and Whistler have become 'Old Masters' in Millais' painting, though one was long dead and the other was Millais' junior. This process anticipates the ways in which modernist art movements would define themselves in relation to immediate precedents and ancient or culturally alien prototypes. It also integrates the academic and 'atelier' or studio models of aesthetic education in a new and distinctive way. Furthermore, this idea that an artist's style represents a way of feeling, as Hazlitt might say, allows for the appropriation of a style to *signify* that state – just as medieval style comes to signify 'purity' and 'piety' for artists such as the Nazarenes, J.R. Herbert and Rossetti.

The most striking instance of this is the way in which Hogarth himself becomes an Old Master for a number of artists in the early nineteenth century, who identify him with the spirit of Britishness and with the model for modern democratic art, a position very different from the civic model of Haydon and the Foggo brothers. It is David Wilkie who initiates this process by reviving Hogarth's style and it is writers such as Allan Cunningham who place him at the head of the British school as an innovator. Cunningham adopts Hazlitt-like rhetoric in describing the artist:

> No man indeed can make a true design, who is deficient in pictorial fancy, and wants the vivid imagination which calls up, in moving form and breathing expression, the beings with whom he is to people his canvass ... Possessing this vividness of imagination, Hogarth was ready at a moment to embody his subjects; and by a sagacity all his own, and a spirit of observation which few have equalled, he had ever original characters at command. He seldom copied on the spot the peculiar objects which caught his notice; he committed them to memory, and his memory, accustomed to the task, never failed him. If, however, some singularly fantastic form or *outre* face came in his way, he made a sketch on the nail of his thumb, and carried it home to expand at leisure.[23]

This Old Master is a product of pure engagement with nature, like Rembrandt as imagined negatively by Hogarth himself or positively by his admirers. As such, to imitate him is to re-create his way of imagining the word. And, of course, this is precisely what many artists did in this era. W.P Frith, E.M Ward, Augustus Egg and others all follow the precedent of Wilkie in adopting Hogarth as Britain's own Old Master. In doing so, they regularly re-enact that moment of engagement with pure human experience that is supposed to define his art. In Frith's painting *Hogarth Before the Governor of*

Calais, the artist himself is depicted showing his sketches to a French official to demonstrate that he is not a British spy recording French fortifications. The subject is derived from an episode in Hogarth's life when he painted his anti-French masterpiece *Calais Gate* and was arrested while he sketched the scene. Frith includes numerous references to Hogarth's art in the painting, repeating motifs from *Industry and Idleness* and other works. This use of Hogarth as a compositional stylistic model is, however, a way of signifying Frith's entry into the truth of the artist's vision, giving back to us the sign of the authenticity of Hogarth's own work. In this respect, it creates a cycle of validation comparable to the 'scientific' affirmation of the Old Masters by deriving abstract models of value from them.

Of course, this process is far from unique to Hogarth, nor is it distinctively British. Raphael was appropriated in the same way internationally – by Jean-Auguste-Dominique Ingres in France with *Raphael and la Fornerina* (1814), by Johann Michael Wittmer in Germany in *Raphael's First Sketch of the 'Madonna della Sedia'* (1853) and by J.M.W. Turner and Henry Nelson O'Neil in Britain with *Rome, from the Vatican. Raffaelle, Accompanied by La Fornarina, Preparing his Pictures for the Decoration of the Loggia* (exhibited 1820) and *The Last Moments of Raphael* (1866) respectively, among many others. All these paintings appropriate his style is a way that functions in a manner comparable to Frith's *Hogarth*, though with a very different meaning. It is the 'charm' and 'harmony' of Raphael that is reflected back to us as a sign, not his vitality and modernity.

This very difference only demonstrates the fact that Raphael and Hogarth have entered into a new kind of equality, like Millais' appropriation of Whistler and Rembrandt. This equality is born of a commercial and populist model which seeks to redefine the Old Master as a sign. The pro-commerce ideals set out by Hogarth and responded to by the Foggos and others represented an important challenge to the academic faith in the Old Masters. The effects on art schooling in England in the aftermath of such reformist and radical positions should not be ignored, as it enabled new and less orthodox multiple relationships to be formed between students, tutors and the Old Masters in a manner that was hugely productive for the British art world.

Acknowledgement

I would like to thank Matthew Potter for his editorial assistance and his suggestions regarding Hogarth's educational activities and George Foggo's discussions on the anatomy lectures at the RA.

Notes

1 Such is the difficulty that a long-running Rembrandt Project pronounces on the difference between authentic Rembrandts, studio copies and works by his pupils. The project began in 1968 and is

currently headed by Ernst van de Wetering. Its research is regularly published by Amsterdam University Press and it has its own website at http://www.rembrandtresearchproject.org.

2 This is by no means simple, however, since the avant-garde could claim to appeal to popular approval, which was supposed to supersede the demands of patronage networks.

3 R. Payne Knight quoted in J. B. Nichols (ed.), *Anecdotes of William Hogarth, written by himself: With Essays on his Life and Genius, and Criticisms on his Works, selected from Walpole, Gilpin, J. Ireland, Lamb, Phillips, and Others. To which are added a catalogue of his prints; account of their variations, and principal copies; lists of paintings, drawings, &c.* (London: J.R. Nichols & Son, 1833), p. 85.

4 Charles Lewis Hind, *William Hogarth, 1697–1764* (London: T.C. & E.C. Jack, 1910), p. 53.

5 G. Baldwin Brown, *William Hogarth* (London: Walter Scott Co., Ltd., 1905), p. 74.

6 Nichols (ed.), *Anecdotes of William Hogarth*, p. 139; see also George Augustus Sala, *William Hogarth: Painter, Engraver, and Philosopher* (London: Smith, Elder & Co., 1866), pp. 309–10.

7 John Ireland and John Nichols, F.S.A., *Hogarth's Works: With Life and Anecdotal Descriptions of His Pictures* (London: Chatto & Windus, 1883, 3 volumes), Vol. III, pp. 57–8.

8 J.B. Nichols (ed.), *Anecdotes of William Hogarth*, p. 138.

9 Hind, *William Hogarth*, p. 32.

10 Austin Dobson, *Hogarth* (London: S. Low, Marston, 1894), p. 77. Charles Lewis Hind quoted such opinion in his biography of a few years later: Hind, *William Hogarth*, pp. 64–5.

11 Baldwin Brown, *William Hogarth*, p. 37.

12 J. Reynolds, *The works of Sir Joshua Reynolds, knight … containing his Discourses, Idlers, A journey to Flanders and Holland, and his commentary on Du Fresnoy's art of painting* (London: T. Cadell, Jr. and W. Davies, 1798, 3 volumes), Vol. I, p. xv.

13 The subjects depicted are the *Rape of Europa* and the martyrdom of St Andrew. The visible image at the end of the battle line is followed by others marked 'ditto'. See Paul Barlow, 'Fear and Loathing of the Academic, or Just What is it that Makes the Avant-Garde So Different, So Appealing?', in R. Denis and C. Trodd (eds), *Art and the Academy* (Manchester: Manchester University Press, 2000), p. 19.

14 The definition of neoclassicism is difficult to be precise about, since some scholars would not include an artist such as Reynolds, as his work lacks the precision associated with David and even Mengs.

15 For the influence of Blake on young artists, see Colin Trodd, *Visions of Blake: William Blake in the Art World 1830–1930* (Liverpool: Liverpool University Press), pp. 13–86.

16 William Blake, 'Appendix 1: William Blake, *Annotations to Joshua Reynolds' Discourses'*, in Robert R. Wark (ed.), *Sir Joshua Reynolds, Discourses on Art* (New Haven, CT: Yale University Press, 1997), p. 291.

17 George Foggo, 'On Anatomy and Expression', *Arnold's Library of the Fine Arts*, 1(5) (1833), p. 378.

18 Ibid., p. 382.

19 Anon., 'EUROPEAN MUSEUM. GERRARD DOW's celebrated PICTURE of the DOUBLE SURPRISE', *The Times*, 7 November 1805; p. 1; col. a. The 'Double Surprise' was well known from an engraving by Jacques Firmin Beauvarlet. It depicts a man catching his servant girl in the act of stealing wine from his wine cellar. He takes advantage of the situation to proposition her. His wife is entering the cellar and sees her husband with his arm round the maid.

20 Wilson describes himself as 'an American loyalist from S. Carolina'. See, J. Wilson, *The plan and new descriptive catalogue of the European Museum: King Street, St. James Square: instituted the 23rd April, 1789, for the promotion of the fine arts and the encouragement of British artists* (London: Smeeton, 1808), title page.

21 Tom Taylor (ed.), *The Life of Benjamin Robert Haydon, from his Autobiography and Journals* (New York: Harper, 1853, 3 volumes), Vol. I, p. 16.

22 Ibid., p. 24.

23 Allan Cunningham, *The Lives of Most Eminent British Painters, Sculptors, and Architects* (London: John Murray, 1830, 6 volumes), Vol. I, pp. 62–3.

The John Frederick Lewis Collection at the Royal Scottish Academy: Watercolour Copies of Old Masters as Teaching Aids

Joanna Soden

THE ROYAL SCOTTISH ACADEMY has purchased the extensive and valuable collection of drawings made by Mr J C Lewis [sic], the eminent water-colour painter, from the most celebrated pictures by the old masters ... The object of the Academy in possessing these works is to afford their pupils the opportunity of studying them; the young Scottish artist not having within his reach a National Gallery of original pictures ...[1]

Thus the *Art Review* announced an innovative move in 1853 by the Royal Scottish Academy (RSA), the only national Scottish artist-driven institution at the time.[2] This acquisition played a significant role in its enterprise to provide educational resources for aspirant fine artists in Scotland. The impact of this collection as an educational tool in Scotland will be explored in this chapter by examining the background to this acquisition, its usage by the RSA and others, and the rationale of the Academy in making this important acquisition.

Since its foundation, the RSA actively encouraged English artists to submit work to its annual exhibitions, and early in 1853 John Frederick Lewis (1805–76) sent a substantial body of paintings. Born in London, Lewis was largely self-taught as an artist, although he spent some time as an assistant to Thomas Lawrence. In 1827 he commenced a series of extensive journeys across Europe, North Africa and the Middle East, during which he built up an extensive corpus of visual research material based on the landscapes and cultures of the countries he visited, as well as copies of Old Master paintings. Using watercolour as the primary medium for exhibition paintings, his studies underpinned these works, many of which were highly regarded, particularly his orientalist subjects.[3] The most important work in his submission to the RSA in 1853 was *The Hhareem* (undated, c.1850).[4] This work had enjoyed

critical acclaim at the Royal Academy and although it was not for sale, it was given star billing in Edinburgh. *The Scotsman*, for example, noted: 'The picture which occupies the post of honour, according to the old-established usage of artistic etiquette in our Edinburgh Galleries is J F Lewis' fine large water-colour No 494 "The Hhareem of a Mameluke Bey, Cairo – the introduction of an Abyssinian Slave"'.[5] Inspired by the quality of this painting and Lewis' use of his medium, the RSA selected for purchase another of his watercolours in the exhibition, *Interior of the Tribune, Florence*.[6] Presenting a view of the famous gallery in the Uffizi with iconic antique sculptures such as the *Venus de Medici*, the *Wrestlers* and the *Dancing Faun* (central to art students' study and widely disseminated through casts) and paintings such as Michelangelo's *Holy Family* (1506–8) and Titian's *Venus of Urbino* (1538), it was in itself a presentation of masterpieces of the art of the past. It was exactly this art of the past that the RSA wished to re-present to young artists in Edinburgh.

Whilst negotiating this purchase, the RSA learnt that Lewis had been in the practice of making studies whilst travelling through Europe. As the painter and pioneer photographer David Octavius Hill (1802–70) noted in a letter to Joseph Noel Paton: 'Mr J Lewis … was reported to have made drawings from Masaccio & Ghirlandajo & on my writing to him … answered that his drawings of these masters was slight – but he … had about sixty drawings in water colours from the great Spanish Italian Flemish & other masters'.[7] Hill served as Secretary to the RSA from 1830 to 1869 and played a central role in the negotiations for securing these studies. A highly intelligent and forward-thinking man who was never shy of innovation, he recognised that such a collection fitted neatly into the RSA's educational strategy. This had recently been drawn up by the RSA's treasurer, the painter William Borthwick Johnstone (1804–68) and approved by the Council and the Assembly of the RSA.[8] As Hill expressed to Lewis, 'regarding your collection of copies from the great Spaniards and the worthies of other countries … we are … deeply impressed with a sense of the vast importance of such an acquisition to the great object our Academy has in view of the advancement of art in Scotland'.[9] The RSA thus decided to purchase the whole collection for the substantial sum of £500.

Comprising 'a collection of Sixty-Four Drawings in Water Colours, copies of Old Masters, made by … [Lewis] while following out his own course of study', including 'Drawings from certain frescoes in Florence', this was a personal assemblage of studies.[10] It referenced paintings ranging in date from the fifteenth to the nineteenth centuries, including oils and frescoes. Some of the copies were of complete works and others of details only. Unlike other colour copies accessible to young artists in Scotland which were generally executed in oils, these were in watercolour and gouache on paper and painted as study pieces on a small scale (the largest measuring merely 27.3 × 41.2 cm).[11] The copies were made in public collections (the Louvre, the Prado, the Uffizi,

the Dulwich Picture Gallery and the National Gallery in London) as well as churches, cathedrals and other institutions in Florence, Padua, Madrid, Seville and Antwerp. They also represented exemplars of the key categories of European painting that were attracting the attention of painters at the time. The majority are either portraits or historical or biblical narratives – there are no still-life paintings and there are very few landscapes. They include three representations of *quattrocento* Florentine frescoes, 14 Venetian paintings, 28 Spanish works, six Flemish paintings (Van Dyck being included in this group), seven Dutch works (almost exclusively Rembrandt) and five French paintings (all by Watteau, except for *The Execution of Doge Marino Faliero, after Delacroix* exceptionally being a copy of near-contemporary work).[12] The collection's numerical bias towards Spain reflected the first phase of the discovery of Spanish painting by Western European artists during the nineteenth century.[13] David Wilkie (1785–1841) had travelled there in 1828, and he was followed by Lewis and David Roberts (1796–1864) in the 1830s. However, this Spanish bias was not necessarily a reflection of the interests of the RSA in 1853, but rather of the artistic interests of Lewis and more simply what was available for purchase at that time.

Although described as drawings, it was colour and the way this was handled that Lewis had been exploring. He explained that he had made them 'with a view to the investigation of their principles, and bringing away with him true Artistic impressions, particularly as to colour and chiaroscuro of the original works'.[14] In addition, Lewis used the process of making these copies to explore the arrangement, scale, gestures and expressions of figures, along with methods of presenting narrative and drama. Far from slavish imitations, they were highly mediated interpretations through which the artist could explore techniques and advance his own creative development. As such, they were not exceptional, but the opportunity the RSA took to acquire them and use them as teaching aids was nevertheless highly original.

So where did this purchase fit into the RSA's vision for the education of fine artists and what was it aiming to achieve? To answer these questions, it is necessary to explore the state of art education in Scotland (and particularly Edinburgh) at the time, to examine the aims of the RSA since its foundation in 1826 and also to understand the activities of other organisations during this period.

In 1760 the Honourable the Board of Trustees for Fisheries, Manufactures and Improvements in Scotland established an art school in Edinburgh known as the Trustees' Academy.[15] Operating with government funding, its founding aim was to encourage and improve Scottish industries through the teaching of drawing and design to artisans, particularly those working in the Scottish textile industries. Although fulfilling an important role at foundation level, its teaching remit did not address the training of aspirant fine artists. Students with such ambitions drifted to London to complete their studies whenever

the opportunity arose – for example, William Allan went to London in 1805, David Wilkie and John Burnet followed suit in 1806, and Andrew Geddes followed in 1807. However, during the next 60 years, the teaching offered at the Trustees' Academy shifted towards improved fine art tuition. This was partly driven by the interests and abilities of its drawing masters (such as David Allan, who served as master from 1786 to 1797, and Andrew Wilson, who served as master from 1818 to 1826) and partly through access to enhanced facilities and an expanding cast collection. This momentum increased when in 1826 the Trustees' Academy was allocated space in the prestigious new building called the Royal Institution on Princes Street. William Henry Playfair's elegant neoclassical galleries had recently been completed to house the Royal Institution for the Encouragement of the Fine Arts in Scotland, hence its name. Founded in 1819 along the lines of the British Institution, this was an organisation comprising primarily of art patrons and connoisseurs to encourage the appreciation of the fine arts in Scotland through the public exhibition of Old Master paintings drawn mostly from its members' private collections.[16]

Alongside the expansion and development of the Trustees' Academy (as a government-funded teaching institution) and the exhibitions presented by the Royal Institution (an independently funded patronage organisation, yet one that benefited from indirect governmental support through the provision of premises), a third player muscled in on the action. On 26 May 1826, a group of painters, sculptors, architects and engravers were summoned to a meeting by the English-born portraitist and miniaturist William Nicholson (1781–1844). In reaction to a perception that advances being made in the promotion and development of the visual arts in Scotland were side-stepping the practitioners (i.e. artists and architects), they voted to establish an independent Scottish academy. Based on the blueprint of the Royal Academy of Arts, its founding aims were:

1st To have an Annual Exhibition open to all Artists of merit ...

2nd To open an Academy where the Fine Arts may be regularly cultivated, and at which the Students in the Arts may find that instruction so long wanted and wished for in this Country, free of expense

3rd To form a Library of Books of Painting, Sculpture and Architecture and all other objects relating thereto, and also of Painting, Prints, Casts and Models and all things useful to the Students in their Art

4th As all are not equally successful ... to raise a sum for the relief of the Members and Widows, and

Lastly ... to admit Honorary Members eminent by their talents and attainments.[17]

Thus the RSA declared an intention to teach the next generation of artists as well as to establish a library and reference collection in support of this activity.[18] During the first 25 years of its existence, the RSA enjoyed some notable successes, particularly with regard to its annual exhibitions and its growth in membership. However, it also encountered challenges, not least the lack of suitable premises and certain points of friction with the other art institutions already operating in Edinburgh at the time. To offset the former, it was allowed to use the Royal Institution galleries for its annual exhibitions from 1835 onwards. However, this led to complex negotiations over shared spaces and timetabling, which at times deteriorated into major spats. Furthermore, with the Trustees' Academy already installed in part of the Royal Institution building, it was not possible to provide space for the RSA's intended Life School (which was to become the teaching arm of the academy as defined in its founding aims). Instead, this was conducted in a hired hall in West Register Street from 1840 to 1846 and afterwards in larger rented premises at 33 Abercromby Place in Edinburgh's New Town. It was during this latter phase that the Academy began to develop its library and reference collections and to consolidate its long-term teaching plans.

The impetus behind the RSA's move to develop its educational role was strengthened in a governmental report of 1847 when an inquiry was commissioned into the management of the Board of Manufactures and related issues. Under the leadership of John George Shaw Lefevre (1797–1879), Secretary to the Board of Trade, its primary remit was to examine the demands of the various art collections currently housed in the Royal Institution building and to make recommendations. By this date, works belonging to the Royal Institution, the University of Edinburgh (Torrie Bequest) and the RSA jostled for space alongside the public exhibition needs of the constituent institutions as well as the Trustees' Academy.[19] However, Lefevre also addressed the question of art teaching in Edinburgh and was supportive of the RSA. He made strategic recommendations embracing both the Trustees' Academy and the Academy's Life School. Although the RSA was unable to fulfil Lefevre's vision in its entirety, his initiative created the impetus to erect a new building immediately behind the Royal Institution to be shared by the RSA and the nascent National Gallery of Scotland.[20] Also designed by William Henry Playfair, the interior of the building contains two suites of galleries on a north-south axis: the west one was allocated to the National Gallery of Scotland and the east one to the RSA.[21] Additional spaces were allocated for other functions such as meeting rooms, stores and the RSA's Life School. As the building neared completion, the RSA held its first annual exhibition in the new galleries in 1855 and later that year it transferred its offices and library there. In 1859 the National Gallery of Scotland opened its doors to the public in the western suite of galleries.[22]

This chronology moves us ahead of the Lewis acquisition, but it is necessary to be aware of these developments as their initiation and progress were key

factors in helping to shape the RSA's policies. For example, the RSA would not have been in a position to collect art at all without adequate storage and display space (it had already learnt this the hard way with its first large-scale acquisitions, such as William Etty's substantial *Judith and Holofernes* series (1827–31), which had been purchased between 1829 and 1831 and became the cornerstone of its modern art collection).[23] The anticipation of purpose-built facilities was central to the formulation of Johnstone's aforementioned *Art-Tuition Policy*. In it he also stressed the importance of travel in the professional development of young artists and made recommendations as to how the RSA should assist. Citing the example of the Royal Academy, he expanded his concept by calling for the RSA to make a collection of high-quality copies of acknowledged masterpieces in colour which would be available for the students to study prior to or, if lacking funds, instead of travel: 'it is not every student who has the time and means to go abroad and examine the works themselves, and to the public in general they are unknown except through the medium of imperfect engravings or still more imperfect description in words'.[24]

Such a collection should be built up methodically to provide a wide-ranging overview of art of the past. As Johnstone argued:

> The Academy ought to possess specimens of every kind of art which has arisen in the important epochs of civilisation, for illustrating both its progress & history that by a knowledge of what has already been done, motives may be called forth for carrying art to still greater excellence … Where are there specimens in this country from which the student can form anything like a just conception of early Italian art? And yet it is the main source from which nourishment flows to modern art … [yet] … this important style of art can only be judged of here by the examination of imperfectly engraved outlines.[25]

Johnstone's key message is the importance of access to visual reference material of the highest quality. With the knowledge of improved accommodation in the near future and sufficient funds at the time with which to make strategic purchases, this report kick-started the RSA's teaching collection. It purchased not only the Lewis collection in 1853 but also two important full-scale copies in oil by William Etty, *St John the Baptist Preaching, after Veronese* (c.1822–3, National Galleries of Scotland) and *Venus of Urbino, after Titian* (1823, RSA).[26]

The RSA celebrated the Lewis acquisition in 1853 by mounting an exhibition in its rooms at 33 Abercromby Place. Lewis arrived in Edinburgh in May with the intention of spending the summer in the city compiling a *catalogue raisonné*. The RSA even made plans to illustrate the catalogue with wood engravings made from photographs of a selection of the watercolours, but in the event it was published unillustrated. The exhibition opened in mid-November, by which time Lewis had been forced to return to London for personal reasons. Admission was free; the public were admitted on weekday afternoons, the mornings being reserved for students to enable them to study and to make copies.

Published anonymously as *Catalogue of a collection of drawings of pictures by the Italian, Spanish, Flemish, Dutch and French Schools executed by J. F. Lewis, the property of the Royal Scottish Academy, with notes on the styles of the artists, as illustrated by their works – intended chiefly for the students of the academy*, the entries were mostly the work of Lewis. Its lengthy preface was written by Johnstone, who used this as a platform from which to expound the RSA's educational aims based on his *Art-Tuition Policy*.[27] He explained the importance of forming a collection of copies 'of the most celebrated works of different schools of painting' which would '[refresh] the memories of those who have already studied those glorious examples … [enlighten and excite] those who have not had the advantage, and [imbue] the public mind with a taste for Art'.[28] Thus they were seen as *aides memoires* for those already fortunate enough to have seen the originals and tasters for those who had not. It was hoped that they would encourage artists to travel to study the originals rather than accept the copies as absolute representations. Johnstone also argued for the relative value of access to good copies of European masterpieces rather than works of dubious quality where poor technique would debase the stature of the originals. This had been recognised as a problem in Edinburgh due to the large-scale importation of paintings described as Old Masters and bearing enthusiastic attributions in order to feed a demand for perceived high-status products with which to enhance the lofty walls of Edinburgh's Georgian New Town. Johnstone highlighted the importance of colour and chiaroscuro in the copies themselves and announced that the RSA would expand its copy collections to address other pictorial issues, such as structure and composition, and to explore other art movements. Clearly, the author of this preface had an agenda to educate and his comments show a highly developed level of connoisseurship. Although a painter and Royal Scottish Academician, Johnstone's interests coalesced with his appointment five years later as the first curator of the National Gallery of Scotland. In all he served as curator and principal curator from 1858 to 1868 and published the first catalogue of its collections: W.B. Johnstone, *Catalogue, descriptive and historical, of the National Gallery of Scotland* (Edinburgh, 1859). Organised alphabetically under the headings 'ancient', 'marbles and bronzes' and 'British artists', this created the structure upon which the Scottish national collection was published throughout the nineteenth century – and it embraced the RSA's art collection (including the Lewis collection), thus acknowledging the national remit of the RSA through this period.[29]

The Lewis exhibition catalogue was structured in a more didactic manner, the material being organised into six schools; Early Florentine, Venetian, Spanish, Flemish, Dutch and French. Within each section, every copy was summarily described and placed in an art-historical context. Assessments were made on the significance of the originals and topical matters were touched upon, such as the collecting policy of the National Gallery in London.

This systematic approach to an historical art collection was in line with current thinking and by drawing artists together in clusters of influence, it follows the methodology of Gustav Friedrich Waagen (1794–1868) which had first been put into effect in his organisation of the Royal Gallery at Berlin in 1844.[30] This enhanced the notion that nationality could be expressed in and reflected through the visual arts. Similarly, the Lewis exhibition sought to promote a didactic, historical perspective and through this a demonstration of the development of nationalistic traits in European painting. This presentational approach, according to national schools, was a deliberate attempt to help foster the concept (by association) of the existence of a native Scottish school of painting. Indeed, 10 years later and after a long period of gestation, the RSA presented a landmark *Exhibition of Selected Works of Deceased and Living Artists in Scotland*, which aimed 'to illustrate the past history and progress, as well as the condition, of Scottish art', thus putting this nationalistic concept into concrete form.[31]

The Lewis exhibition received extensive press coverage and the RSA was widely lauded for its enterprise. *The Art Journal* praised the RSA's initiative for its pragmatic approach to the problem of art collecting (in its acquisition of modern, high-quality copies of Old Masters at a relatively low cost rather than purchasing dubious originals at great expense) and looked forward to a similar enterprise coming to fruition in London at the Crystal Palace.[32] Lewis himself reported the reaction of the English academicians in London: 'I am delighted to hear that the Abercrombie Exhtn [sic] has opened with such éclat. This is very cheering … I saw E Landseer & Mulready last night … Mulready is quite charmed at the initiative which the Scottish Acad. have taken'.[33] *The Scotsman* newspaper published two extensive and important reviews that enhanced the catalogue's verbal interpretation and offered fresh analyses.[34] They progress systematically through the exhibition, discussing every work in detail and highlighting technical points for students. The most likely candidate for authorship of this article is the painter Robert Scott Lauder (1803–1869) who was an Academician (and therefore an insider) as well as a master at the Trustees' Academy at the time.[35] In this latter role he was ideally placed to give practical information on technique for the benefit of students. Furthermore, the emphasis on colour and chiaroscuro was close to his heart and the message conveyed was in tune with his own work.[36] Specifically intended to complement the exhibition catalogue, which did not discuss technique, these reviews are highly practical. By examining a selection of the copies alongside the texts in both the catalogue and the reviews, it is possible to gain insights into the educational aims of the exhibition.

The catalogue opened with the Early Florentine School as represented by three watercolour copies of details of frescoes from the Carmine Chapel and Sta Maria Novella in Florence after Masaccio, Fra Filippo Lippi (Figure 3.1) and Ghirlandaio. In studying these extensive *schemas* in situ, Lewis

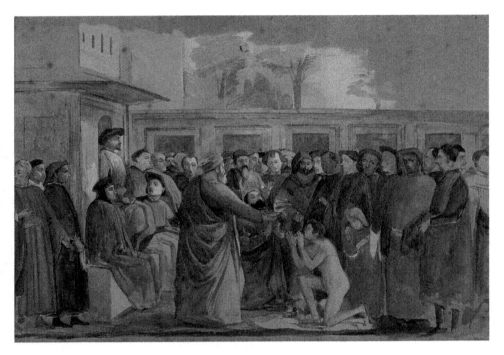

3.1 John Frederick Lewis, *SS Peter and Paul Restoring the King's Son to Sight, after Fra Filippo Lippi* (undated) watercolour with gouache, Royal Scottish Academy.

was investigating methods of presenting narrative and the organisation of complex spaces, as well as the sheer visual excitement and colourful richness they offered. After contextualising each artist, the catalogue explained the narrative of each fresco. In contrast, the newspaper reviewer explored Lewis' technique and his choice of materials:

> These drawings, though but slightly executed, give most truthfully the general effect of the frescoes, which are of a quiet and subdued tone of colour ... To the student they are useful examples, showing what these great artists aimed at; dignity of form being a leading characteristic ... even in a mechanical point of view, these studies are instructive, showing how a master of his materials produces, in a way most suited to the purpose, the best resemblance of the original ... [Lewis] has chosen crayon paper of a colour suited to the middle tint of the pictures, every wash opaque colour.[37]

The question of fresco was highly topical in Britain at the time and in Scotland there had been experiments in this technique, notably by David Scott (1806–49) and John Zephaniah Bell (1794–1883). Although unable to replicate the medium and scale in his studies, Lewis' employment of gouache on tinted paper and his broad treatment of the subjects, for example, in *The Raising of*

Theophilus' Son, after Filippino Lippi, effectively gives a shorthand account of his chosen subject. This is in marked contrast to the accuracy and intricate detail of another colour version of the same fresco published a decade later as a chromolithograph by the Arundel Society, which was widely disseminated to art teaching institutions, including the RSA.[38] Thus, in later years the Lewis version provided a valuable counterpoint by demonstrating that 'less is more' in the organisation of complex figure groups and narratives.

Moving on to the Venetian School, the catalogue introduces the 'Fête Champêtre. In the Louvre ... Giorgione' (since reattributed to Titian) by informing the reader of the size of the original, it being vastly reduced in Lewis' copy, and then discussing the characteristics of Giorgione's work in general and his 'peculiar poetic mode of treatment' so that '[his] pictures ... have a luminousness and internal glow, contrasted with a solemn and dignified repose'.[39] The newspaper reviewer (who was evidently familiar with the original, as Lauder would have been, given his visit to Paris and the Louvre on his way to Italy in 1833) explained the technique behind the copy: 'The utmost brilliancy being here required, a white ground has been selected ... this drawing, which is given with great force, has much of the sparkle of the original pictures, and for richness of tone and brilliancy of colour it is perhaps unsurpassed'.[40] Thus, not only was Lewis' depth of colour in his watercolour technique highlighted, a radical alternative to the widespread employment of watercolour to tint drawings (the common practice in Scotland at the time), but so was his direct drawing technique. Throughout the reviewer emphasises the use of colour as he works his way around the exhibition. For example, of *The Entombment, after Titian*, he explained: 'This drawing, also on a white ground, is perhaps the most carefully finished in the collection. It conveys a perfect representation of the picture, one of the best works of this great colourist'.[41]

Along with *The Supper at Emmaus, after Titian*, these pieces represent works that had been widely copied, studied and published. For example, John Burnet's analysis of *The Entombment* in his *Practical Hints* of 1827 explored Titian's use of complementary warm and cool colours, and his use of tonal contrasts to aid composition and narrative.[42] Burnet referred back to Reynolds, thus positioning his analysis within the academic agenda as expounded at the Royal Academy. Although he never studied at the Royal Academy himself, Lewis would have been familiar with these theories and used his watercolour copies as a means of self-improvement. Indeed, for art students, his watercolours had distinct advantages over reproductions of the type published by Burnet, due to their livelier and more accurate colouring, and also for the fact that they were not reversed through the act of copying, as was the case with engraved reproduction techniques.

Moving on to the Spanish School, the catalogue concentrates primarily on the work of Velazquez. Changing political circumstances in Spain and the

3.2 John Frederick Lewis, *Study of a Portion of the Picture of the Adoration of the Shepherds, after Velazquez* (now reattributed to Neapolitan School) (1833), pencil, watercolour and gouache, Royal Scottish Academy.

opening of the Prado in 1819 had made Spanish art and the work of Velazquez in particular accessible to artists who were able to travel. Of *Study of a Portion of the Picture of the Adoration of the Shepherds, after Velazquez* (Figure 3.2), the catalogue describes it as an early work showing the influence of Caravaggio on Velazquez.[43] Indeed, Lewis' decision to concentrate on just a few highly expressive and gestural figures is evidence that this was what interested him here. The almost hurried chalk work describing some of the form and hinting at other figures adds a personal interpretation on what was already a highly charged subject in the original.[44] By way of contrast, *The Scotsman* ignored Lewis' interpretation and went straight to practical matters: 'This study is on crayon paper, and drawn with black and red chalks, fixed by a wash, and finished by touches of body colour in their highlights. A useful example in execution'.[45] Velazquez is represented with 17 copies in this collection, whereas Murillo is represented with eight. However, unlike the former, Murillo's work was already relatively accessible in Britain, most notably at the Dulwich Picture Gallery (which had opened in 1814), home of *The Flower Girl*. The

Lewis copy of this painting employs brighter colours than the original, but faithfully reproduces the arrangement of the figure. However, more important than its composition in this instance is the copying and legitimising of an idea; a low-status yet picturesque character occupying virtually the whole of the picture space in a manner usually reserved for portraiture. The catalogue's attempt to elevate the subject was to focus attention on physiological detail, thus categorising this piece as an example of ethnographical recording, a sub-genre already well established in the 1850s, for 'there is realised in ... a most pleasing manner and with the truth of nature, all the striking characteristics of the Spanish race, in which a Moorish origin is traceable'.[46] The combination of travel and colourful ethnographical recording was a growing creative niche and many Scottish artists of the next generation would turn this into a lucrative speciality, such as John 'Spanish' Phillip (1817–69) and Robert Herdman (1829–88).[47]

Thereafter, the catalogue continues with the Flemish, Dutch and French Schools, and thus the whole exhibition is discussed. Not only were visitors invited to appreciate the contents of the works and to recognise the salient qualities of the paintings of Titian and Veronese in contrast to those of Velazquez and Murillo, but between the exhibition catalogue and the reviews, students and visitors were given insights into Lewis' watercolour technique and his use of different papers, thereby concentrating on the artist's mediation of the originals. This two-pronged didactic interpretation was carefully orchestrated to relay messages to educate artists as well as lay visitors.

The RSA Life School was in abeyance between 1853 and 1859, but on the roll of the Trustees' Academy for the 1853–4 session were Robert Herdman, Hugh Cameron (1835–1918), George Paul Chalmers (1833–78), Peter Graham (1836–1921), William McTaggart (1835–1910) and John MacWhirter (1839–1911), and soon to be joined by William Quiller Orchardson (1832–1910) and John Pettie (1839–98). It was precisely this audience that the RSA was targeting with Johnstone's education policy. As students, they had privileged access to the Lewis watercolour exhibition in the Academy's rooms in Abercromby Place and later in the RSA's new galleries on The Mound where it remained on display.[48] As the RSA's report for 1853 noted:

> Arrangements have been made by which Students of Art, not necessarily professional, may have exclusive admission at certain hours of the day for the purpose of study, and to make copies ... the good which must accrue from the continued presence of those brilliant memories of Old Masters, must exercise ... an immediate beneficial effect on the productions of the Artists of our time and country.[49]

With these galleries sited immediately behind the building containing the Trustees' Academy, the proximity of the Lewis watercolours greatly facilitated their use by this generation of students, who could examine small-scale

versions of famous paintings that were otherwise only available through verbal descriptions or engravings. This was a critical opportunity to broaden the visual outlook of these young artists. For example, although McTaggart and Chalmers visited the *Art Treasures of the United Kingdom* exhibition in Manchester in 1857 and acknowledged its importance in their development, they did not travel in Europe as students; therefore, the only easily accessible Old Masters for them were those hanging in Scotland.[50] Pinnington refers to Chalmers copying Lewis' watercolours after Rembrandt, as well as the impression made on him by Van Dyck (*The Lomellini Family*) and Veronese (*Mars and Venus*) in the collection of the Royal Institution.[51] Indeed, the influence of Rembrandt (whether inherited through Wilkie or drawn from the Lewis copies and originals seen in Manchester) can be seen in many of Chalmers' later works, such as *The Legend* (1864 onwards, National Galleries of Scotland).

Where Lewis' copying of a compositional device from Rembrandt influenced Chalmers, it was the artist's technique that impacted on William McTaggart. In all his copies, Lewis' brushwork is visible, thus giving a powerful sense of immediacy. By placing these works on exhibition, the RSA was legitimising a radically freer approach to finished (i.e. exhibition quality) artworks. This highly visible brushwork, in appearance close to handwriting, was a technique that McTaggart was to explore and make his own in his later paintings. Furthermore, McTaggart's use of the ground layer as a visible and constituent part of his finished paintings may well have had its genesis in the example of Lewis.

Although Lewis' copies represent personal interpretations of Old Master paintings, the overall impact of these jewel-like colour studies provided significant back-up to Robert Scott Lauder's teaching at the Trustees' Academy. Titian's bold use of red as a significant compositional aid to attract the eye was made clear for example in Lewis' versions of *The Entombment* and *The Supper at Emmaus*. In the latter, the red cap belonging to the figure beside Jesus forms an apex in the triangle on the left side of the painting, and this leads the eye down to the bread and wine, key elements of its subject. This highly effective use of colour, analysed by Burnet, studied by Lewis and taught by Lauder, was developed by his pupils to such an extent that it became a hallmark of the group.[52] For example, John Pettie in *The Disgrace of Cardinal Wolsey* (1869, Sheffield Galleries and Museums Trust) employed the colour of the subject's robes for compositional purposes as well as relishing it for heightened dramatic effect. Such usage was maintained by this group of artists throughout their careers, for example, in William Quiller Orchardson's *Marriage de Covenance – After!* (1886, Aberdeen Art Gallery), where the red armchair serves to focus on the total isolation of the deserted husband who is the subject of the painting.

By way of a coda, further evidence of the impact of the Lewis watercolours is available in the work of a more mature artist, Samuel Bough (1822–78).

Based in Hamilton at the time and painting in Cadzow Forest, he was accustomed to work from sketches made outdoors and his watercolours achieve a remarkable immediacy. Through his use of translucent washes on white paper, he was particularly successful in recreating the fleeting effects of sunshine, clouds and rain. Late in 1853, Bough painted *Snowballing outside Edinburgh University* (National Galleries of Scotland). This piece is quite different. Using a tinted paper as his base to provide the mid-tone, he applied watercolour brushstrokes to delineate the figures and architecture of the subject, and added thick white gouache to recreate the effects of snow and also to articulate the buildings. The technique echoes Lewis' practice in his copies, most strikingly in *The Embarkation of the Doge, after Leandro Bassano*, where the coloured paper provides the overall unity in an otherwise busy scene. Its striking perspective, with a steep vanishing point, and the bold use of gouache to describe the architectural details of the buildings are features also used by Bough in his Edinburgh watercolour. Furthermore, the scale and disposition of the figures is remarkably similar in both paintings. Although Bough did not repeat this formula to any great extent in his later watercolours, instead reverting to the use of translucent watercolour over white paper, the example of Lewis was a catalyst in the evolution of his career.

The adoption of Johnstone's *Art-Tuition Policy* enabled the RSA to establish an active, structured collecting policy from 1853 onwards, in addition to the passive accumulation of its Diploma Collection.[53] Specifically targeting Scottish art students, its underlying aims were to introduce the work of European masters (and thereby to inspire and generally broaden horizons) and to offer specific information on aesthetics and technique. It recognised the element of compromise engendered by a reliance on copies, but in consequence directed the RSA to acquire only the highest-quality work possible. This was launched in 1853 with the acquisition of the Lewis collection and two major copies in oils by William Etty. Johnstone's recommendation to broaden the scope of work represented in the medium of watercolour was acted upon in the following years. In 1854 the RSA expanded its *Quattrocentro* copy collection with the purchase of *The Tribute Money, after Masaccio* and *The Annunciation, after Fra Angelico* by William Hausoullier (1818–91), an artist resident in Florence, and in 1856 it purchased a further nine copies of the work of Italian masters by the young Scottish artist Robert Herdman. In addition, alongside copies per se, the RSA's visual reference collection made significant advances in its library with an expanding collection of folios of reproductions. For example, it subscribed to the series of autotypes taken from sections of Michelangelo's frescoes in the Sistine Chapel by Jean Adolphe Braun (1812–77). Braun's images allowed close-up study of this major cycle and enabled students to appreciate the breadth of the artist's technique, whereas the RSA's subscription to the Arundel Society's series of chromolithographs allowed for a further study of colour through its intricate, if sterile, colour copies of Italian frescoes.

However, within 20 years, the RSA's interest in its copy collections had dissipated and active purchasing ceased. The reasons were threefold. First, with the opening of the National Gallery of Scotland in 1859, a major resource was instigated and, although the development of the national collection was gradual and even piecemeal to begin with, it became apparent to the RSA that its funds and energies might be more usefully expended on activities other than building up an art collection referencing European art movements. Indeed, this leads to the second reason, which was the RSA's return to an active teaching role in 1859 when, after an hiatus of six years, the RSA re-opened its Life School. Now in its own suite of rooms at the north end of the new building shared between the National Gallery of Scotland and the RSA, it operated in effect as a postgraduate class for elite students from the Trustees' School of Art (previously known at the Trustees' Academy) and elsewhere in Scotland. The RSA thus reverted to the active practice of one of its founding aims and it continued to operate in this capacity until January 1911, when its facility migrated to the recently opened Edinburgh College of Art. The third reason for the decrease in interest in copy collections was an outcome of the increased accessibility of the major art collections of Europe due to vastly improved transport systems, most notably the railways. From 1870 onwards, the students attending the RSA Life School were regularly making their way to France, the Low Countries, Germany, Italy and Spain to study the art of these countries and increasingly to spend time in their art academies and artists' studios.

When the Lewis collection was first put on public display in Edinburgh, the potential of watercolour as a medium in its own right was made highly demonstrable. Prior to this, watercolour had been largely perceived as a medium for the amateur or as a preliminary research medium (in fact, exactly as Lewis had used it for these very copies); only on very rare occurrences had it been the focus of an exhibition, such as that of Hugh William Williams' landscapes in 1822.[54] Therefore, the RSA's Lewis exhibition helped to bring watercolours in from the cold, although it was not until 1887 that a specialist exhibiting society equivalent to the Royal Watercolour Society was founded with the creation of the Royal Scottish Society of Painters in Watercolours (RSW) in Glasgow. More immediately with regard to this medium, it was the dazzling intensity of colours and the varied effects demonstrated by a skilled practitioner such as John Frederick Lewis that, above all else, inspired and helped to give direction to a rising generation of Scottish artists.

Acknowledgement

This chapter draws on an unpublished PhD thesis: Joanna Soden, 'Tradition, Evolution, Opportunism: The Role of the Royal Scottish Academy in Art Education 1826–1910' (University of Aberdeen, 2006).

Notes

1 Anon., 'Minor Topics of the Month', *The Art Journal* (August 1853), p. 206.

2 The most recent account of the history and activities of the RSA is Esme Gordon, *The Royal Scottish Academy 1826–1976* (Edinburgh: Charles Skilton, 1976) preceded by William D. McKay and Frank Rinder, *The Royal Scottish Academy 1826–1926* (Glasgow: James Maclehose & Sons, 1917) and George Harvey, *Notes on the Early History of the Royal Scottish Academy* (Edinburgh: Edmonston & Douglas, 1873).

3 For a discussion on the life and career of J.F. Lewis and references to the RSA collection, see M-G. Michael Lewis, *John Frederick Lewis RA 1805–1876* (Leigh-on-Sea: F. Lewis Publishers, 1978), pp. 26–7 and 44–5; John Sweetman, 'John Frederick Lewis and the Royal Scottish Academy I: The Spanish Connection', *Burlington Magazine*, CXVII (May 2005), pp. 310–15; and John Sweetman, 'John Frederick Lewis and the Royal Scottish Academy II; Italy, the Netherlands and France', *Burlington Magazine*, CXLVIII (March 2006), pp. 194–200.

4 Lent by Joseph Arden, now in the collection of Nippon Life Insurance Company, Osaka.

5 Anon., 'Royal Scottish Academy's Exhibition. Second Notice', *The Scotsman*, 19 February 1853, p. 3.

6 Catalogue no. 552, described as *Tribuna, Florence*, transferred to the National Galleries of Scotland in 1910.

7 National Library of Scotland: Joseph Noel Paton letters, MS Acc no 11315: D.O. Hill to J.N. Paton, 15 February 1853.

8 Royal Scottish Academy, RSA Archives (RSAA): artist files: William Borthwick Johnstone, *Suggestions by the Treasurer on Art-Tuition laid before the President and Council of the Royal Scottish Academy on 17 January 1853*, MS document, no pagination.

9 RSAA letter collection: D.O. Hill to J.F. Lewis (draft), 5 February 1853.

10 Anon., *Catalogue of a collection of drawings of pictures by the Italian, Spanish, Flemish, Dutch and French Schools executed by J. F. Lewis, the property of the Royal Scottish Academy, with notes on the styles of the artists, as illustrated by their works – intended chiefly for the students of the academy* (Edinburgh, 1853).

11 For example, the Royal Institution (see below) was already assembling an art collection that included some significant copies, such as a full-scale copy by an obscure Inverness-shire born artist, Grigor Urquhart of *The Transfiguration, after Raphael*, which had been purchased in 1827.

12 Painted in 1827, the original is in the Wallace Collection, London. Lewis probably made this copy when it was on exhibition at the British Institution in 1828.

13 Gary Tinterow and Genevieve Lacambre, *Manet/Velazquez: The French Taste for Spanish Painting* (New Haven, CT: Yale University Press, 2003); and David Howarth, *The Invention of Spain: Cultural Relations between Britain and Spain 1770–1870* (Manchester: Manchester University Press, 2007).

14 Anon., *The Twenty-Sixth Annual Report of the Royal Scottish Academy* (Edinburgh, 1853), p. 12.

15 Frequently abbreviated to Board of Trustees or Board of Manufactures, Alexander W. Inglis, 'Minutes of Evidence', *Board of Manufactures Committee, Report by Departmental Committee to Enquire into the Administration of the Board of Manufactures* (Edinburgh: HMSO, 1903), p. 3.

16 Francis Haskell, *The Ephemeral Museum, Old Master Paintings and the Rise of the Art Exhibition* (New Haven, CT: Yale University Press, 2000), pp. 46–63.

17 RSAA: copy of letter, J. Elder to Lord Advocate of Scotland, 6 December 1826, Minute Book 1826–1830, pp. 39–43.

18 In 1838 it received a royal charter and thereafter has been called the Royal Scottish Academy (RSA).

19 Alexander Monro, *Scottish Art and National Encouragement containing a view of the existing controversies and transactions during the last twenty-seven years, relative to art in Scotland* (Edinburgh, 1846).

20 The Trustees' Academy remained in the Royal Institution building until 1908, when it transferred to the new Edinburgh College of Art.

21 Colin Thomson, *Pictures for Scotland. The National Gallery of Scotland and its Collection: A Study of the Changing Attitude to Painting since the 1820s* (Edinburgh: National Galleries of Scotland, 1972).

22 In 1911 the RSA relocated to the Royal Institution, the building being renamed the Royal Scottish Academy, and its headquarters has been based there ever since. The vacated spaces in the shared building behind enabled the National Gallery of Scotland to expand into the whole building.

23 Transferred to the National Galleries of Scotland in 1910.

24 Johnstone, *Suggestions*, no pagination.

25 Ibid.

26 The Etty was transferred to the National Galleries of Scotland in 1910.

27 Anon., 'The Royal Scottish Academy', *The Art Journal*, VI (January 1854), p. 28.

28 Johnstone, *Suggestions*, no pagination.

29 The RSA later produced a catalogue independently, *Art Property in the Possession of the Royal Scottish Academy* (Edinburgh, 1883).

30 G.F. Waagen, 'Thoughts on the New Building to be Erected for the National Gallery of England, and on the Arrangement, Preservation, and Enlargement of the Collection', *The Art Journal*, 5 (1853), pp. 101–3. In 1828 Charles Lock Eastlake (1793–1865) had befriended Waagen during his travels through Europe, thus commencing a close and lasting relationship, with an exchange of ideas further cemented through Lady Eastlake's work as a translator. Prior to her marriage, Lady Eastlake (née Elizabeth Rigby) had been part of a circle of friends and associates in Edinburgh that included D.O. Hill, T. Duncan and W.B. Johnstone.

31 Anon., *The Thirty-Sixth Annual Report of the Royal Scottish Academy* (Edinburgh, 1863), p. 11.

32 *The Art Journal*, VI (1854), p. 28.

33 RSAA: letter collection: J.F. Lewis to W.B. Johnstone, 11 November 1853.

34 Anon., 'Fine Art. Royal Scottish Academy. Collection of Copies and Studies from the Old Masters', *The Scotsman*, 16 November 1853, p. 3; and Anon., 'Fine Arts. Royal Scottish Academy. Second Notice', *The Scotsman*, 23 November 1853, p. 3.

35 Lauder served as Master of the Antique at the Trustees' Academy from 1852 to 1861.

36 Lindsay Errington, *Master Class: Robert Scott Lauder and His Pupils* (Edinburgh: National Galleries of Scotland, 1983), p. 34.

37 Anon., 'Fine Art. Royal Scottish Academy. Collection of Copies and Studies from the Old Masters'.

38 Signor Mariannecci, *SS Paul and Peter raising the King's Son, in the Brancacci Chapel, Florence*, chromolithograph (Arundel Society, 1863).

39 *Catalogue of a collection of drawings*, p. 11.

40 Anon., 'Fine Art. Royal Scottish Academy. Collection of Copies and Studies from the Old Masters'.

41 Ibid.

42 John Burnet, *Practical hints on colour in painting illustrated by examples of the works of the Venetian, Flemish and Dutch Schools* (London: James Carpenter & Son, 1827), pp. 26–8.

43 The original is now identified as seventeenth-century Neapolitan.

44 This study is the only one in the collection to be signed and dated 'J. F. L. 1833', evidence that Lewis regarded it as a finished piece.

45 Ibid.

46 *Catalogue of a collection of drawings*, p. 29.

47 Helen Smailes, *Robert Herdman 1829–1888* (Edinburgh: National Galleries of Scotland, 1988).

48 The collection was loaned to the Royal Manchester Institution's thirty-seventh exhibition in 1857, which coincided in timing with the *Art Treasures of the United Kingdom* exhibition.

49 Anon., *The Twenty-Sixth Annual Report of the Royal Scottish Academy*, p. 13.

50 Letter from G. P. Chalmers quoted in Edward Pinnington, *George Paul Chalmers and the Art of His Time* (Glasgow: T. & R. Annan & Sons, 1896), pp. 94–5.

51 Ibid., p. 75.

52 Burnet, *Practical hints on colour in painting*, pp. 26–8.

53 Joanna Soden, *Paintings from the Diploma Collection of the Royal Scottish Academy* (Edinburgh, 1992), pp. 6–7.

54 Anon., *Catalogue of Views in Greece, Italy, Sicily, and the Ionian Islands painted in water colours by Hugh William Williams … now exhibiting in the Calton Convening-Room, Waterloo Place, 1822* (Edinburgh, 1822).

British Art Students and German Masters: W.B. Spence and the Reform of German Art Academies

Saskia Pütz

'The artist in this country has thus two great evils to contend with; in youth, the want of the means of education – in manhood, the want of proper and well-directed patronage'.[1] As Charles Heath Wilson, at that time Director of the Edinburgh School of Design, pointed out, the training opportunities for art students in Scotland in the first half of the nineteenth century were limited – a situation that extended to all of Britain at that time. Compared to other European states, institutionalised artistic training had for a long time played only a minor role. 'Our school is, and has been, entirely self-educated' the *Art Union* stated in 1848, criticising the lack of academic tuition. In matters of English schools of art, the journal asserted that 'the Royal Academy stands almost alone, and this is more a school in *name* than in *fact*' being 'inefficient to the last degree' and even going to such lengths as asserting the dispensability of this institution: 'But again, the celebrated pupils of the Academy had been no less celebrated than they are, had there been no Academy'.[2] Only a few private and public institutes provided teaching in Britain and they differed far more from each other than the academies in France or Germany, for instance, which were more uniform in their organisation. Due to their self-reliant organisation and considerable independence from the government – all having their origins in private initiatives – standardisation of their training had never been established.[3] The British situation was further distanced from that in German countries, where a constructive reorganisation of art education had already taken place.[4] It comes as no surprise then that around the middle of the nineteenth century, a great many British students went to art academies not only in France but also in Germany for their artistic training. The complexity of this transfer of artistic skills and knowledge is the subject of this study, which focuses on the influence of the upheaval at German art academies in the first decades of the nineteenth century, especially Peter

von Cornelius and the 'Munich School', upon educational requirements and practices in Britain. This approach should shed some light on several aspects of intercultural exchange, which is far more differentiated than a simple one-sided influence, comprising individual motivation, selective appropriation and refusal, as well as national rivalry and stereotypes of national characters.

William Blundell Spence (1814–1900) was an early example of this, attracted by the Academy of Munich, which had not previously enjoyed a reputation outside Germany. From 1835 until 1836, he is listed in the matriculation register of the Academy of Fine Arts, Munich as a guest student enrolled for painting.[5] This cosmopolitan art student had already gained experience in the studios of Giuseppe Bezzuoli in Florence and Ingres in Paris. Prior to going to Germany, he stayed from 1833 until 1835 with his family in England. Significantly, he did not pursue his artistic education either at an art school or in an artist's workshop, but went to the British Museum for drawing exercises from ancient marbles on his own, thus undertaking the common preparation for artistic education at the Royal Academy according to the later survey in the *Art Union*.[6] The opportunities offered by Germany thus encouraged him to break with his previous autodidacticism. His rising interest in the Bavarian capital was not random, but has to be considered against the broader context of the British interest in German literature, education and scholarship (especially in historiography, theology and natural sciences) in the 1820s and 1830s. The developments of the 'Neue Deutsche Kunst' (New German Art) in particular were presented to Britons by accounts of artists and travellers in the press since 1817.[7] This increasing public interest encouraged more visitors to travel to Germany, mainly to the Rhineland, Bavaria and Prussia. First-hand reports on the situation in the German states appeared in various travelogues like Henry David Inglis' *The Tyrol: With a Glance at Bavaria* (1833), Anna B. Jameson's *Visits and Sketches at Home and Abroad* (1834) and John Strang's *Germany in 1831* (1836).[8] In these descriptions the rising arts, especially in the Bavarian capital, were a point of major interest. Aware of 'a singular and mutual ignorance in all matters appertaining to art and, consequently, a good deal of injustice and prejudice on both sides', Jameson reported in detail on individual German artists and their works of art. She pointed out particularly the German accomplishments in history painting, bearing in mind their relevance to the contemporary crisis in British history painting that was an important motivation for her writing: 'It is certain that we have not in England any historical painters who have given evidence of their genius on so grand a scale as some of the historical painters of Germany have recently done. We know that it is not the genius, but the opportunity which has been wanting, but we cannot ask foreigners to admit this'.[9]

At the same time, journals took up this issue and reported on the German art scene and artistic community. Since 1833, a considerable number of articles were published in the *Athenaeum*, and later the *Art Union* and the *Ecclesiologist*,

concerning the modern German school of painting, Bavarian state patronage under Ludwig I, fresco painting in particular and the leading German artists, above all Peter von Cornelius.[10] This media coverage of the Munich art scene in Britain was fundamentally related to – if not directly affected by – the activities of German art critics. From the beginning, the Bavarian king saw the utility of garnering good public relations with his art-politics and therefore appointed Ludwig Schorn, the editor of the *Kunstblatt*, the principal journal of the German art scene at that time, as a professor both at the university as well as at the Academy of Fine Arts in Munich. As a result of this, the news and reports on cultural activities in Munich were accounting for up to a quarter of the pages in each edition.[11] In Britain this met with a good response: the *Art Union* especially publicised German art as a fitting model for the British. Later in 1839 the journal even declared the Germans 'certainly the greatest artists of Europe'.[12] Since the late 1830s, scholarly considerations on the arts in Germany were also better available, above all Count Athanasius Raczynski's three-volume account *Histoire de l'art moderne en Allemagne*, published from 1836 until 1841 in French and German, received rave reviews in the English press.[13] A publication on contemporary German art by Hippolyte Fortoul with 'superior claims' in 'extent and variety of information' and also translated into English was in print three years later.[14] Already the detailed summaries of those publications as well as of diverse others serve as good sources of information themselves.[15] Descriptions of contemporary German art were also incorporated in general compendia on art history like George Cleghorn's two-volume *Ancient and Modern Art, Historical and Critical* from 1837 (and 1848) or later Franz Kugler's *Hand-Book of the History of Painting*, edited in an English translation 1842. Thus, young artists or students had manifold options for gathering information on German art and academies.

Studying in Germany became attractive to such an extent that even a vast compendium on *The Student Life of Germany* appeared in 1839. Its author, William Howitt, informed prospective British students therein about official and non-official aspects of student life at German universities, instancing Heidelberg as a case in point. The university system, organisation and matriculation are explained as well as the various conventions of student life, in particular the student leagues and their customs.

Due to the Westminster Hall Competitions as well as connected rumours about the employment of German artists, the situation concerning art students had altered remarkably only five years after Spence's departure.[16] So in the 1840s quite a significant group of British aspiring artists went to Germany to enhance their skills. Munich – the 'hot-house of arts in Germany' – was, in particular, a place of special interest.[17] A lot of artists like Alfred Elmore, Henry James Townsend, Henry O'Neil or George Edmund Street at least visited the Bavarian capital or stayed and worked a couple of months with the well-known artists Julius Schnorr von Carolsfeld, Heinrich Maria von Hess,

Joseph Schlotthauer, Carl Schorn, Moritz von Schwind, Ludwig Schwanthaler or Wilhelm von Kaulbach. Quite a few Britons were, like Spence, even enrolled at the Munich Academy of Fine Arts to study under the new German Masters and their colleagues or were pupils in their studios, like Edward Matthew Ward, Harold John Stanley, William Cave Thomas, Thomas Sibson, John Calcott Horsley, John Tenniel, Anna Mary Howitt and Charles West Cope, or less-renowned artists like Aiton John Smith and Robert Douglas Aiton (see the Matriculation Register of the Academy of Fine Arts, Munich).[18]

The central figure at the Munich Academy for painting at this time was the influential Peter von Cornelius (1783–1867). Also in England, he was the best-known artist from the *'Neue Deutsche Kunst'*, associated intimately with the so-called Nazarenes. Cleghorn even identified him as a 'synonymous term' with the 'School of Munich'.[19] Virtually no article about German art or the Munich art scene was written without at least mentioning him. In Britain Cornelius was regarded as the mighty leader of the German fresco movement, followed by Schnorr, Hess and Zimmermann. He was especially well known to the British art scene due to his journey to England in 1841.

After his appointment by the Bavarian king in 1819, Cornelius was fundamentally involved in the reconstruction of the Residency and especially since his assignment as director in 1825, he was concerned with the reorganisation of the Munich Academy. Spence wrote about the changes that had taken place at the Bavarian residence: 'I was astonished to find splendid, magnificent buildings, churches, pinacotecas, etc., all owing to good king Ludwig, the sovereign patron of art and artists of all descriptions'.[20] Due to the engagement of Ludwig I, the arts were increasing significantly and the former small town had grown into a cultural centre. During his stay in Munich, Spence participated in the resulting academic reform as well as the enormous prosperity of the arts, especially in connection with the large-scale mural projects. From 1820, Cornelius was in charge of the fresco decoration of the newly built Glyptothek and in 1836 he started the wall paintings in the likewise recently constructed Ludwigskirche when Spence was still in town. When he arrived, Spence found Cornelius at work on the cartoons for his monumental *Last Judgment* fresco in the Ludwigskirche (Figure 4.1). The reception in the English press on this commissioned piece by Ludwig I in apparent competition with Michelangelo's Sistine Chapel was controversial. While the *Athenaeum* did not question Cornelius as 'a masterly draughtsman' relating to the cartoons, it did disapprove of the artist's pretentions. Jameson's description in her travelogue was quite enthusiastic and two years later the *Art Union* would review this principal work of Cornelius at great length in an article about the artist and would cite it as an example of a change in his often-criticised chart of colour range: 'In this picture Cornelius seems inspired to surpass himself, for his colouring, usually feeble, here takes a deeper tone'.[21] Spence might probably have read those early reports before heading for

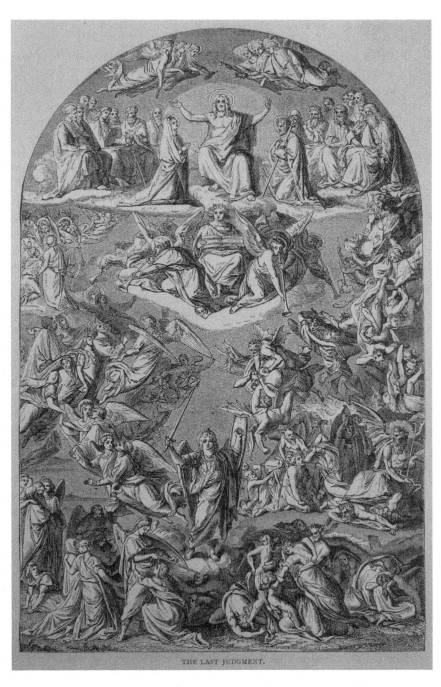

THE LAST JUDGMENT.

4.1 Peter von Cornelius, *Last Judgement* (detail) (completed in 1880), fresco, Munich, Ludwigskirche, author's photo.

Munich and he certainly knew about Cornelius and his school from his time in Rome.

Munich was not the first place for Spence to pursue his artistic training. He had lived in Florence and Rome with his parents since 1829. It is not known whom he might have met among the German artists there, but in 1831, he became verifiably acquainted with Bertel Thorvaldsen, who, despite being Danish, was a central figure and go-between for the German art community. The Danish sculptor also represented an important link between the older generation of artists and the Nazarenes, and he was a graduate of the Copenhagen Academy and thus was also affected by Asmus Jacob Carstens, an influential German artist trained at the Copenhagen Academy. So, when Spence decided to become an artist in 1831 and went to Florence to copy the frescos by Andrea del Sarto in SS. Annunziata in the autumn of that same year, considering this to be 'la grande scuola per i giovani', this seems to be very much influenced by Nazarene thoughts still alive in Rome.[22] Obviously the enthusiasm for fresco still endured, dating back to the second decade of the nineteenth century when the Nazarenes in Rome favoured the frescos of the early Renaissance Masters and accomplished their first large-scale orders for fresco cycles in the Roman Casa Bartholdy and the Casino Massimo. These two major commissions, finished in 1817 and 1827, were the most important achievements executed by the Nazarenes as a group in their early years in Rome and attracted a lot of international attention. Spence certainly knew about these movements and so it seems to have been a logical progression for him to continue his studies in Germany under the masters formerly based in Rome, i.e. Peter Cornelius in Munich. In between Spence had an episode in Ingres' studio in Paris which he left, complaining about the 'stump technique' he had to learn there together with about 100 other students, an aspect of the French artistic training with which he certainly was very familiar.[23]

When arriving at Munich, the young British student even had a letter of recommendation for 'the great painter Peter Cornelius'. Official enrolment at the academy was also free of charge to foreigners, as the *Literary Gazette* informed, and allowed admittance to the different classes for drawing and painting, etc.[24] Nevertheless, a personal visit and application to the academy professors was necessary to enter their studio and work closely with them. So, during his stay, Spence worked for Cornelius' assistant, Joseph Schlotthauer, a recently appointed 'Inspektor' at the Munich Academy. Spence also visited Cornelius once a week for supervisions. Like Hess and Zimmermann, Schlotthauer was a member of Cornelius' workshop and one of the main artists to accomplish the frescos designed by the director. Schlotthauer in particular was very much engaged in developing the technical aspects of fresco further. Unlike the large ateliers in Paris, which accommodated numerous students, in Munich Spence worked together only with about half a dozen other artists. They would primarily be concerned with history painting in fresco technique.

At the academy classes the élèves learned mainly drawing after life, plaster casts and Old Masters, as well as painting in oil and art history, as will be discussed later.

The motivation and aims of this movement for artistic renewal which Spence came to know in Munich originated in the dissatisfaction of young German art students with the situation they found in the early nineteenth century. In an often-cited letter dating from 1814, Peter Cornelius expressed this discontent with the following words:

> Regrettably one has to characterize [the arts] at this point in time as having been surpassed by the nation not only with regard to true education [*Bildung*] but also in terms of intellect and living. For the least of the heroes, who volunteered to join those veritable crusades, was – if I might describe it like this – carrying more exalted poetry in his heart than any leading professor of some ostensibly wisdom-crammed academy, shrouded in the dust fog of his negative eclectic artistic junk room [*Kunstrumpelkammer*] … The free development of this kind of art is in my opinion impeded, in the most disastrous manner by … [t]he mendacious spirit of modern art in general, which in its negative eclecticism, totally accords with the triviality and weakness of our great ones, and is an actual expression of those. And then more particularly the disagreeable art academies in our native land and their thick-skinned leaders, who are only concerned with themselves, with mechanical accuracy and nothing more, and who are adept at guiding whatever valuable support the state is willing to give to art into their own channels, where it vanishes into thin air – for ever since academies have existed nothing of lasting worth has been created.[25]

Cornelius was vocalising a fundamental paradigm shift towards new artistic feelings, perceptions and expressions to be regarded as more veritable, truthful and poetic. In his letter, Cornelius complains to the addressee, Joseph von Görres, the founder and editor of the *Rheinischer Merkur* (*Rhenish Mercury*), the most influential political journal in Germany at that time, about the conditions in which artistic education took place at the Düsseldorf Art Academy. So what exactly was Cornelius' point of criticism?

Cornelius condemned the form of academic art education as completely ineffective in preparing students for their subsequent artistic careers. He complained about mechanistic techniques, dry theories and disconnected studies of isolated objects. These were the key words of the general critique of academic instruction spreading throughout Europe during the nineteenth century, of which the German upheaval marks the beginning. Later, Benjamin Haydon's scorching criticism of the Royal Academy of Art in London, for instance, also reveals the same anti-academic objections, culminating in his polemic treatise *On Academies of Art (more particularly the Royal Academy) and their pernicious effect on the Genius of Europe* in 1839, as does the later complaint of Frederick Brown about the copying of mechanically printed templates at the Royal College of Art in 1870.[26]

Like most Continental art academies at that time, the Düsseldorf Academy, where Cornelius studied from 1798 until approximately 1805, was a state-run institution. Established by Wilhelm Lambert Krahe in 1775, like most of the other academies founded in the second half of the eighteenth century, the Düsseldorf Art Academy was organised according to the French prototype of the *Academie royale de peinture et sculpture* (established 1648).[27] The purpose of the academy in Düsseldorf was mainly the instruction of drawing and giving lessons in anatomy and perspective.[28] Cornelius studied in his birthplace just when the city came under French administration and the conditions at the academy as well as the inventory of the gallery declined dramatically. Nevertheless, the configuration, function and organisation of the Düsseldorf Art Academy had remained unaltered since the eighteenth century, and lasted even after its annexation by Prussia in 1815, when Düsseldorf became part of the Rhine provinces. The city awoke to new cultural life and the Academy was re-established in 1819 by the Prussian King Friedrich Wilhelm III. Neither compulsory education nor regulated curricula had been established in the Rhineland at that time, therefore the drawing classes were intended to have a broader preparatory function in a more general sense for all sorts of different trades instead of being focused on an exclusively artistic education for academic students. In Düsseldorf, constitutional changes had not been accomplished until the reorganisation of the Academy in 1819.[29]

At the time of Cornelius' studies, academic classes in Düsseldorf – as in most other European art academies – consisted mainly of copying the works of the Old Masters as well as body parts or plaster casts with chalk, pencil and charcoal on blackboard and paper. These eclectic didactics were justified by the classicist point of view, which held that as perfect beauty does not exist in nature, it must instead be composed from separate individual component parts by artists themselves.[30] Normally painting, especially oil painting and fresco, was not part of the academic program. So it was in Düsseldorf. The students had to take private lessons with teachers of their own choice, which generally had to be paid for separately, and this system was well established.

These critiques and other vivid depictions of wasted time at the art academies have dominated the academic literature about Cornelius and his contemporaries for a long time. Cornelius, however, was far from being the only person to proclaim discontent. The severe criticism of academies and the claim for alternative, nature-based educational models as well as the free development of the individual genius can be found expressed more or less explicitly in the letters and memories of many other artists who attended German art academies during the first decades of the nineteenth century. Ernst Rietschel's retrospective *Erinnerungen aus meinem Leben* (*Memories of My Life*) from 1863, Wilhelm von Kügelgen's *Jugenderinnerungen eines alten Mannes* (*Memories of an Old Man*) from 1869 and Ludwig Richter's *Lebenserinnerungen eines deutschen Malers* (*Memories of a German Painter*) from 1885 serve as examples.[31]

Generally speaking, revolting against courtly academicism and its dogmatic norms and rules concerning aesthetics, teaching methods and strong hierarchies had become more and more popular since the turn of the nineteenth century. The insurgence began at the very moment when the complete 'academisation' of artistic education was achieved. This might seem paradoxical because originally academies were established precisely in order to protect the autonomy of artists.[32] Already in the seventeenth century, one of the principal reasons for founding the French Art Academy had been to defend artists against the controlling and patronising behaviour of the trade guilds. The emancipation of the fine artists only happened gradually. Step by step the separation of artists in fine and decorative arts was realised throughout Germany though with regional differences. The distinction of the fine arts in Britain was even more drastic: the comparatively small Royal Academy of Arts was a private body fulfilling a public task under royal protection, but was not a state-run institution and did not assume responsibility for governmental or mercantile duties as did the other academies throughout Europe.[33] Being an exclusive forum for artists, the members of the Academy tended historically to dissociate themselves from the applied arts rather than merging with them. Morris even characterised the institution as being 'essentially a trade protection society of portrait painters' where teaching was regarded to be a 'loss-making side line maintained only to improve the Academy's public image'.[34] At the Royal Academy of Art in London, it was actually a principle not to teach drawing, and drawing teaching was of such little social prestige that it was regarded as posing a threat to one's artistic career.[35] Thus, hardly any reputable artist would take employment as a drawing master, like Constable, who refused such a course following Benjamin West's advice.[36] On that account, an associated system of provincial or municipal drawing schools, like those in France, Germany, Spain or Italy, had not been established in Great Britain, though the *Royal Society for the Encouragement of Arts, Manufactures & Commerce* had existed since 1754. Single foundations as in Edinburgh and London remained an exception but achieved little success.[37]

On the Continent, with the emancipation of the artist from lowly association with handcrafts, their work was legitimised by their individual genius and talent and was finally proved in public competitions with their peers at the Academy. Knowledge and techniques were no longer passed down by traditions and supervised by trade guilds. As a consequence of the French Revolution and the decline of corporative structures and craftsmen associations, the academies asserted their authority over the instruction of artists. By the eighteenth century, academies had already become a political instrument for maintaining the sovereign's power and control. Therefore, from about 1800, an artist had to graduate from an art academy, if only subsequently distancing himself from its principles and practices, in order to be taken seriously and become successful through gaining access to public

grants and royal commissions. This academisation of the artistic training had taken place throughout Europe – with the exception of Britain, where a mélange of different private drawing schools was common instead of broad and highly skilled academic education.

In the German states, the academic revolt can be regarded as a movement of substance among the young art students. An important precursor and role model of this movement was Asmus Jacob Carstens, who not only criticised the fragmented study methods but also haughtily rejected a second prize awarded to him by the Copenhagen Academy for the reason that he considered himself the best candidate. The younger students in Copenhagen, among them Bertel Thorvaldsen, were impressed by Carstens' stand and his ensuing dismissal by the Academy.[38] Carstens gained even more popularity among his fellow artistic colleagues later in Rome and posthumously after Fernow's biography was published in 1809, in which the story of the rebellious genius was told within a modern art-historical context for the first time.

In this Carstens became the 'Leitfigur', a leading figure, and progenitor of a whole generation of oppositional artists, who turned critically against the existing academic conventions. Bertel Thorvaldsen, Eberhard von Wächter and Gottlieb Schick in Rome also continued to refer to Carstens. They, as well as the Swiss Josef Anton Koch, who is another singular example of artistic uprising against academic didactics, preceded the most famous of the artistic rebels in Rome: the so-called Nazarene brotherhood.[39] Some of the Nazarenes, including Franz Pforr, Friedrich Overbeck, Ludwig Vogel and Johann Konrad Hottinger, left the Vienna Academy in 1810 and moved to Rome because of their discontentment with the teaching methods they experienced. There they experimented with alternative forms of collective living, working and studying for a while. Their alternative concept was aimed at producing a complete synthesis of life and work based on the logic of Carstens' critiques of the artificial, inefficient and inappropriate academic systems – notably, Overbeck and Cornelius refer to Carstens as a role model. Affiliated and in personal contact with some of the leading German philosophers and theoreticians of the time associated with the idea of *Bildung*, for example, Friedrich Schlegel and Wilhelm von Humboldt, the Nazarenes developed a concept of true art that was directly connected to and emerging from the artist's personality – and therewith were 'determined to restore the *mind* of the art', as an eyewitness, the English painter Seymour Kirkup, reported in 1817 to his fellow countrymen in the *Annals of the Fine Arts* regarding the nearly finished Bartholdy frescos.[40]

By contrast, in this aesthetic concept the artist's personality was affected and acculturated – in the sense of *Bildung* – by art.[41] Fundamental to this idea of 'Bildung' is the romantic idea of an authentic, natural and true self which one has to come to terms with faithfully in order to express this through authentic and original artworks.[42] An important predecessor for this new artistic self-

consciousness is the concept of the genius, which is fundamental for the aesthetic theory of the eighteenth century. In his *Kritik der Urteilskraft* (*Critique of Judgement*), Immanuel Kant denies the existence of predictable rules in the arts and rejects the rule-governed system of previous academic lectures: the only way to gain precepts for artistic practice was by analysing and emulating exemplary art objects. Rules are given to art only by ingenious artists. Their artwork could serve as examples to other artists by succession. According to Kant, the only way for young artists to gain a feeling for their own inner originality was to follow the methods of geniuses and their artworks instead of imitating them directly.[43] Thus, a repertoire of reasoning was established, influencing forthcoming generations of artists in German-speaking countries. The topos of the autonomous and self-consciously developing genius had already been established in antiquity, but now it obtained a specific educational and academically critical definition: the artists desired to achieve a typical form of expression of their own – despite and not due to their academic education.[44] In 1811 Cornelius had joined the Nazarenes in Rome and in the following year became one of the leading artists among this group, having succeeded Pforr after the latter's death in 1812. Their pedagogical ideals also spread beyond Rome: two decades after Carstens, Philipp Otto Runge and Caspar David Friedrich entertained similar grievances against the Copenhagen Academy, which ranked among the leading German academic educational institutions around in 1800.[45]

This German model of education thus offered something excitingly cutting-edge to British art students, uniting the pedagogical potential of Old and New Masters with an empowering element of self-reliance in a mixture that was not yet to be found anywhere in English art educational institutions. The revolutionary spirit also continued to have an effect on artists in Vienna who stayed behind after the first Nazarene exodus in 1810. So, for example, when the young academic scholar Johann August Heinrich, who was in close contact with the circle of artists and intellectuals around the Olivier brothers and Julius Schnorr von Carolsfeld in Vienna, moved to Dresden in 1818, the urge for new educational methods became more and more virulent among Saxony's students.

This student movement arising during the second decade of the nineteenth century, of which Cornelius was a part, not only considered the problems connected with technical training skills or individual teachers or specific academies, but also turned against the academic system as a whole. Likewise, whole canons of literature and artists were rejected. Cornelius as well as Koch, Richter, Overbeck, Kügelgen, Rietschel and many other students abandoned study of the Old Masters as well as their actual teachers because to these young artists, what they were teaching did not convey 'what it really was about'.[46]

The ideas of this artistic upsurge also spread in Britain. According to William Vaughan, who in his seminal study on *German Romanticism and English*

Art explained the importance of individual artists for the cultural exchange between Germany and England, among the Britons in Rome, Charles Lock Eastlake was most likely the best informed and most important mediator to communicate these new artistic requirements to his home country. Eastlake was Rome-bound from 1816 until 1830 and closely witnessed the activities of the German artists' colony, even establishing a close friendship with Schnorr. He was inspired by a lot of the artistic innovations and ideas and had the opportunity to communicate them to the 'Select Committee' as a result of his decisive position as secretary. Constantly referring to the independence and autonomy of the British artists in the appendix to the report from 1841, Eastlake points out the example of the 'national ardour of the Germans', but admonishes them for copying without grasping the underlying spirit: 'We have seen that a considerable degree of imitation of early precedents is mixed up with the German efforts: this of itself is hardly to be defended; but the imitation of that imitation, without sharing its inspiring feeling, would be utterly useless, as well as humiliating'.[47]

As explained above, the situation in Britain then differed considerably compared to that on the Continent due to the lack of a strong tradition of full academic training in fine as well as applied arts. The indistinct position of the Royal Academy, still in 1863 characterised by the Royal Commission to be 'anomalous and ambiguous', drew the institution constantly into conflicting interests between royal, public, aristocratic, bourgeois and industrial needs, and exposed it to recurrent discussions and official inquiries about its constitution, government, finances and membership, as well as its teaching and other basic structures.[48] In the course of these recurring challenges, the governmental endeavours to improve artistic training and patronage in Britain took into consideration the solutions proposed by German artistic educational systems that had been developed since the mid-1830s.

What was it really all about for the German artists then? What was the reason for Cornelius and his generation to reject former ideals? Why did this shift of paradigm concerning matters of knowledge and academic traditions happen? And what were the consequences of this, which British students like Spence travelled to Munich to experience first-hand?

This generation of oppositional artists and their urge for a change in the educational system led to academic reforms in the 1820s. The same rebels who went to Rome to become the Nazarenes and their followers ultimately returned to Germany to become the next generation of academic professors. Old teachers had to relinquish their seats to their juniors. This changing of the guard was not only due to the need of an educational reform but also to the desire of young artists to achieve tenure. At the beginning of the nineteenth century in Germany, a public appointment, for example, a professorship at an academy or a position in one of the newly founded museums, remained a major source of income for nearly all visual artists, even though a free market

for art was about to be established. A high but unknown number of poor artists existed, unable to earn a living in the fine or applied arts.[49] Aside from a few successful freelance painters, who were able to live off the sale of their works, mostly in Italy, the anti-academic rebels needed to return to the alma mater to pursue their artistic objectives and continue working in the sector of the fine arts. From the mid-1820s until the 1830s, most academies in Germany went through reforms primarily concerning the educational system. The Düsseldorf Academy was among the first to modify its teaching system, and Cornelius played a key role in this process. After two futile applications as a professor in Düsseldorf in 1806 and 1812, Cornelius was finally nominated Director of the re-established Düsseldorf Art Academy in 1819, taking office in 1821.[50]

In the above-cited letter, Cornelius already suggested the revival of mural painting in order 'to lay a foundation for German art for a new great direction adequate for the era and spirit of the nation'.[51] His initial point was based on the opinion that the artist had to develop freely from his inner nature and that art on the other side had to serve religion and public life, ideas shared by all of the members of the St Luke's brotherhood. Mural painting was supposed to be the best genre to perform this task due to its interconnection with architecture and presentability in open public spaces.[52] Cornelius' letter was written in 1814 after the Napoleonic War of Liberation during a time of national enthusiasm, of which Görres' journal was a political organ. Cornelius wanted to deploy the arts for national education to regain the unison of nation and art, apparently lost since the sixteenth century. The plans were not to be realised immediately. Cornelius, however, took them up on his appointment as Professor at the Düsseldorf Art Academy and refined his ideas with the assistance of Karl Ignaz Mosler in 1820 into a detailed concept on the reorganisation of the Academy, entitled the *Plan für die Kunstschule Düsseldorf* (*Plan for the Düsseldorf Art School*). A further opportunity arose to carry out his plans when he became Director of the Munich Art Academy in 1824.

The Bavarian king had realised the potential of art-politics very early on and understood how to employ Cornelius' art ideals. The rise of a taste for beauty, of national consciousness and pride as well as of religious devotion among the people was at the core of Ludwig's interest. Therefore, he did not predominantly employ the arts for courtly representation and splendor, as was common usage previously. The addressee of his art projects was the nation, the public, encompassing all classes. Buildings as well as monuments had been regarded as 'Gesamtkunstwerk' (all-embracing art form) and their iconographic programs visualised the new idea of 'Bildung'. The concept was well conceived abroad, as shown in the explanations of Thomas Wyse recorded in the House of Commons Parliamentary Papers: 'The effect upon the Public at large is equally diversified; the higher class has an opportunity of judging of the propriety of the classic illustrations, while I have seen the peasants of

the mountains of Tyrol holding up their children, and explaining to them the scenes of the Bavarian history almost every Sunday'.[53] At the same time, the economic and political dimension of the projects played a significant role as well: on the one hand, increasing the different industrial branches involved, like glass and porcelain manufactories, including their painting, bronze casting, stone cutting, artistic blacksmithery, as well as art reproduction, etc., and on the other hand, improving and spreading the international reputation of the Crown. This was a successful move, as noted in reports at the beginning of the 1840s from the 'Select Committee on Fine Arts', for instance, and in the *Edinburgh New Philosophical Journal*. Wilson described the King of Bavaria as 'the greatest patron of art now living' in whose:

> capital we may see numerous proofs of the results which a well-directed patronage of the arts can produce. The Bavarian artists now enjoy an European reputation … The King of Bavaria has resolved that his capital and dominions shall contain monuments to rival those erected by the magnificence or piety of former days, and he has to a wonderful extent succeeded in his object.[54]

Art became an important instrument for the state pertaining to 'strategies of nationing culture and identity'.[55] The various sources, above all the report from the 'Select Committee', make obvious that the 'Munich School' was considered to be a successful model for effective art-politics and that the fresco projects in particular were received in terms of fruitful art patronage, enhancing national culture and education.

For the above outlined art political enterprises in Munich, the Academy of Fine Arts was the central organ and Cornelius its omnipotent director. An important change that Cornelius realised concerning the educational system was the introduction of the system of *Meisterklassen* (master classes). This pedagogical method was inspired by the idea of artist studios and the lodges of stonemasons in the Middle Ages, as well as by the teaching methods adopted by Raphael, where masters and students worked and often lived closely together. The idea of such a workshop already occurred in Germany in literary form at the end of the eighteenth century in the famous Romantic novels *Herzergießungen eines kunstliebenden Klosterbruders* (*Outpourings of an Art Loving Friar*) from Wilhelm Heinrich Wackenroder from 1797 and Ludwig Tieck's *Franz Sternbalds Wanderungen* (*Franz Sternbald's Wanderings*) from 1798.[56] Indeed, these texts articulate the relationship between master and disciple, but they do not explain the practical possibilities of instruction in workshops, as Büttner remarks.[57] The Nazarenes attempted to realise this ideal of collective working, living and learning in the abandoned monastery of San Isidore in Rome. Later, when they became professors and directors of art academies in Germany, they held on to this idea of a personal master-pupil relation and thus reintroduced the workshop idea, which the academies

were originally opposed to and attempted to replace. The new concept replaced academic imitation and copying by the personal transmission of practice through master-pupil lines of succession.[58] The experiences were handed down to the students, as Charles West Cope reported. Though not even a matriculated student at the Munich Academy, he obtained detailed information and advice from Heinrich Maria Hess on technical questions regarding fresco painting.[59]

The *Meisterklassen* did not exist in Britain (only a looser form of apprenticeship in the eighteenth century) and other than the academies of Antwerp, Florence, Paris or Copenhagen, an attempt to adopt this system was never made, though the concept had advocates, such as William Dyce and Charles H. Wilson.[60] Both had been on the Continent and especially to Germany to examine the academies and schools of design in Prussia and Bavaria as well as actual art projects. In their recommendation to the 'Board of Trustees for the Encouragement of Arts and Manufactures in Scotland', they took up the ideal of the workshop, citing Gustav Waagen's example of Raphael, and proposed that everything should be 'controlled and directed by one master-mind'.[61] Charles Eastlake pointed out the prospective benefits of the division of work in monumental fresco projects on the side of the masters, that '[a]fter a few years, when assistants would be formed, more leisure might be gained', enabling them to pursue oil painting at the same time and profit from feedback on their wall paintings, especially concerning the colouring. In regard to the pupils, Eastlake stated that:

> Owing to the self-educating system of painters in this country, the younger artists are more independent than they are elsewhere, and they might have some reluctance to co-operate in works in which their best efforts would only contribute to the fame of the professor under whom they might be employed. In Italy, and in recent times in Germany, this subordination was not felt to be irksome, and the best scholars were soon entrusted with independent commissions.

He finally hoped that 'artists thus created in England would be commissioned to decorate private houses' and that 'the result, at all events, would be that the school would gain in design, and probably without any sacrifice of the more refined technical processes in colouring, in which the English painters now excel their Continental rivals'.[62] In any case, the model was not taken up by the official British educational systems: in 1848, the *Art Union* still complained that 'a system of study under one master for a series of years, steadily pursued with reciprocal attachment between master and pupil, in the spirit of an earlier time, is a thing not understood among us'.[63]

The introduction of the system of *Meisterklassen* in combination with the revival of mural painting was the core of Cornelius' academic reform. Fresco was regarded as the all-encompassing art form, superseding all other genres.

Following the assessments of Friedrich Schlegel and Wilhelm Schelling, Cornelius considered that the disintegration of the arts as a whole was the result of artists specialising too narrowly in specific genres. As a consequence, he abolished the class for landscape painting in 1824 and introduced courses in art history the following year.[64] However, these were to remain the only constitutive differences from the traditional system. Related to his academic changes, Cornelius dropped far behind his own former requirements. On the whole, he took over the previous three-step degree programme of the old academy without radical changes.[65] Only the final course was to be replaced by the *Meisterklasse*. The actual realisation of the programme reveals that his main interest was to form a 'school' of his own and thus to recruit capable students for his monumental fresco projects, which were commissioned by the Bavarian and later also the Prussian kings. Although his idealistic and programmatic reform plans resulted from the idea of an independent development of the artistic genius, in reality they were in conflict with the process of creation based on the division of labour as Cornelius practised it. The nucleus of Cornelius' art concept was the cartoon, i.e. the visual invention of the whole setting of the mural painting, drawn in a linear style and in life-size. It was considered to be the actual art work. The transferal of the design to the wall in fresco was not deemed to be as crucial a component, and the artist happily left this work to assistants more or less under his control. Since the uniformity of invention and design was of substantial interest to Cornelius, despite his idealistic demands for an artistic autonomy for students, his collaborators – who were mainly the students from his *Meisterklasse* – did not have much creative freedom. They had to be executors of the idea of their master, subsumed under his name as the *Cornelius-Schule* (Cornelius School).[66] This system was transferred to the other arts and affiliated schools of applied art. There too, renowned artists would be in charge of the training as well as the execution of considerable works commissioned by the King. Wilson points this system out to be a central reason for the excellence and accomplishments of the arts in Bavaria – with his focus on the applied arts in particular. And Eastlake referred to this when he recommended 'one directing head' to the 'Select Committee on Fine Arts' in matters of the decoration of the Palace of Westminster.[67]

So at the time when Spence studied in Munich, Cornelius was at the peak of his success. He dominated the art scene to the extent that no other styles could flourish and all students of historical genre were dependent upon his classes.[68] When Spence worked at Schlotthauer's studio, as mentioned above, he was presumably among the selected group of artists being prepared for or actually participating in the accomplishment of the monumental fresco projects.

To enter the *Meisterklasse*, a student had to successfully complete the prerequisite academic training and then be singled out by the professor based

on his skills and merits. According to the experiences and reports of British students, a lateral entry to the professor's workshops was possible, but in most cases access to this route relied upon personal recommendation. Even though the common practice of private training parallel to the academic instruction was terminated to a large extent, exceptions still existed, enabling mainly women to pursue an artistic education. So Anna Mary Howitt, daughter of the above-mentioned William Howitt, was also allowed to work in Wilhelm von Kaulbach's studio even though she was excluded from the Academy: 'Admission into the Academy, as we had hoped, we find is impossible for women: the higher classes of artists receive no pupils'.[69]

Some idea of the expectations which the English students carried with them to Munich is given by Anna Mary Howitt's account of her first meeting with the German master:

> I told him earnestly we longed *really to study*; how we had long loved and revered his works; how we had come to him for his advice, believing he would give us that, if not his instruction, which we heard was impossible. I know not how it was, but I felt no *fear* – only a reverence, a faith in him unspeakable. And what did he do? He looked at us with his clear keen eyes, and his beautiful smile, and said – 'Come and draw here; this room is entirely at your disposal'. 'But', said we, 'how often, and when?' He said, 'Every day, and as early as you like, and stay as long as there is day-light'. We knew not how to thank him; we scarcely believed our ears: but he must have read our joy, our astonishment, in our countenances.[70]

Surprise at such a reception was tempered by the reality of the situation. Travelling to Germany for art tuition was far from being an 'easy option' and difficulties were apt to trigger doubts. As Anna Mary Howitt continued:

> The amount of our joy may be estimated by considering what was exactly our position the evening before – nay, indeed, at the very time we entered the studio. The evening before, we were discouraged and disheartened to an extreme degree; our path in study seemed beset by obstacles on every hand: in fact, we asked ourselves for what had we come – how were we better off here than in England?[71]

Before the 'British mural revival' began, inspired by the decoration of the new Houses of Parliament from 1840, Spence had already developed a fascination for fresco.[72] So when he left Munich in 1836, reluctant to return to Florence with his wife, his ambition for monumental mural painting was immediately realised with cartoons for a commission to decorate the Meridiana wing of the Palazzo Pitti. As far as it is known, Spence did not obtain major orders for monumental frescos either in Italy or in England. Of course, in 1843 he participated in the competitions for the decoration of the new House of Lords with a cartoon of *The Baptism of Ethelbert*, but was not awarded a prize or commission to carry it out at Westminster.

A quotation from Spence documents his last attempt to attract a major order for wall paintings. In 1853 he wrote to a member of the royal household after an audience with Prince Albert:

> I executed some frescos merely as a trial for the Marquis of Claricade in Carlton House Terrace, some three or four years ago, since then I have had a good deal of experience in this style of painting and my great ambition would be to be able to execute for their Majesties any decoration in this line, however slight and entirely at my own risk and peril, as a specimen of my powers, as the benefit I should derive from such an ordeal would amply reward me for my pains and trouble … Supposing that at Windsor there was any wall, pavilion or room that I might try my hand on, I would draw the cartoons in Italy and execute them next summer on my arrival.[73]

Unfortunately, to our knowledge none of the mentioned few large-scale works produced for private clients has survived. Although the popularity of mural painting underwent a substantial upsurge in England in the 1840s, Spence's ambitious efforts did not gain sufficient recognition among British art patrons and collectors. Crucially, he was never fortunate enough to receive the royal commissions he so earnestly sought in emulation of the art scene in Munich, even though Eastlake himself is said to have appraised one of his works as 'the Apollo above the Orpheus, the best bit of modern fresco he had seen'.[74] One can only speculate as to the reasons for Spence's failures in his chosen genre of monumental art. He ultimately changed career paths around the mid-1850s and was very successful as a dealer in the work of the Old Masters. His German training under the strong influence of Cornelius and his close followers might have finally turned out to be a handicap. As Emma Winter has demonstrated convincingly, the reception of the Bavarian example of fresco painting in Britain not only has to be seen in the context of the establishment of a national school of history painting, but also as 'an integral part of a broader endeavour to construct a national culture in Britain that was both patriotic and socially inclusive'.[75] The previous pro-German attitude which promoted the German fresco model, art patronage and training systems in Britain as a means to the end of a national British cultural revival ultimately would ironically trigger a rejection of foreign cultural types, especially those considered to be German. The appraisal of the 'German school' altered and ended up representing opposite values to those which it originally stood for – the *Athenaeum* even declared its influence to be 'repressive of sincerity and originality, and dangerous to our national character'.[76] Cornelius in particular had attracted severe criticism for his style and division of labour.

Seemingly Spence had come full-circle and his former escape from the Old Masters (in the form of British educational practices) had ultimately been short-lived, while his dealing in Old Masters works perhaps catered better to English artistic tastes. Though the members of the 'Select Committee on the Fine Arts' who were in charge of the guidelines and selections for the

decoration of the Houses of Parliament took great interest in Cornelius' working process and discussed this issue, as cited above, this model of organisational structure for art education was never accepted in Britain.[77] Two years later, the *Art Union* criticised the collaborative process in Schnorr's workshop as a 'manufacturing system': 'he has produced unconsidered, undigested, uncorrected works, which many a German artist deplores as erroneously looked upon as specimens of the "German school"'.[78] Finally in 1866, Henry O'Neil, himself studying under Schnorr in Munich for two months in 1840, would depict the German School and particularly the Munich example 'wholly as a warning' in his lecture at the Royal Academy. He stressed the disadvantage of close professor-pupil relations, 'for it would seem that, no matter under what master the artist studied, the result would invariably have been the same'.[79]

With regard to the system of *Meisterklassen*, it has to be concluded that it did not succeed in Britain, though there had been quite a number of advocates as well as artists who experienced it in Munich first-hand. Nevertheless, in Britain, when large-scale mural paintings were undertaken, they too had to be mostly executed with the aid of assistants. A later example are the frescos of Frederic Leighton, *The Arts of Industry as Applied to War* and its pendant *The Arts of Industry as Applied to Peace* in the South Kensington Museum. Though Leighton first vehemently insisted that they should 'in the end be painted by no hand but mine', they were finally accomplished as a result of a long process (commissioned in 1868 and finished in 1880 and 1886 respectively) by students under the supervision of F.W. Moody and Edward Poynter.[80] Leighton himself received his schooling and the majority of his academic education in Germany, mainly in Frankfurt am Main. He proves that the artistic exchange between Britain and Germany continued, despite the official rejection and discredit of the 'German School' in Britain in consequence of the demarcation of national borders.[81]

Notes

1 Charles Heath Wilson, 'Observations on some of the Decorative Arts in Germany and France, and on the causes of the superiority of these, as contrasted with the same Arts in Great Britain. With suggestions for the improvement of Decorative Art', *Edinburgh New Philosophical Journal* (July–October 1843), p. 264.

2 Anon., 'The Art Schools of London', *Art Union* (January 1848), p. 19, and Cultor, 'Schools of Art in England', *Art Union* (August 1848), p. 233.

3 See the surveys in Anon., 'The Art Schools of London', *Art Union* (January 1848), pp. 19–20 and Edward Morris, *French Art in Nineteenth-Century Britain* (New Haven, CT: Yale University Press, 2005), pp. 27–9.

4 Nikolaus Pevsner, *Academies of Art: Past and Present*, reprint of the 1940 edition with a new preface by the author (New York: Da Capo Press, 1973), p. 219.

5 Archive of the Academy of Fine Arts Munich: Matriculation Number 02382 Wilhelm Blundell Spence, Matriculation Register 1809–41.

6 Cultor, 'Schools of Art in England', p. 233.

7 Samuel Kirkup, 'Letter from Italy', in *Annals of the Fine Arts* (1816–20: 5 volumes), Vol. III (1817), pp. 222–9; Anon., 'From Italy, November 1818', *Literary Gazette* (19 December 1818), p. 810; Anon., 'Description of Certain Frescos, Painted by Some German Students Not at Rome', *London Magazine* (August 1820), pp. 149–54; Anon., 'Fine Arts: Modern Historical Painters at Rome', *Literary Chronicle* (9 October 1824), pp. 653–4; Anon., 'Illustrations of Italian Poets, Painted in Fresco', *Parthenon* (October 1825), pp. 215–18.

8 Emma L. Winter, 'German Fresco Painting and the New Houses of Parliament at Westminster, 1834–1851', *Historical Journal*, 47 (2) (2004), p. 299.

9 Anna Brownell Murphy Jameson, *Visits and Sketches at Home and Abroad, with tales and miscellanies now first collected and a new edition of the Diary of an ennuyée* (London: Saunders & Otley, 1834, 4 volumes), Vol. II, p. 199.

10 Anon., 'The Arts in Germany', *Athenaeum* (7 September 1833), p. 603; Anon., 'Foreign Correspondence', *Athenaeum* (15 February 1834), p. 126; Anon., 'Foreign Correspondence', *Athenaeum* (6 December 1834), p. 888 et seq.; Anon., 'Foreign Correspondence', *Athenaeum* (13 December 1834), p. 905 et seq.; Anon., 'Foreign Correspondence. History of Modern German Art', *Athenaeum* (17 September 1836), p. 675 et seq.; Anon., 'Foreign Correspondence. The Arts at Munich', *Athenaeum* (10 April 1841), p. 285; Anon., 'The German School', *Art Union*, Vol. II (September 1840), p. 145; Anon., 'Foreign Art', *Art Union*, Vol. I (1839), p. 45; Anon., 'German Artists and Critics', *Art Union*, Vol. I (September 1839), p. 136; Anon., 'The German School. Pierre Cornelius', *Art Union*, Vol. I (November 1839), p. 168.

11 Frank Büttner and Karl Schlögel, 'Die Akademie und das Renommee Münchens als Kunststadt', *Zeitenblicke: Online-Journal Geschichtswissenschaften*, p. 26, available at: http://www.zeitenblicke. de/2006/2/Buettner/index_html.

12 *Art Union* (September 1939), p. 136; Lionel Gossman, 'Unwilling Moderns: The Nazarene Painters of the Nineteenth Century', *Nineteenth-Century Art Worldwide*, 2 (3) (2003), available at: http:// www.19thc-artworldwide.org/index.php/autumn03/273-unwilling-moderns-the-nazarene-painters-of-the-nineteenth-century.

13 Anon., 'Foreign Correspondence. History of Modern German Art', *Athenaeum* (17 September 1836), pp. 675 et seq.; Anon., 'Art. VI.-1. De l'Art Moderne en Allemagne. Par M. le Comte A. de Raczynski. Paris 1836. Tome 1. 4to., 2. Die neuere Deutsche Kunst. Berlin. 1836. 1ster Band. 4to.', *Foreign Quarterly Review* (October 1836), pp. 109–18; Anon., 'History of Modern Art in Germany; A Review of "Histoire de l'Art Moderne en Allemagne" par le Comte A. Raczynski', ibid., (July 1840), pp. 406–19 (the selfsame article also appeared in *Surveyor, Engineer and Architect* (September 1840), pp. 184–8); Anon., 'Art. VIII.-Histoire de l'Art moderne en Allemagne, par le Comte A. Raczynski. Tom III. 4to. pp. 582. Paris', ibid., (January 1842), pp. 455–68; Anon., 'Art. V. – Histoire de l'Art moderne en Allemagne. Par le Comte A. Raczynski. 3 vols. 4to. Paris, 1836–1841', *Monthly review* (September 1844), pp. 74–90; The later part in the anonymous cumulative review, 'Art. I.-1. Histoire de l'art Moderne en Allemagne. Par le Comte A. Raczynski. Berlin, 2 vols. 4to. 1841., 2. Die Düsseldorfer Mahler Schule. Von J. J. Scotti. Düsseldorf. 1842, 3. Report from the Select Committee on Fine Arts. London 1844', *Quarterly Review* (March 1846), pp. 322–48, was used for a discussion of German art in competitive relation to English art.

14 Anon., 'Foreign Publications Concerning Art. De l'Art en Allemagne, par H. Fortoul, Paris, 2 tomes, 8°, 1842. On Art in Germany, by H. Fortoul. Rolandi, London, 2 tomes, 8°, 1842', *Art Union* (May 1842), p. 112.

15 *München, seine Kunstschätze, seine Umgebungen, und sein öffentliches Leben* (1841) is reviewed in the *New Quarterly Review*, or *Home, Foreign and Colonial Journal* (July 1844), pp. 29–54; *Kunst und Künstler in München* (1840) and *Münchner Jahrbücher für bildende Kunst* (Leipzig, 1839–40), in the *Dublin Review* (August 1841), pp. 53–104; *Munich, ou Aperçu de l'Histoire des Beaux-Arts en Allemagne, et surtout en Bavière* (1844), together with Karl Schnaase's *Geschichte der bildenden Künste* (1843) and Franz Kugler's *Handbuch der Kunstgeschichte* (1842), in the *New Quarterly Review*, or *Home, Foreign and Colonial Journal* (October 1844), pp. 412–26.

16 Winter, 'German Fresco Painting'; Clare A.P. Willsdon, *Mural Painting in Britain 1840–1940. Image and Meaning* (Oxford: Oxford University Press, 2000); William Vaughan, *German Romanticism and English Art* (New Haven, CT: Yale University Press, 1979); T.S.R. Boase, 'The Decoration of the New Palace of Westminster, 1841–1863', *Journal of the Warburg and Courtauld Institutes*, 17 (3/4) (1954), pp. 319–58.

17 Anon., 'Foreign Correspondence', *Athenaeum* (13 December 1834), pp. 905 et seq.

18 Vaughan, *German Romanticism and English Art*, pp. 284 et seq.; Willsdon, *Mural Painting in Britain 1840–1940*, p. 3.

19 George Cleghorn, *Ancient and Modern Art, Historical and Critical*, 2nd edn (Edinburgh and London: William Blackwood and Sons, 1848, 2 volumes), Vol. II, pp. 134 et seq.

20 John Fleming, 'Art Dealing in the Risorgimento II', *Burlington Magazine*, 121 (917) (1979), p. 493.

21 Anon., 'Foreign Correspondence', *Athenaeum* (13 December 1834), p. 905; Anon., 'The German School. Pierre Cornelius', *Art Union*, Vol. I (November 1839), p. 168.

22 Fleming, 'Art Dealing in the Risorgimento II', p. 493.

23 Ibid.

24 Anonymous, 'Review of New Books. *The Tyrol*', *Literary Gazette* (6 April 1833), p. 209.

25 Joseph von Görres, *Gesammelte Schriften*, Vol. VIII, Abt. 2, 2 (Munich: Literarisch-artistische Anstalt, 1874), pp. 433, 436: 'Leider muß mann von derselben sagen, daß sie (in der gegenwärtigen Zeit) sowohl an wahrer Bildung als an Geist und Leben von der Nation ist überflügelt worden. Denn der geringste von denen Helden die freywillig mitzogen in jenen wahrhaften Kreuzzug, trug (wen ich's so nennen darf) eine höhere Poesie in seiner Brust, als der erste Professor irgend einer hochweisen Akademie, vom Dunstkreyse seiner negativen eklektischen Kunstrumpelskammer umnebelt ... Was nun aber der freyen Entwicklung einer solchen Kunst furchtbar entgegensteht, ist meines erachtens ... [d]er Lügengeist der Modernen Kunst überhaubt, der mit seinem negativen Eklektizismus, mit der Nichtigkeit und Schwäche unserer Großen aufs vollkommenste übereinstimt und ein eigentlicher Ausspruch desselben ist. Dann ins Besondere die fatalen Kunstakademien und deren lederne Vorsteher in unserm Vaterland, die nur sich, ihre maschinenmäßige Richtigkeit, und weiter Nichts zum Ziel haben und alles was der Stadt von wichtigkeit für die Kunst thuen will, in ihre Kanäle zu lenken weiß; wo es sich in Schaum und Rauch auflößt; den solange die Akademien existiren, ist nichts Ewiges entstanden'.

26 Benjamin Haydon, *On Academies of Art (more particularly the Royal Academy) and their pernicious effect on the genius of Europe* (London 1839); Stuart Macdonald, *The History and Philosophy of Art Education* (London: University of London Press, 1970), Chapter 3; Pevsner, *Academies of Art*, p. 222.

27 Thomas Kirchner, 'Der europäische Kontext. Die akademische Bewegung im 18. Jahrhundert – Wien und Stockholm', in *Die Kunst hat nie ein Mensch allein besessen: 1696–1996 Dreihundert Jahre Akademie der Künste, Hochschule der Künste Berlin* (Berlin: Henschel, 1996), p. 60; Anke Fröhlich, *Landschaftsmalerei in Sachsen in der zweiten Hälfte des 18. Jahrhunderts. Landschaftsmaler, -zeichner und -radierer in Dresden, Leipzig, Meißen und Görlitz von 1720 bis 1800* (Weimar: Verlag und Datenbank für Geisteswissenschaften, 2002), pp. 39 et seq. The 'Kurfürstlich-pfälzische Akademie der Maler, Bildhauer- und Baukunst' arose from the 1762 founded drawing school. Already initiated in 1773, the establishment process of the Düsseldorf Art Academy was not completed until 1777.

28 Ekkehard Mai, *Die deutschen Kunstakademien im 19. Jahrhundert. Künstlerausbildung zwischen Tradition und Avantgarde* (Cologne, Weimar, Vienna: Böhlau, 2010), pp. 107 et seq.; Werner Busch, 'Die Akademie zwischen autonomer Zeichnung und Handwerksdesign – zur Auffassung der Linie und der Zeichen im 18. Jahrhundert', in Herbert Beck, Peter C. Bol and Eva Maek-Gérard (eds), *Ideal und Wirklichkeit in der bildenden Kunst im späten 18. Jahrhundert* (Berlin: Gebr. Mann Verlag, 1984), pp. 177–92; Wolfgang Kemp, *"... einen wahrhaft bildenden Zeichenunterricht überall einzuführen." Zeichnen und Zeichenunterricht der Laien 1500–1870* (Frankfurt am Main: Syndikat Autoren- und Verlags-Gesellschaft, 1979).

29 Mai, *Die deutschen Kunstakademien*, pp. 112–14; Pevsner, *Academies of Art*, p. 230.

30 Erwin Panofsky, *Idea. Ein Beitrag zur Begriffsgeschichte der älteren Kunsttheorie*, 2nd edn (Berlin: Verlag Bruno Hessling, 1960), pp. 57–63; Hans Dickel, *Deutsche Zeichenlehrbücher des Barock. Eine Studie zur Geschichte der Künstlerausbildung* (Hildesheim: Olms, 1987), pp. 51–62.

31 Ernst Rietschel, *Jugenderinnerungen*, Monika Schulte-Arndt (ed.), 4th expanded edn (Leipzig: Evangelische Verlagsanstalt, 2002), p. 67; Wilhelm von Kügelgen, *Jugenderinnerungen eines alten Mannes. Neuausgabe nach der kritischen Ausgabe von Johannes Werner* (Leipzig: Koehler & Amelang, 1989), pp. 360 et seq.; Ludwig Richter, *Lebenserinnerungen eines deutschen Malers* (Frankfurt am Main: Verlag von Johannes Alt, 1885), pp. 40–51; see also Saskia Pütz, *Künstlerautobiographie. Die Konstruktion von Künstlerschaft am Beispiel von Ludwig Richter* (Berlin: Gebr. Mann., 2011), pp. 205–13.

32 Thomas Kirchner, 'Das Modell Akademie. Die Gründung der Akademie der Künste und mechanischen Wissenschaften', in *Die Kunst hat nie ein Mensch allein besessen*, p. 25.

33 Pevsner, *Academies of Art*, pp. 180–82.

34 Morris, *French Art in Nineteenth-Century Britain*, p. 27.

35 Anon., 'The Art Schools of London', *Art Union* (January 1848), p. 19.

36 Morris, *French Art in Nineteenth-Century Britain*, p. 29.

37 Anthony Burton, 'Putting South Kensington to Work: The Department of Science and Art', in Franz Bosbach et al. (eds), *Prinz Albert und die Entwicklung der Bildung in England und Deutschland im 19. Jahrhundert* (Berlin: Saur 2000) p. 99; Pevsner, *Academies of Art*, p. 242.

38 Karl Ludwig Fernow, *Carstens, Leben und Werke. Hrsg. u. erg. v. Herman Riegel* (Hannover: Carl Rümpler, 1867), pp. 53–4, 315–24; Alfred Kamphausen, *Asmus Jacob Carstens* (Neumünster: Wachholt, 1941), pp. 28–30; Pevsner, *Academies of Art*, pp. 192–7.

39 Klaus Gallwitz (ed.), *Die Nazarener in Rom: ein deutscher Künstlerbund der Romantik* (Munich: Prestel, 1981), p. 65.

40 Kirkup, 'Letter from Italy', p. 227.

41 Frank Büttner, 'Bildungsideen und bildende Kunst um 1800', in Reinhart Koselleck (ed.), *Bildungsbürgertum im 19. Jahrhundert. Teil II* (Stuttgart: Klett-Cotta, 1990), pp. 272–85.

42 Mitchell Benjamin Frank, *German Romantic Painting Redefined. Nazarene Tradition and the Narratives of Romanticism* (Aldershot: Ashgate, 2001), pp. 37 et seq.

43 Immanuel Kant, *Kritik der Urteilskraft. Mit einer Einl. u. Bibliogr. hrsg. v. Heiner F. Klemme* (Hamburg: Meiner, 1790/2001), §49.

44 Pevsner, *Academies of Art*, pp. 189–235.

45 Johannes Bilstein, 'Nichts den Lehrern schulden. Über Künstler als Prototypen der Selbstkonstitution', *Neue Sammlung*, 38 (1998), pp. 19–39.

46 Richter, *Lebenserinnerungen*, p. 44: 'worauf es denn eigentlich ankomme'.

47 Charles Lock Eastlake, *Contributions to the Literature of the Fine Arts* (London: John Murray, 1848), pp. 23, 25.

48 House of Commons, *Royal Commission Report on the Present Condition of the RA* (1863); Gordon Fyfe, *Art, Power and Modernity: English Art Institutions, 1750–1950* (Leicester: Leicester University Press, 2000), pp. 77–100.

49 For a detailed analysis of the artists' employment situation in Germany in the nineteenth century, focused on the second half of it, see Wolfgang Ruppert, *Der moderne Künstler. Zur Sozial- und Kulturgeschichte der kreativen Individualität in der kulturellen Moderne im 19. und frühen 20. Jahrhundert* (Frankfurt am Main: Suhrkamp, 1998), especially pp. 193–203.

50 Frank Büttner, 'Peter Cornelius in Düsseldorf', in Wend von Kalnein (ed.), *Die Düsseldorfer Malerschule* (Mainz: Von Zabern, 1979), p. 48.

51 Görres, *Gesammelte Schriften*, p. 436: 'der deutschen Kunst ein Fundament zu einer neuen großen, dem Zeitalter und Geist der Nation angemessenen Richtung zu geben'.

52 Büttner, 'Peter Cornelius in Düsseldorf', p. 51.

53 House of Commons, *Report from the Select Committee on Fine Arts; together with the minutes of evidence, appendix, and index, Session 1* (1841), p. vii.

54 Wilson, 'Observations', pp. 264 et seq.

55 Fyfe, *Art, Power and Modernity*, p. 3.

56 Magdalena Droste, *Das Fresko als Idee. Zur Geschichte öffentlicher Kunst im 19. Jahrhundert* (Münster: Lit. Kunstgeschichte: Form und Interesse, 1980, 2 volumes), Vol. II, pp. 29 et seq.

57 Frank Büttner, *Peter Cornelius. Fresken und Freskenprojekte* (Stuttgart: Franz Steiner, 1999, 2 volumes), Vol. II, p. 2.

58 Frank Büttner, 'Overbecks Ansichten von der Ausbildung zum Künstler. Anmerkungen zu zwei Texten Friedrich Overbecks', in Andreas Blühm and Gerhard Gerkens (eds), *Johann Friedrich Overbeck, 1789–1869. Zur zweihundertsten Wiederkehr seines Geburtstages* (Lübeck: Museum für Kunst und Kulturgeschichte, Behnhaus, 1989), p. 20; Pevsner. *Academies of Art*, pp. 207–17; see also Frank Büttner, 'Der Streit um die "Neudeutsche religios-patriotische Kunst"', in Wolfgang Frühwald, Franz Heiduk and Helmut Koopmann (eds), *Aurora. Jahrbuch der Eichendorff-Gesellschaft* (Frankfurt am Main: Freies deutsches Hochstift, 1983), Vol. XLIII, pp. 55–76. This system of master classes at German art academies has more or less been maintained to this day.

59 Charles Henry Cope, *Reminiscences of Charles West Cope* (London: Richard Bentley & Son, 1891), pp. 153 et seq.

60 Pevsner, *Academies of Art*, pp. 216 et seq.

61 William Dyce and Charles Heath Wilson, *Letter to Lord Meadowbank and the Committee of the Honourable Board of Trustees for the Encouragement of Arts and Manufactures, on the best means of ameliorating the arts and manufactures of Scotland in point of taste* (Edinburgh: Thomas Constable, 1837), p. 29.

62 Eastlake, *Contributions*, p. 29.

63 Cultor, 'Schools of Art in England', p. 19.

64 Mai, *Die deutschen Kunstakademien*, p. 133; Birgit Jooss, 'Die verhängnisvolle Verquickung von produzierendem und lehrendem Künstler', in Léon Krempel and Anthea Niklaus (eds), *Cornelius, Prometheus, der Vordenker* (Munich: Haus der Kunst, 2004), p. 26.

65 Büttner, 'Peter Cornelius in Düsseldorf', p. 54; Jooss, 'Die verhängnisvolle Verquickung von produzierendem und lehrendem Künstler', p. 29.

66 Ibid., p. 30.

67 Eastlake, *Contributions*, §584; Willsdon, *Mural Painting in Britain 1840–1940*, p. 53.

68 Ibid., p. 31.

69 Anna Mary Howitt, *An Art-Student in Munich* (London: Longman, Brown, Green and Longmans, 2 volumes, 1853), Vol. I, p. 2. Women were admitted to the Munich Academy until 1841.

70 Ibid., Vol. I, p. 4.

71 Ibid.

72 Willsdon, *Mural Painting in Britain 1840–1940*, p. 3; Boase, 'The Decoration of the New Palace of Westminster'; Vaughan, *German Romanticism and English Art*.

73 Fleming, 'Art Dealing in the Risorgimento II', p. 494.

74 Ibid.

75 Winter, 'German Fresco Painting', p. 295.

76 Anon., 'Fine Arts. Contributions to the Literature of the Fine Arts. By Charles Locke Eastlake, R.A. Murray', *Athenaeum* (23 December 1848), p. 1301; for further examples, see Matthew C. Potter, *The Inspirational Genius of Germany: British Art and Germanism, 1850–1939* (Manchester: Manchester University Press, 2012); and Winter, 'German Fresco Painting'.

77 House of Commons, *Report from the Select Committee* (1841), Sir M. Archer Shee, 25 May 1841, p. 12; and William Dyce Esq., 28 May 1841, pp. 30 et seq.

78 Anon., 'The Frescoes of Schnorr', *Art Union* (August 1843), p. 221.

79 Henry O'Neil, *Lectures on Painting Delivered at the Royal Academy* (London: Bradbury, Evans, & Co., 1866), pp. 116 et seq.

80 Richard Ormond, *Leighton's Frescoes in the Victoria and Albert Museum* (London: Victoria and Albert Museum, 1975), p. 15.

81 Matthew C. Potter, 'Lord Leighton: Made in Germany?', in Potter, *The Inspirational Genius of Germany*, pp. 93–143.

Standing in Reynolds' Shadow: The Academic Discourses of Frederic Leighton and the Legacy of the First President of the Royal Academy

Matthew C. Potter

This chapter explores a particular example of inspirational practice in British art education, where the activity of the first President of the Royal Academy formed an important model for one of his successors in the nineteenth century. Historians have often reflected upon the separate institutional functions of the RA: providing exhibition space and prestige for its professional members, and an educational forum for its students.[1] These two core missions were included in the petition to George III on 28 November 1768, in which the assembled artists declared:

> that the two principal objects we have in view are, the establishing [of] a well-regulated School or Academy of Design, for the use of students in the Arts, and an Annual Exhibition, open to all artists of distinguished merit, where they may offer their performances to public inspection, and acquire that degree of reputation and encouragement which they shall be deemed to deserve.[2]

When the Academy's founding President, Joshua Reynolds, declared in his inaugural address on 2 January 1769 that 'The principal advantage of an Academy is, that, beside furnishing able men to direct the Student, it will be a repository for the great examples of the Art', the emphasis seemed to have subtly shifted.[3] A collection of Old Masters and the guidance of professors now seemed the key benefits that the institution could offer to the nation. Nevertheless, historians have continually identified the prominence of the studio and lecture hall as integral to the learning process at the RA. As A.L. Baldry wrote in 1903, Reynolds' *Discourses on Art* were produced 'with special reference to the functions of the Academy as a teaching institution'.[4] As Robert R. Wark declared more recently: 'A less conscientious man than Reynolds

might not have worried so much about his immediate responsibilities to the academy and his students and directed his remarks simply to the intelligent general public. But Reynolds took these responsibilities very seriously, and the *Discourses* themselves were affected accordingly'.[5] However, appearances can be deceptive and, as discourse theory warns, public pronouncements like this should never be taken at face value. It must be remembered that the *Discourses* had a double purpose: first, to educate art students and, second, to broadcast the educated and enlightened virtues of the new Academy to a broader public, especially through the printed medium. Given their delivery in an often incoherent manner and heavy Devonshire accent, it is perhaps unlikely that the *Discourses* could ever have succeeded in their primary educational remit in their original spoken form. As James Northcote recalled, whilst the *Discourses* produced 'general satisfaction', were well reviewed in the periodical press and contributed to an improvement in Reynolds' personal standing, his oration was seriously flawed:

> the delivery of these discourses was not particularly happy … and cannot be much commended; which may be accounted for from two causes: first, that his deafness might have prevented his being well able to modulate his voice; but secondly, I am rather of [the] opinion, that the real cause was, that, as no man ever felt a greater horror at affectation than he did, therefore he feared to assume too much the air of an orator, lest he should have the appearance of conceit. Hence he naturally fell into the opposite extreme, as the safest retreat from what he thought the greatest evil. But most certainly his voice was not so distinct and audible as might be desired, when the matter was so excellent.[6]

As President of the RA (PRA) from 1878 to 1896, Frederic Leighton arguably made the single most important contribution since Reynolds to deliver upon the institution's manifesto aims of 1768. Following the golden days of Reynolds and Benjamin West, PRAs had been frequently distracted from their teaching duties by a range of factors of varying legitimacy: Thomas Lawrence (PRA 1820–1830) by his portraiture practice and obsessive collecting of Old Master drawings; Martin Archer Shee (PRA 1830–1850) by defending the RA from invasive Royal Commissions; Charles Eastlake (PRA 1850–1865) by his duties advising the government and running the National Gallery; and Francis Grant (1866–78) by his society commitments. Lawrence did deliver one Presidential *Address*, on 10 December 1823, but such an isolated effort could reap few long-term rewards.[7] When Leighton was awarded the presidency, he must have been conscious of the failures of his forebears and, taking up the reins, proceeded to steer a new course for the RA that would serve the national interest by promoting artistic education *and* professionalism. His contribution as a consummate manager of public relations for the RA must be acknowledged: defusing calls for the educational and constitutional reform of the RA, seeing off the rival forums for professional practice that emerged like the Grosvenor Gallery (1877) and courting young talent.[8]

Yet, despite these achievements, Leighton's legacy has received a mixed reception amongst historians, and his role as an educationist has been identified for particular criticism, with his revival of the programme of Addresses to the students being judged as staid and unspontaneous. To support such claims, there has been a tendency to compare Leighton's lectures to those of Reynolds in order to prove that Leighton failed 'to match the ... intellectual vigour' of his predecessor.[9] Yet such approaches have tended to overlook the methodological problems involved in undertaking a straightforward comparison. First, neither of the two 'texts' was thought out or executed in one sitting. The internal incoherency of series of lectures which spanned 21 and 14 years respectively for Reynolds (between 1769 and 1790) and Leighton (between 1879 and 1893) makes the task of comparison particularly difficult. In terms of responses, individual lectures or passages might reflect Leighton's momentary interest in something written by Reynolds, perhaps, but it would possibly be fantastical to assume from this that Leighton had a premeditated plan to emulate Reynolds in his own academic lectures whether in form or content. Such an assessment of the relationship between the two is perhaps especially convincing when it is considered that there is only one reference to Reynolds in Leighton's *Addresses*.[10] Whilst Leighton was no doubt always conscious of the precedent and model of the *Discourses*, this chapter adopts the modified tactic of assessing Leighton's *Addresses* also according to the intellectual standards of the nineteenth century. By judging Leighton according to the criteria of his peers as well as his predecessor, a better view of the relative merits of these educationalists can be obtained and can ultimately answer the question of how Reynolds' legacy informed the education practices of Leighton as a historically-engaged art teacher.

Leonée Ormond's conclusion that 'Leighton's addresses to the R.A. students ... suffered from the same ornateness of style as his speeches' succinctly captures the main reasons for judging his lectures as being of poor quality.[11] Leighton has been perceived to be over-ambitious in his intellectualism, attempting pretentious displays that did not quite succeed. In contrast to the seductive style of contemporaries like John Ruskin or William Michael Rossetti, Leighton expressed complex ideas in impenetrable prose. Eye-witness accounts have been produced to substantiate these claims. Leighton's inability to respond impromptu to the eloquent and charming deference of John Everett Millais at the post-election celebrations of 1878 is repeatedly cited as proof of his mental inflexibility and his inability to adapt to the mood of his audience.[12] The reminiscences of Charles Lewis Hind have also been used to support this judgement. In response to Leighton's 1889 lecture, Hind wrote:

> The subject of the address was Velasquez. Leighton was at the top of his most flowery and most flamboyant form. His rounded, honeyed periods soared and swayed in rhythmic sweeps. I lost his meaning, could not pin my mind to anything definite; the students shuffled and coughed; my neighbours looked at one another, and the looks meant half admiration, half despair ...[13]

Despite first impressions, it is in fact debatable what Hind's exact intentions were for this anecdote regarding the evaluation of Leighton's learning or mental flexibility. Elsewhere in Hind's memoires, he comfortably listed the PRA alongside avant-garde artist-contributors to *The Yellow Book* alongside Walter Sickert and William Rothenstein, and, recalling his own interview for *The Globe* in the same year as the Address on Spanish art, noted not only how Leighton 'was an ideal President of the Royal Academy. In looks, manner, culture, courtesy, and kindness, one might have searched the English-speaking world in vain for a better man to fill that high office', but also that in conversation: 'He was delightful; he talked life and art with the ease of a bird singing. He flowed on like an Ambassador'.[14] None of this bore witness to the PRA's character as dull or rigid. Was Leighton guilty either of poor technique or out of kilter with the intellectual fashions of his audience? In the preface to the second edition of the *Addresses*, Leighton's sister and executor Alexandra Orr reflected upon the difficulty of editing a text that contained an 'excess of material' and 'the mass of emotionalised thought and fact which had gathered round his subject during its period of incubation, and which was still too much part of himself to be quite amenable to literary form'.[15] Regardless of later detractors, it was surely more than the loyalty of friendship that motivated F.G. Stephens' declaration in 1866 that Leighton's work redeemed the 'intellectual quality' of the RA.[16] Leighton's legendary modesty perhaps did more than anything to undermine his standing as an intellectual:

> He was not free from misgivings in regard to the substance of his discourses. … He could not be blind to the exceptional merits of his work, but he knew they were not of a nature to command general interest and appreciation. He often feared that what he had to say was beyond the immediate grasp of the students to whom it was addressed; and if this did not impel him to change his course, it was because no other way was open to him. His intellectual conception of the subject with which he dealt, his emotional attitude towards it, alike rendered a less serious treatment impossible.[17]

Whatever Leighton's personal reservations or his failings as a speech writer, a more robust analysis of his ideas and their reception is needed before such conclusions can be accepted. Hind should surely have been interested in the historical-mindedness of Leighton's lectures, given the fact that he himself became an art critic in the 1890s and penned a series of art-historical books between 1906 and 1924.[18] Leighton's 1889 lecture was macroscopic in its purview, looking to the national character of 'Art in Spain' and citing the repeated disruption of the indigenous Celtiberian culture by successive waves of Romans, Arabs, Goths and Visigoths so that 'the annals of Spain up to the end of the fifteenth century are the recital of one long, stern, and finally triumphant struggle to shake off an alien master – a story of constantly growing and intensified national consciousness and national pride'.[19] Leighton reproached

the British historians of Spanish art for their shortcomings: naming particularly Richard Ford's *A Hand-book for Travellers in Spain* (London, 1845; 2 volumes) and William Stirling-Maxwell's *Annals of the Artists of Spain* (London: 1848; 3 volumes), and identified the German scholarship of Carl Justi's *Velazquez und sein Jahrhundert* (1888) as a 'valuable corrective' before dubbing that artist 'the greatest initiator perhaps since Leonardo in modern Art'.[20] Justi's monograph was translated into English by Augustus Henry Keane as *Diego Velazquez and His Times* in 1889, so was an important and accessible resource for those of Leighton's students who did not read German. Given these facts, it is surely significant that the earliest of Hind's historical texts was on this subject: *Days with Velasquez* [sic] (1906). Even if the forms of Leighton's *Addresses* were difficult for some, their subjects were germane to contemporary interests. There are eight references to Justi in Hind's account and in the first of these he openly acknowledged his 'authoritative *Life* of Velasquez, to the pages of which I am much indebted'.[21] That Hind first heard of Justi's scholarship via Leighton's speech is hard to prove, but it is possible. Early on in his own book, Hind recorded the recent revival in interest in the Spanish Master – citing the scholarship of William Stirling-Maxwell, Henri Regnault, George Clausen, Sir Walter Armstrong, R.A.M. Stevenson, Charles Ricketts and Señor Aureliano De Bereute y Moret – but he did not count Leighton amongst their number.[22] Perhaps this was explicable as Leighton's lecture was, after all, on Spanish art, not just Velazquez. However, in a modest way, Hind did recognise the President as part of this art historiographic renaissance for 'slowly, silently, and surely [Velazquez] advanced into the position of the painters' painter. Leighton, always learning, devoted one of his last Discourses to Velasquez'.[23] For Leighton, Italian Renaissance styles suppressed the idiosyncratic genius of Spanish artists and only in the seventeenth century did Velazquez liberate them.[24] Hind's memory of the original lecture was possibly distorted by his re-reading of Leighton's Sixth *Address* on its publication in 1897 when its self-deprecatory conclusion perhaps stuck in his mind:

> And now I must conclude, and I do so with even more than my usual consciousness of a task inadequately performed. The picture I have traced before you is crowded inevitably, and I fear to confusion, and yet much has been omitted which might have helped to its better understanding had time furnished me with a larger canvas. It must suffice to me if I have in any way stimulated you to the further consideration of a deeply interesting chapter in the history of Art.[25]

Perhaps Leighton had done exactly that and inspired Hind's 'further consideration' of the genius of Spain and Velazquez.

Far from intellectually naive, the 1889 lecture was historically grounded not just in terms of its research of the facts of artistic and material culture of Spain from antiquity to the present but also in its engagement with the

Hegelian spirit of the generation of academics that gathered around Benjamin Jowett. Although Leighton did not attend Oxford himself, through his auto-didactic efforts and social connections, he developed a good understanding of current historical thinking at universities.[26] Leonée and Richard Ormond suggest that Leighton's lecturing was done through a sense of obligation, not inspiration, that working them up in the manner he did – carefully planned in advance then learnt by heart for delivery – was a 'source of great strain and effort' and undertaken 'not because he enjoyed them, but because he felt a profound responsibility for widening the boundaries of aesthetic appreciation and knowledge'.[27] Nevertheless, if this were the case, it would be no obstacle to drawing parallels between the two PRAs. Reynolds himself laboured in composing the *Discourses*. As Derek Hudson noted:

> How much he suffered for his ideals can only be fully realized by those who
> have studied the drafts of his literary compositions. He was a determined
> writer, and by dint of immense effort he succeeded. He achieved a literary
> style with the same recipe of hard work that he had used to acquire a style for
> living and a style for painting. Whenever he sat down to pen and paper he was
> under immense strain, continually correcting, even simple words and phrases,
> and re-writing ... His indecision makes his drafts agonizing to read; but he
> persevered – and his *Discourses* are cited as models of lucid English prose.[28]

What is clear is the necessity of the comparison of Leighton to his illustrious predecessor Reynolds, both for contemporaries and modern art historians. In 1885 the *Magazine* of *Art* described Leighton 'with the exception of Sir Joshua Reynolds ... [as] the most skilful administrator and most enlightened President that the Academy has ever had'.[29] As Ormond writes, 'Leighton's own Academy lectures, on various historical schools of art, were planned in emulation of the famous Discourses by Reynolds'.[30] Yet as has already been noted it is Ormond's evaluation of Leighton's Addresses which causes potential damage for they:

> fail to match the latter's [Reynolds'] intellectual vigour. Carefully worked
> and reworked during his autumn journeys abroad, the Addresses seemed
> laborious and over-studied to the audience who heard them, and they are no
> more lively when read today. They are typical of the concern for detail and
> finish that Leighton also brought to his paintings.[31]

Leighton's esteem for his predecessor was evident not only in his desire to pick up Reynolds' educational baton through public art discourse but also in other, more personal aspects of his life. Leighton owned four paintings by Reynolds; he collected the chairs Reynolds used for his portrait sittings; he was flattered by the Prince of Wales' presentation to him of a Zoffany print showing Reynolds with the Prince Regent, alluding to his own royal favour; he was presented in his last weeks with Burke's copy of Reynolds' discourses;

and posthumously joined Reynolds at his resting place when buried at St Paul's Cathedral.[32]

In his own art, Leighton made seemingly self-conscious links to Reynolds' practice, most notably in his portraiture. Paul Barlow notes how Leighton used Reynolds' conventions of country settings, loose handling of paint, and fashionable dress for his portraits of Victorian ladies.[33] The self-portraits of the two Presidents represent even closer connections: be it their shared costume of Oxford doctoral robes or the palpable dialogue invoked either by Leighton's complementary painterly style of 'solidity and impasto worthy of Reynolds' or his knowing divergence from the model, in shunning the theatricality of Reynolds' dramatic pose in favour of a 'direct frontality'.[34]

The intellectual calibre of Leighton's *Addresses* may perhaps better be measured by supplementing contemporary judgement with diligent study of their content. While Ormond's suggestion that the *Addresses* were a 'great strain' and that Leighton undertook the task due to a sense of duty not pleasure pays ample tribute to his public spiritedness, it is a rather sideways compliment, discounting his intellectual stature.[35] In fact, he can be seen as a fitting heir to Reynolds: his academic lectures on art were no mere copies of the *Discourses*, in terms of either form or content. Like the lectures of Reynolds, Leighton's *Addresses* were infused with the spirit of their age and were couched with a sturdy intellectual, historical and cultural framework that readily provided purpose and drive for artistic practice.

To understand the areas of divergence between the two sets of lectures, one must consider them separately from each other but alongside the intellectual climate in which they were produced. Richard Wendorf has persuasively described Reynolds' life and art as being a product of eighteenth-century political economy, with the parameters of his art and social life being set by aristocratic models.[36] Gentlemanly artists like Reynolds, and the Academy he helped to establish, were defined by contemporary discourses on education and politeness.[37] It was the social, professional and intellectual distinctions of Reynolds that ensured his election as President regardless of the court manoeuvrings of other candidates.[38] Furthermore, even if the quality of Reynolds' intellectualism was not of the highest order, it was not too far off achieving such a rank and was representative of the cutting-edge liberal educational ideals of the time.[39] He chose his friends in response to this intellectual climate, with Samuel Johnson and Edmund Burke chief amongst them.[40] As a child, Reynolds had been heavily influenced by classical thought through his father, who was a village schoolmaster, and the Platonist Zacariah Mudge, and in adulthood he supplemented these with his friendships with Johnson and Burke (the latter influencing the style of the *Discourses* to such a degree that rumours were generated over who their true author was).[41] F.W. Hilles disputes the assumption that Reynolds was not well read, founded on his statement in the seventh *Discourse* that for a student 'it is not necessary that he

should go into such a compass of reading, as must, by distracting his attention, disqualify him for the practical part of his profession, and make him sink the performer in the critic'.[42] Rather, Reynolds' mastery of such classical authors as Pliny, Virgil, Ovid and works of art history and theory such as Jonathan Richardson's Essay on the Theory of Painting (1715), Algarotti, Junius and Vasari, led Hilles to conclude that: 'There can be little doubt that the bulk of Sir Joshua's reading could be characterized as philosophical … not for amusement but to "improve and enlarge his mind"'.[43] Using these sources, Reynolds synthesised the Discourses from the sum of wisdom on the arts as supplied by the best historical and latest examples of philosophical writing, and in doing so drew upon a tradition of thought that represented a virtual continuum of civic humanism from the ancients, via the Renaissance, to the eighteenth century, personified in the triumvirate of Pliny, Vasari and Burke.[44]

Yet the Humanist tradition was arguably most obviously manifested in Reynolds' suggestions concerning the moral effect of art education. Burnet noted how: 'The example of Burke and the daily intercourse with Dr. Johnson, could not fail to infuse into these Discourses a considerable portion of eloquence and morality'.[45] The Discourses took their ethical lead from Richardson's Theory of Painting and went on to develop humanistic claims for painting with a demand for mental industry that was as much empirical as a priori in its logic.[46] It is therefore no surprise to discover his avocation of genius in art as an assumed position, a behavioural gesture:

> the industry which I principally recommend, is not the industry of the hands, but of the mind. As our art is not a divine gift, so neither is it a mechanical trade. Its foundations are laid in solid science: and practice, though essential to perfection, can never attain that to which it aims, unless it works under the direction of principle.[47]

Regarding this cultivation of taste, Reynolds spoke, in the seventh and ninth discourses particularly, of 'the general principles of urbanity, politeness, or civility, [which] have been ever the same in all nations' and the role of establishments, like the Academy, as a 'school of morality, where the mind is polished and prepared for higher attainments' and 'just taste'.[48] Humanist axioms populate the pages of the Discourses: 'We have no reason to suspect there is a greater difference between our minds than between our forms; of which, there are no two alike, yet there is a general similitude that goes through the whole race of mankind'.[49] Reynolds' intention was that his Discourses should serve a specific moral function, promoting the ideals of public service and self-improvement to as wide an audience as possible. For men like Beechy, Reynolds had succeeded for the 'Public taste, we repeat, has been considerably improved by the works of Sir Joshua Reynolds'.[50]

Did Leighton share such a view? It is clear that where Reynolds consciously engaged with the ethical components of the civic humanist tradition of

Shaftesbury and Burke, Leighton delved perhaps deeper, beyond the functional impact of the morality of art on society, to consider the abstract advantages to the mind of such pursuits. As he exclaimed in his First Address: 'Art [is] … in harmony with the ethical, the intellectual, and the aesthetic characteristics of the societies in the midst of which it arose'.[51] Leighton's philosophical approach was inflected by a lifetime of exposure to German artistic and intellectual culture which prioritised the agency of mind and consciousness in the history of human endeavours.[52] In speaking of such things at the RA, Leighton assumed an objectivity that had been part of Immanuel Kant's call for disinterested objectivity in the philosophy of art. Leighton duly set out the views of the opposing camps of moral didacticism and aestheticism in order to allow his audience the benefit of an informed judgement.[53] Unsurprisingly, given his early interests in post-Kantian idealism, he then employed a quasi-Hegelian dialectical form of logical discourse to arrive at synthetic conclusions:

> Art is indeed, in its own nature, wholly independent of Morality, and whilst the loftiest moral purport can add no jot or tittle to the merits of a work of Art, *as such*, there is, nevertheless, no error deeper or more deadly, and I use the words in no rhetorical sense, but in their plain and sober meaning, than to deny that the moral complexion, the ethos, of the artist does in truth tinge every work of his hand, and fashion, in silence, but with the certainty of Fate, the course and current of his whole career.[54]

Yet, as a good Hegelian and like his contemporary Walter Pater, Leighton supported his hypothetical theories with historical evidence.[55] Tracing the history of Renaissance art, he saw its rise as a product of scientific and classical learning which 'loosened the hold on them of … the intellectual thraldom in which the Church had hitherto sought to hold them'.[56]

Leighton's repeated profession of the importance of anthropomorphism was perhaps evidence of humanist tendencies that had been incorporated in a wider nineteenth-century world view.[57] He gave the 'anthropomorphic impulse', to use Leighton's own terminology, a primary position within art:

> In the emotion aroused by the phenomena of life, which we said was at the root of all Art, the central and culminating fact is our interest in Man; he is, and must always be, the end and the means of whatever is greatest in the plastic Arts – as in every Art that tells of him; in the Art of Phidias, in the Art of Leonardo, in the Art of Homer, in the art of Shakespeare … The most deeply impressive works are those in which the human interest and the aesthetic quality are most fully blended. Decay is imminent when the expression of this interest ceases to be sincere, and man no longer recognises his humanity in Art.[58]

While such musings undeniably possess something of Reynolds' grand rhetorical air about them, their content and the injection of a Romantic concern for individual perception and the overarching threat of decay speaks more of

Schlegel and Schiller than Shaftesbury, bypassing political economy for more poetic concerns. Leighton's understanding of the moral agency of art was subtle, for he saw that crude moral didacticism was not the only way to bring about the reform of human conduct.[59] Far from subscribing to the universalist rules of the civic humanist tradition, as Reynolds had done to a great degree before him, Leighton ultimately believed in idealism inflected by relativism, especially in his view that the material circumstances of artistic form could inspire a diverse range of moral effects depending upon their contexts:

> through this operation of Association, lines and forms and combinations of lines and forms, colours and combinations of colours have acquired a distinct expressional significance, and, so to speak, an *ethos* of their own, and will convey, in the one province, notions of strength, of repose, or solidity, of flowing motion and of life, in the other sensations of joy or of sadness, of heat or of cold, of languor or of health.[60]

This was a singularly important conclusion for an educator to arrive at, for the belief that no aesthetic principle possessed universal validity had important implications on curricula. In the eighteenth century, strict unchanging academic precepts for art schools had been buoyed up by the physiocratic perspective of Enlightenment philosophy, which in turn sought to discern the rational logic behind social systems. Leighton's stance would alternatively accept if not always inspire flexibility and experimentation. Once more, theoretical principle was backed up by historical examples for Leighton. In its excessive imposition of an ethical order, Leighton believed the martial imperative of imperial Rome stifled artistic creativity: intellectuals berated artistic activity as 'little becoming the dignity of a Roman citizen', individual works were deficient, and only architecture with its monumental presence was tolerated as a means to an end of subjugation and furtherance of the 'imperial instinct', leaving the state 'barren of great results'.[61] Simply put, 'Art, as æsthetic expression, nowhere, in fact, held to the roots of the Roman-temperament … the impulse was ethic rather than æsthetic'.[62]

That the overall style and composition of the academic lectures of Reynolds and Leighton contrast is not a cause for great surprise for they were, after all, formed under the influence of discrete intellectual traditions. If closer examination reveals greater differences than similarities in their abstract discussion of culture and the history of ideas, was there greater proximity in the area that dealt more specifically with the practical matter of teaching art? While refraining from providing a precise schedule or curriculum for the modern art student, Reynolds' *Discourses* deployed a multitude of principles with which to organise a course of study. In the second *Discourse* he set out the practical parameters of his mission: 'In speaking to you of the Theory of the Art, I shall only consider it as it has a relation to the *method* of your studies'.[63] Reynolds described three stages in the 'study of painting': he assumed that his

assembled audience had passed through the first of these (technical proficiency in drawing, colouring and composition), would go on to the second (the collecting of models, subjects and ideas for painting), and would then conclude with the third (achieving freedom from mannerism – painting according to subjective but reasoned judgement).[64] Such a structure was commensurate with Reynolds' perception of the evolution of students and their steadily improving capabilities from physical to intellectual: 'it is the natural progress of instruction to teach first what is obvious and perceptible to the senses, and from thence proceed gradually to notions large, liberal, and complete, such as comprise the more refined and higher excellencies in Art'.[65] The relative distance from the technical aspects of applying paint to canvas adopted by Reynolds in the *Discourses* is explained by the fact that his principal concern was to obtain an overview of the whole matter of artistic practice rather than being distracted by the minutiae of pedagogical detail. He therefore repeatedly stressed in the *Discourses* that he was offering hints for students and tutors, but refrained from dictating exact modes of teaching, refusing even to delve into his own personal experiences, for example, in order to share this wisdom with students as a guide for what to do and see in Italy. The reason for this was that 'what degree of attention ought to be paid to the minute parts ... is hard to settle' for 'it is expressing the general effect of the whole which alone can give to objects their true and touching character'.[66] Reynolds was therefore consistent in his thought and practice in art – the grand idea and manner forming a perfect partnership. The motivation for Reynolds' stance was not a Romantic belief in the primacy of individual perception, but was rather due to his Platonic approach of stripping down precepts to reveal ultimate (simple) truths. It was also due to a physiocratic recognition of the mundane demands of practicality. Not all examples referred to by a teacher would be available to students due to chance circumstances. Furthermore, Reynolds believed that a student's mind responded better to their own instinctive interest than dogmatic indoctrination, so that 'I would rather wish a Student ... to employ himself upon whatever he has been incited to by any immediate impulse, than to go sluggishly about a prescribed task'.[67] The 'grand effect' of learning in such a manner was equally evident in his advice for painting, as: 'The great advantage of this idea of a whole is, that a greater quantity of truth may be said to be contained and expressed in a few lines or touches, than in the laborious finishing of the parts, where this is not regarded'.[68] Nevertheless, he was careful to avoid encouraging sloppiness, and this connected to his deeper moral message. All artists had to exercise moral restraint in study and practice; Reynolds advised discipline for both young and mature artists:

> In the practice of art, as well as in morals, it is necessary to keep a watchful and jealous eye over ourselves: idleness, assuming the specious disguise of industry, will lull to sleep all suspicion of our want of an active exertion of strength. A provision of endless apparatus, a bustle of infinite enquiry and

research, or even the mere mechanical labour of copying, may be employed,
to evade and shuffle off real labour – the real labour of thinking.[69]

While Reynolds' often ambiguous suggestions for points of curricula were
informed by his ideal principles, Leighton stepped further away from practice
into theory with his advocacy of abstract observations on cultural history as
opposed to art practice per se: as he stated in his very first address, 'I am impelled
to set aside … all purely practical and technical matters'.[70] He confessed that it
was his intention in the *Addresses* to 'assail the minds of students who think as
well as work'.[71] In many ways Leighton's approach was complementary to that
of Reynolds: thought and mind were central to both. Yet whilst the mode of
thought invoked by Reynolds came from the British stable of Richardson, Burke,
Shaftesbury et al. (albeit further inflected by the French academic tradition
of Charles Le Brun), the definition of mind adopted by Leighton was from a
markedly different national school – that of the German philosophy of Kant,
Hegel, and Schiller.[72] Reynolds' Anglo-French position had a fundamentally
different drive from Leighton's Anglo-German mindset: the former had at
its base the concern to develop good 'behaviour' in artists to promote public
virtue and benefit the common good, with Reynolds declaring his high esteem
for 'rules for the conduct of the artist which are fixed and invariable'; the latter
addressed itself to the advance of the individual spirit as an end in itself, which
is obvious in Leighton's view of Greek sculpture as representative of 'a body
not … at war with the spirit, but working harmoniously with it towards one
common central ideal of perfection'.[73]

Leighton's greater disengagement with art-making concerns in his *Addresses*
was nevertheless more than made up for by his practical contributions in the
reform of the Royal Academy Schools, especially between 1869 and 1874. These
were the first act of a politically ambitious man, choosing a cause that served the
dual purpose of promoting his own reputation (having recently been elected
a full Academician) whilst also making changes for the benefit of students.[74]
Overall, 'the reform of the Schools which took place during the 1870s must
be attributed, to a very great extent, to initiatives set in motion by him during
this period'.[75] Leighton was an avid teacher who served in the schools for one
month a year in the life class between 1872 and 1878, and in the painting school
in 1872, 1873 and 1875, and he sought to make informed changes to the system
from within based on his experiences, and thus undermined calls for more
drastic measures that came from outside the institution. The reforms were
ambitious at the start, achieving immediate impact in the life class, cast gallery
and working spaces generally, although his attempts to bring in a general
director of the schools, a professor of sculpture, instruction in engraving and
the continental atelier system were thwarted by conservative members like
John Callcott Horsley.[76] Following his election to the Presidency in 1878, he
was in a far better position to secure change, and the raft of reforms introduced
between 1887 and 1889 led to the RA 'adjusting the regulations and methods

of instruction to the changing exigencies of the times but never going so far as to question the fundamental premises of the Academy's pedagogy'.[77] He also lobbied for greater access for female students, writing to Henry Wells on the historical precedents for such measures.[78]

Perhaps the definitive factor uniting theory and practice in the art educational lectures of Reynolds and Leighton was their attitudes to the Old Masters and, by association, the light this sheds on their view of the present. It was in learning from the Masters that Reynolds united his axioms of idealism, universalism and empirical study, for:

> A painter should form his rules from pictures rather than from books or precepts: rules were first made from pictures, not pictures from rules. Every picture an artist sees, whether the most excellent or the most ordinary, he should consider from whence that fine effect or that ill effect precedes; and then there is no picture ever so indifferent but he may look at to his profit.[79]

The reason for recourse to the Old Masters (or, to use Reynolds' terminology, 'great masters' or 'most eminent Painters') was their unimpeachable status as models of good practice. He reiterated this central position in the First and Sixth Discourses, describing them as a repository of 'great examples of the Art' for students:

> By studying these authentick models, that idea of excellence which is the result of accumulated experience of past ages, may be at once acquired; and the tardy and obstructed progress of our predecessors may teach us a shorter and easier way. The student receives, at one glance, the principles which many Artists have spent their whole lives in ascertaining.[80]

Dispelling the idea that artistic talent was a 'magick' gift, Reynolds argued instead that continual study of the Old Masters would 'impregnate our minds with kindred ideas' and that 'A MIND enriched by an assemblage of all the treasures of ancient and modern art, will be more elevated and fruitful in resources in proportion to the number of ideas which have been carefully collected and thoroughly digested'.[81] He pointed to examples from art history to dignify this process of emulation, Raphael chief amongst them in taking inspiration from Masaccio.[82] Yet, keen to protect against sycophancy, Reynolds called for a composite study in influence. The modern artist (student or professional) should therefore take not one model but many, for a 'variety of models' allowed artists to 'avoid the narrowness and poverty of conception which attends a bigotted [sic] admiration of a single master'.[83] Copying was, in fact, a problematic issue for Reynolds to negotiate. As has already been seen, he was insistent on the futility of copying details from past art and instead called for an understanding of general principles. Beechy noted Reynolds' command that 'Instead of copying the touches of those great masters, copy only their conceptions', and description of 'general copying as a delusive

kind of industry; the student satisfies himself with the appearance of doing something; he falls into the dangerous habit of imitating without selecting, and of labouring without any determinate object' so that the Old Masters should be constantly consulted as 'councillors'.[84] 'Polite' deference and the 'classic' status of canonical artists protected modern artists from accusations of plagiarism.[85] Again, Reynolds argued for this consistently from a historical perspective: in the Sixth Discourse, for example, he referred to the contrasting examples of the 'narrow, confined, illiberal, unscientific and servile kind of imitators' and those from the school of the Caraccis who learned from many models and surpassed these with their independent thought.[86]

Reynolds' view of the Old Masters was neither wholly abstract nor a product of academic idealism. It was to a large extent contingent upon his socio-political environment. Invoking Pierre Bourdieu and the conceptual agency of taste and 'distinction', Richard Wendorf has convincingly argued that the artistic practice of Reynolds was informed by the wider social milieu of his times.[87] His theorisations presumably followed a similar pattern: if Reynolds' social behaviour was a product of his esteem for his aristocratic patrons, it makes sense to view his studio practice and theoretical approach to the Old Masters in a similar light. Put simply, Reynolds emulated their practice in order to become like them.

Leighton shared this deference for the Old Masters; his notebooks abound with references to the art of the past and reveal his passionate admiration for the work of the Old Masters. Crucially, he agreed with Reynolds about the pitfalls of blindly following their lead.[88] Leighton tackled head-on the issues raised by Reynolds' advocacy of the Old Masters as models for students in his *Addresses*, and expressed sympathy for the lot of the student, who was:

> The fortunate but bewildered heir to a boundless inheritance of artistic treasure, he finds himself frequently in the presence, almost at the same moment, of various works, each of high excellence, all bearing the impress of genius, and yet wholly different one from the other in the manner of their excellence, each apparently preaching to him a different doctrine and beckoning to him in a different direction. He will see on the same day a work by Phidias and a work by Michael Angelo – a portion of the Parthenon and a fragment from Lincoln Cathedral – a canvas signed by Titian and one from the hand of Albert Dürer – a Rembrandt, and a Masaccio; all noble works, yet all how different! Whom then shall he follow? Whom out of so many giants shall he propose to himself as his model? But with this question a further misgiving mixes itself, and he is forced to ask himself whether the great masters of old, if they could live again in our day, would not produce works in many ways different from those which they have left us, and whether to follow them in the letter would not be to wander from them in the spirit.[89]

Copying the masters for Leighton was a dangerous pursuit for the same reasons Reynolds had identified in the *Discourses*: the intellectual spirit, not the idiosyncratic painterly touch of the Masters, was what students should

be seeking in their studies of their illustrious predecessors. Yet emulation can be traced in the studio practice of the Presidents, for example, from Leighton's *Fatidica* (Figure 5.1: c.1893–4) through Reynolds' *Mrs Siddons as the*

5.1 Frederic Leighton, *Fatidica* (c.1893–4), oil on canvas, 153 × 111 cm/© Lady Lever Art Gallery, National Museums Liverpool/Bridgeman Art Library.

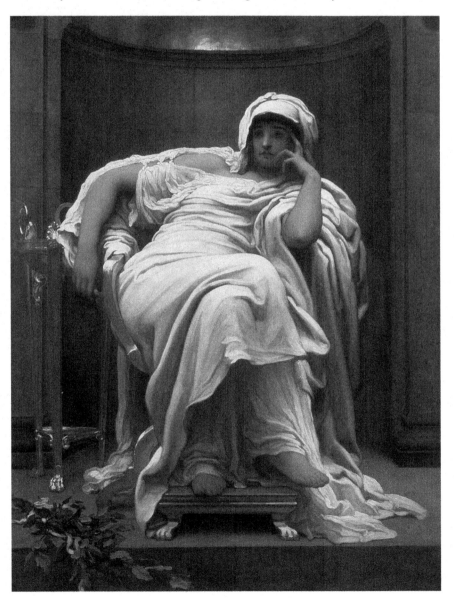

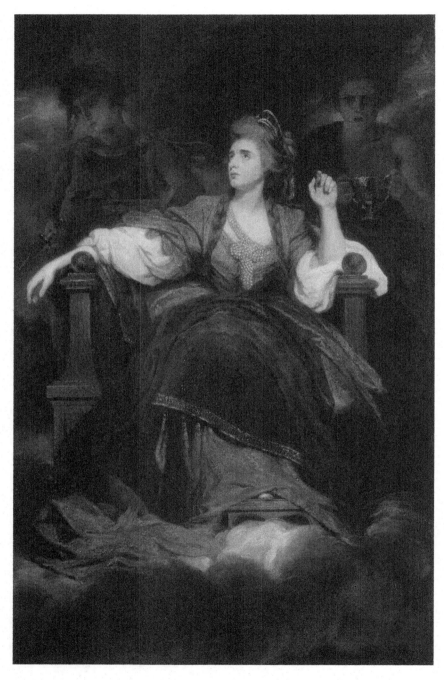

5.2 Sir Joshua Reynolds, *Mrs. Siddons as the Tragic Muse* (1789), oil on canvas,
239.7 × 147.6 cm/© Dulwich Picture Gallery, London, UK/Bridgeman Art Library.

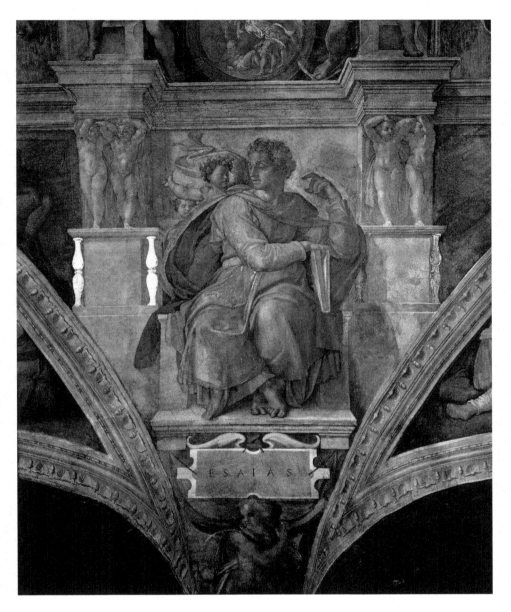

5.3 Michelangelo, *Sistine Chapel Ceiling: The Prophet Isaiah* (1508–12), fresco/Vatican Museums and Galleries, Vatican City/Bridgeman Art Library.

Tragic Muse (Figure 5.2: 1789) back to the common source of Michelangelo's *The Prophet Isaiah* (Figure 5.3: 1508–12) in the Sistine Chapel.[90] In terms of subject matter, the main characters in the three works are linked by the

possession of prophetic powers. While both modern artists switch the sitter's gender from male to female in their re-imaginings, Reynolds arguably takes the greatest liberties of the two. Taking the form of *Isaiah*, he removes the figure from its squared architectonic frame and drops it into a meteorological maelstrom that creates a sense of brooding melodrama. Given the hegemonic associations of many art works in the Vatican and Reynolds' own position at the head of an authoritative institution, much like the Pope, the decision to subvert such hierarchical characteristics seems strange, but no doubt it speaks of his expressive, stylistic, and moral agendas for the work. Leighton's *Fatidica* by contrast is a closer reiteration. The apse behind her is rendered in a Renaissance Italian style and the fingers of her left hand, although not identically configured, have greater affinities to those of Michelangelo's *Isaiah* with their geometric or angular nature. That both Presidents found elements within Old Master works that could be adapted for contemporary art amply demonstrates their belief in the benefits of continued learning from the Masters.

Looked at in sequence and in parallel, Reynolds' *Discourses* and Leighton's *Addresses* provide valuable insights into the attitudes towards the art of the past entertained by two of the most important Presidents of the RA. In their lectures, neither gave specific instructions on technical matters to help students starting out on their professional careers, but both made emphatically clear that this was not their primary concern. Such work took place in the RA schools, not in the lecture hall. Both Reynolds and Leighton were convinced that intellectual education was more important for the creation of great artists: guiding the mind rather than the hand of the artist. Reynolds used his Enlightenment discourse of civic humanism to convince the wider world of the virtues of the arts in society and the benefits of the RA as an institution working for the British nation. Arguably little had changed in the century since, as the debates surrounding the Government Schools of Design in the second and third quarters of the nineteenth-century illustrate with their continued use of arguments of political economy when speaking of utility in art education. However, as Leonée Ormond rightly states, Leighton's lectures were essentially on 'the relation between the spiritual, cultural and social conditions of a given epoch and the art which it produced'.[91] Agreeing with many of the values expressed in Reynolds' *Discourses*, Leighton had ultimately applied his personal intellectual ambitions and subtly remodelled the remit of the Presidential lectures from promoting the political benefits of a liberal arts education to the deeper philosophical goal of exploring the mind of the artist.

Ultimately, Leighton's engagement with the complicated idealist philosophy of his day might have made his lectures indigestible to some, but it ensured that its calibre was of the highest order. The accusation that Leighton's *Addresses* were intellectually inferior to Reynolds' *Discourses* seems ungenerous. While Leonée and Richard Ormond believe Leighton, unlike Reynolds, failed to

draw useful lessons from the Old Masters to help contemporaries in their practice, perhaps this is to misread his intentions and the relationship between his lectures and those of his predecessor.[92] Leighton was as much a product of the historical-mindedness of Victorian culture as John Ruskin, Matthew Arnold or Walter Pater, and his lectures were meant to be heard in light of the synthetic Hegelian *zeitgeist*: surveying large patterns in the cultural record for general truths. Looking at the philosophy, psychology and history of art offered lessons for art students in the present and future. Leighton's *Addresses* sought to elaborate a truly academic view of art history, the influence of which would be felt not just in art schools but also universities, engaging with the latest paradigms in history, ethics and aesthetics available from the continent. Leighton's ultimate end was not self-indulgent existentialism, but rather to train students for the task of painting pictures that were intellectually significant, engaging with the contemporary concerns of a world haunted by the anxieties of modernity: pollution, social iniquity, and moral and religious crisis. Far from dismissing Leighton as unschooled and vague, his lectures should be seen as intellectually ambitious and precise. His cautiousness in employing prescriptive commandments reflected not indecisiveness but prudence, and this was similar to the conclusion that Reynolds had come to a century earlier. According to such criteria, Leighton may justly be seen as Reynolds' peer as an intellectual, an accomplished art educator, and, perhaps above all, a Master.

Notes

1 Holger Hoock, *The King's Artists: The Royal Academy of Arts and the Politics of British Culture 1760–1840* (Oxford: Oxford University Press, 2003), pp. 52–67, 234–52.

2 Quoted in Sidney C. Hutchinson, *The History of the Royal Academy 1768–1986* (London: Robert Royce Ltd., 1986), p. 24.

3 Joshua Reynolds, 'Discourse I, January 2, 1769', in Sir Joshua Reynolds (Robert R. Wark (ed.)), *Discourses on Art* (New Haven, CT: Yale University Press, 1997), p. 15.

4 A.L. Baldry, *Sir Joshua Reynolds* (London: George Newnes Ltd., 1903), p. x.

5 Robert R. Wark, 'Introduction', in Reynolds, *Discourses on Art*, p. xv.

6 James Northcote, *The Life of Sir Joshua Reynolds* (London: Henry Colburn, 1819, 2 volumes), Vol. I, pp. 177–9.

7 Hoock, *The King's Artists*, p. 323.

8 Leonée Ormond, 'Leighton and the Royal Academy', in Royal Academy, *Frederic Leighton 1830–1896* (London: Royal Academy of Arts, 1996), pp. 18–19; Anna Gruetzner Robins, 'Leighton: A Promoter of New Painting?', in Tim Barringer and Elizabeth Prettejohn (eds), *Frederic Leighton Antiquity, Renaissance, Modernity* (New Haven, CT: Yale University Press, 1999), pp. 315–30.

9 Ormond, 'Leighton and the Royal Academy', p. 13.

10 Frederic Leighton, '[Second] Address, December 10th, 1881: Relation of Art to Morals and Religion', *Addresses Delivered to the Students of the Royal Academy* (London: Kegan Paul, Trench, Trübner & Co., 1897), p. 41: Leighton invoked the colourful practices of Gainsborough and Reynolds as reasons for why there would be no enthusiastic subscription in Britain to the German distaste for excess in this particular area of art.

11 Leonée and Richard Ormond, *Lord Leighton* (New Haven, CT: Yale University Press, 1975), p. 112.

12 Ibid; Ormond, 'Leighton and the Royal Academy', p. 14.

13 C. Lewis Hind, *Napthali* (London: John Lane, The Bodley Head, 1926) p. 119; see also Leonée and Richard Ormond, *Lord Leighton*, p. 112.

14 Lewis, *Napthali*, pp. 87, 132–3.

15 A. Orr, 'Preface', in Leighton, *Addresses*, p. vii.

16 Ormond, 'Leighton and the Royal Academy', p. 16.

17 Orr, 'Preface', pp. vii–ix.

18 Charles Lewis Hind, *Romney* (London: T.C. & E.C. Jack, 1907); Charles Lewis Hind, *Constable* (London: T.C. & E.C. Jack, 1909); Charles Lewis Hind, *Hogarth* (London: T.C. & E.C. Jack, 1910); Charles Lewis Hind, *Watteau* (London: T.C. & E.C. Jack, 1910); Charles Lewis Hind, *Turner's Golden Visions* (London: T.C. & E.C. Jack, 1910); Charles Lewis Hind, *The Post Impressionists* (London: Methuen & Co., Ltd., 1911); Charles Lewis Hind, *The Art of Stanhope A. Forbes, R.A.* (London: Virtue & Co., 1911); Charles Lewis Hind, *Hercules Brabazon Brabazon, 1821–1906; His Art and Life* (London: G. Allen & Company, Ltd., 1912); Charles Lewis Hind, *Landscape Painting from Giotto to the Present Day* (London: Chapman & Hall, 1923–4).

19 Frederic Leighton, '[Sixth] Address, December 10th, 1889: Art in Spain', in Leighton, *Addresses*, p. 179.

20 Ibid., pp. 189–90.

21 Charles Lewis Hind, *Days with Velasquez* (London: A&C Black, 1906), pp. 3, 4, 8, 52, 98, 111, 116, 146.

22 Ibid., pp. 8–9.

23 Ibid., pp. 5–6, 24.

24 Leighton, '[Sixth] Address' (1889), pp. 208–10.

25 Ibid., p. 215.

26 Matthew C. Potter, *The Inspirational Genius of Germany: British Art and Germanism, 1850–1939* (Manchester: Manchester University Press, 2012), pp. 100, 109, 122.

27 Ormond and Ormond, *Lord Leighton*, p. 112.

28 Derek Hudson, *Sir Joshua Reynolds: A Personal Study* (London: Geoffrey Bles, 1958), pp. 64–6.

29 Quoted in Ormond, 'Leighton and the Royal Academy', p. 13.

30 Ibid.

31 Ibid.

32 Ibid.; Christopher Newall in Royal Academy, *Frederic Leighton 1830–1896*, p. 46; Stephen Jones in Royal Academy, *Frederic Leighton 1830–1896*, p. 145; Louise Campbell, 'Decoration, Display, Disguise: Leighton House Reconsidered', in Barringer and Prettejohn (eds), *Frederic Leighton*, p. 278.

33 Paul Barlow, 'Transparent Bodies, Opaque Identities: Personification, Narrative and Portraiture', in Barringer and Prettejohn (eds), *Frederic Leighton*, pp. 203, 205.

34 Ormond and Ormond, *Lord Leighton*, p.121; Tim Barringer and Elizabeth Prettejohn, 'Introduction', in Barringer and Prettejohn (eds), *Frederic Leighton*, p. xxiii; Lene Østermark-Johansen, 'The Apotheosis of the Male Nude: Leighton and Michelangelo', in Barringer and Prettejohn (eds), *Frederic Leighton*, p. 111.

35 Ormond and Ormond, *Lord Leighton*, p. 112.

36 Richard Wendorf, *Sir Joshua Reynolds: The Painter in Society* (London: National Portrait Gallery, 1996), p. 106.

37 Hoock, *The King's Artists*, p. 5.

38 Ibid., p. 23.

39 Sam Smiles, 'Introduction', in Sam Smiles (ed.), *Sir Joshua Reynolds: The Acquisition of Genius* (Bristol: Sansom & Company, 2009), p. 13.

40 Henry William Beechy, *The Literary Works of Sir Joshua Reynolds* (London: Bell, 1878), pp. 141–6.

41 Frederick Whiley Hilles, *The Literary Career of Sir Joshua Reynolds* (Hamden, CT: Archon Books, [1936] 1967), pp. xix, 7, 13, 14, 138–9.

42 Reynolds, 'Discourse VII, December 10, 1776', p. 118.

43 Hilles, *The Literary Career of Sir Joshua Reynolds*, p. 117.

44 Ibid., pp. 5, 10–11, 113, 115, 119–21, 123–47.

45 John Burnet, *The Discourses of Sir Joshua Reynolds* (London: James Carpenter, 1842), p. i.

46 Wendorf, *Sir Joshua Reynolds*, pp. 25–6, 89–90, 100.

47 Reynolds, 'Discourse VII' (1776), p. 117, emphasis in original.

48 Ibid., pp. 134, 142; 'Discourse IX, October 16, 1780', p. 169.

49 Reynolds, 'Discourse VII' (1776), p. 131.

50 Beechy, *The Literary Works of Sir Joshua Reynolds*, p. 83.

51 Leighton, '[First] Address' (1879), p. 9.

52 Potter, *The Inspirational Genius of Germany*, pp. 109, 120, 123.

53 Leighton, '[Second] Address' (1881), pp. 39–41.

54 Ibid., p. 42, emphasis in original.

55 Potter, *The Inspirational Genius of Germany*, p. 113.

56 Leighton, '[Second] Address', (1881), pp. 46–9.

57 Leighton, '[First] Address, December 10th, 1879: Position of Art in the World', in Leighton, *Addresses*, pp. 18, 25.

58 Ibid., pp. 16–17.

59 Leighton, '[Second] Address', (1881), pp. 54–5.

60 Ibid., pp. 57–8, emphasis in original.

61 Leighton, '[Fourth] Address, December 10th, 1885: Art in Ancient Italy; The Etruscans; Rome', pp. 126–9.

62 Ibid., p. 127.

63 Reynolds, 'Discourse II, December 11, 1769', p. 25, emphasis in original.

64 Ibid., pp. 25–6: Reynolds reiterates his position on the rational method of study in 'Discourse XV, December 10, 1790', p. 270.

65 Reynolds, 'Discourse VIII, December 11, 1778', p. 154.

66 Reynolds, 'Discourse XI, December 10, 1782', pp. 193–4, 197 199; 'Discourse I' (1769), p. 16; 'Discourse VI, December 10, 1774', p. 93; 'Discourse XI (1782), p. 11; 'Discourse XII, December 10, 1784', p. 207.

67 Reynolds, 'Discourse XII' (1784), p. 208.

68 Reynolds, 'Discourse XI' (1782), p. 201.

69 Reynolds, 'Discourse XII' (1784), p. 210; see also 'Discourse I' (1769), p. 17; 'Discourse II' (1769), p. 32; 'Discourse XI' (1782), pp. 198, 202, 204; 'Discourse XII' (1784), pp. 209, 211, 214.

70 Leighton, '[First] Address' (1879), p. 3.

71 Leighton, '[Second] Address' (1881), p. 37.

72 Potter, *The Inspirational Genius of Germany*, pp. 106, 108–9, 112–13, 115–6, 118–21, 123–4, 126, 129, 134.

73 Reynolds, 'Discourse VII' (1776), p. 123; Leighton '[Third] Address, December 10th, 1883: Relation of Art to Time, Place and Racial Conditions. Egypt, Chaldea and Greece', p. 92.

74 Ormond and Ormond, *Lord Leighton*, pp. 48, 66–7; Ormond, 'Leighton and the Royal Academy', p. 17.

75 Rafael Cardoso Denis, 'From Burlington House to the Peckham Road: Leighton and Art and Design Education', in Barringer and Prettejohn (eds), *Frederic Leighton*, p. 248.

76 Ibid., pp. 249–52.

77 Ibid., p. 255.

78 Ormond, 'Leighton and the Royal Academy', p. 18.

79 An oft-quoted passage that appears in Northcote, *The Life of Sir Joshua Reynolds*, Vol. I, p. 39; Allan Cunningham, *The Lives of the Most Eminent British Painters and Sculptors* (New York: J&J Harper, 1831, 3 volumes), Vol. I, p. 203; and Beechy, *The Literary Works of Sir Joshua Reynolds*, p. 76.

80 Reynolds, 'Discourse I' (1769), p. 15.

81 Reynolds, 'Discourse VI' (1774), p. 99; see also pp. 94, 111, 113.

82 Reynolds, 'Discourse XII' (1784), pp. 216–17, 219.

83 Reynolds, 'Discourse VI' (1774), p. 103; 'Discourse II' (1769), p. 26.

84 Reynolds, 'Discourse XI' (1782), p. 204; Beechy, *The Literary Works of Sir Joshua Reynolds*, pp. 73, 75; Reynolds, 'Discourse II' (1769), p. 29; 'Discourse XII' (1784), p. 220.

85 Reynolds, 'Discourse VI' (1774), p. 106.

86 Ibid., pp. 104–5.

87 Wendorf, *Sir Joshua Reynolds*, pp. 1–3.

88 Ormond and Ormond, *Lord Leighton*, p. 83.

89 Leighton, '[First] Address' (1879), p. 11.

90 Leonée Ormond, 'Fatidica', in *Frederic Leighton, 1830–1896* (RA 1996 exhibition catalogue), p. 235.

91 Ormond and Ormond, *Lord Leighton*, p. 112.

92 Ibid.

Opening Doors: The Entry of Women Artists into British Art Schools, 1871–1930

Alice Strickland

> Each generation has to re-create the meaning of our Old Masters by critical appreciation: it is only by that means that they are kept alive. Indiscriminate worship would kill them.[1]

Roger Fry's statement made in his last publication, *Reflections on British Painting* (1934), aptly illustrates the importance of the Old Masters to early twentieth-century British art. Both an art critic and art history lecturer during the early half of the twentieth century, Fry (1886–1934) was instrumental in shaping how art students of this period reflected on works of the past. This chapter seeks to explore the role that Old Masters played in the curricula to which British female art students specifically were exposed in the closing decades of the nineteenth century and opening decades of the twentieth century. During the period of present concern, British women's social, political and cultural circumstances underwent radical change: the Married Women's Property Acts of 1870 and 1882 allowed wives to legally be the rightful owners of the money they earned and to inherit property, and in 1918, the Representation of the People Act was passed, which allowed women over the age of 30, who met a property qualification, to vote in parliamentary elections. However, it was not until the Equal Franchise Act of 1928 that women over the age of 21 were able to vote and women finally achieved the same voting rights as men. The full emancipation of women allowed them to play a greater part in public life, a part which had been expanded with the introduction of the Sex Disqualification (Removal) Act of 1919, in effect lifting most of the existing common law restrictions on women; they were now able to serve as magistrates, for example, and enter the professions. Marriage was no longer legally considered a bar to a woman's ability to work. In this period of social and political flux, the provision of art education in Britain from 1852 to 1913 was largely through the Government Schools of Design, established

by Henry Cole, and based on the teaching then offered at the Royal Academy (RA) Schools. In 1913 Sir Henry Cole's system was replaced by the Board of Education's Drawing Examinations in Life, Antique, Memory & Knowledge, Architecture, Anatomy and Perspective.

The main options for women seeking an art education in the late nineteenth and early twentieth centuries were private art schools such as Dickinson's Academy and Leigh's Academy (later Heatherley's) or private tuition. Lady Butler (1846–1933) believed life model study to be so important for her artistic education that she left both the South Kensington School and the Female School of Art (previously the Government School of Art for Females), where working from the nude was forbidden, and enrolled in a private art school. The Government School of Art for Females provided opportunities for women wishing to pursue an artistic career. The School later known as the Female School of Art was founded in 1842 by a grant distributed by the government for the establishment of schools for design. The School was established 'partly to enable young women of the middle class to obtain honourable and profitable employment and partly to improve ornamental design in manufacturers, by cultivating the taste of the designer'.[2] In 1851 the School was moved, because of its growing size, to Gower Street. For 17 years, it received £500 out of the annual £1,500 grant until 1859, when the government ceased its funding. A private subscription allowed it to continue and permanent premises were finally bought in Queen's Square, giving the institution some security.

In the 1850s the campaign for women's suffrage, employment and education was promoted by the 'Langham Place' circle. Out of this circle emerged the Society of Female Artists, 'an important outlet of the Women's Movement, which strove to provide more exhibition space for women and to enhance the possibility of sales'.[3] Its leaders included Mrs Roberton Blaine, whose husband, Delabre Roberton Blaine, was one of the few witnesses at the 1863 Royal Academy Commission to speak in favour of the rights of women. The Society of Female Artists was founded in 1857, later becoming the Society of Women Artists, and it attempted to remedy the limited exhibiting opportunities offered to female artists. The Society emerged at a time when it was unthinkable that women should have careers or seek recognition outside of the home. Significantly, it provided women artists with the opportunity to control their own exhibitions in the capital. In 1859, 38 women signed a petition requesting the privilege to study from the Antique and life under the direction of qualified RA teachers, which was then sent to every Royal Academician and published in the *Athenaeum* on 30 April 1859.

Since its inception in 1768, no woman had been allowed to attend the RA Schools. However, the year after the petition by the Society of Women Artists was sent out, one female artist, Anna Laura Hereford, was passed into the RA Schools in 1860 by an entirely unsuspecting Council. Hereford sent her drawings into the RA with her Christian names in initials only. 'The laws

were searched, nothing was found in them prohibitory to the admission of females, and so took her place amongst the boys'.[4] According to George Leslie in *The Inner Life of the Royal Academy* (1914), Miss Laura Hereford was 'undertaken solely with a view to the advancement of female artists'.[5] She was 'eventually only grudgingly granted entrance, her admittance was allowed after much debate and resistance when it was discovered that the "L. Hereford" who had applied and been accepted was a woman'.[6] Hereford and 12 other women were awarded places at the RA School between 1861 and 1863. These female students were permitted to draw from casts in the Antique Class and paint from the draped model in the Painting School, but were forbidden from studying the nude model. However, in 1863 the RA voted to ban the admission of women students on the grounds of lack of space.[7] By March 1867, this ruling was lifted to allow the number of women to remain constant, only to be revoked completely by May. By 1870, however, the number of women at the RA schools numbered 23. In George Leslie's 1914 account of the RA Schools, he states in a chapter entitled 'The Invasion of the Schools by Females' that 'It is very pleasant work teaching girls, especially pretty ones, who somehow always seemed to make the best studies … as a general rule, the prettier the girl the better the study'.[8] Even when logistical bars were raised, gender prejudices obviously continued.

By exploring the educational opportunities available to women artists, this chapter seeks to recover the educational experience of individual women artists and provide a greater understanding of the peculiarities of the art training undertaken by women during this period. The chapter will also look at how this new cohort of women students negotiated the male-dominated traditions of the past. From the mid-nineteenth century, British art schools began to offer a wider range of training for all artists. University-based institutions like the Slade, established in 1871, provided students with a thorough academic training focusing on life drawing, whilst Government Schools of Art, such as the Central School of Art, established in 1896, provided a basic artistic training with a stress on design.[9] This chapter will focus heavily on the academic artistic training undertaken by women students at the Slade School of Drawing, Painting and Sculpture, University College London, because of the high calibre of both the women artists who worked there and those individuals who taught at the School from its foundation in 1871 until the end of Henry Tonks' tenure as Slade Professor in 1930.

Until the end of the nineteenth century, female art students were prevented from receiving the academic training considered essential to becoming a prominent artist.[10] Excluding women from art academies did not completely prevent women from seeking careers as artists. However, Whitney Chadwick argues that a general artistic encouragement for women existed as early as the eighteenth century, when many more women outside the traditional groups of artists' daughters and well-born amateurs began to enter the profession.[11]

The admission of women to art schools in the second half of the nineteenth century has traditionally been seen as the decisive event that not only increased the number of women artists in Britain but also established equality of access to art education as a principle.

The previous exclusion of women from art schools created a major obstruction to women exhibiting, entering the artistic profession and, perhaps most importantly, professional recognition. As Rozsika Parker and Griselda Pollock observe in their seminal work *Old Mistresses: Women, Art and Ideology* (1981), the barring of women from art academies 'signified their exclusion from power to participate in and determine differently the production of the language of the arts, the meanings, ideologies, and views of the world and social relations of the dominant culture'.[12] Parker and Pollock reiterate the view that women artists were forced to occupy a separate 'sphere' in the art world to men, restricted by the confines of their sex rather than their artistic talents, and mirroring the gender-dividing configuration of the wider world. Women's admission to art institutions provided them with access in 1860 to the RA Schools and the Slade from its foundation in 1871. The Slade was founded in circumstances of widely felt dissatisfaction with contemporary teaching methods.[13] Along with the RA Schools, the Slade was free from the often restricting regulations of Cole's state system and benefited from the sound financing that private schools often lacked. The School's affiliation to the University of London also brought additional status. Women attending the Slade during the opening decades of the twentieth century were taught by an all-male staff, a situation that was to remain until 1928 and the appointment of a female assistant teacher, Margaret Alexander.

Sir Edward Poynter (1836–1919), the first Slade Professor from 1871 until 1876, declared at the opening of the Slade that its system of teaching was to be different from that provided at the RA and Royal College of Art Schools. The teaching at the Slade was to follow the path of Continental drawing schools and academies, and was to allow women students to engage with the depiction of the human form. Poynter's inaugural lecture, delivered on 2 October 1871, included 'a vigorous attack on the system at South Kensington [Royal College of Art], where students were required to produce an elaborately stippled drawing from the antique before admission to the School ... drawing with chalk and bread for 6 months or more, learning nothing whatever after the first setting of it out, and becoming quite blind to the original before him'.[14] Poynter declared that: 'It is my desire that in all classes, except of course those for the study of the nude model, the male and female students should work together'.[15] Not until 1893 were women at the Slade granted access to the nude model rather than the draped model. Under Poynter, born in Paris and trained in the studio of Charles Gleyre in Paris (who worked in the strictest traditions of Ingres and the French classicists), teaching methods at the Slade concentrated on drawing and painting from

the model. 'Following the French atelier system, poses were set for about a week from which students were to paint directly, emphasising tone, form and colour'.[16] In Poynter's inaugural lecture, he further stated: 'I shall impress but one lesson upon the students, that constant study from the life-model is the only means they have at arriving at a comprehension of the beauty in nature, and of avoiding its ugliness and deformity, which I take to be the whole aim and end of study'.[17] Life drawing skills were considered both essential and central to the Slade's methods of training students of both sexes. In marked contrast to the Slade, the RA Schools considered that studying from the nude was morally dangerous and women students were banned from the life room. Alison Smith refers to the 'Horsleyana' controversy. On 20 May 1885, *The Times* printed a letter entitled 'A Woman's Plea' and signed by a 'British Matron'. In fact, the letter was penned by J.C. Horsley, treasurer of the RA and its unofficial publicist. Horsley was a long-standing opponent of women studying from the nude due to the problematic issues of gender and morality that accompanied it. In a speech Horsley delivered to the Church Congress in Portsmouth in October 1885, he 'argued that life study was unwomanly and violated Christian principles'.[18] He finished his speech by stating that the RA Schools had recently 'firmly' rejected three applications from female students to study from life.

The Slade had 49 students when it opened its doors in 1871.[19] Between 1912 and 1946, it had three times as many female as male students. The Slade was the first art school to allow women students access to the life model, allowing women to follow the same course of fine art training as men. During their time at the School, all students followed the same schedule: they began their training in the antique room and then progressed to the life room. When they arrived at this last stage, they were segregated, with male and female students working in separate studios and, as previously mentioned, the female students were only allowed to study from a lightly draped male model until 1893. Despite these restraints, by granting female students access to life classes, the Slade was engaging in progressive practice in tune with contemporary debates on the viewing and representation of the nude. The study of the nude reinforced the traditionalist attitude of many at the Slade, given the academic esteem of figure and history painting. The Slade's art training therefore aimed to combine study of the nude with the observation of nature and the study of the Old Masters. The Slade reinstated the Old Master tradition of long and concentrated study of the life model by the production of rapid constructive linear drawings. The Slade's courses of study, during this period, were: Drawing from the Antique and Life; Sculpture; Painting from the Antique and Life; Composition; Perspective and Lectures.

Poynter was supported in his aims at the Slade by Professor Frederick Brown (1851–1941), Henry Tonks (1862–1937) and Philip Wilson Steer (1860–1942). Tonks and Steer, Professor Brown's assistants, were in awe

of the Renaissance Masters, believing that their students could learn much from studying these Masters. Under Tonks and Steer, Slade students were taught within a framework that set Michelangelo and Ingres as the pinnacles of artistic achievement to which modern students could aspire. Tonks, who taught drawing at the Slade from 1892 until 1930 and was Slade Professor between 1918 and 1930, was a formidable presence at the Slade for 38 years. He encouraged his students to 'look back to the Renaissance tradition of accurate but fluent draughtsmanship, and the precise painting of imaginary composition' in order to develop their own talents and stretch their technique.[20] In an essay by Hubert Wellington in Fothergill's *The Slade* (1907), Wellington provides a useful insight into how the work of the Old Masters was utilised by Tonks in his teaching:

> [The Slade's] attitude towards the Old Masters is not one of ceremonies and conventional admiration; it suggests no attempt to bandage the eyes of the student and blind him to what is not to be found in their works. It is rather a love of, and familiarity with, the old work, a habit of living easily with it and constantly referring to it for help in difficulties. Such an attitude produces a stimulating sense of nearness rather than an overwhelming one of distance.[21]

Tonks 'preached the doctrine that drawing is by far the rarest gift necessary to an artist. "You must start with this gift and then cultivate it always," he would say. "There is no drawing without tears"'.[22] Tonks taught the students how to draw by both the example of the Old Masters and the anatomy of the body. Prior to his appointment as Assistant Professor in 1892, he had been a surgeon and Demonstrator in Anatomy at London Hospital Medical School. His prior training in anatomical drawing formed the basis of his approach as both artist and teacher. Under him, students were encouraged to study techniques from Old Master prints and drawings in the British Museum, the National Gallery and University College London's collections. Students served their apprenticeship under Tonks drawing Michelangelo's *Dying Slave* (1513–16) or the Greek sculpture of *The Discobolus* (discus thrower) (c.460–450 BC) 'until judged sufficiently advanced to draw from life'.[23] Only with his permission could students move on to full-time study in the Life Room.[24]

Poynter's professorship was followed by that of Alphonse Legros (1837–1911), Slade Professor from 1876 to 1892. According to A.S. Hartrick (1864–1950), who was a student at the Slade under Legros in 1884–5, Legros' method, 'teaching drawing based on that of the old Italian masters … is the best, if not the only one for the proper training of a student'.[25] Both Poynter and Legros made drawing the key skill for their education programmes and both took from their experiences in Paris ateliers the essential of drawing from life.[26] In Paris, Legros had attended the drawing school of Lecoq de Boisbaudran (the *Petite Ecole*) and evening classes of the Ecole des Beaux Arts. A skilled draughtsman, he gave regular demonstrations to the students of painting a

model's head at great speed. The method of working that he demonstrated had been used for centuries by European portrait painters, but was new to his British students, who were used to labouring for months on each of their drawings.[27] Legros believed in the copying of the Old Masters; on the school's walls he framed a collection of full-sized photographs of drawings by Raphael, Leonardo and Michelangelo. He also recommended travelling scholarships for students to enable them to study and copy the technique of masterpieces in European art collections.

For women artists in the last decades of the nineteenth century and the first decades of the twentieth century, foreign travel was open only to those with both parental agreement and the financial funds. At the end of the nineteenth century, Elizabeth Thompson (1846–1933) went to Italy and Louise Jopling (1843–1933) to Paris. Anna Lea Merritt (1844–1930) travelled to Europe in the 1860s and was tutored in Dresden, Florence and Paris. Alison Smith states that for women artists, 'Studying abroad represented a bid for independence in the 1850s: however, by the 1870s a foreign education became more socially acceptable, especially as tutors were able to command higher fees from women'.[28] A foreign education allowed women to engage with the works of the Old Masters on the Continent, but for those Slade women students who were unable to travel, the Slade's teaching methods would have opened another door in their art education.

The Slade arguably had its finest period following Legros' professorship during the long tenure of Frederick Brown from 1892 until the outbreak of the First World War. Brown was a strongly committed educationalist who had already successfully built up the Westminster School of Art. He had also helped to found the New English Art Club (NEAC) in 1886 as an alternative exhibition ground to the stuffiness and closed-shop atmosphere of the Academy. Brown, Tonks and Steer were the members of the NEAC who formed the teaching staff of the Slade. Brown 'has always been the backbone of the revolt against the Academy, first in the New English Art Club, and later at the Slade School, and has insisted on an intelligent teaching of drawing and painting'.[29] The NEAC was 'unquestionably the most vital artistic movement in English painting of the last half-century; one which has put new life into the teaching in art schools, the administration of public galleries, and has even affected that stronghold of tradition, the Royal Academy'.[30] The NEAC first arose as an idea in 1885 among a group of painters who had all studied in Paris and wished to form a society with an elective jury along the lines of the Salon. Moreover, the NEAC provided an exhibiting outlet for Slade students, and by 1900 the NEAC had become the Slade's 'unofficial shop window to the world'.[31] Despite this avant-garde attitude, the NEAC still represented a potential obstacle to female education, for as Vanessa Bell (1879–1961), a graduate of the Slade and an exhibitor at the NEAC, described the situation, she had to be prepared to remain 'silent and afraid' amongst the NEAC's exclusively male leadership.

Yet there was some cause for optimism. Brown did much to reform teaching practices at the Slade, ordering that all staff be working artists, and encouraged an individualistic approach to student practice. From 1895, he allowed women to draw from the nude model in a separate life room, following from the precedent he had set at Westminster. Women students at the Slade were taught in separate overcrowded life rooms until 1946. The overcrowded accommodation and situation in which female Slade students were taught are recounted by Michael Reynolds a student at the Slade during the 1920s:

> The girls were the chief sufferers; there were many more girls than men, and their life and painting rooms were crammed – new girls had to spend two or three terms in the Antique waiting for a vacancy ... the men seldom spent more than one term there ... Professor Tonks – who, if not a woman-hater, had no doubt of the superiority of his own sex – sometimes admitted older men to the life room without any probationary period.[32]

Michael Reynolds' view of Tonks as a misogynist is not only repeated in numerous accounts but also finds support in anecdotal evidence; allegedly Tonks remarked to one woman student 'Your paper is crooked, your pencil is blunt. And now you are crying, and you haven't got a handkerchief!'.[33] However, Tonks' biographer Joseph Hone writes that Tonks found 'girls are easier to teach and make quicker progress than men'.[34]

In *Modern Painting in England* (1936), Mary Chamot (1899–1993), Assistant Keeper at the Tate Gallery from 1949 to 1965, stated that Professor Brown gave greater encouragement to women students than they had received before, 'with the result that some excellent works were produced'.[35] An important art historian and museum curator, Chamot had studied at the Slade, gaining her Fine Art Diploma in 1922. After leaving the Slade, she worked as an occasional relief lecturer at the National Gallery (1922–4) and at the Victoria and Albert Museum (1924–39), and as an Extension (extra-mural) Lecturer for the University of London.[36] Chamot's days at the Slade introduced her to a wide circle of artist friends, including Stanley and Gilbert Spencer, Edward Bawden and Jim Ede, who would visit her at the Tate.[37] In the preface to *Modern Painting in England*, Chamot explained how most books on modern art up until that point dealt mainly with the French school, omitting English painting altogether or only dealing with a few artists incidentally.[38] Yet the distinctive feature of this book was its inclusion of a relatively high proportion of women artists: there are 43 women among the 271 artists included in the biographical index.[39]

In his first year as Slade Professor (1892), Brown created a new Slade painting prize, the Summer Composition Competition Prize, which became the most prestigious of the prizes awarded to students at the Slade. Students were given the title of the work at the beginning of the summer holiday and were tasked

with executing a large-scale, multi-figure composition of a subject from history or literature over the course of the summer. Herbert Wellington's essay 'The Slade School Summer Composition since 1893' in *The Slade* of 1907 gives a contemporary view of the prize's aims: 'The painting of a figure composition based on a given subject is the final test of accomplishment in nearly every school of art ... In such a work a student may display all that he has learnt in the school, and elsewhere, of drawing and painting from life, of the setting of figures in space, of the design and construction of a picture'.[40] In 1897, Edna Waugh won second prize for the Summer Composition Competition with her *Rape of the Sabine Women*. One of the first women artists to distinguish herself at the Slade under Frederick Brown's professorship, Waugh (1879–1979) (later Lady Edna Hall Clarke) was described by Henry Tonks as 'a kind of child prodigy' when she entered the Slade at the age of 14, studying at the Slade for four years.[41] According to Mary Chamot, Waugh's early drawings, 'done with a firm line and cross-hatched in the manner of Michelangelo, are remarkably full of vitality'.[42] Reflecting on the prize-winners of 1897, Wellington described Waugh's watercolour composition as having 'a freshness of conception, with a freedom and enjoyment in the carrying out, both delightful and unusual in a competition on a set subject'. Slade students were encouraged to forge their own path, as Joseph Hone, Tonks' biographer, notes: 'The standpoint of the Slade school is non-academic and individual, but its training is no less thorough and searching than the traditional and academic'.[43] First prize for the 1897 competition was won by Maxwell Balfour; the work is praised by Wellington as 'extremely thoughtful and thorough working out of the theme. The treatment, composition and scheme of colour are largely based on the Old Masters, the influence of Rubens and Van Dyke predominating'.[44] Fothergill goes on to state that Edna Waugh's 'composition is not so complete, not so logically subordinated to a general scheme, as Mr. Balfour's, but the groups are full of "go" and of great variety'.[45] Whether this was a case of gender prejudice in action is doubtful, as Fothergill looked at both works by Balfour and Waugh in terms of the Slade tradition, not the individual or their sex. The success of Waugh's work at the Slade may account for it being illustrated in *The Quarto*, 4(8) (1898) and why in Fothergill's publication *The Slade*, he includes a chapter written by her sister, Rosa Waugh, alongside chapters written by male artists, including Augustus John and William Orpen.

Edna Waugh was part of a large group of women students who trained at the Slade between 1895 and 1899, which also included Gwen John (1876–1939). During the years that John attended the Slade, five out of the seven Slade Scholarships awarded were given to women students.[46] In 1872 the Slade introduced its first two scholarships, both won by women, Miss E.M. Wild and Miss B.A.R. Spencer.[47] Gwen John and Edna Waugh attended the Slade at a time which Augustus John, Gwen's younger brother, described as 'the Grand Epoch of the Slade', but while the 'male students cut a poor figure ... In talent,

as well as in looks, the girls were supreme. But these advantages for the most part came to nought under the burdens of domesticity'.[48] At that time, it was still assumed that if a woman artist married, she would have to give up her painting career: both Ida Nettleship and Stella Bowen, Slade contemporaries of John and Waugh, relinquished painting after their marriages to Augustus John and Ford Madox Ford respectively. Gwen John never married; in 1904 she moved to France, living first in Paris and then in Meudon, where she lived and painted for the rest of her life.

Gwen John's *Self-Portrait* (c.1900) in the National Portrait Gallery, produced during her time as a student at the Slade, is a particularly important painting because it is one of the few student works produced by a woman at the Slade during this period to have survived.[49] John's self-portrait illustrates well the Slade training she received and the study of the Old Masters that formed part of her training. The work makes use of the conventions of Old Master portraits, but also creates an alternative femininity to the highly decorative images of women created by other artists of the 1890s. Her use of a half-length portrait format and the pose she has adopted reflect her awareness and knowledge of a long line of male artist self-portraits, notably Rembrandt's *Self-portrait aged Thirty-Four* (1640) at the National Gallery. In 1899 the RA and print room of the British Museum both held exhibitions of Rembrandt's work, arousing keen interest in his work at the Slade, and the fact that this was an inspiration to Gwen John is proven by her name appearing in the National Gallery's *Copyists Register 1901–1946*. John's portrait in its pose and composition also highlights her awareness of portraits by Van Dyck and Velazquez, whose work she would have been encouraged to visit at art galleries and copy. She also learned the methods of the Old Masters from Augustus John's friend, Ambrose McEvoy:

> From McEvoy she learned the painstaking method of building up colour in glazes, picking out the lights and dark; unifying them with a colour glaze, then layering up the paint with further tones and glazes. This way, brush strokes were not in and of themselves part of the painting, but served to contribute to the build-up of colour.[50]

In *Self-Portrait*, John stands with her gaze fixed on the viewer, her right hand resting on the belt of her black skirt, her brownish pink blouse with billowing sleeves tied at the neck with a large black bow. The resulting image is a strong and uncompromising image of her as an artist. Her self-portrait follows in the tradition of a male artist's self-portrait; she has used the tradition of male artistic self-representation to execute her self-portrait as a woman artist.

Gwen John's awareness and knowledge of the Old Masters, highlighted in her self-portrait, would have been broadened by her attendance at the Slade's history of art lectures. History of art was taught to Slade students from the School's foundation, albeit on an ad hoc basis. This was not an exceptional

situation – art theory was also taught to all students at the RA Schools. It was also reinforced by the access to art history texts that women students at the Slade would have had at both the library of University College London and public libraries. At the beginning of the twentieth century, notable figures were teaching art history at the school. From 1903, D.S. MacColl (1859–1948) gave art history lectures at the Slade. MacColl was a British exponent of French impressionism and in the year before he started teaching at the Slade, he wrote *Nineteenth Century Art* (1902), a survey of the painting of that century and one of the first works to place French impressionism in context. In 1901 MacColl gave Impressionism its first British retrospective at the 1900 Glasgow Exhibition. Such early writings praised the Modernist artists of French impressionists and the English followers. MacColl went on to become Keeper at the Tate Gallery from 1906 to 1911; renowned for his attacks on the art establishment, he took the initiative in reforming the administration of the Chantrey Bequest so that representative works by painters outside the Academy might be purchased, including works by Slade teachers and students such as Augustus John.[51] In 1909, Roger Fry succeeded MacColl as a visiting lecturer at the Slade to teach a course entitled 'The Appreciation of Design in the History of Art', which encouraged Slade students 'to think about Cezanne as much as the early Italian Masters'.[52] Fry gave weekly lectures on Italian art, including subject matter like the Florentines Giotto and Fra Angelico, the Venetians Titian and Tintoretto, the Roman Piero di Cosimo and the Umbrian Piero della Francesca. In the closing years of the nineteenth century, Fry had established his reputation as a scholar of Italian art by producing an early monograph on *Bellini* (1899). In 1894 he despaired of ever finding in modern art the logical coherence that he had witnessed in early Italian painting, writing to his father 'the more I study the Old Masters the more terrible does the chaos of modern art seem to me'.[53] Nevertheless, by the time he commenced teaching art history at the Slade, he had begun to find a way to understand modern art through the work of Cezanne, Gauguin, Van Gogh, Matisse and Picasso. Between 1913 and 1914, he lectured at the Slade on subjects as 'inflammatory' as 'The Problem of Representation and Abstract Form' and 'Elements of Abstract Design'.[54] In a letter of 1912 to the author Gerald Brennan, Dora Carrington (1893–1932), who was a Slade student between 1910 and 1914, wrote about Fry's series of lectures: 'Tracing the development of design, and "significant form" in painting. He has amazing slides. Giotto and the Sienese school. He always shows one a great many that one has never seen before … Roger's lectures (on the Italian pictures) have inspired me to start some big compositions. Suddenly reviewing my last year's work it seems disgracefully amateurish and "little"'.[55] In 1912, midway through her time at the Slade, Carrington produced a work entitled *Female Figure Lying on her Back* (UCL Art Collection), which won second prize in the Slade's life painting competition of the same year. The painting demonstrates

well that drawing and painting from the life model and the study of the stylistic concerns and palette of the Old Masters were at the heart of the Slade's curriculum at this time and hugely influential on the practice of the female as well as male students.

The year after his appointment at the Slade, Fry challenged Tonks' and Steer's emulation of the Old Masters by mounting the exhibition of 'Manet and the Post-Impressionists' at the Grafton Gallery. For Fry, the early Italian artists now had modern counterparts. Indeed, it was Fry's understanding and knowledge of early Italian art that laid the foundations for his advocacy of the developments in French painting in the early twentieth century, a development he designated as 'Post-Impressionism'. In 1912 came the Italian Futurists at the Sackville Gallery, to be followed by Fry's 'Second Post-Impressionist Exhibition' at the Grafton Gallery with its emphasis now on Cubism and its inclusion of English artists. Following the opening of the first exhibition in 1910 and the second exhibition in 1912, Slade tutors 'found themselves fighting an unsuccessful rearguard action against Post-Impressionism'.[56] Paul Nash (1889–1946), a student of the Slade in 1910–1911, wrote:

> The Slade was then seething under the influence of Post-Impressionism. The professors did not like it at all ... Tonks made one of his speeches and appealed, in so many words, to our sporting instincts ... he could only warn us and say how very much better pleased he would be if we did not risk contamination but stayed away [from the Second Post-Impressionist Exhibition].[57]

Tonks took a firm stand against Fry; he 'decided to be damned with Steer, Turner and Ford Madox Brown than go to heaven with Fry, Matisse and Picasso'.[58] Tonks, Brown and Steer exerted their influence to try and dissuade Slade students from visiting the exhibitions and 'catching the virus of the new art', and Tonks referred to the Post-Impressionists as 'the Roger Fry rabble' and a 'contamination'. Fry's fellow Slade teachers chose not to incorporate the ideas of Post-Impressionism into their teaching; indeed, during the time that William Roberts (1895–1980) attended the Slade in 1910–1913, there was a 'time-honoured notion that would-be professional artists could only hope to achieve anything of real value by emulating the Old Masters'.[59] Students of Roberts' generation at the Slade were obliged as Sketch Club projects to deal with subjects drawn from the Old Masters by way of exercise.[60] But as hard as Tonks and his fellow Slade tutors tried to resist the idea, during the years 1910–1912, the terms of reference for modern art were being radically altered for a whole generation of younger artists by Fry's Post-Impressionist exhibitions. Alongside Carrington's admiration for the Italian masters, the Post-Impressionist Cezanne was a particular star. Carrington and fellow Slade student Mark Gertler (1891–1939) bought postcards of Cezanne's work from the British Museum to study in detail. However, Carrington's admiration for

the French Post-Impressionists did not last and in a letter to Lytton Stratchey
dated 27 April 1925, she wrote:

> I could write you a long letter on the modern French painters. Really they
> filled me with an unspeakable rage. They are fifty times worse, I think, than
> any other painters, English or German. Because they are morally wicked,
> being charlatans, cheats and imitators and outwardly they produce hideous,
> vulgar pictures ... I shall be interested to hear what Roger and Clive have to
> say on these most modern monsters when they come back.[61]

Tonks sought to counteract the growing interest in Fry's revolutionary
message by promoting decorative painting and its sister mural painting,
which sought to denote 'subject matter removed from everyday life and given
a classical or primitive treatment'.[62] Women were to play an important role in
its revival, especially at the Slade. Tonks was convinced that by encouraging
artists to work on large-scale decorative painting, the modern artist would be
kept in touch with the traditions of the Renaissance. The increasing interest
in 'decorative painting' in Britain at the turn of the twentieth century was
promoted by the formation in 1901 of the Society of Painters in Tempera,
amalgamating with the newly formed Mural Decorators' Society in 1912.
According to Mary Sargant-Florence (1857–1954): 'It was no longer a question
of egg-tempera versus oil medium but the consideration of all known
media other than oil by practical tests founded on intimate knowledge of
the raw material'.[63] Mural painting as a distinct art form began to receive
a new 'impetus' in 1881, when a prize for mural decoration at the Royal
Academy was introduced. In 1901 the Royal College of Art established its
own Decorative Painting School. The Slade followed shortly afterwards,
introducing Decorative Painting into its curriculum. A member of the Society
of Painters in Tempera, Sargant-Florence had also been a distinguished pupil
under Legros at the Slade and returned under Brown to lecture on fresco and
tempera painting. The Slade School's enthusiasm for mural painting reflected
its desirability as an important training tool for students. Mural painting
offered art students the chance to design on a large scale, using techniques
and media other than oil on canvas, and also the chance of public service,
serving a useful role within society. The campaign undertaken by the Society
of Mural Decorators and Painters in Tempera was not fought in vain. In the
period 1900–1935, some of the best British painters, including Slade alumni,
were decorating the walls of both public and private buildings. The increase
in numbers of both educational and welfare murals in Britain during the first
decades of the twentieth century reflects the considerable efforts of art schools
to train artists in mural painting.[64]

In the summer of 1913, Dora Carrington (about to begin her final year at
the Slade) and her fellow Slade student Constance Lance (1892–1944) were
invited by Lord Brownlow to paint a fresco cycle on the library walls at

Brownlow Hall.[65] Carrington and Lance were both interested in the technique that produced Giotto's works in Padua and Florence and Michelangelo's Sistine Chapel ceiling. Carrington wrote to her friend John Nash (1893–1977): 'Lance and me feel like great masters controlling this band of men and having the big wall to cover with our works of art. Fresco painting is awfully hard all this afternoon I have been struggling to learn'.[66] Nash and Carrington shared a love of English landscape and he helped to turn her away from the Post-Impressionists, asking in 1914: 'What is Cubism or anything else to nature?'[67]

In 1914 Fry was succeeded as art history lecturer at the Slade by the Italian Renaissance scholar Tancred Borenius (1885–1947), who was known as the 'Flying Finn'. Gilbert Spencer believed that Tonks' anger at Fry for including Stanley Spencer's painting *John Donne Arriving in Heaven* (1911) in the Second Post-Impressionist Exhibition contributed to Fry's departure from the Slade. Tonks was able to convert an endowment left by Sir Edwin Durning-Lawrence into a chair in the History of Art, and Borenius became its first occupant in 1922. Writing some of his most well-regarded texts during this period, including *Florentine frescoes* (1930), Borenius remaining in the post until his death in 1947. Tonks gathered around him a group of like-minded individuals following his ascension to the Slade professorship in 1918, a position gained on Brown's retirement.

As Slade Professor, Tonks held the work of his female students in high regard. His biographer Joseph Hone notes: 'A marked side of him was an intense interest in feminine aspirants after art, and a considerable belief in women's power of achievement'.[68] David Boyd Haycock believes that Tonks was 'intrigued by women', an interest that was 'first kindled' when he saw nurses at their Christmas concert whilst he was a medical student at Brighton: 'For the first time I seemed to understand the beauty of women, set off, as it was, by their neat hospital uniform. The change in my life was complete'.[69] It appears that Tonks' esteem for the art of women students was based on purely personal reasons rather than on political or philosophical ones.

One of the most promising female students taught by Tonks at the Slade was Winifred Knights (1899–1947). Knights studied at the Slade under both Brown and Tonks in 1915–17 and 1918–20. During the beginning of Tonks' tenure as Slade Professor in 1919 and as a Slade scholar, Winifred Knights won the Summer Composition Competition with *A Scene in a Village Street with Millhands Conversing* executed in tempera on canvas. The work used the conventions of decorative painting, characterised by the use of colour and composition primarily for aesthetic effect, rather than subordinated to narrative and realistic depiction.[70] Her use of the conventions of decorative painting in this work led in the following year to her becoming the first woman to win the prestigious government-funded Rome Scholarship in Decorative Painting with *The Deluge* (Tate Gallery), a subject prescribed for the competition which was in many ways similar to the Slade Summer

Composition Competition; the Scholarship rules required that a painting was produced in oil or tempera six foot by five foot, together with a cartoon, both of which were to be executed within eight weeks.

The British School at Rome, founded in 1901, placed stress upon Decorative Painting and the study of Renaissance murals in Italy. Building on the importance of Italy as a destination for artists, scholars and connoisseurs in the eighteenth and nineteenth centuries, the British School at Rome provided the means for students and academics to benefit from lengthy exposure to Italian art and architecture. The foundation of Rome Scholarships in Architecture, Painting and Sculpture in 1912 coincided with a recognisable need for state patronage of the arts, and engraving was added in 1921. At this time, Tonks was Honorary Secretary to the Board of the British School at Rome, which managed the Rome Scholarships. In a letter to a friend, he stated his belief that 'Italy up to near the end of the sixteenth century will always be the best school for all those who want to learn what drawing can explain'.[71] For students, the 'close encounter with Italian art and architecture was intended to complement and extend their artistic training'.[72] During her time at the British School in Rome, Winifred Knights took an impromptu visit to Arezzo to view the revered frescoes by Piero della Francesca: 'These paintings had a special appeal for a generation of students who were looking for "decorative" qualities verging on the abstract, and a certain detachment from the subject matter' – inspirational material for a student's development.[73] She executed *Italian Landscape* in 1921 (Tate Collection) whilst at the British School. Her husband, Thomas Monnington, wrote on 13 May 1958 that *Italian Landscape* is a view of the Tiber from the outskirts of Rome to the north.[74]

The effect of Tonks' enthusiasm for Italian art and the work of the Old Masters upon women students at the Slade during his professorship are further illustrated by Clara Klinghoffer's work. Klinghoffer (1900–1970) studied at the Slade from 1919 until 1921, at the very beginning of Tonks' professorship. Chamot wrote that Klinghoffer's 'drawings were comparable to the great Italian masters'.[75] By the tender age of 19, Klinghoffer was receiving critical praise: the *Daily Telegraph* stated that she was able to 'draw like Raphael' and 'must be regarded as a new star. Her work is strongly individualistic and original, her point of view strictly her own, her power great. If she elects to do a thing it is done with masterful force'.[76] Her *Rose, with Mortar and Pestle* (1919), oil on canvas, produced whilst attending the Slade, depicts one of her six sisters and a favourite model of Jacob Epstein. Epstein wrote of her as 'an artist of great talent – a painter and draughtsman of the first order'.[77] Her work produced during her studentship at the Slade helps to illustrate the powerful influence of Tonks as an advocate of the Old Masters when the New Masters promoted by Roger Fry were in the ascendancy.

This chapter has shown how female art students admitted to the Slade between 1871 and 1930 were exposed and reacted to the artistic heritage of the Old Masters through their art school training. This highlights the influence

that the Old Masters had over the curricula that female art students were taught and shows how the teaching they received was translated into their work. This chapter has examined how the teachings of the Old Masters, as a pinnacle of artistic achievement, were challenged by Roger Fry and the New Masters of Post-Impressionism, and the effect this challenge had on the outlook and work of female art students at the Slade. By seeking to investigate and understand the influences exerted upon female art students, the chapter demonstrates that women negotiated the male-dominated traditions of the past by learning from the Masters, Old and New alike.

Notes

1 Roger Fry, *Reflections on British Painting* (London: Faber & Faber, 1934), p. 18.

2 John Cordy Jefferson, 'Female Artists and Art-Schools of England', in *Art Pictorial and Industrial* (London: Sampson Low, Martson Low, and Searle, 1870), p. 52.

3 Alison Smith, *The Victorian Nude: Sexuality, Morality, and Art* (Manchester: Manchester University Press, 1996), p. 42.

4 G.D. Leslie, *The Inner Life of The Royal Academy: With an account of its schools and exhibitions principally in the reign of Queen Victoria* (London: John Murray, 1914), p. 42.

5 Ibid.

6 Patricia Zakreski, *Representing Female Artistic Labour, 1848–1890: Refining Work for the Middle-Class Woman* (Aldershot: Ashgate, 2006), p. 88.

7 Smith, *The Victorian Nude*, p. 43.

8 Leslie, *The Inner Life of The Royal Academy*, p. 49.

9 Tarnya Cooper (ed.), *Drawing Practices, Mediums and Methods 1500–1950*, Exhibition Catalogue, Strang Print Room (London: UCL, 10 May–16 June 2000), p. 50.

10 Carl Goldstein, *Teaching Art: Academies and Schools of Art from Vasari to Albers* (Cambridge: Cambridge University Press, 1996), p. 62.

11 Liz Rideal, *Mirror Mirror: Self Portraits by Women Artists* (London: National Portrait Gallery, 2001), p. 24.

12 Rozsika Parker and Griselda Pollock (eds), *Old Mistresses: Women, Art and Ideology* (London: Routledge & Kegan Paul, 1981), p. 49.

13 Stuart Macdonald, *The History and Philosophy of Art Education* (London: University of London Press, 1970), p. 270.

14 John Fothergill (ed.), *The Slade: A Collection of Drawings and Some Pictures Done by Past and Present Students of the London Slade School of Art 1893–1907* (London: Slade School of Fine Art, 1907), pp. 5–6.

15 Ibid., p. 6.

16 Smith, *The Victorian Nude*, p. 190.

17 Fothergill, *The Slade*, p. 7.

18 Smith, *The Victorian Nude*, p. 228.

19 *Report of the Council*, 28 February 1872, UCL Archives, p. 16.

20 A. Powers, 'Honesty of Purpose', *Country Life*, 27 February 1986, pp. 512–14, at p. 512.

21 Fothergill, *The Slade*, p. 22.

22 Joseph Hone, *The Life of Henry Tonks* (London: William Heinemann Ltd., 1939), p. 172.

23 Jane Hill, *The Art of Dora Carrington* (London: Herbert Press, 1994), p. 13.

24 David Boyd Haycock, *A Crisis of Brilliance* (London: Old Street Publishing, 2009), p. 28.

25 Macdonald, *History and Philosophy of Art Education*, p. 277.

26 Ruth Artmonsky, *Slade Alumni 1900–1914 William Roberts & Others* (London: Artmonsky Arts, 2001), p. 2.

27 Ibid., p. 271.

28 Smith, *The Victorian Nude*, p. 44.

29 Mary Chamot, *Modern Painting in England* (London: Country Life Ltd., 1937), p. 37.

30 Ibid., p. 28.

31 Simon Watney, *English Post-Impressionism: 1930–1939* (London: Studio Vista, 1980), p. 26.

32 Michael Reynolds, 'The Slade: The Story of an Art School, 1871–1971' (University of London, Slade School of Fine Art Archives, unpublished), p. 271.

33 Artmonsky, *Slade Alumni*, p. 8.

34 Hone, *The Life of Henry Tonks*, p. 25.

35 Chamot, *Modern Painting in England*, p. 64.

36 D. Farr, 'Obituary: Mary Chamot', *The Independent*, 17 May 1993.

37 Ibid.

38 Chamot, *Modern Painting in England*, p. 5.

39 Katy Deepwell, *Women Artists between the Wars: 'A Fair Field and No Favour'* (Manchester: Manchester University Press, 2010).

40 H. Wellington, 'The Slade Summer Composition since 1893', in Fothergill (ed.), *The Slade*, p. 21. See also Emma Chambers, 'Redefining History Painting in the Academy: The Summer Composition Competition at the Slade School of Fine Art, 1898–1922', *Visual Culture in Britain*, 6(1) (2005).

41 Hone, *The Life of Henry Tonks*, p. 72.

42 Chamot, *Modern Painting in England*, p. 64.

43 Hone, *The Life of Henry Tonks*, p. 22.

44 Fothergill, *The Slade*, p. 23.

45 Ibid.

46 University College London Archive: Calendar and Session Book, 1896–7 and 1898–9.

47 Reynolds, 'The Slade', p. 48.

48 Augustus John, obituary for Lady Smith [Gwen Salmond], *The Times*, 1 February 1958, quoted in David Fraser Jenkins and Chris Stephens (eds), *Gwen John and Augustus John* (London: Tate, 2004), p. 36.

49 David Peters Corbett and Lara Perry (eds), *English Art 1860–1914: Modernities and Identities* (Manchester: Manchester University Press, 2000), p. 168.

50 Sue Roe, *Gwen John* (London: Vintage, 2002), p. 20.

51 Chamot, *Modern Painting in England*, p. 41.

52 Christopher Green, *Art Made Modern: Roger Fry's Vision of Art* (London: Courtauld Gallery, Courtauld Institute of Art, in association with Merrell Holberton, Publishers, 1999), p. 68.

53 Denys Sutton (ed.), *Letters of Roger Fry* (London: Chatto & Windus, 1972), p. 159.

54 Green, *Art Made Modern*, p. 69.

55 David Garnett (ed.), *Carrington: Letters and Extracts from Her Diaries* (London: Cape, 1970), p. 236.

56 Charles Harrison, *English Art and Modernism 1900–1939* (New Haven, CT: Yale University Press, 1994), p. 65.

57 Paul Nash, *Outline, an Autobiography and Other Writings* (London: Faber, 1949), p. 65.

58 Hone, *The Life of Henry Tonks*, p. 102.

59 Andrew Gibbon Williams, *William Roberts: An English Cubist* (Aldershot: Lund Humphries, 2004), p. 13.

60 The Slade Sketch Club issued a series of titles each month and students worked on compositions which were displayed and criticised at its meeting.

61 Garnett, *Carrington*, p. 316.

62 Alan Powers, 'Decorative Painting in the Early Twentieth Century: A Context for Winifred Knights', in *Winifred Knights 1899–1947* (The Fine Art Society Plc and Paul Liss in association with the British School at Rome, 1995), p. 14.

63 M. Sargant-Florence (ed.), *Papers of the Society of Mural Decorators and Painters in Tempera*, Vol. III, 1925–1935 (Brighton: Dolphin Press, 1936), p. 139.

64 C.A.P. Willsdon, *Mural Painting in Britain 1840–1940: Image and Meaning* (Oxford: Oxford University Press, 2000), p. 256.

65 Boyd Haycock, *A Crisis of Brilliance*, p. 150.

66 Roland Blythe, *First Friends: Paul and Bunty, John and Christine – and Carrington* (Huddersfield: Fleece Press, 1997), p. 38: DC to JN, 1913.

67 Ibid., p. 84: JN to DC, 1914?

68 Hone, *The Life of Henry Tonks*, p. 44.

69 H. Tonks, 'Notes from "Wander Years"', *Artwork*, 5(20) (1929), p. 223.

70 Powers, 'Decorative Painting in the Early Twentieth Century', p. 14.

71 Hone, *The Life of Henry Tonks*, p. 173.

72 Sam Smiles and Stephanie Pratt, *Two-Way Traffic: British and Italian Art 1880–1980* (exhibition catalogue, University of Plymouth, 1996).

73 Canterbury College of Art, *British Artists in Italy: Rome and Abbey Scholars 1920–1980* (Kent County Council, Education Committee, 1985).

74 Mary Chamot, Dennis Farr and Martin Butlin, *The Modern British Paintings, Drawings and Sculpture*, Vol. I, Artists A–L (London: Tate Gallery Catalogues, 1964), p. 364.

75 Chamot, *Modern Painting in England*, p. 98.

76 *Daily Telegraph*, 3 May 1920, p. 26.

77 Jacob Epstein, 30 March 1939; see www.claraklinghoffer.com.

Struggling with the Welsh Masters, 1880–1914

Matthew C. Potter

The history of art education in Wales has been commonly treated as a marginal field in the wider history of British art. Given past 'conventional wisdom that Wales was deficient in the visual arts', it is perhaps unsurprising that little effort has been expended in exploring either the attitudes of artistic leaders in Wales towards the problems of establishing a national school of art or the role education and Welsh masters – 'Old' and new – played within this.[1] The beginnings of official schools of art in Wales are integrally connected to the Government Schools programme established by the Normal School in London in 1837. This evolved into the South Kensington School system in the 1850s and as part of this process, Schools of Art opened nationwide, with the first Welsh institutions appearing in Caernarfon and Swansea in 1853, followed by Cardiff (1865), Newport (1875) and Carmarthen (1880).[2] Alternative initiatives outside this centralised scheme were undertaken elsewhere, such as in the attempted programmes of the Royal Cambrian Academy from 1881 onwards and in the Wrexham School of Science and Art in 1887. In looking at the activities of art educators in Wales during the 35-year period around the turn of the twentieth century, this chapter explores how art history was used to construct a vernacular school to inspire Welsh art students. What were the institutional difficulties that art education faced and how were Welsh Old Masters incorporated into their curricula? What were the main factors that drew Welsh artists to alternative centres of education at this time? How did art-historical perceptions affect the politics of art education generally? The following pages explore how these factors combined in the period from 1880 to 1914 to generate a consciousness of a national school of Welsh art and how art training was seen as a method of preserving artistic traditions for the future professional practice.

The issue of Welsh nationalism has occupied an awkward position within the historiography of Celticism and Britishness, for as Neil Evan writes: 'It is

hard to discuss Wales with the same degree of precision that Irish and Scottish historians have brought to their subjects'.[3] As noted in the Introductory essay, a distinct Welsh national identity (like Celts more generally) originated in opposition to external forces dating back to antiquity and continuing through subsequent Anglo-Saxon, Anglo-Norman (particularly those of Edward I) and Tudor invasions, so that for the last millennium at least, as Gwyn Williams writes: 'What defined the Welsh in the end were the English'.[4] The concept of 'internal colonialism' has been used to describe the hybridised cultural identities created by hegemonic relationships between the core and periphery of nation states. Michael Hechter has profiled how different ethnic groups collide within such nations and the dominant group forces the less powerful one to either assimilate (through 'diffusion') or remain distinct as an initially marginalised but ultimately empowered and assertive sub-group (via 'internal colonisation').[5] Hechter's model has attracted criticism for its tendency towards excessive generalisation and simplification in modelling the Celtic periphery, but, despite its ambition, it is nevertheless appealing to some. In many ways, Hechter's understanding of the 'colonisation' of Wales is predicated on its dependency on a British economic infrastructure (to varying degrees from the status of outright 'colony' to more autonomous 'dependent periphery'), with the cultural performances of an ethnic minority representing a rearguard assertion of alienation within the larger national system. Yet the status of Wales as a colony is suspect: not only is Hechter's use of terminology fast and loose but the conquest and settlement of Wales has been seen by many as an early stage in an otherwise smooth transition (or assimilation) of its social elite, with 'colonial' Wales ultimately ending in the 1707 Act of Union.[6]

Two aspects are raised here regarding Wales: the issue of assimilation (and the creation of a 'tertiary' or synthetic Anglo-Welsh cultural strata) and its status as colonised. The economic facts have been interpreted by many as failing to equate to subordination; unlike other British imperial possessions, South Wales, for example, was a metropolis in and of itself, both in terms of politico-economic power and influence.[7] Furthermore, the connection between Wales and the British Empire was a strong and complex one. Not only was the phrase 'British Empire' itself the invention of a sixteenth-century Welshman (John Dee), but the cultural and economic 'national' renaissance of Wales arguably mixed 'imperial' and 'colonial' experiences.[8] Taking place within an 'accepted British Imperial framework', Welsh stakeholders in the British empire not only provided an important source of professional expertise (especially in engineering, industry and the ministry) but also could empathise with the current victims of metropolitan imperial expansion given their own experience of such matters in times gone by.[9]

Anglicisation was not only a political policy of conquest, but has been especially linked by Marxist historians with the conditions of modernity: a

nation within a nation state, Wales felt the effects of Anglicisation through the twin agency of ideology (transforming 'regional' Welsh legends into 'national' British mythology) and capitalism (Anglo-Scottish imperial mercantilism).[10] The influx of economic migrants, especially to South Wales through industrialisation and urbanisation, further diluted the Welsh-speaking caucus.[11] Unlike in Ireland, where colonisation was arguably a more accurate description of Anglo-Irish Protestant land ownership, Wales' main complaint was over the Anglican Church and, to the majority of its population, Welsh nationalism meant disestablishment.[12] Yet it also incorporated other conservative cultural aspects, for as Alan Butt Philip wrote: 'Welsh nationalism is in many ways a reaction against the forces of industrialization, modernization, and centralization that have swept through Europe'.[13] It might nevertheless be dangerous to discount Welsh nationalism as wholly docile, for in a series of articles in October and November 1886, the journalist Thomas John Hughes, who, interestingly, was based in Pontypridd, South Wales, publicised the oppressed lot of the Welsh farmers and tenants who were subject to excessive rent and tithes by their Tory English landlords. Hughes created a tension in his allusions. He invoked Ireland in order to highlight the comparative pacifying effect of the Welsh Methodist preacher's 'pulpit, but for the dissuasive accents of which the Celt in Wales might have been as retributive and fear-compelling a power as his brother Celt in Ireland', but he also referred to the Welsh claim to the rights of Magna Carta.[14] It must be remembered that these discussions were far from marginal, as when Home Rule was granted to Ireland in 1914, it had been the intention to also extend this to Wales and Scotland.[15] The two distinct forces of economics and culture were thus reinforcing. Despite the general lack of an antagonistic separatist movement, there was a sense in the twentieth century of distinct Welsh and Anglo-Welsh cultural communities. Especially in rural locations, the Welsh-speakers kept apart from the English, and in cities like Cardiff, the 'English' civic life often existed in isolation from social and intellectual spheres.[16] The Anglo-Welsh elite set itself further apart by subscribing to the imperial foreign policy and the Liberal domestic politics of Westminster.[17]

In cultural discourse, the issue of a national artistic school is often tied closely to the foundation of purposeful institutions aimed at both cultivating indigenous talents and generating publicity for the political and economic advantages of art patronage. Welsh art institutions were conspicuous for their limited geographical range of influence. Their focus tended to be extremely localised, based on individual cities that competed amongst each other for a limited number of students. Furthermore the vocational remit and practical bent of the Government School of Design system meant that institutions such as the Cardiff School of Art made no attempt to teach using art history or the Old Masters. This situation generated dissonance rather than resonance in building up a chorus call for a national school. To compare the situation

with the other member nations of the United Kingdom of Great Britain and Ireland for one moment, Wales was the last to establish a 'national' academy: the Royal Academy of Arts (London, 1768), the Royal Hibernian Academy (Dublin, 1823), the Royal Scottish Academy (Edinburgh, 1826) and finally the Royal Cambrian Academy (Conwy, 1881). Whilst the lag time after London can be explained by issues of funding, local politics, and logistics, the fact that Dublin and Edinburgh had sufficient need for a national outlet in the 1820s makes the wait for another 55 years in Wales remarkable, and that it finally occurred in Conwy, not Cardiff as the most populous city of Wales, is all the more noteworthy.

Political economy has a large role to play in the discussion of national schools of art. In Britain the most prominent model for such debates existed in England and had its base in the educational structure of the Royal Academy. Between Joshua Reynolds and Richard Redgrave, the rhetoric moved from eighteenth-century roots in cosmopolitan civic humanism and the utility of educating public taste to the mid-nineteenth-century belief in a national identity represented in artistic practice by naturalism. In Reynolds' eyes, the issue of an English national school (he did not use the term 'British') was effectively moot, for until the creation of the Royal Academy, there was neither cohesion nor sustained effort.[18] Building on the aesthetic values of William Hazlitt, Augustus Welsby Pugin and John Ruskin, the school-building exercise was further codified in *A Century of British Painting* (1866) by Richard Redgrave and his brother Samuel. While they blamed the historical absence of a British School upon the dual effects of the Reformation and the paucity of art historians, they saw its eventual triumph as due not to Reynolds' academic ideals, but rather those of the landscape and genre painters of the 1800–1860 period like J.M.W. Turner and David Wilkie.[19] What is clear is that Old Masters as much as institutions were integral to the success of establishing or charting a discrete School of Art for all the various nations of the British Isles in the period between the 1760s and the 1880s. Yet for the Redgraves, Richard Wilson's Italianate schooling and academic approach, expressing the 'general' as opposed to 'individual', meant that 'he became the first of the great race of landscape painters, who have made English landscape art so pre-eminent in Europe'.[20] Intriguingly in his sole reference to Wilson in the *Discourses*, Reynolds found his art 'too near common nature to admit supernatural objects' when emulating a Claudean manner.[21] Reynolds and the Redgraves were neither interested in Wilson's 'Welshness' nor felt it incongruous to use him in their advocacy of an English or united British school.

Crucially, Wales suffered from a double weakness: institutionally and art historically, it was inchoate rather than under-endowed. Private art schools in Llanelly and Merthyr were often short-lived and generally provided only the most basic of training. Wales was subject to the same division of training between practical mechanical tuition, thought to be adequate and appropriate

to the industrial and commercial activities of nineteenth-century Wales, and the fine art educational programmes which were under-funded. Despite the opening of the Cardiff School of Art in 1865, art education in Wales failed to produce productive institutions to rival those in the rest of the British Isles. A report from the Cardiff-based *Western Mail* in 1886 gives some estimate of the impact of the Government Schools of Design:

> Regarding the general progress of high art in Wales, Colonel Cornwallis West recently gave some interesting statistics bearing upon the departmental branches for the encouragement of science and art established by Government aid. There were five schools with 442 pupils, and of art classes in other schools there were eight with 248 pupils, thus making a grand total of 700 students receiving instruction more or less distinctly artistic. This number was doubtless now increasing, and this showed an awakening interest in art education.[22]

William Cornwallis West (1835–1917) served as Lord-Lieutenant of Denbighshire from 1872 until his death and was Member of Parliament for Denbighshire West between 1885 and 1892. His loyalties to Wales were very much part of wider Liberal developments of the time. A small optimistic elite in Wales were convinced of the necessity of improving art education in Wales, and West (later known as Cornwallis-West) was a key representative of this group. West's wife, Mary Fitzpatrick, known as Patsy, was a former paramour of Edward, Prince of Wales. Subsequent to her marriage to West in 1872, the couple played host to the future king and such socialites as Lillie Langtry at their second home, Newlands Manor, in Lymington, Hampshire.[23] Cultural initiatives were central to this elite set, as their involvement in the Grosvenor Gallery demonstrates. It was no doubt through these connections and his own interest in painting that West developed his involvement in the cultural life of his nation.[24]

In terms of art history, while there were sufficient Welsh Masters for art teachers to point to, they were in fact rarely used; as Peter Jones has written, 'We have been slow to recognise the variety and dignity of our visual traditions'.[25] John Ingamells has identified a threefold problem in the quality of the building blocks for a Welsh national school: first, there is a conspicuous absence of great indigenous painting in Wales from the sixteenth to eighteenth centuries; second, Richard Wilson (1714–82) and his pupil Thomas Jones (1742–1803) were of 'cosmopolitan making'; and, third, as geographical factors conspired to make Wales artistically isolated, only Romantic spirits were attracted before the coming of the railways.[26] Yet even so, at the time of the establishment of the Royal Hibernian and Royal Scottish Academies, even the railways were a long way off: the Chester and Holyhead Railway ran services from Chester through to Bangor from 1848 and through to Holyhead by 1850, and the South Wales Railway (later incorporated into the Great Western Railway) opened between Chepstow and Swansea in 1850 (servicing Cardiff), and reached Haverfordwest in 1854 and Neyland in 1856.

The stimulus of the railway is part of the myth-making of the Cambrian Academy. Jack Shore, for example, cites the ease of travel the rail network introduced as being instrumental in feeding a supply of artists from Wales, Manchester and Liverpool to the artist colonies at Betws-y-coed and the Conwy Valley.[27] The early years of the Cambrian Academy were dogged by the same 'cosmopolitan making' that had characterised the work of Wilson and Jones and crippled the formation of a distinctive indigenous school. The honorary membership of leading London-based academics, including Frederic Leighton, Henry Stacy Marks, John Everett Millais and Lawrence Alma-Tadema, and the display of key English 'modern' masterpieces like Leighton's *Cimabue's Madonna* (1855) and Millais' *Blind Girl* (1856) in 1887 are indicative of the conservative and metropolitan prejudices of the Cambrian Academy's foundational ethos. Furthermore, the itinerancy of its financially-disappointing exhibitions at Llandudno (1881), Rhyl (1883) and Cardiff (in 1884, and at its recently opened University College of South Wales in 1885) before settling finally at Plas Mawr, Conwy, in 1887 was aggravated by the reality of Welsh art practice being split into groups that seldom mixed, located either in North or South Wales.[28]

Receiving its charter in 1883, the Royal Cambrian Academy possessed a self-appointed educational remit from early on. At a meeting of the committee, Edwin A. Norbury explored the rationale for the new institution, and *The Rhyl Journal* reported on the speech.[29] Norbury set out clearly the institution's national scope:

> You are no doubt all aware that the Royal Cambrian Academy has been instituted by the resident artists of Wales to supply a want long felt in the Principality; viz., the holding of annual exhibitions and the establishment of schools on the plan of the Royal Academy Schools, in which the great principles of art may be taught. In fact, the Royal Cambrian Academy is intended to be to Wales what the Royal Scottish Academy is to Scotland, and what the Royal Hibernian Academy is to Ireland. (Hear, hear.)[30]

Norbury drew attention not only to the native beauties of the Welsh landscape but also the undeveloped artistic tastes of the Welsh public. Adopting the broader educational ideals of Reynolds' rhetoric, Norbury believed that the Royal Cambrian Academy would help develop Welsh appreciation for painting to parallel the nation's love of music. In terms of the provision of art education itself, he noted that:

> Technical art is not as yet in much demand in Wales, though I think the Government Schools of Art, in connection with the South Kensington Science and Art Department established in Cardiff, Swansea, Carmarthen, Carnarvon, and elsewhere, may be taken as fair indications that the Welsh are gradually awakening to the necessities of art education.[31]

In his speech, Norbury also addressed four major objections given by the opponents of the Royal Cambrian Academy as the reasons why it would fail: that Wales had no 'eminent painters'; that membership should be restricted to Welsh artists; that there was not a town large enough in North Wales to act as a base for the institution; and that London would be a better market for Welsh art. Answering on behalf of the Council, Norbury stated that the Royal Cambrian Academy would remedy the first of these by encouraging native talent to flower, conceding that: 'There may not be at present any very eminent painter among this limited number, but I think it would be fair to assume that the land which produced Inigo Jones, Owen Jones, Richard Wilson, and John Gibson may be reasonably expected in the fullness of time to bring forth others of a similar calibre'.[32] Art history was an important fuel for firing up a national school, according to the art educational beliefs of Norbury and the Royal Cambrian Academy committee. The issue of nationality was balanced out in his answers to the other charges; not only did he point out that the other Academies in Britain had no bar on members according to their ethnic origins, for 'nationality has little or nothing to do with elections to these Academies', but also that establishing galleries in North Wales for the winter and South Wales in the summer would bring a practical solution to the problems of geographical division and would unite the various Welsh schools in a common project. Their educational remit would be furthered by the establishment of allied institutions and free tuition, for 'Efforts will also be made to form a national collection, a sculpture gallery, and a museum. It is intended that students be admitted by competition, and that when elected that they shall receive their art education free, the members of the academy undertaking their duties of mastership by rotation'.[33] Norbury's rhetoric was also adopted by local politicians. The Mayor of Cardiff, Mr Robert Bird, spoke at the opening of the 1884 exhibition about the ambitions of the Royal Cambrian Academy for 'laying hold of the young and promising talent of Wales, and rightly directing it. It will seek to take up the work at the point where your schools for science and art leave off; that is, there will be established academy schools, where, under the guidance and direction of academicians, the greatest possible quantity of art talent may be developed'.[34] Bird was no doubt prompted by Norbury, for he paraded the same gallery of geniuses (Inigo and Owen Jones, Wilson and Gibson) as proof of Welsh talent.

These noble intentions were difficult to realise. Financial problems due to poor sales at the first four Royal Cambrian Academy exhibitions were aggravated by rivalry with the University College of South Wales, and infighting within the Royal Cambrian Academy committee conspired to obstruct their development of such schemes.[35] A letter dating from autumn 1888, from a member of the Hogarth Club in London, Arthur Bertram Loud, nevertheless drew attention to their failure to deliver.[36] The Hogarth Club was originally set up by Pre-Raphaelites as an alternative artistic forum to

the Royal Academy; as such, the choice of William Hogarth as its namesake was apposite.[37] However, following the cessation of its original configuration in 1861, it was revived in a less confrontational format, with many Associates of the Royal Academy also holding membership of the Hogarth Club and celebrating their appointments with convivial dinners.[38] Writing to the first President of the Royal Cambrian Academy, Henry Clarence Whaite, Loud declared that he had 'heard several people and artists in London lately (in speaking of the Academy) remark that it is strange – calling our Selves an Academy – that there is no provision made for teaching whatever ~~and~~ consequently we do not carry out the proper idea of an Academy and are really no more or less than a body of painters who have come together and mutually hold an exhibition annually'.[39] Loud went on to note:

> the other evening one man here at the [Hogarth] Club thought that even if we only had one room at Plas Mawr devoted to teaching or even a life class with a half dozen pupils that we should be doing something in the right direction and would prevent people observing that we neglected what we ought to do. Of course I feel that you agree as I do also with the idea and now that we are permanently settled at Plas Mawr I write this to ask you whether you think it is time to take some steps in the direction of teaching which of course is the principal duty of an Academy. I feel that the Cambrian Academy was [stabled] and got together with the idea of increasing ~~and educating~~ the appreciation of Art in Wales and amongst the Welsh people and educating them for that purpose.[40]

Loud felt that the main problem was the expense involved, but if several Academicians were to offer to shoulder the duties for a month, in exchange for a small payment, then 'it is quite possible to have the educational department of the Academy fairly started which I consider would do more than anything to advance the position of the Academy'. Loud believed the scope of teaching could extend well beyond the previous limits of the life class, for: 'Amongst the members I think it ought to be possible to provide teaching in all branches and I think ~~I have~~ there are several members now who have gone through a course of Academic study which would enable them to attend to that division'.[41]

It was perhaps in response to such inquiries that Edwin Norbury wrote to Whaite with an 'Outline of suggested School Scheme', in which he sketched 'the object of enlarging the scope of the Academy's usefulness by making it in every sense a National Institution; it is proposed that like its Sister Institutions the R.A. the R.H.A. & the R.S.A. it should as soon as possible open schools for the instruction of High Art'.[42] Interesting features of the proposal, which was presumably based on the discussions of the Royal Cambrian Academy committee, were the resolution to provide facilities 'particularly for teaching landscape painting' and to charge fees for instruction in the 'absence of any Educational endowment'. It also proposed the creation of professors of landscape and figure painting, to receive two-thirds of the collected fees as

remuneration, but, more significantly, also suggested that the Royal Cambrian Academy should be given control of the 'National System of Examination in Elementary Art similar to systems of South Kensington & Oxford & Cambridge', establishing tests not only for admission to the Royal Cambrian Academy's new schools (trees or perspective studies for the 'Landscape School' and anatomical or cast studies for the 'Antique & Life School') but also 'Local Exams in Second Grade Freehand, Model, Geometric, and Perspective drawing' for local towns and their art schools.[43] The battle for bureaucratic dominance still raged over the examinations system, as is revealed by letters between members of the Royal Cambrian Academy committee in November 1890. At this time they also pushed to take over the administration of the Carnarvon School of Art, following the death of its master, John Cambrian Rowland (who was formerly the Drawing Master at the North Wales Training College in Caernarfon and had been in post since the creation of the Government School of Science & Art in 1853).[44] It is also clear that Norbury was partially responding to opportunities arising from local governmental educational reforms; he referred to the 'New act' in writing to Whaite on 31 December 1890, for example.[45] The plans were evidently circulated amongst the Royal Cambrian Academicians. Quoting key sections from the plan, one of them, Charles Jones (1836–92), a London-based painter of pastoral landscapes predominantly with sheep, wrote in support of the scheme:

> I think in many respects the plan proposed by Mr Norbury is one to be recommended. And I am very sorry not to be with the Meeting tomorrow. I should much like to have been but cannot possibly manage it. I think the plan good in this one respect 'that it will keep all the schools of Wales in touch with the R.C.A.' – so that in time to come when we a school established of our own at the Academy of Wales (which I trust will be the case before many years are gone) we shall have to do 'with a great deal better class of students'. There is one thing I should like to mention. It is this. That before any certificates are given to successful candidates they should be compelled to do probation work as is the case in the 'Royal Academy' before the Applicant becomes a pupil of the Academy. 'All the different schools send their drawings and the R.A.s decide on them. And those who are selected have two months allowed them, to do certain things, under the eyes of the R.A.s themselves'. Now this is an important thing, otherwise: 'how are we to know the Student really did the drawings submitted in his name'. I do not see this point mentioned in the circular, and therefore thought it best to mention it myself. If you think well of my remarks you might mention them, at the meeting. I almost wish we could have waited until we have our own schools and the 'the affair could have been arranged, as it is in London, when all the schools submit their drawings for competition'.[46]

In his Presidential report for 1889, Whaite recognised that:

> The question of teaching is a matter of very great importance for the consideration of the members and one which I must confess has given me

a great deal of anxiety and consideration. I am not prepared at the present moment to lay a complete scheme before you but only throw out a few suggestions for your consideration. – Calling ourselves, as we do, an Academy I feel we ought at least to show that we have some right to that name by giving instruction in Art, and spreading a love for it throughout the Principality.[47]

Whaite suggested using spare attic space at Plas Mawr to hold life study classes for which they should advertise for pupils. Crucially, he felt that more ambitious programmes were simply impractical in a town the size of Conwy, as it could draw neither sufficient staff nor students.

A Schools Committee was formed at the suggestion of Whaite. Even though large Academy schools were not established, some understanding of the level of art class provision and the obstacles faced by the Royal Cambrian Academy can be gained from the reports and correspondence generated. A two-hour weekly life class, led by Norbury and J. Cuthbert Salmon, was finally established in December 1889.[48] This was, however, a cause of great disappointment and reinforced the previous conclusions of Whaite, for it was 'a complete failure for only one has joined and he was not one who signed the petition'.[49] A resolution to reduce the price and offer a half-fee for artisans was passed. However, this did not result in any change of circumstances. While the member classes for 1890 were well attended, the classes for students were again a failure.[50] By 1891, advertising and changes of times still failed to attract more than two students (ten was decided on as the critical number for them to be continued) and perhaps even worse as an indicator of the Royal Cambrian Academy's resolve, the members were now failing to attend their own classes; Whaite reported his dissatisfaction with 'our schools and classes for our very name (Academy) indicates we are a teaching body – and the matter we are about to apply for lays great stress upon this point which makes me anxious about its success'.[51] In 1893 the general class was cancelled, and while the Royal Cambrian Academy Committee renewed its efforts three years later by offering morning and evening classes, once again Whaite would soon report that 'few have joined and the attendance [is] not at all good'.[52] From that point, Presidential reports noted the lapsing of classes for the years 1897 and 1899, and the matter subsequently slipped from prominence, presumably abandoned as a lost cause.[53] In his notes for the report for 1903, Whaite remarked that:

We have had various artisan classes in Plas Mawr with paid teachers; also advanced classes for the study of draped models, intended more for the members and associates or any artist who might be residing in the locality. These for some years were a great success, but change of residence and other matters interfered with the steady and continuous working and the classes are now in abeyance.[54]

A further attempt, perhaps in response, was made by Slater to revive the schools,[55] although again by 1908, the attendance numbers declined once

more so that in 1909 it was cancelled.[56] The Royal Cambrian Academy clearly wished to institute an educational facility at Conwy that would adhere to the academic models established on the Continent and elsewhere in the British Isles. While landscape was the dominant genre of its members, the commitment to figure painting and the provision of life classes represent an important aspect of its ambitions to meet general academic criteria. However, without any studio tuition of students and the absence of lectures of the kind that generated aesthetic and art-historical perspectives for students, there was perhaps little opportunity to fasten Welsh art history and its Old Masters onto the educational carriage of the Royal Cambrian Academy.

As Norbury and Bird's comments show, Welsh Old Masters did form a recognisable if not completely coherent group. Neo-classicism united the practice of Inigo Jones (1573–1652), Wilson and Gibson (1790–1866), even if they worked in different media and times. The reference to Owen Jones (1809–74) seems out of place, given his alternative ethos of eclecticism in architecture and design, but his relative contemporaneity perhaps explains his inclusion as part of a rhetorical strategy to flag up recent Welsh genius (although like many 'Welsh' artists, he was born in England and was only of Welsh descent). If nothing else, the reference to neo-classical foundations for Welsh Old Masters reinforces the sense of how 'cosmopolitanism', fostered by tuition abroad in London or on the Continent, constituted an obstacle for those wishing to establish vernacular traditions in the arts for educational purposes. Indeed, Peter Lord has suggested that the thorough penetration of such standards (whether through Anglicisation or the formation of a rival Anglo-Welsh base) was responsible for the choice of the antiquarian label of 'Cambrian' for the Academy, signalling disengagement with the contemporary nationalist movement.[57] This may be reading too much into the gentrified use of a Latinate term, but it is clear that the alternatives of using either the Anglo-Saxon 'Welsh' or Celtic 'Cymru/Gymreig' denominations would have pushed the institution further along the scale of political association in one of two diametrically opposed directions.

The equivocality of Welsh attitudes to their Old Masters is further compounded by their often ambiguous attitude to nationality. As landscape became the key genre for the national image promoted by the Royal Cambrian Academy, so too did it provide the core rationale for some attempting the construction of a canon of Welsh Old Masters. For thinkers and artists like Tom Ellis, Evan Williams and Thomas Matthews, the masters of Welsh landscape painting became the custodians of spiritual and moral values for the nation. Relying on non-conformist religious tradition, for example, Matthews found the pictures of J.M.W. Turner egotistical and extravagant in contrast to Wilson's more modest and minimalist approach to divine nature.[58] Yet matters were not always so straightforward. Due to his activities around Betws-y-coed in the mid-nineteenth century, David Cox developed

into something of a rallying-point for a new indigenous school, with such images as *The Welsh Funeral, Betwys-y-Coed* (Figure 7.1: 1847–50). Cox painted this subject on multiple occasions but the Tate picture perhaps offers the most definitive version with its emotive stormy sky and imposing background topography.[59] The nationalist potential of such a resource was too good to miss for Thomas Matthews, who in a series of articles in 1911 in *Cymru* reworked the English artist as a Celt, going to the lengths of renaming him Dafydd Coch.[60] Yet it seems that such a gambit was largely irrelevant to many young artists of the time. The Welshness of Gwen John is a case in point, for example, as she made little of her origins.[61] Much the same is also true for her brother, Augustus John. Although he fantasised at odd moments about Welsh standing stones 'imported (like me) from Precelly', he made infrequent visits to paint the countryside and eventually became President of the Royal Cambrian Academy in 1935 only after persuasion: he had little real interest in Welsh affairs and cultivated an air of 'Outsiderliness' due to his personal romantic inclination.[62]

Collections of the works of Master artists were at this time recognised almost universally as invaluable teaching aids. The Royal Cambrian Academy

7.1 David Cox, *The Welsh Funeral, Betwys-y-Coed* (1847–50), oil on paper, 540 × 749 mm, purchased 1936. Tate/Digital Image © Tate, London 2011.

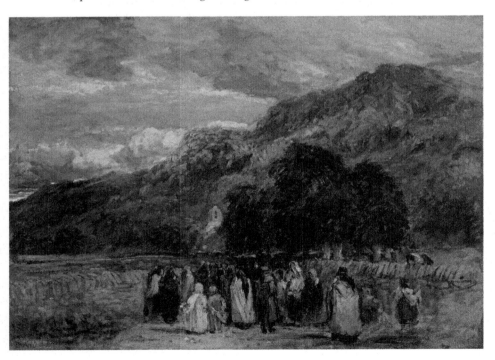

had publicly advertised in 1883 its commitment to establishing a 'national collection, a sculpture gallery, and a museum'.[63] Without income or a benefactor, the Royal Cambrian Academy had no hopes of obtaining Old Masters for such ends. Yet this did not mean that the institution gave up its ideals easily. More than a decade later, Whaite expressed his belief in 'the desirability of each [Academician] giving a diploma work which would form a permanent collection in Plas Mawr. I believe almost every other Art Academy do this and it is an unwritten law we should follow their example'.[64] Such an alternative would be a cost-effective if time-consuming solution to the problem.

The desire to have a national collection could also be met through other institutions and could piggy-back on the bourgeoning nationalist sentiments of the times. Nationalist sentiment briefly flowered at the end of the nineteenth century with *Cymru Fydd* (Young Wales). Politically active from 1886, the movement was ultimately curtailed by the problematic Welsh division between the mostly rural North and the predominantly urban South. Nevertheless, cultural institutions became an important battleground for establishing a separate Welsh national identity and arguably these outlived narrower political initiatives.[65] William Cornwallis West again played an instrumental role in these events, for not only did he organise the first major art-historical exhibition in Wales at Ruthin Castle in 1868, but he was also responsible for the exhibition at the Wrexham Eisteddfod in 1876 that aped Manchester's great Arts Treasures exhibition of 19 years earlier.[66] The Eisteddfodau were important expressions of artistic ambition from the time of the new round of festivals from 1861 onwards, focusing public attention on Welsh culture in art, music and literature, and the interest generated contributed to the growth of bourgeoning peripheral art scenes. The first Welsh art galleries opened in the 1870s partly due to the popularity of the arts and crafts exhibitions that took place under the aegis of the Eisteddfodua.[67]

Little remains in the form of records of exhibited items or the public reception of these exhibitions; however, pictures by Wilson were amongst those displayed at the Wrexham Eisteddfod exhibition in 1876.[68] Displays such as these must have contributed to the demand for a permanent collection of historic art to rival the National Galleries of London (established 1824), Scotland (established 1850) and Ireland (established 1854) which would not only raise public taste but would also benefit art students as an educational resource. As with the divisive competition that existed in the arena of art schooling in Wales, plans to establish a cultural hub in a national museum were inconvenienced when two candidates emerged. In 1894 Cardiff tendered a proposal that it should have the National Library and Museum, whilst the recent acquisition of Welsh manuscripts by Aberystwyth College fueled its calls for the establishment of a Welsh Library there. Welsh educational leaders, like the Principal of Aberystwyth in 1896, saw the creation of a 'national university' as an important spur to nationalism.[69] The financial feasibility

of any such projects was reliant on the political activity of Welsh Liberal MPs under David Lloyd George. Their vocal opposition to the Unionist government of the day in 1902–3 (and especially to the Education Act (1902)) led to Arthur Balfour's policy of appeasement. During this period Cardiff continued to lobby for itself as the host of the Museum.[70] In response, the government adopted Welsh national ideas in order to hang on to power. With the return of a Liberal government under Sir Henry Campbell-Bannerman in 1905, these policies came to fruition, with Westminster in 1907 dividing up the proposed national institutions, the Museum going to Cardiff and the Library to Aberystwyth accordingly.[71] The art collection at this new National Museum promised to finally fill the gap left in art educational needs. It was to subsume the collection of the Cardiff Museum, which was originally established as part of the 1864 expansion scheme that saw the creation of the Cardiff Free Library, Museum and Schools for Science and Art. It is difficult to reconstruct either the collection of the Cardiff Museum or its intended pedagogical function; however, this institution had originally been part of the Mechanics' Institute (1841–56) and presumably partly catered to the needs of artisanal technical training.[72] With the separation of the museum from the working men's educational association in 1907, the new museum could finally embrace the Welsh Old Masters and free itself from the functional blinkers that beset the Government Schools with their particular pedagogical mode.

According to *The Times* in 1912, the National Museum of Wales (NMW) was the 'latest outcome of the modern movement, national but not "Nationalist" in character'.[73] It is unclear whether this was meant to avoid antagonising Westminster over what was a costly concession or whether this was a conscious attempt to represent the inclusive remit of the NMW to collect examples from all artistic schools regardless of their national origins. Nevertheless, Old Master aspirations must have haunted the minds of certain benefactors and custodians. To focus on Wilson, for example, several oil paintings entered the collection during this time of growing nationalist sentiment, not all of which retain their previous attributions. A *Classical Landscape, Strada Nomentana* (NMW A 5201) was gifted to the collection in 1892, and the *Self-portrait* (NMW A 5190) and *A White Monk* (Figure 7.2: NMW A 5192) were purchased in 1889 and 1901 respectively. The message sent by collecting such work would have been marked: Wilson's Italianate palette, smooth finish and picturesque classicism in rendering a landscape contrasted starkly with both the expressive style of Cox and the brooding Romanticism of Whaite and his contemporary landscape artists at the Royal Cambrian Academy. The creation of the National Museum allowed this base to be built upon, with five further works being acquired between 1911 and 1914: *Dolbadarn Castle* (NMW A 5203) purchased in 1911; *Caernarfon Castle* (NMW A 73) purchased in 1913; and *Coast Scene near Naples* (NMW A 5195), *Welsh Landscape* (NMW A 5205) and *Landscape with Two Figures* (NMW A 5204), all purchased in 1914.

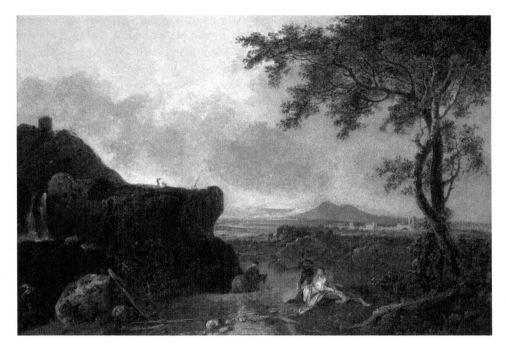

7.2 Richard Wilson, *A White Monk* (undated), oil on canvas, 94 × 133.3 cm; 1946; gift; F.J. Nettlefold; NMW A 5192 © Amgueddfa Cymru – National Museum Wales, 2012.

Yet in the period up to the First World War, the National Museum of Wales was unable to perform the function of a teaching aid due to the logistics of constructing a new civic complex. The Cardiff Museum was in the process of planning a new building in the years before 1901 at Cathays Park until the National Museum scheme superseded this.[74] Five years after the founding of the National Museum, building work began in 1912, but due to the First World War and subsequent disruption, the first small section was opened to the public only in 1923 and work continued until it received its official opening by King George V and Queen Mary in 1927.[75]

Individual collectors were also important in sustaining the interest in the Old Masters in Wales. Although they are best known for their avant-garde collecting of modern Masters, Gwendolyn and Margaret Davies were also significant as purchasers of British Old Masters. There was 'patriotism' in the Davies sisters' purchase of work by Turner in 1906, 1919, 1920 and 1921, Henry Raeburn and George Romney in 1908, Thomas Lawrence and John Constable in 1919, and Edward Burne-Jones in 1920. However, it is also clear that the cosmopolitanism of their tastes was responsible for the relatively minor presence of Welsh artists in these acquisitions: Wilson and Augustus John were amongst the few Welsh purchases made by the Davies sisters.[76] The

cosmopolitan significance of such patronage was perhaps also represented in the fact that, before leaving them to the NMW, these works remained in London, not their family home in Llandinam, so that as Robert Ashwin Maynard recalled, 'the evidence of their wealth was more apparent at the flat than in the wilds of Montgomeryshire'.[77] However, the Davies sisters were not exceptional in their collecting tastes and relative indifference to Welsh artists: when William Goscombe John left a collection to the NMW, the works of Welsh artists, including his own and those of William Llewellyn and Frank Brangwyn, were outnumbered by those of other modern British artists, including Burne-Jones, George Clausen, Walter Crane, Stanhope Forbes, George Frampton, Alfred Gilbert, Leighton, Edward John Poynter, Hamo Thornycroft and John William Waterhouse.[78]

Lloyd George gave nationalistic commissions to artists like Christopher Williams, who produced works of this nature in the 1910s, taking subjects, for example, from the *Mabinogion* (a collection of medieval Welsh folk stories) and creating allegorical representations such as *Deffroad Cymru* or *The Awakening of Wales* (1911).[79] These concerns were further reflected in Williams' first public address at the Llangollen National Eisteddfod in 1908, when he attacked the poor state of art education in Wales, calling for political and private patronage to remedy the situation and for the provision of art for everyone, not just the elite. Yet, as previously noted, not all Welsh artists were so driven by nationalist questions. Gwen John was more typical in fact in having 'no interest in political issues'.[80]

So if Welsh art educators effectively failed to pass on the models of the Old Masters, Welsh or international, how were young Welsh artists to learn these traditions at a time when such lessons were deemed crucial? Given the relative lack of opportunities in Wales, it was inevitable that alternatives would be sought further afield. Few Welsh artists attended the Royal Academy Schools and only enjoyed associations with that institution in later life: this pattern was true from the early days of Gibson, elected Associate Member of the Royal Academy (ARA) in 1833, at the age of 43, and RA in 1836, through to the late nineteenth and early twentieth centuries with William Goscombe John (1860–1952) (elected ARA in 1899, at the age of 39, and RA in 1909) and Augustus John (1878–1961) (elected ARA in 1921, at the age of 43, and RA in 1928). Such associations supplemented training elsewhere, for example, at the Cardiff Art School in the case of Goscombe John. RA connections were thus professional, and even when educational influences came out of these, it usually led them further away from their Welsh roots – for example, Gibson's departure for 'cosmopolitan' Italy at the suggestion of John Flaxman. Towards the end of the nineteenth century and at the very time when the Royal Cambrian Academy was established, many artists like Frank Brangwyn (1867–1956), born in Belgium but claimed for Welsh art, drew inspiration from other traditions. Brangywn, for example, sought practical training with the great English and

Scottish Arts and Crafts designers of his time, Arthur Heygate Mackmurdo, William Morris and Siegfried Bing.[81] For those who could not afford costly stays in Europe, it made more sense to decamp to London, the long-standing professional refuge of Welsh artists.

Yet in the period from 1880 to 1914, it was the Slade which provided a careful balance of progressive but high-quality training, drawing upon the best of the British and Continental studio models. Like the RA, the professors there provided a scholarly curriculum that complemented studio practice with intellectual engagement through lectures on historical costumes to the general promotion of history painting.[82] Artists like James Dickson Innes (1887–1914) and Evan Walters (1893–1951) did attend local Welsh art schools in Carmarthen and Swansea respectively; however, the lure of the Slade was generally too great, and Innes moved there in 1906.[83] Perhaps the greatest modern Welsh master, Augustus John, also benefited from its educational system.[84] John seems to have blamed the Government Schools of Design for the general poor quality of art education in Britain, as he later reflected: 'The system of State Art Education inaugurated by Prince Albert the Good at the Great Exhibition in Hyde Park in 1854 [sic] seems unfortunately to have blighted every trace of talent which suffered under its inexorable discipline'.[85] He bemoaned the demoralising effect of 'a course of "Stumping" in the State-endowed schools' and the boring process of drawing geometric shapes, casts and life models. As John continued:

> I, myself, though I attended no official Art School, became at an early age the modest recipient of a Certificate at a local examination, but of the third class only. For this mediocre success my acknowledgements are due to my instructress, Miss O'Sullivan of Tenby, Pem. At the Slade School of Art, which I had the good fortune to join later, a very different system prevailed under Frederick Brown and his chief lieutenant Henry Tonks. There 'Stumping' was severely banned and the students had to do the best they could with the point of a stick of charcoal and a sheet of 'Michelet'. They were even encouraged to study the Old Masters![86]

The historical element was evident in Tonks' teaching of contour study from Paleolithic to European art. In fact, the experiences of students like John at the Slade were heavily indebted to the Old Masters. Whilst it gave access to great professional opportunities with progressive groups like the New England Art Club and Carfax in Chelsea, Augustus and his sister Gwen John both emerged with traditionalist methods.[87] This was in spite of the anti-establishmentarian influence of friends like Percy Wyndham Lewis, who took pot-shots at the Old Master reverence of Tonks and Roger Fry.[88] As David Fraser Jenkins and Chris Stephens state:

> At the Slade School of Art the Johns were taught how to draw like the old masters, at first from copying sculptures, and then, in separate classes for men

and women, from posed, naked models. This was an ideal kind of art, and it was expected that they should progress to design compositions of figures, and make paintings in the tradition of the art teaching at an academy.[89]

Gwen John drifted off to Paris to embrace more aesthetic manners, attending the Academie Carmen in 1898. This followed the pedagogical ideals of James Abbott McNeill Whistler, with weekly studio critiques and an emphasis on the figure. However, even this was 'academic' in its ideals for 'The process, as with the Old Masters, is one of continual education … It is based on laws which never change. Whistler teaches his students the rules of composition but leaves them to develop their individual talents. The officials of the South Kensington & other schools should take note'.[90] Furthermore, although it is generally recognised that Augustus 'owned' the Old Master approach, Gwen also employed it knowingly in such works as her *Self-Portrait* (c.1900).[91]

One way or another, it is clear that Welsh artists who studied or were trained during the period from 1880 to 1930 did internalise the lessons of the Old Master tradition. In reminiscence, Frank Brangwyn would declare that: 'The influence of the Masters is found in all serious work. An artist *must* be influenced by the old. He should study them and try to understand their outlook. They give him an open path to follow, pointing out to him some of the endless ways of seeing beauty in nature, things that without this early training would pass unnoticed', before railing against the modern ill-disposition to such study for 'To-day it's considered all wrong to study the Old Masters'.[92] Augustus John had given great attention to their work as a young artist, especially in 1910 when he visited Italy to study its fifteenth-century artists, but such engagement continued to be a feature of his work through the rest of his life, drawing upon Rembrandt, Rubens, Velazquez and Goya.[93] Yet perhaps the uneasy position of the Old Masters in Wales, the complicating factor of the modernist mindset and John's egotism itself ultimately took its toll, as in his final years, he rejected the wisdom of studying the Old Masters, for:

> The aspiring student who thinks he may best find himself by pursuing the Old Masters, is in grave danger of losing sight of his guides as well as his goals. He must take his directions, as did his distinguished predecessors, from life itself. Fidelity to venerable traditions too consistently practised and for too long may rob him of his fire and end in impotence. The subtle magic of antiquity can induce a form of hypnosis from which there is no awakening. The conjuration of an illustrious name, instead of fortifying, may only corrupt the student's innocence and damp his courage so that he sinks into the false security of precedent and the second-hand.[94]

In the decades either side of 1900, Wales was experiencing an important groundswell in national consciousness. Young and established artists alike looked to art-historical legacies for inspiration in driving forward the arts of Wales. Before the First World War and its aftermath, Welsh artist-educators

were unable to effectively seize upon the traditions of the Old Masters to further their nationalistic aims. The reality of poor finances and delays in establishing institutions such as the Royal Cambrian Academy and the National Museum of Wales presented impediments to the creation of a through-going and historically-informed educational infrastructure in Wales at that time. Faced with the need to study the greats, young Welsh artists migrated to established artistic centres, such as London and Paris, as the choices of Augustus and Gwen John demonstrate. It would be many decades before sufficient investment in art training would provide long-term solutions to these problems, but even then the regional divisions within Wales continued to impede both the growth of a truly national school and the creation of a nationalist sensibility amongst students attending its art educational institutions.

Notes

1 Peter Lord, *Clarence Whaite and the Welsh Art World: The Betwys-y-coed Artists' Colony 1844–1914* (Llandudno: Coast and Country Publications, [1998] 2009), p. 119.

2 There is some ambiguity over when the Government School for Art first became active in Cardiff. The website of the modern-day Cardiff School of Art and Design (part of Cardiff Metropolitan University) states 1865 as the foundation year, but Macdonald dates it to 1868 (Stuart Macdonald, *The History and Philosophy of Art Education* (London: University of London Press, 1970), p. 384). It appears that 1868 was when the first South Kensington examinations were taken in Cardiff and prizes awarded – and Macdonald may have dated the School's opening from this evidence. Lord Bute presented the annual awards to students in the Cardiff Art and Science classes for the second time in November 1869 (Anon., 'CARDIFF ART AND SCIENCE CLASSES', *Western Mail*, 4 November 1869, p. 2 col. d–e) and in distributing the prizes for 1878, the Mayor of Cardiff, Dr Taylor, 'referred to the gratifying manner in which the Cardiff Schools had extended during the past ten years' (Anon., 'CARDIFF SCIENCE AND ART CLASSES', *Western Mail*, 11 April 1878, p. 3 col. i). However, activity before 1868 is implied by an 1869 report which, in debating the inadequacies of the buildings that housed the Schools, reported that 'Each successive anniversary has proved that the public of Cardiff is alive to the importance of these classes' (Anon., 'SCIENCE AND ART SCHOOLS', *Western Mail*, 1 May 1869, Issue 1. p. 2, col. c). If the School had been founded in 1868, it would only have celebrated one anniversary at that point.

3 Neil Evans, 'Internal Colonialism? Colonization, Economic Development and Political Mobilization in Wales, Scotland and Ireland', in Graham Day and Gareth Rees (eds), *Regions, Nations and European Integration: Remaking the Celtic Periphery* (Cardiff: University of Wales Press, 1991), p. 249.

4 Charlotte Aull Davies, *Welsh Nationalism in the Twentieth Century: The Ethnic Option and the Modern State* (New York: Praeger, 1989), pp. 26–7; Alan Butt Philip, *The Welsh Question: Nationalism in Welsh Politics, 1945–1970* (Cardiff: University of Wales Press, 1975), p. 1; G.A. Williams, 'When was Wales?', in Stuart Woolf (ed.), *Nationalism in Europe, 1815 to the Present* (London and New York: Routledge, 1996), p. 194; Sarah Prescott, '"Gray's Pale Spectre": Evan Evans, Thomas Gray, and the Rise of Welsh Bardic Nationalism', *Modern Philology*, 104(1) (2006), pp. 72–95.

5 Michael Hechter, *Internal Colonialism: The Celtic Fringe in British National Development, 1536–1966* (London: Routledge & Kegan Paul, 1975), pp. 4, 7–10.

6 Evans, 'Internal Colonialism?', pp. 236, 239, 241, 244.

7 Williams, 'When was Wales?', pp. 200, 202; Davies, *Welsh Nationalism in the Twentieth Century*, p. 199.

8 Williams, 'When was Wales?', p. 197.

9 Aled Jones and Bill Jones, 'The Welsh World and the British Empire, c.1851–1939: An Exploration', *Journal of Imperial and Commonwealth History*, 31(2) (2003), pp. 57, 59–60.

10 Williams, 'When was Wales?', pp. 192, 196, 199–200.

11 Philip, *The Welsh Question*, p. 3; Chris Williams, 'The United Kingdom: British Nationalisms During the Long Nineteenth Century', in Timothy Baycroft and Mark Hewitson (eds), *What is a Nation? Europe 1789–1914* (Oxford: Oxford University Press, 2006), p. 286.

12 Robert Gildea, *Barricades and Borders: Europe 1800–1914* (Oxford: Oxford University Press, 1987), pp. 328, 383

13 Philip, *The Welsh Question*, pp. 41–2.

14 Adfyfr (a.k.a. Thomas John Hughes), *Neglected Wales (reprinted by permission from the Daily News)* (London: National and Liberal Printing & Publishing Association Ltd., 1887), pp. 3–5, 13.

15 Victor Kiernan, 'The British Isles: Celt and Saxon', in Mikuláš Teich and Roy Porter (eds), *The National Question in Europe in Historical Context* (Cambridge: Cambridge University Press, 1993), p. 27.

16 Ned Thomas, *The Welsh Extremist: A Culture in Crisis* (London: Gollancz, 1971), pp. 99–100. See also Williams, 'The United Kingdom', p. 287.

17 Davies, *Welsh Nationalism in the Twentieth Century*, pp. 10, 22.

18 Joshua Reynolds, 'Discourse I (January, 2, 1769)', *Discourses on Art; with an Introduction by Robert R. Wark* (New Haven and London:Yale University Press, 1997), p. 16.

19 Richard and Samuel Redgrave, *A Century of British Artists* (London: Phaidon, [1866] 1947), pp. 1, 3, 10, 288–9, 365.

20 Ibid., p. 40. Interestingly the neo-classical sculptor John Gibson is the only other Welsh artists who received mention by the Redgraves and only then as a sitter for a portrait by William Boxall (p. 358).

21 Reynolds, Discourse XIV (December 10, 1788), p. 255

22 National Library of Wales, NLW, HRC8/1: Press cuttings 1882–1912; *Western Mail*, 17 March 1886.

23 Raymond C. Curry, *The Wild West Show: A Story of the Cornwallis-West Family* (Christchurch: Natula, 2009).

24 Tim Coates, *Patsy: The Story of Mary Cornwallis West* (London: Bloomsbury, 2004), p. 5.

25 Peter Jones, 'Foreword', in Eric Rowan (ed.), *Art in Wales, 2000 BC–AD 1850: An Illustrated History* (Cardiff: Welsh Arts Council, 1978), p. 5 .

26 John Ingamells, 'Painting in Wales 1550–1859', in Rowan (ed.), *Art in Wales*, p. 101.

27 Jack Shore, 'The Foundation and Early Years of the Royal Cambrian Academy of Art', in Royal Cambrian Academy of Art, *A Centenary Celebration: Paintings Selected from the Annual Exhibitions of the Royal Cambrian Academy of Art Held in Wales 1882–1982* (Llandudno: Mostyn Art Gallery & Royal Cambrian Academy of Art, 1982), p. 7.

28 Ibid., pp. 7–9, 11.

29 NLW, HRC7/3, Papers relating to Plas Mawr 1881–1911: Article 'The Art Gallery of North Wales', reproduced from the *Rhyl Journal* (10 February 1883).

30 Ibid.

31 Ibid.

32 Ibid.

33 Ibid.

34 NLW, HRC8/1: Press cuttings 1882–1912; 'The Royal Cambrian Academy: Fine Art Loan Exhibition at Cardiff: Opening Ceremony', *South Wales Daily News*, 15 February 1884.

35 NLW, HRC2/1: Letters 1883–1885: Edwin Seward to Whaite, 24 February 1885, stating that the Cardiff exhibition had resulted in a loss of £1,800, with £600 of this still unpaid; HRC2/8: Letters 1896: various correspondence refers to the divisions within the Royal Cambrian Academy due to a 'clique'; including S. Lawson Booth to Whaite, 20 January, 24 February and 21 May 1896; and Charles Potter to Whaite, 28 May 1896; NLW, HRC2/9: Letters 1897; the rift between Whaite and the W.J. Slater (honorary secretary) was a source of concern for many: J. Pain Davis to Whaite, 5 January 1897; J[oseph] Knight to Whaite, 13 and 15 January 1897.

36 J. Johnson and A. Greutzner, *The Dictionary of British Artists, 1880–1940* (Woodbridge: Antique Collectors' Club, 1976), p. 318, col. b; Royal Birmingham Society of Artists, *The Sixty-Third Autumn Exhibition, at the Rooms of the Society 1889* (Birmingham: Hudson and Son, [1889]), pp. 30, 42, 74; Algernon Graves, *The Royal Academy of Arts: A Complete Dictionary of Contributors and their Work from its Foundation in 1769 to 1904* (London: Henry Graves and Co., 1905, 8 volumes), Vol. V, p. 93 col. b.

37 Deborah Cherry, 'The Hogarth Club: 1858–1861', *Burlington Magazine*, 122(925) (April 1980), p. 241.

38 Anon., 'Hogarth Club', *The Times*, 28 February 1884, p. 7, col. e: membership was close to 100 and included C.B. Birch, A.R.A., Luke Fildes, A.R.A., E.J. Gregory, A.R.A., Colin Hunter, A.R.A., J.D. Linton, Seymour Lucas, R.W. Macbeth, A.R.A., and Linley Sambourne.

39 NLW, HRC2/4: Letters 1888–1889: Loud to Whaite.

40 Ibid.

41 Ibid.

42 NLW, HRC2/4: Letters 1888–1889: Newbury to Whaite, 18 December 1888.

43 Ibid.

44 NLW, HRC2/5: Letters 1890–1891; Lord, *Clarence Whaite and the Welsh Art World*, p. 110.

45 NLW, HRC2/5: Letters 1890–1891: Norbury to Whaite, 31 December 1890.

46 NLW, HRC2/5: Letters 1890–1891: Charles Jones to Whaite, 13 May 1891.

47 NLW, HRC3/1: President's reports 1886–1895: report for 1889.

48 NLW, HRC2/5: Letters 1890–1891, Furness to Whaite, 7 December 1890.

49 NLW, HRC3/1: President's reports 1886–1895: 25 January 1890, report for 1889.

50 NLW, HRC3/1: President's reports 1886–1895: 24 January 1891, report for 1890.

51 NLW, HRC3/1: President's reports 1886–1895: 9 January 1892, report for 1891.

52 NLW, HRC3/1: President's reports 1886–1895: 27 January 1894, report for 1893; HRC2/8: Letters 1896: Notice dated Nov 27th 1896; HRC3/2: President's reports 1896–1901: 23 January 1897, report for 1896.

53 NLW, HRC3/2: President's reports 1896–1901: 28 January 1898, report for 1897; 27 January 1900, report for 1897.

54 NLW, HRC2/12: Letters 1902–1904: 21 March 1903, Furness' notes on Presidential report for correction.

55 NLW, HRC2/12: Letters 1902–1904: Advertising Bills for 10 and 25 October 1904.

56 NLW, HRC3/3: President's reports 1904–1911: 30 January 1909, report for 1908; 20 January 1910, report for 1909.

57 Lord, *Clarence Whaite and the Welsh Art World*, p. 115.

58 Ibid., pp 183–4.

59 N. Neal Solly, *Memoir of the Life of David Cox* (London: Chapman and Hall, 1873) noted that Cox witnessed the funeral of the local girl 'which, according to the habits in North Wales, took place in the evening' (p. 174). Other versions are an oil at the Birmingham Museum and Art Gallery (1848: 46.4 × 71.1 cm) and a large watercolour in the Whitworth Art Gallery (1847–9: 76.2 × 99 cm).

60 Lord, *Clarence Whaite and the Welsh Art World*, p. 178.

61 Ceridwen Lloyd-Morgan, *Gwen John Papers at the National Library of Wales* (Aberystwyth: NLW, 1988), p. 6.

62 David Fraser Jenkins and Chris Stephens (eds), with contributions by Tim Batchelor et al., *Gwen John and Augustus John* (London: Tate Publishing, 2004), pp. 12–13; Augustus John, *Finishing Touches* (London: Jonathan Cape, 1966), p. 34; Shore, 'The Foundation and Early Years of the Royal Cambrian Academy of Art', pp. 11–12.

63 NLW, HRC7/3, Papers relating to Plas Mawr 1881–1911: Article 'The Art Gallery of North Wales', reproduced from *The Rhyl Journal* (10 February 1883).

64 NLW, HRC3/2: President's reports 1896–1901: 28 January 1899, report for 1898; 27 January 1900, report for 1897.

65 Philip, *The Welsh Question*, p. 8; See also Kiernan, 'The British Isles: Celt and Saxon', pp. 21–4; and Williams, 'The United Kingdom', pp. 287–8.

66 Lord, *Clarence Whaite and the Welsh Art World*, pp. 109, 113.

67 Ibid., pp. 108, 110, 112–14.

68 Ibid., p. 121.

69 Robert Anderson, 'Learning: education, class and culture', in Martin Hewitt, ed., *The Victorian World* (London and New York: Routledge, 2012), p. 491

70 Anon., 'Proposed National Museum For Wales', *The Times*, 9 January 1902, p. 5, col. d.

71 Anon., 'Deputations to Ministers. A National Museum for Wales', *The Times*, 21 April 1904, p. 15, col. a; Anon., 'National Museum For Wales', *The Times*, 24 June 1904, p. 14, col. e; Prys Morgan, 'The Creation of the National Museum and National Library', in John Osmond (ed.), *Myths, Memories and Futures: The National Library and National Museum in the Story of Wales* (Cardiff: Institute of Welsh Affairs, 2007), pp. 15–17.

72 Gordon Roderick, 'Technical Instruction Committees in South Wales, United Kingdom, 1889–1903 (Part 2)', *Vocational Aspect of Education*, 45(2) (1993), pp. 145–6.

73 Anon., 'The Royal Visit to Cardiff. The King on Welsh Enterprise. Ceremony at the National Museum', *The Times*, 27 June 1912, p. 8, col. a.

74 Anon., 'Welsh National Museum. Seward v. Lord Mayor and Corporation of Cardiff', *The Times*, 2 February 1911, p. 3, col. f.

75 Anon., 'National Museum of Wales. An Appeal for £100,000', *The Times*, 4 February 1926, p. 9, col. f; Anon., 'National Museum of Wales', *The Times*, 10 January 1927, p. 19, col. d; Anon., 'The King and Queen at Cardiff: National Museum of Wales Opened', *The Times*, 22 April 1927, p. 16, col. a.

76 Eric Rowan and Carolyn Stewart, *An Elusive Tradition: Art and Society in Wales 1870–1950* (Cardiff: University of Wales Press, 2002), pp. 135–7, 148–9.

77 Ibid., p. 135.

78 National Museum of Wales, *Works of Art Given to the National Museum of Wales (Cardiff) by Sir William Goscombe John, R.A.* (Cardiff: National Museum of Wales, 1943).

79 Rowan and Stewart, *An Elusive Tradition*, p. 102; Lord, *Clarence Whaite and the Welsh Art World*, pp. 145–7.

80 Cecily Langdale and David Fraser Jenkins, *Gwen John: An Interior Life* (Oxford: Phaidon, 1985), p. 36.

81 Libby Horner, 'Biography', in Libby Horner and Gillian Naylor (eds), *Frank Brangwyn 1867–1956* (Leeds: Leeds Museums & Galleries, 2007), pp. 30–31.

82 See Emma Chambers, 'Redefining History Painting in the Academy: The Summer Composition Competition at the Slade School of Fine Art, 1898–1922', *Visual Culture in Britain* (2005), pp. 79–100.

83 Lloyd-Morgan, *Gwen John Papers at the National Library of Wales*, p. 15.

84 Emma Chambers, *Student Stars at the Slade 1894–1899, Augustus John and William Orpen* (London: University College of London Art Collection, 2005); Dennis Farr, *English Art, 1870–1940* (Oxford: Clarendon Press, 1978), pp. 192–3.

85 Augustus John, 'A Note on Drawing', in Lillian Browse (ed.), *Augustus John: Drawing* (London: Faber & Faber, 1941), p. 9.

86 Ibid., pp. 9–10.

87 David Fraser Jenkins, 'Gwen John and Augustus John: Mutual Differences', in Fraser Jenkins and Stephens (eds), *Gwen John and Augustus John*, pp. 11, 16.

88 John, *Finishing Touches*, pp. 116, 118–19.

89 David Fraser Jenkins and Chris Stephens, 'A Common Start: Paintings, Drawings and Etchings to about 1906', in Fraser Jenkins and Stephens (eds), *Gwen John and Augustus John*, p. 48.

90 University of Glasgow, GB 0247 MS Whistler P202: Letter from [E[lizabeth] R[obins] Pennell] to Pavillon Madeleine, 4 October 1899.

91 Langdale and Fraser Jenkins, *Gwen John*, p. 25.

92 William de Belleroche, *Brangwyn Talks* (London: Chapman & Hall, 1946), p. 23, emphasis in original.

93 Fraser Jenkins, 'Gwen John and Augustus John: Mutual Differences', p. 16; Fraser Jenkins and Stephens, 'A Common Start', pp. 55, 68; and David Fraser Jenkins and Chris Stephens, 'Gwen and Augustus: Portraits, Indoors and Out of Doors c. 1906–1913', in Fraser Jenkins and Stephens (eds), *Gwen John and Augustus John*, p. 98.

94 John, *Finishing Touches*, p. 128.

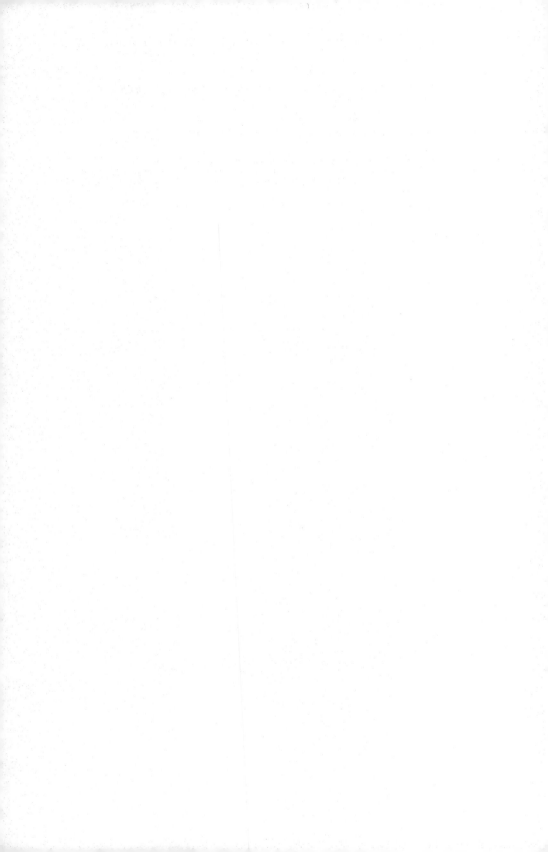

Emulation and Legacy: The Master-Pupil Relationship between William Orpen and Seán Keating

Éimear O'Connor

> The artist makes himself, but he can make himself quicker with the help of other artists, who must, however, be convinced of his sincerity before they will assist him.[1]

One of the best-known master-pupil relationships in Irish art in the early years of the twentieth century was that between the Anglo-Irish upper-class Dublin-born Protestant William Orpen (1878–1931) and Seán Keating (1889–1977), a lower-middle class Catholic from Limerick city. Precociously gifted and immensely sociable, Orpen exerted enormous influence as a teacher, artist and arts activist at the Dublin Metropolitan School of Art (DMSA). His pedagogical concerns are perhaps best exemplified in Keating's work from 1913 to 1915. In turn, throughout his 70-year career, Keating was resolute about his artistic inheritance from ancient Rome via Orpen and the Slade School of Art. He went on to develop a new form of instantly recognisable social realism for New Ireland, premised on academic training but fused with socio-political purpose. There was a brief but highly significant moment in 1915 when student became mentor. It coincided with Orpen's apparently conflicted sense of place and identity at the onset of the First World War, and at the same time, it signalled his approval of Keating as his soon-to-be successor in Ireland. With the advent of the Irish Free State in 1922, tension emerged between academic and modernist artists and critics over the conceptualisation and visualisation of a correspondingly new national identity.[2] The anthropologist Clifford Geertz has described this tension in post-colonial communities as one between 'essentialism' or tradition and 'epochalism' or the modern. He has written that: 'There is no simple progression from "traditional" to "modern", but a twisting, spasmodic, unmethodical movement which turns as often toward repossessing the emotions of the past as disowning them'.[3] Although

the debates and arguments were unavoidable, and ultimately vital to the evolution of a post-colonial national identity, Keating could not have realised that his determined attachment to Orpen would lead to unconstructive evaluations of his context and career from the 1950s onwards. Indeed, in later years, the work of both artists has been critically misinterpreted – Orpen's as 'mere exercises of soulless skill' and Keating's as merely a weak derivative of Edwardian style.[4]

Orpen was born in the affluent south Dublin suburb of Blackrock, the son of an upper-class Protestant solicitor. At the age of 13, he enrolled as a student at the DMSA. He proved a talented and hard-working student, and won every award available during his time there. His youthful sense of Irish identity was Edwardian in aesthetic and impulse, and was influenced by aspects of the Irish Cultural Renaissance led by William Butler Yeats, Lady Augusta Gregory and John Millington Synge, all of whom came from a similar background.[5] He described his boyhood literary influences, although somewhat lacking, as 'more English than Irish', and he claimed to have had no interest in the ubiquitous Irish question. After his death in 1931, his early biographers were careful to note that:

> His judgements of his fellows were as acute as his powers of observation.
> But judgements were only expressed in paint. He had taken the advice that
> Michael Davitt had given him. 'Don't take any side, just live and learn to try to
> understand the beauties of this wonderful world'.[6]

Between 1897 and 1899, Orpen completed his education at the Slade School of Art in London.[7] The teaching environment at the DMSA had been conservative and unadventurous by comparison with the Slade, and he revelled in the artistic freedom available there. The Slade had fewer students, and classes were taught by male artists based on their own studio practices, whose objective was to pass on their skills and experience gained through a lifetime of committed work. Although socially relaxed, it was an environment that encouraged and inculcated hard work. The pedagogical concerns at the Slade were underpinned by a method that was 'not a system, but the absence of a system'.[8] As a result of his experiences there, Orpen came to believe that 'students at art school should be taught by the best painters of their own period', but that those artists could not possibly be available on a full-time basis or they would 'cease to be painters'.[9] The lack of a system was, for the most part, successful. But it was dependent on the strength of personality and the authority of its artist teachers, all of whom 'favoured excellence, ignored the mediocre and threw out the bad', thereby establishing a teaching method that eventually transferred, via Orpen and Keating, to the students at the DMSA.[10]

Henry Tonks (1862–1937), Professor of Fine Art at the Slade from 1918 to 1930 and the only artist teacher who did not study in Paris, proved resistant

to Post-Impressionism, Futurism and abstract art. It has been argued that this opposition, coming from the influential Slade School, left its legacy in Ireland through Orpen's successors because their mentor 'was not in a position to aid his students towards a rapprochement with developments since impressionism'.[11] But, from the perspective of the twenty-first century, this seems an inadequate explanation for the debates and controversies about Irish visual identity in the early twentieth century, in which tension between traditionalists and modernists was, surely, a prerequisite to any form of conclusion. Furthermore, Orpen's attitude to modern developments in art was, like Keating's, far more nuanced than might first seem apparent, and while neither ever claimed to be modernist artists, both men experimented with pigment and application.

Despite his resistance to certain movements in art, Tonks was a leading and highly respected mentor. Moreover, several senior teacher artists at the Slade were more than familiar with French avant-garde art, and their enthusiasm was passed on to the next generation of student artists.[12] Irish painters and writers, especially those of the upper-middle class, were well educated and well-travelled: many spent time studying or working in Paris and its environs, while others visited to see the most up-to-date exhibitions. In 1899, the vitality of avant-garde art was introduced to Irish audiences at the exhibition 'Modern Paintings', which opened to critical acclaim in the Leinster Hall, Molesworth Street, Dublin that year. By the time that 'new French ideas', derived from Cubism, were shown in Dublin in 1923, a New Ireland, in need of an independent national visual identity, had emerged. Over the course of time, the discourse about national aesthetics became far more polarised, politicised and modulated with subtle shades of meaning.

After an impressive career at the Slade School, Orpen joined the teaching staff at the DMSA in 1902. He taught, on a part-time basis, until 1914. In the meantime, he had established an extraordinarily successful studio practice in London. He visited the DMSA twice yearly, usually in May or June, and again in August or September. He would 'teach for an hour, set up canvas on his easel, and demonstrate, then leave the work in progress standing for all to see … he worked very fast … he taught that sufficient paint to create the illusion of light and shade, tone and colour, was enough', and he laughed at 'touch' and 'impasto'.[13] Orpen usually stayed in Dublin for two or three weeks. During that time, he worked on his own commissions in a room at the DMSA, thereby instigating a tradition followed by his successors.[14] He was, in modern terms, a gifted superstar artist and art master, with a celebrity clientele in London and a devoted group of students at the DMSA. He was a teacher in the Slade style: dedicated to those who chose to work and having no time for those who did not. While seemingly harsh, his attitude was necessary at the DMSA, which was overcrowded, under-resourced and had no entrance examination, and was rapidly becoming a finishing school for dilettantes. Nevertheless, a

strict work ethic was accompanied by a number of important changes at the DMSA aimed at producing a more informal working environment; Orpen allowed smoking and noisy conversation, whereas, in his youth, utter silence had been expected throughout the school. He was of the opinion that the staid and mechanical teaching at the school, including the repetitive drawing of the male nude, was a 'mere survival of the old South Kensington'.[15] Thus, it was Orpen who 'liberated art' by making sure that his students had the opportunity to work with female nude models on an ongoing basis after 1906.[16] He felt that this was a vital aspect of artistic training which had, during his time as a student at the DMSA, been at best, ad hoc.[17] He had an innate ability to inspire confidence in his students and is quoted as saying: 'I don't think any of the students care a damn about the authority of any teacher, and for my part, I did not give a damn about the students who did not work'.[18]

The community of the DMSA represented a microcosm of the complexities of Irish socio-political life during Orpen's years teaching there and, indeed, after he left. In 1914 two staff members and 14 students joined the British army.[19] In the years leading up to the Easter Rising in Dublin in 1916, several young people who were to become involved in events of that week had been enrolled at the DMSA: Willie Pearse attended the school irregularly between 1898 and 1910; Countess Markievicz attended night classes; Patrick Tuohy, who fought in the siege of the General Post Office (GPO) in 1916, started in the night classes in 1909; and Grace Gifford, an active Nationalist in 1916, and the subject of Orpen's idealised vision in *Young Ireland* (1907), studied at the DMSA before moving to the Slade School to complete her training. These were the years leading to the dusk of Ireland's Cultural Revival and the dawn of a New Ireland, to which Orpen, by virtue of his dislocated identity, could not belong. Although he painted images such as *Young Ireland* and *An Aran Islander* (c.1908), his was a representation of the Edwardian, Anglo-Irish era that was literally swept away between 1914 and 1922. Ultimately, it was his student, Seán Keating, who was to become both his successor at the DMSA and one of the leading painters of, and contributors to, Ireland's 'spasmodic' progression towards modernity.

Although he enjoyed the adulation of clients and students, Orpen was serious in his efforts in art education and 'committed himself to supporting the development of art in Ireland'.[20] Having spent the best years of his youth at the DMSA, he was acutely aware of the problems it faced. Thus, in 1905 he accepted an invitation to submit his considered opinion to an official parliamentary inquiry into the management of the DMSA and the Royal Hibernian Academy (RHA). Perhaps to the surprise of the beleaguered management of the DMSA, Orpen was severely critical of the manner in which the school was run, owing to a dire lack of funds and a scarcity of suitable teaching space. As a result, he was removed from his bright studio at the DMSA. The full report of the inquiry, which investigated matters such as

teaching hours, general practices at the DMSA and funding for both the school and the RHA, was published in 1906.[21] The management realised that Orpen had been trying to help, and soon afterwards he was given 'a little store room' before eventually being given a 'large and spacious studio' in which to work.[22] But the problems remained and worsened as the years progressed. In 1901 a recommendation had been made that the DMSA and RHA drawing schools should amalgamate to form one 'life school'.[23] Orpen subscribed to this idea as he felt that there was 'no room for two schools of Fine Arts in the city of Dublin'.[24] The proposed merger, which was suggested for financial reasons, did not happen, but the 1906 report recommended that a 'Professorship of Painting from Life' should be established at the DMSA.[25] Orpen was duly 'appointed to the life class on Mondays, Wednesdays, Fridays and Saturdays', thereby setting up a timetable that more-or-less continued until after Keating retired in 1958.[26] But when Orpen left the school in 1914, there was still no official professorship, and it was not until 1937, as a long-awaited result of the 'French Report', that Keating and others obtained some form of resolution to the problems that had been raised in 1906.

Orpen's teaching years at the DMSA also coincided with his 'involvement with the RHA'.[27] His resignation from the Academy and the DMSA in 1914 upset his plans and, according to him, 'stopped great things that might have happened, indeed, they were very nearly happening at the time'.[28] Had he succeeded with the amalgamation, it is possible that both the RHA and the DMSA would have been the beneficiary of better funding from the Department of Education, thereby producing an environment less troubled by financial worries and more concerned with promoting progressive practices in teaching and training.

Keating's circumstances could not have been more different from Orpen's. He was born in Limerick, the eldest of seven children, to a Catholic lower-middle-class family. His mother was a dress-maker and his father was a clerk. The family story illustrates well the complexity of Irish life at that time: of his three brothers, Paul became a priest, Claude left home at the age of 14 to join the British army and Joe became a member of the Irish Volunteers and the Irish Republican Brotherhood.[29] Keating was well educated, but he was restless and bored at school. He spent many days on Limerick dockside, instead of in the classroom, before finally deciding to leave school in 1904. It was the middle of his final year. He had already witnessed the boycott of the Jewish community in Limerick and he may well have taken an interest in the revival of the constitutional Home Rule Party in 1906.[30] But from the time he left school in 1904 until he finally decided to train to become an artist and art teacher in 1907, he had spent three idle years and showed no resolve, commitment or ambition. The decision to enroll in the Limerick Technical School of Science and Art, which he later described as an 'epiphany', was the point at which his life changed.[31] He won several awards for painting and

drawing, and, having done so well, it would appear that his ambition was to train at the DMSA in Dublin. Given Orpen's celebrity and acknowledged artistic brilliance, it is likely that Keating had already heard of him, and may have even aspired to emulate him at that early stage.

In the summer of 1911, encouraged by his successes in Limerick, Keating took part in an art competition at the DMSA and, as a result, he was offered a scholarship to study at the school.[32] He arrived in Dublin in the autumn of 1911 to study art and art education on a small stipend in consideration of rent, utilities, food and art equipment. His scholarship paid one guinea a week during the academic term only. He was often severely short of money, so in order to eat, and to earn extra cash for rent and materials, he frequently resorted to hunting in the Dublin Mountains. He could not set up his own studio until he qualified from the DMSA. In short, there was an enormous disparity in terms of class between Orpen and his student. Many years later, Keating wryly noted: 'It was typical of the man who had plenty of money and plenty of friends to forget to arrange that I should have some'.[33]

Between 1911 and 1914, when he successfully completed his training, Keating immersed himself in the system of education at the DMSA. He was taught by several members of staff, including the stained glass artist Harry Clarke (1889–1930) and possibly the mural painter James Ward (1851–1924). But it was Orpen that made the greatest impression on Keating, not simply for his persuasive skills as an artist and teacher, but crucially because he inculcated a sense of hard work and dedication to an artistic life in his pupil. For Keating, who had found it difficult to devote time to anything useful prior to meeting Orpen, learning about, and subsequently adhering to, a committed creative life, premised on firm academic training, gave him a sense of purpose that he had not experienced before. He noted that: 'When at first I met him [Orpen], I thought him peremptory and harsh. There was an immense disparity of accomplishment between us ... but as I came to know him and learn from him, I grew to respect and love him extremely'.[34]

However dogmatic Orpen may have initially seemed, Keating flourished, and on examination and comparison of their art work at that time, there is no doubt about the influence of the master over his pupil. A previously unknown and rare example of student work by Keating, *Reflection in a Mirror* (c. 1911–13), illustrates this point.[35] The painting features a small plaster or marble sculpture of a curiously lifelike woman gazing into a mirror. Keating conveys well the visual opposition between the smooth, cool figure and the textural warmth and luxury of the different materials on display. Compositionally, the picture literally reflects and emulates Orpen's lifelong artistic concerns: anatomy, portraiture, texture, light and shade, attention to detail, and the multiplicity of creative possibilities offered by the use of a mirror, both as a compositional object and as the physical apparatus of artistic self-reflection, in all its guises. The content of the painting can also be seen as an early

demonstration of Keating's desire to inscribe layers of meaning to his work: recent cleaning has revealed that while the seated figure appears to be made of plaster, her reflection takes on a Pygmalion-like human quality.[36] This is the first display of the extent of Keating's intellectual engagement with his subject matter and audience, which ultimately led to him producing some of the finest socio-political and allegorical paintings of twentieth-century Ireland. Orpen did not subscribe to modernism in its abstract form, but it is clear from Keating's *Reflection in a Mirror* that he encouraged his student to consider the intended and the implicit meaning in his imagery. This skill was to prove vital to the development of Keating's brand of Irish social realism. With Orpen's support, Keating matured as an artist. He won many student prizes, including the Orpen Composition Award in 1913, for a celebratory image of the people of the Aran Islands.[37] He first visited the Aran Islands in 1912 or 1913 and continued to do so until 1965. There is no doubt that the people, landscape and traditions of Aran were to become paramount to his personal sense of identity as an artist and nationalist. His attitude was initially highly political and motivated by the desire for independence, a stance that is abundantly clear in, for example, *Men of the West* (1915).[38] Thus, it was profoundly different from Orpen's aforementioned well-meant, but idealistic contributions to the Celtic Revival.

In the meantime, Orpen's artistic influence on Keating was perhaps best exemplified in a final student work created especially for the Royal Dublin Society Taylor Award Scholarship in 1914. The picture represented the culmination of four years of training and the completion of Keating's studentship at the DMSA. It was to be, in essence, his passport to a professional career. In order to be considered eligible for entry for this prestigious prize, students were required to work within a particular theme decided by the panel of judges. In 1914 one of the themes was 'An Appeal for Mercy'.[39] Keating submitted his work with a title that referenced the official requirements, but that gave him more imaginative space in which to develop his theme: *The Reconciliation* (Figure 8.1).[40] That he chose to represent a moment of reconciliation rather than the actual theme as directed by the judging panel clearly reflects Orpen's encouragement to extend the meaning of the painting beyond the immediately obvious. The painting illustrates a group of three, two of whom seem to be in deep discussion with the young lady in the coral hat, apparently entreating her to make reconciliation for some misdemeanour. There is a vaguely unrepentant, even defiant look on her face as her accusers, or confessors, try to appeal to her. Quite what she has done is unclear – perhaps she has argued, returned late from a night out, or borrowed the fur coat she is wearing without permission. As if to augment the implicit meaning of the work, the models were actually Keating's siblings, Mary Frances, Vera and Paul, who was training to become a priest at the time. The fur coat belonged to a member of the family and it appears in several of

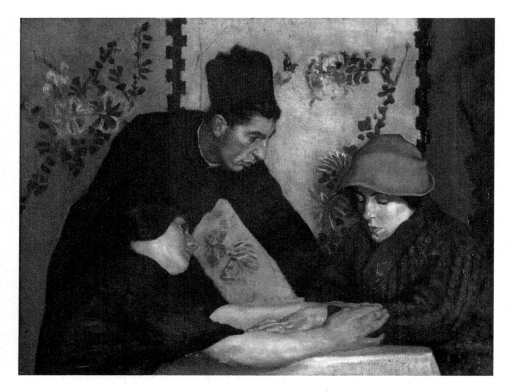

8.1 Seán Keating, *The Reconciliation* (1914), oil on canvas, 110 × 90 cm. Private collection. Photograph © and courtesy of John Searle. Painting © The Keating Estate.

Keating's later portraits of his sisters. The screen in the background of the painting, the inclusion of which enfolds the group in their familial discussion, was a gift from Keating's brother Claude to his mother.

The artistic concerns between mentor and student are clear if comparison is made between *The Reconciliation* and, for example, Orpen's *Grace Orpen: The Coral Necklace*.[41] The colour used for the coral hat and lipstick of Keating's central character echo that used in the necklace and lipstick in Orpen's portrait. The treatment of the skin tones and highlights, and the shadow cast by the coral hat seem to directly mirror Orpen's work. Even the demeanour of the girl in the coral hat is similar to that of her slightly older antecedent. The rendition of fur and the texture of the materials in the painting are evidence of Orpen's attitude to attention to detail, although perhaps enhanced by Keating's youth spent among the fabrics of his mother's dress-making business in Limerick. The decorative partition balances the colour and composition, while also closing off the rest of the room, thereby emulating Orpen's use of swathes of background material in many of his portrait works. The painting was

fashioned by Keating in deliberate emulation and reflection of Orpen, and with a singularly unambiguous aim: to win first prize.

Keating won the Royal Dublin Society Taylor Award with *The Reconciliation*. He received a gold medal and £50, which he used to finance a year in London as Orpen's studio assistant.[42] The First World War was advancing rapidly, bringing with it far-reaching changes. In Ireland, a group of revolutionaries were planning a rising. It was to be the end of Old Ireland, the 'end of an era'.[43]

Orpen, by now settled in London, seems to have realised that his time in Ireland was over. Whether or not he was aware that Keating would assume his position at the DMSA is not clear, but he certainly appears to have had a vision of the future for his former student, which soon came to fruition. During the time that Keating was in London, Orpen painted a commissioned self-portrait in the Edwardian Celtic Revival style entitled *The Man from Aran*.[44] He had never been to the Islands and, although the title might suggest otherwise, there was no political meaning attached to the image, which was part of a series that included the aforementioned *Young Ireland*. Keating, on the other hand, was imbued with a strong sense of separatist nationalism owing to the general atmosphere in Dublin and the political environment at the DMSA, and he readily identified with the Aran Islands as a place of unspoilt Irish tradition. He saw it as the birthplace for a new twentieth-century school representative of Irish art. He was very specific in his attitude to the West of Ireland. At an early stage, he understood that the modernist project had borrowed elements from 'outsider' communities, such as Africa, which were taken out of context to create something new in European art. He also understood that Irish art in general, and the DMSA in particular, had been strongly influenced by English aesthetic values that would be rejected in the climate of the New Ireland. His focus on the West of Ireland was well thought out: he believed that a new school of art could not be born from the ashes of the ascendancy, and that there was a lack of authenticity in 'outsider' art forms and sources.[45] Thus, inspired by Keating's enthusiasm, Orpen revisited *The Man from Aran*. He fashioned from it an iconic and brooding image of his former student entitled *Man of the West: Seán Keating*.[46] In doing so, Orpen created a powerful visual identity for Keating and, at the same time, he acknowledged, and even anointed, his twentieth-century successor.

Twenty years after his death, Orpen's work was condemned by John Rothenstein for its 'dismissal of intellectual preoccupation'.[47] That assessment was made in the context of an era that privileged modernism in its various forms. Yet close examination of some of Orpen's work between 1913 and 1915 demonstrates the extent of his 'intellectual preoccupation' in relation to Ireland, even though it was not an obviously politicised engagement in the manner of early twentieth-century Irish nationalist painting. He made a series of three paintings, using an experimental marble dust technique, that embody a sardonic analysis of Ireland's past, present and future.[48] In a

disruption of Rothenstein's view, these were allegorical, albeit problematic works that even at the time of exhibition warranted explanation by the artist.[49] Of the three large-scale paintings, *The Holy Well* (1915–16) is perhaps the most challenging.[50] It also demonstrates something of the extent of the reciprocal relationship between former mentor and student. It is 'a strange work, with a bizarre, dream-like atmosphere derived from the flat, opaque colouring, the sharpness of light and the dramatic composition'.[51] The setting is that of the Aran Islands, a view that Orpen had never seen, but one that had most likely been described to him by Keating.[52] The background appears two-dimensional and flat, rather like a stage setting, while the foreground is inhabited by vignettes borrowed from the history of art. As if in response to the over-Catholicised attitude towards sex and sexuality in contemporary Ireland, Orpen refused to paint the celebratory display nude in favour of the shamed Adam and Eve type of Masaccio.[53] He presented, at an extraordinary moment in Irish history, an anomalous and deeply symbolic image; a critique of blind obedience to ritual and tradition. Keating stands overlooking the scene, purveyor and surveyor of the ancient custom, as if pleased to be visually presented by Orpen as the *Man of the West* and, as such, greater than the submissive acolytes below. What is the message in this work in which Keating's presence is so dominant? It suggests that although Keating was interested in the West of Ireland as source material for a new art form, both he and Orpen were aware of the potential failure of New Ireland as a result of unquestioning national compliance with official dogma.

This series of paintings were Orpen's final comment on Ireland. Although enigmatic, they reflect his sense of humour and his self-estrangement from the New Ireland. As the First World War closed in, he chose to stay in England. He became a war artist of great renown and a generous benefactor to the war effort. Although he returned to Ireland on a few occasions and kept in touch with Keating, he never again taught at the DMSA or showed work at the RHA.[54]

Keating began his career as he meant to continue. He returned to Dublin: 'the young American back to Ireland just before the rising of 1916'.[55] Quite why he described himself as such, as opposed to 'young Irelander', is unclear, but may have reference to the 'Young America' cultural nationalist movement of the 1840s.[56] Full of self-confidence, he set about the creation of a new Irish art form. There was absolutely no hesitancy in his project. The visual identity that Orpen created for his student in *Man of the West* was deliberately transposed into his first political painting *Men of the West* (Figure 8.2: 1915) perhaps in honour of his former mentor, and certainly as a statement of artistic intent. It is an extraordinary work that resolutely locates Keating in the Aran Islands and as the 'young American', while also giving testament to his separatist nationalist ideals. First shown in the RHA in 1917, the painting is evidence of his resolve to create a new aesthetic for twentieth-century Ireland,

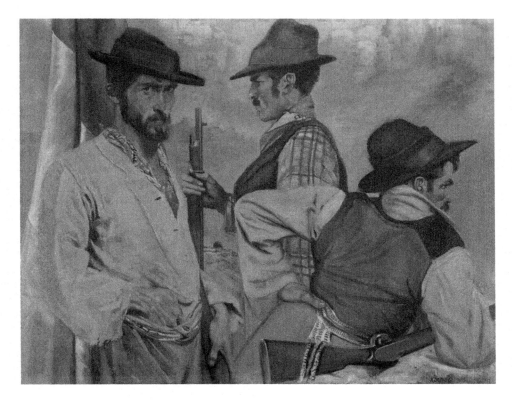

8.2 Seán Keating, *Men of the West* (1915, exhibited 1917), oil on canvas, 125 × 95 cm. Courtesy of Collection of the Dublin City Gallery The Hugh Lane. Painting © The Keating Estate.

the philosophy of which was informed by Orpen's academic methods and James Connolly's belief in a socialist nationalist Ireland. It was, at the time of exhibition, a threefold, life-sized, visual declaration: Keating was now a professional artist, with nationalist ideals, and a committed belief in the importance of the arts and artists to the creation and sustenance of a New Ireland. His rise to national and international recognition was as impressive as Orpen's had been. He was elected an Associate of the RHA in 1918, a full member in 1923 and President of the organisation in 1950. He resigned as President in 1962 in order to complete a large-scale mural commission for the International Labour Office in Geneva, but continued to show work at the RHA until he died in 1977. He exhibited work at several other important venues in Ireland. He also sent work to Belgium, England, Scotland and, until the start of the Second World War, to several states in America.

Keating began to teach, in the style of Orpen, at the DMSA summer schools in 1916. In 1919 he was placed on a part-time year-long contract and was appointed to teach anatomy. This same contract was renewed on a yearly

basis until 1937. Students have given varying accounts of Keating as a teacher: some negative and many positive. Like Orpen, and for similar reasons – overcrowding and lack of facilities – he spent more time with the students he thought had talent.[57] Hardly surprisingly, he was, at all times, firm about academic standards. In 1925, at the request of a government official, he wrote a report on the DMSA, which noted that little had changed since Orpen's contribution to the parliamentary inquiry in 1905.[58] Returning to Orpen and the Slade School method, Keating noted that: 'The formula for the making of a good School of Art is "By Artists for Artists". A School of Art needs a few artists, a few students, a registrar, and money in reason. Big buildings, elaborators, expensive apparatus do not count at all'. One of the main issues concerning Keating was that the DMSA should have academic standards akin to those of universities: 'It is clear that the school should be either reorganised as a University for those who intend to make Art their profession, or that it should be abolished'.[59] Ultimately, Keating's report, and observations by well-known critics such as Thomas Bodkin, eventually led to the 'French Report' in 1927. But it was not until 1937 that many of the substantive issues were resolved and Keating was appointed as Professor of Anatomy on a permanent, although part-time basis. In the meantime, he became a well-respected, if controversial cultural commentator and broadcaster. One of his many concerns was the creation of an 'Irish' school of art, which, he felt, would emerge as a result of official support for all artists. When in 1931 a group of artists, whose work had not been accepted for the summer exhibition at the RHA, put up their own 'reject' exhibition, Keating supported their stance and loaned some of his work to their show. He took the opportunity to castigate academies and art critics, noting that:

> To suggest that an Academy has no use for youth or courage or novelty or enterprise, for indignation against injustice – real or imaginary – is to suggest that it is dead. But as long as privilege and authority are dear to humans, as long as middle-age brings caution and laziness, so long will academicians tend to conservatism, arrogance and the vices of middle age. That is why, in my opinion, every institution ought to be abolished every 25 years. It is awful to contemplate how institutions which came into being as incubators end as refrigerators.[60]

By successfully fusing his Orpen-esque training with a desire to create a new Irish social realist art, Keating created some of the best-known images of the emerging Irish Free State between 1917 and 1924. These included *Men of the South* (1921–22), *On the Run, War of Independence* (1922) and *An Allegory* (1924).[61] Throughout the 1920s, he produced a series of portraits of Irish 'types': sportsmen, ordinary workers and intellectuals. These included *Fireman Jim Conway* (1926), *Race of the Gael* (1927) and *The Tipperary Hurler* (1928). Between 1926 and 1927, he documented the up-to-the-minute engineering feat taking place on the River Shannon at Ardnacrusha in County Limerick. A joint

venture between the Irish government and the German company Siemens, the 'Shannon Scheme', as it became known, was the first hydroelectric dam in the country and the earliest project of its type in the Irish Free State, and indeed, in Europe.[62] Keating visually connected the modernity and muscularity of the project with the embryonic potential of post-colonial Ireland, and the results were critically acclaimed.[63] Taking a lead from Orpen's problematic symbolic paintings about Ireland, he produced the first of many highly successful allegorical works in 1924. *An Allegory*, for example, was meant as a socio-political assessment of the pointlessness of the Irish Civil War (June 1922–May 1923) in which his formerly heroic self-portrait, constructed initially by Orpen, now lay disillusioned and worn out, beneath the branches of an ancient oak tree. Although he subscribed initially to violent nationalism, he repudiated those beliefs after the Civil War, professing subsequently to have little interest in politics:

> I used to feel strongly about things between 1916 and [19]22, but the situation after 1922 was so heartbreaking that I thought no more about it. I knew the people concerned and I recorded some aspects of the events, a pictorial record. I wasn't concerned with politics, in which I don't believe. I was getting a record of the events, the places, the struggle, which was heroical.[64]

When the Treaty of Independence was signed in December 1921, New Ireland became an official entity and there began an ongoing debate among critics, commentators and artists concerning the development of Irish art. It was vital discussion, replete with tension and controversy, all of which was necessary to a newly emerging and developing nation. Keating's initial youthful and ebullient hope in the New Ireland turned to frustration as successive governments continually failed to deal with economic instability, job losses and emigration. Although his name had become synonymous with colourful images of the life of Aran Island people, in the late 1940s and early 1950s he returned to images of the West of Ireland, and to allegorical work, in order to once again critique the 'rotten state of things', evident in *Ulysses in Connemara* (1947) and its pendant *Economic Pressure, or A Bold Peasant Being Destroyed* (Figure 8.3: 1949–50).[65]

Several of the crucial debates emerged during a series of art controversies in the 1940s and 1950s with which Keating, as an advocate of academic training, was involved. Although his work, and teaching style, continued to be popular, these controversies, and his tenure as President of the RHA, served to alienate him further from art critics who supported modernist tendencies. His time as President of the RHA also coincided with the formation of the Arts Council of Ireland (1951), which was established to support Irish art, but initially appeared to support modernist work, as opposed to that seen as traditional or academic. He joined in the discussions with great enthusiasm, even inventing a pseudonym in order to write provocative correspondence to Irish cultural agencies.[66] By the

8.3 Seán Keating, *Economic Pressure, or A Bold Peasant Being Destroyed* (1949–50), oil on canvas, 122 × 122 cm. Courtesy of Collection of the Crawford Art Gallery, Cork. Painting © The Keating Estate.

time of the student riots and lockouts in the National College of Art (formerly the DMSA) in the late 1960s and early 1970s, he had retired from teaching, and the nature and extent of the academic training that he had undertaken as a student, and espoused as a teacher, had become deeply unpopular.[67]

For his entire working life, Keating felt a deep sense of gratitude to Orpen. He appreciatively absorbed all that Orpen had to offer: artistic skills, self-esteem and, most importantly, the ability to commit to a life of hard work. Assured of his ancestry in the tradition of the history of art, Keating openly acknowledged that Orpen had given him his 'first break'.[68] Through his

educational relationship with Orpen, he felt a significant contact to these important Old Masters:

> I have never been in Rome, I regret to say, tho' I may fairly claim to have inherited a share in Latin culture and civilization via the Beaux Arts and the Prix de Rome from the men who taught the men who taught Tonks who taught Orpen who taught me.[69]

Even if Keating did feel he had been imbued with the Grand Manner of the Old Masters through his tutor, no analogies to the teacher's Masaccian models appeared in the social realist images produced by the pupil. Keating's emulation of Orpen did not produce work that was derivative of his mentor. Their artistic relationship, certainly at that moment in 1915, was reciprocal. Keating intentionally fused his academic training with his firm belief that art and artists had a role in society. He developed a highly recognisable and entirely original 'Irish' style as his contribution to the creation of a New Ireland. Owing to the socio-economic conditions in the country, he had to teach, as well as operate a studio practice, for the rest of his life. He taught, every day, for over 50 years.

Orpen, who was socially well connected, had a deservedly spectacular career in London. After 1914, he never taught again. His apparently non-political stance seems to have been contrived and indicative of a sense of dislocation from the Old Ireland that he had known as a child. His emotional displacement from the heart of the Anglo-Irish Cultural Revival, to which he had willingly contributed idealised, if problematic, paintings of beautiful, over-dressed and decorated women, and symbolic images of the West of Ireland, came about as a result of the emergence of a New Ireland analogous to the First World War. The final paragraph of his autobiography, *Stories of Old Ireland and Myself*, published in 1924, a poignant year in Irish history, would suggest that he was well versed in Irish politics: 'A new era has come to land. No longer is the shamrock put to shame by being trodden underfoot. No longer are men and women hanged for the wearing of the green. Now the shamrock has its place in the sun, and long may it remain there, green and verdant'.[70] But this was a new era in which Orpen knew he could not live. Having visually declared his former student as the real *Man of the West*, he left it to Keating to successfully create an authentic art form for twentieth-century Ireland, one that audiences could identify with, and students might emulate and bring on into their own time.

Described as 'a man of great honesty and distinctiveness', Keating was not, according to Colm O'Briain, 'a world art figure, but that was because the entire period in which he worked was unknown internationally, and it was just becoming known now'.[71] Yet he was 'an outspoken advocate of a better position for the artist in Irish society', whose experience over the years had proven that 'the Minister for Education was a negligible person, because [art] was always the last thing on the agenda', while 'art critics came between the

artist and the public … the critic of art is not a menace, but a nuisance'.[72] After a lifetime of service to his easel, to his students and to various institutions, Keating firmly believed, even in the face of his critical reception from the 1950s, that the 'apostolic succession of art is not broken. There are no gaps or flying leaps into the dark of futurity'.[73] The student-teacher relationship between Keating and Orpen was thus a vital art-historical connection which reacted to changing political and cultural interests in Ireland after the 1920s. The importance of traditions and authenticity within this pedagogical bond allowed Keating to lay sturdy foundations for what he hoped would be a national school of art for New Ireland.

Notes

1 National Archive, Dublin: State Papers, file S 3458: John Keating, R.H.A., 'Report to Mr Joseph O'Neill at his request in 1925', p. 4. For the full text, see Éimear O'Connor, *Seán Keating in Context: Responses to Culture and Politics in Post-Civil War Ireland* (Dublin: Carysfort Press, 2009), pp. 75–7.

2 The Irish Free State came into being in 1922 as a result of the Anglo-Irish Treaty (1921). For further theoretical discussion on tradition and modernity in Ireland in the post-Civil War era, see Éimear O'Connor, 'Seán Keating: Contemporary Contexts', catalogue essay for the eponymous exhibition at the Crawford Art Gallery Cork (Cork, 2012) and Éimear O'Connor, *Seán Keating: Art, Politics and Building the Irish Nation* (Dublin: Irish Academic Press, 2013), which both utilise the concept of 'essentialism and epochalism' as outlined by anthropologist Clifford Geertz to tease out the cultural issues that emerged in post-Civil War Ireland.

3 Clifford Geertz, 'The Politics of Meaning', in *The Interpretation of Cultures* (New York: Basic Books, 1973), p. 319.

4 Kenneth McConkey, 'Sir William Orpen: His Contemporaries, Critics and Biographies', in *Orpen and the Edwardian Era* (London: Pyms Gallery, 1987), p. 13. McConkey quotes John Rothenstein, *Modern English Painters: Sickert to Smith* (London: Eyre and Spottiswoode, 1952, 3 Volumes), Vol. I, pp. 218, 222 and 226.

5 Roy Foster, 'Orpen and the New Ireland', in Robert Upstone (ed.), *William Orpen: Politics, Sex and Death* (London: Tate Publishing, 2005), p. 63.

6 P.G. Konody and Sidney Dark, *Sir William Orpen, Artist and Man* (London: Seeley Service, 1932), p. 41.

7 For a full biography, see Bruce Arnold, *Orpen: Mirror to an Age* (London: Cape, 1981).

8 Ibid., p. 38.

9 Ibid., pp. 39–40.

10 Ibid., p. 39.

11 John Turpin, *A School of Art in Dublin since the Eighteenth Century: A History of the National College of Art and Design* (Dublin: Gill & Macmillan, 1995), p. 221.

12 Alphonse Legros (1837–1911) joined the staff of the Slade in 1876 and introduced etching, modelling and French Realism to the syllabus. His etchings, such as *The Wayfarer*, owe a great debt to Gustave Courbet (1819–77). Frederick Brown (1851–1941), who succeeded Legros in 1892, also studied in Paris at the *Académie Julian*, a popular place of pilgrimage for Irish students at the time. He was further inspired by the work of Jules Bastien-Lepage (1848–84), James McNeill Whistler (1834–1903) and Wilson Steer (1860–1942). He appointed Steer and Henry Tonks (1862–1937) to the staff of the Slade in 1893. Steer travelled to Paris to study at the *Académie Julian* in 1882. He too was inspired by the work of Bastien-Lepage, Whistler and Edgar Degas (1834–1917).

13 Seán Keating, 'William Orpen: A Tribute', *Ireland Today*, II (1937), p. 21.

14 Sir William Orpen, *Stories of Old Ireland & Myself* (London: Williams and Norgate Ltd., 1924), p. 78.

15 Turpin, *A School of Art in Dublin*, p. 219.

16 Bruce Arnold, *William Orpen: 1878–1931* (Dublin: Town House in association with the National Gallery of Ireland, 1991), p. 29. See also, Turpin, p. 220 and Arnold, *Orpen: Mirror to an Age*, p. 165.

17 Orpen, *Stories of Old Ireland*, p. 25. Orpen writes in *Stories* about the one female model he remembered being brought to the DMSA when he was 12 years old: 'Her extremities were dirty and the rest of her beauty was marred by countless spots as if she had been in an altercation with a wasp's nest'.

18 Turpin, *A School of Art in Dublin*, p. 220, quote taken from Orpen, *Stories of Old Ireland*, p. 78.

19 Turpin, *A School of Art in Dublin*, p. 192.

20 McConkey, 'Sir William Orpen', p. 10.

21 A Report by the Committee of Inquiry into the work carried out by the Royal Hibernian Academy and the Metropolitan School of Art was published in November 1906. See Arnold, *Orpen: Mirror to an Age*, p. 166.

22 Arnold, *Orpen: Mirror to an Age*, p. 162.

23 Turpin, *A School of Art in Dublin*, p. 217. The recommendation was made by Sir William Abney in a report on behalf of the Department of Science and Art.

24 Orpen, *Stories of Old Ireland*, p. 62.

25 Turpin, *A School of Art in Dublin*, p. 217.

26 Arnold, *Orpen: Mirror to an Age*, p. 162.

27 Ibid., p. 123.

28 Orpen, *Stories of Old Ireland*, p. 62.

29 Keating had three sisters: Mary Frances became a well-known cookery writer; Vera an ardent feminist and secondary school teacher; and Claudia read science at University College Dublin. See O'Connor, *Seán Keating: Art, Politics and Building the Irish Nation* (Dublin: Irish Academic Press), chapter 1.

30 For an analysis of the boycott of the Jewish community, see Dermot Keogh and Andrew McCarthy, *Limerick Boycott 1904: Anti-Semitism in Ireland* (Cork: Mercier Press, 2005).

31 Helen Buckley, 'Seán Keating, Artist Extraordinary', *The Limerick Leader*, 26 February, 1972, p. 13.

32 KPPC (Keating Papers, Private Collection, catalogued by Éimear O'Connor) 735/45(1)/2, letter from the Department of Agriculture offering Keating a 'teachership in training' place at the DMSA, 21 July 1911.

33 Kerry McCarthy, 'Portrait of the Artist as an Angry Old Man', *Irish Independent*, 6 June 1973, p. 8.

34 Seán Keating, 'A Tribute to William Orpen', *Ireland Today*, II (1937), p. 26.

35 Keating gave this painting to his mother in about 1913. It is now in a private collection. See O'Connor, *Seán Keating: Art, Politics and Building the Irish Nation*, p. 51.

36 Ibid.

37 Entitled *Pleáraca ar Arainn* (*A Happy Time on Aran*), whereabouts unknown. Described in 1917 as 'depicting an Aran piper in full "war paint", playing lustily on his pipes for his friends': John J.R. O'Beirne, 'A Coming Irish Artist, The Work of John Keating', *The Rosary*, 21 (1917), pp. 571–75.

38 *Men of the West* is discussed in greater detail later in this chapter.

39 The judges of the RDS Taylor Award were representatives from the RDS, from the RHA and from the National Gallery of Ireland.

40 See O'Connor, *Seán Keating: Art, Politics and Building the Irish Nation*, pp. 54–5. This painting had been missing since 1914. It was identified by the author in 2005 and is now in a private collection.

41 See illustration in Arnold, *Orpen: Mirror to an Age*, p. 97.

42 While teaching at the DMSA, Orpen invited two of his students to assist him at his London practice. James Sleator (1885–1950), whom Keating replaced as studio assistant to Orpen in 1915, came from the Portadown area of County Armagh. Having studied at the Belfast School of Art,

he joined the DMSA in 1909, remaining there until he travelled to London with Orpen in 1914. Once he left London, Sleator had a varied and well-travelled career, returning to Orpen's studio as assistant again in 1927. It was Sleator and not Keating who was approached to fulfil Orpen's portrait commissions on the death of the older artist in 1931. Sleator was elected President of the RHA in 1945 after the death of Dermod O'Brien. He died in January 1950 after which Keating was elected to the role. Keating was President of the RHA from 1950 until his retirement from the position in 1962.

43 Arnold, *Orpen: Mirror to an Age*, heading for chapter 22.

44 Commissioned by Mrs Howard St. George and purchased, with *The Holy Well*, in 1916. Private collection.

45 O'Connor, *Seán Keating in Context*, p. 10.

46 Limerick City Gallery of Art. For further discussion, see O'Connor, 'Seán Keating: Contemporary Contexts', pp. 12–13 and *Seán Keating: Art, Politics and Building the Irish Nation*, pp. 58–59.

47 McConkey, 'Sir William Orpen', p. 13. McConkey references John Rothenstein, *Modern English Painters, Sickert to Smith* (London: Eyre & Spottiswoode, 1952, 3 volumes), Vol. I, p. 222.

48 *Sowing the Seed* (1913), collection of the Mildura Arts Centre, Australia; *The Western Wedding* (1914), whereabouts unknown, study in the Graves Collection, National Gallery of Ireland; *The Holy Well* (1915), collection of National Gallery of Ireland.

49 See Foster, 'Orpen and the New Ireland', p. 72, for Orpen's explanation of *Sowing the Seed*. Foster references a letter dated 15 August, 1914 from Orpen to Adelaide Public Library Board, quoted in Arnold, *Orpen: Mirror to an Age*, p. 290.

50 Keating returned to London in 1915 with items of clothing from the Aran Islands. Orpen was, according to Keating, delighted with the Aran clothes and invited his wife, children and their cousin Eileen around to the studio to dress up, and it was from this particular afternoon that his *The Holy Well* emerged. See Arnold, *Orpen: Mirror to an Age*, p. 292. Arnold quotes from a verbal interview with Keating carried out in the summer of 1977.

51 Arnold, *Orpen: Mirror to an Age*, p. 295.

52 Comparison with Keating's *Thinking Out Gobnait* (1917) suggests that he may have at least contributed to painting the background for Orpen's *The Holy Well*.

53 The nudes in *The Holy Well* make visual reference to Masaccio's fresco series in the Brancacci Chapel, Santa Maria del Carmine, Florence, Italy. See also, Arnold, *Orpen: Mirror to an Age*, p. 295 which refers to nudity as an 'anathema in Ireland' at that time.

54 KPPC 162/22a/6 is an undated letter from Orpen to Keating in which he wrote that he had just returned from a visit to Meath. He advised Keating to go to Aran for a rest because he had 'burned himself out' and that he would make sure that his 'job at the school would go on'. The content suggests a date c.1916–19 and indicates that Orpen had influence on the management of the DMSA.

55 John Skehan, 'Palette and Palate', *Word*, April 1965, unpaginated.

56 See, for example, Edward L. Widmar, *Young America: The Flowering of Democracy in New York City* (Oxford: Oxford University Press, 1999).

57 See John Turpin, 'The School under Keating and McGonigal', in *A School of Art in Dublin*, pp. 331–47.

58 Keating, 'Report Made to Mr Joseph O'Neill at His Request in 1925', p. 1. See O'Connor, *Seán Keating in Context*, pp. 75–77.

59 Ibid., p. 77.

60 John Keating, 'Talk on Artists and Academicians', broadcast on 2RN, 22 May 1931. See the full text in O'Connor, *Seán Keating in Context*, pp. 82–6.

61 *Men of the South* and *On the Run, War of Independence* reside in the Crawford Art Gallery, Cork, while *An Allegory* is in the collection of the National Gallery of Ireland, Dublin.

62 See Andy Bielenberg (ed.), *The Shannon Scheme and the Electrification of the Irish Free State: An Inspirational Milestone* (Dublin: Lilliput Press, 2002). See also Éimear O'Connor, 'Seán Keating and the ESB: Enlightenment and Legacy', catalogue essay for the eponymous exhibition (Dublin: Electricity Supply Board, 2012).

63 Most of these paintings are now in the collection of the Electricity Supply Board (ESB).

64 Skehan, 'Palette and Palate'. Further allegorical work includes *Sacred and Profane Love* (1927), a comment on the potentially negative effect of consumerism, and *Homo Sapiens, An Allegory of Democracy* (1930), a self-explanatory observation about the alienation of man from the modern world that he, in the quest for progress, created.

65 Private collection and Crawford Gallery Cork respectively.

66 O'Connor, *Seán Keating in Context*, pp. 48–9.

67 In 1937 the DMSA became the National College of Art (NCA). It is now the National College of Art and Design (NCAD).

68 Inscribed by Keating on the frontispiece of Orpen's book, *Stories of Old Ireland*, 4 March 1967.

69 Keating, 'Letter to a Reverend Mother', Pontifical Irish College Rome, January 1974, in response to a series of questions about his *Saint Patrick Lights the Paschal Candle at Slane* (1931/2), donated to the Irish College in 1937 by the Haverty Trust.

70 Orpen, *Stories of Old Ireland*, p. 94. Orpen mentions many political issues throughout the book, including the Phoenix Park murders and the official arming of Ulster.

71 Willie Kealy, 'Work and Personality Evoke Many Tributes – Keating – A Portrait of the Artist', *Irish Press*, 22 December 1977, p. 4.

72 Ibid.

73 Ibid.

Prototype and Perception: Art History and Observation at the Slade in the 1950s

Emma Chambers

The diary of William Townsend for 17 October 1947 describes a conversation between himself, William Coldstream and Victor Pasmore when they were all teaching at Camberwell School of Arts and Crafts:

> Walk with Victor and Bill beside the canal at Peckham between afternoon and evening teaching sessions. We talked about the difference of attitude, especially of attitude to the objective world, between realist painters of our kind and the contemporary romantics or the idealists of the école de Paris. Bill, pointing to a crane, folded against one of the warehouses across the canal, stated like this the fundamental divergence between the painter interested first in a world outside himself and the painter interested in a world of his reactions with only the picture as an outside object. 'They start where we leave off. They believe that they can draw that crane without any difficulty, the only problem is where to place it and in what picture. We are not sure we can draw it as we see it and the whole picture is our attempt to do so and we consider we have done well if we get somewhere near it'.[1]

This conversation sums up the conceptual split between different methods of art practice and teaching at the Slade School of Fine Art in the 1950s, a decade when the School was in transition, following the appointment of Coldstream as Slade Professor in 1949. Coldstream had trained at the Slade under Henry Tonks between 1926 and 1929, and subsequently was a founder member of the Euston Road School and Head of Art at Camberwell. His own painting practice relied on a perceptual method of objective painting, which sought to resolve the problem of how to represent what the artist saw truthfully and accurately. He addressed the existing relationships of objects in space as important in themselves rather than as material to be manipulated to produce a pleasing visual effect, and composition was incidental to his work. The gap between observation and representation was bridged by a meticulous method

that attempted to fix the reality of the visible world by means of measurement. He established the proportions and relative locations of key features with horizontal and vertical marks, and these were left visible in many of his finished canvases. His goal was to establish the 'rightness' of objects in space; the measuring marks that represented the struggle to do so were an integral part of the finished painting.[2]

When Coldstream studied at the Slade in the 1920s under Tonks, he trained in a system virtually unchanged since the 1890s. After a short period in the antique studio, students studied intensively from the life model. Tonks taught a linear method of constructive drawing where the surface form of the figure was expressed through contour rather than tone and was determined by the underlying anatomical structure. Students were expected to look intently at the model in order to understand its form, but Tonks also used Italian Renaissance drawings as examples to show how this observation of anatomical form should be translated into two dimensions. He emphasised the value of study from the Old Masters, and students were encouraged to draw from artworks in the National Gallery and British Museum Print Room. However, this study was not expected to replace observation or to encourage an imitation of style, but instead to inculcate an understanding of method. Nonetheless, despite Tonks' emphasis on observation, what the students saw and represented in the life studio was preconditioned by two *a priori* visual sources – a knowledge of anatomy and existing artistic prototypes – as Tonks' demonstration drawing and its visual sources demonstrate (Figures 9.1–9.3).[3]

In 1907 the School produced a publication entitled *The Slade: A Collection of Drawings and Some Pictures Done by Past and Present Students of the Slade School of Art 1893–1907*. This aimed to define the School's concepts of drawing and composition. In John Fothergill's essay on the Slade's concept of drawing, emphasis was placed on observation as a means of understanding form, and it was argued that artistic style would grow naturally out of this process of observation and understanding, rather than be acquired by superficial imitation of Old Master drawings:

> Style then, is the expression of a clear understanding of the raw material from which the artist makes his creation. In drawing, the raw material is the forms of nature. Without this clear understanding no style is possible … Therefore, to attempt to employ the manner of another would be to suppose in yourself a perfect coincidence of temperament … Your work would be quickly esteemed unspontaneous and false by those who know nature and the truth of your original. Style as understanding cannot be imitated.[4]

The combination of observation and use of art-historical prototypes that characterised teaching at the School was exemplified by the Slade's Summer Composition Competition. This followed a tradition established in European academies of art since the seventeenth century, where students would

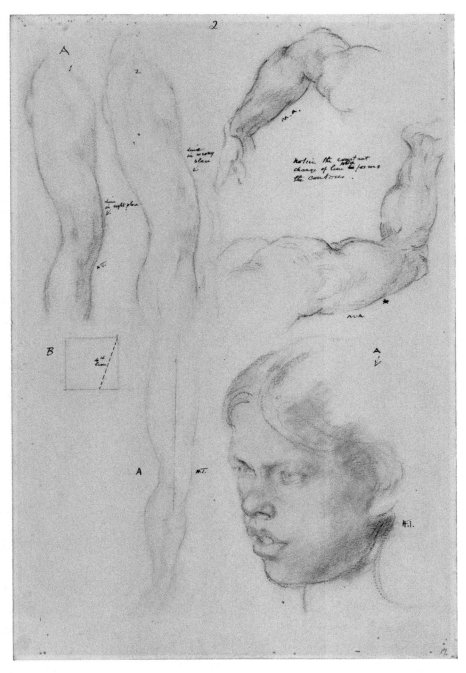

9.1 Henry Tonks, *Demonstration Drawing* (c.1908), pencil and red chalk on paper, 40.6 × 28 cm, UCL Art Museum, University College London.

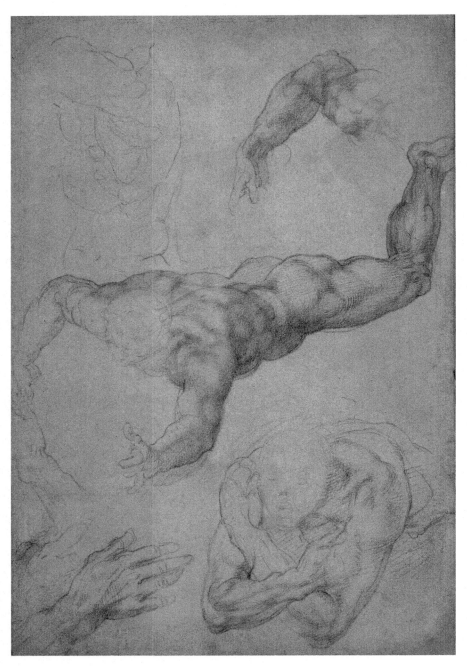

9.2 Michelangelo, *Studies for the Last Judgement* (1534), black chalk on paper, 40.4 × 27 cm
© The Trustees of the British Museum.

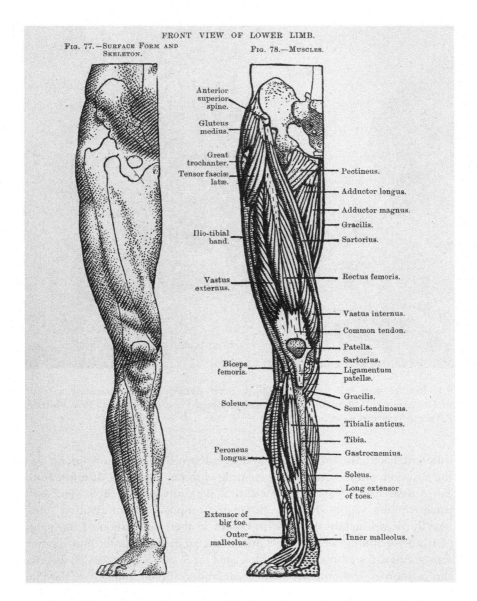

FRONT VIEW OF LOWER LIMB.

FIG. 77.—SURFACE FORM AND
SKELETON.

FIG. 78.—MUSCLES.

Anterior
superior
spine.

Gluteus
medius.

Great
trochanter.
Tensor fasciæ
latæ.

Ilio-tibial
band.

Vastus
externus.

Biceps
femoris.

Soleus.

Peroneus
longus.

Extensor of
big toe.
Outer
malleolus.

Pectineus.

Adductor longus.

Adductor magnus.

Gracilis.

Sartorius.

Rectus femoris.

Vastus internus.

Common tendon.

Patella.

Sartorius.
Ligamentum
patellæ.

Gracilis.

Semi-tendinosus.

Tibialis anticus.

Tibia.

Gastrocnemius.

Soleus.

Long extensor
of toes.

Inner malleolus.

9.3 Front View of Lower Limb, figures 77–8 from Eugene Wolff, *Anatomy for Artists* (1925), UCL Art Museum, University College London.

execute a large-scale history painting in their final year. This painting was considered to be the culmination of the student's studies, where the range of skills acquired in figure drawing, perspective and composition could be demonstrated, and the Slade's Summer Composition Competition was no

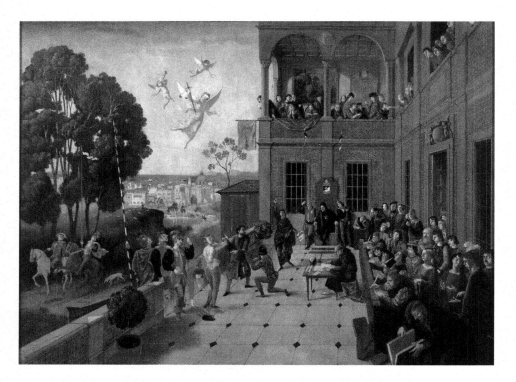

9.4 Rex Whistler, *Trial Scene from 'The Merchant of Venice'* (1925), oil on canvas,
91.4 × 122 cm, UCL Art Museum, University College London © Estate of Rex Whistler.
All rights reserved, DACS 2012.

different. Each summer, students at the Slade were set a title to work on over
the vacation and the paintings were judged in the following Autumn Term.
Titles were usually taken from classical literature or the Bible, and early
prize-winning works from the Summer Composition Competition relied
heavily on art-historical prototypes, both in their adaptation of the genre
of history painting and in their quotations from Old Master and modern
artists. Augustus John's painting *Moses and the Brazen Serpent*, which won the
competition in 1898, employed the classic compositional strategies of Baroque
history painting, where supporting figures interpret the central dramatic
event for the viewer through their reactions, and quoted from artists such
as Rubens, Michelangelo, Tintoretto and El Greco.[5] The requirements for the
Summer Composition Competition remained unchanged in the 1920s, when
Coldstream attended the Slade, but the range of set subjects had broadened
and the students' response to them embraced different stylistic models. Rex
Whistler's *Trial Scene from 'The Merchant of Venice'* (Figure 9.4), which won first
prize in 1925, took its stylistic cues from the revival in decorative painting,

influenced by Quattrocento Italian frescoes, at this period. This style of painting continued to dominate student entries for the Summer Composition Competition in the 1930s and 1940s.

Tonks retired as Slade Professor in 1930, and under his successor, Randolph Schwabe, staff and teaching at the School remained virtually unchanged. Schwabe's professorship coincided with a difficult period when the Slade moved to the Ruskin School in Oxford during the Second World War. In an effort to re-establish the identity of the School after its return to London in 1945, the Slade's pedagogical values were publicly articulated by George Charlton, a member of the teaching staff, in an article published in *The Studio* in October 1946 that emphasised the importance of tradition in the success of the School:

> The essence of the Slade is its tradition, continuous from its first day ...
> Broadly this tradition is founded on the study and admiration of the Old
> Masters, but in no slavish spirit ... More precisely the basis of the Slade
> tradition is the intense study of constructive drawing.[6]

However, despite this celebration of tradition in Charlton's article, over the course of the 1930s and 1940s, the reputation of the School had declined, and an unquestioning adherence to tradition was partly to blame. Most of the staff teaching at this period had been taught and appointed by Tonks, and they continued to follow his methods. But without Tonks' strong personality, the School lacked direction, and without his talent for teaching, the quality of students' work declined. Sharing Tonks' dislike for modernism, staff and students had also failed to respond to developments in the wider art world, and the School had come to represent an inward-looking academicism which lacked relevance to contemporary art practice.

Coldstream's appointment as Slade Professor in 1949 initiated a change of approach at the Slade. He immediately requested an increase of staff to bring staffing levels up to those of Camberwell and the Royal College of Art.[7] In his first two years at the School, he appointed fellow Euston Road School and Camberwell artists Townsend, Sam Carter, Andrew Forge, Claude Rogers, Lynton Lamb and Patrick George to the staff. However, Townsend noted in his diary 'it is of some moment that the new set-up should be a broad-based one, not consisting entirely of recruits from Camberwell', and Coldstream achieved this by also appointing artists such as John Aldridge, John Buckland-Wright, Lucian Freud and Robert Medley to the Slade staff.[8] To further diversify the teaching staff and ensure a connection to the wider European art world, Coldstream set up a system of visiting teachers. These included Edward Ardizzone, Alberto Giacometti, Fernand Leger, Jacques Lipchitz, Marino Marini, Henry Moore, Victor Pasmore, John Piper, Graham Sutherland and Keith Vaughan. Alongside these new appointments, staff such as Peter Brooker, George Charlton, Allan Gwynne-Jones, Franklin

White and John Willkie who had taught under Schwabe continued to teach at the School.

The new regime at the Slade resulted in a different approach to life drawing and painting at the School. Coldstream's own approach to painting, and the teaching methods of newer staff members such as Carter, encouraged many students to think of their work in the life room as an investigation of perception and representation rather than as a process of acquiring proficiency in a method of constructive drawing, as had been the case in Tonks' day. At the same time, Coldstream was also aware of continuities between his working methods and the tradition of realism based on observation that had been central to the Slade throughout its history. This was emphasised in a new historical introduction to the Slade prospectus that interpreted the Slade tradition in the light of current practice, emphasising investigative observation over the imitation of method and style: 'From the beginning, students at the Slade School were allowed to draw from the life after only a short period in the cast room. They were expected to inquire into the principles of drawing and to use their own vision rather than to accept without question academic convention'.[9]

In the 1950s, the Slade, with its tradition of figurative observational practice, appeared to be in the ideal position to capitalise on the revival of realism in British art. The early 1950s saw an intense debate about the nature of realism in which opposing positions were taken by critics such as David Sylvester and John Berger. Broadly speaking, Sylvester's concept of realism focused on Francis Bacon's imaginative evocation of the human condition, whilst Berger's politically committed realism demanded realist subjects and was more closely aligned with the 'Kitchen Sink' painters.[10] In 1954 Alfred Garrett's article 'The New Realism in English Art' defined realism in more pluralistic terms, identifying four categories of realism (objective, political, sense and philosophical).[11] Whilst Coldstream's own practice centred on objective realism, and he was cited by Garrett as exemplary of this category, the practice of observational realism at the Slade was in constant tension with the exemplars of art history.

Coldstream later wrote about the tension between theory and practice in Tonks' concept of drawing, and the difficulty of reconciling empirical observation with an *a priori* knowledge of the Old Masters:

> The difficulty about art schools in our time which I imagine applied to art schools for a very long time before, was that one's programme was very unrealistic, based on an ideal of painting which had no existence anywhere, the mixture of trying to achieve a Renaissance drawing, which of course was an impossibility really, coupled with an almost surrealist juxtaposition of, say, Sickert or Wilson Steer. It produced a situation in which one was almost bound to postulate the kind of painting which didn't exist and which one couldn't imagine. One was trying to do something quite impossible as far as the academic side of it went.[12]

Despite his wariness of the imitation of art-historical prototypes, Coldstream was convinced of the importance of art history in providing an intellectual foundation for the students' studies. He included a paragraph in the prospectus that traced the teaching of art history at the Slade from its introduction in 1890 to the appointment of Rudolph Wittkower in 1949, emphasising the centrality of the subject to the curriculum. The content of Wittkower's inaugural lecture was recorded by Townsend, who also noted its importance for establishing the Slade as an intellectual force within the university:

> He struck a good blow for the Slade which can no longer be dismissed as a home of eccentrics and scatter-brained 'arties', but now encloses an air as dense with learning as any faculty of the college. It was an admirable lecture, closely argued and clear ... on the relationship of the artist and his art to the 'liberal arts'.[13]

Wittkower's lectures at the Slade provided an important link between studio practice and theory. Instead of following a traditional art-historical chronology, Wittkower focused on traditions of image production and aspects of the artist's profession such as patronage, status, studio practice, colour theory, the history of drawing and ideas of space in art and science which had more relevance to Slade students as producers of art.[14] Wittkower was succeeded in 1956 by Ernst Gombrich. At this time, Gombrich was developing his ideas for *Art and Illusion* (1960) and his lectures at the Slade focused on the history of ideas.[15] Coldstream also invited distinguished speakers from outside the Slade such as the art critic David Sylvester, who regularly gave lectures and seminars, including an influential series of lectures on realism in 1953.[16] Other visiting lecturers included Kenneth Clark, Roland Penrose, Richard Wollheim, Ellis Waterhouse and Patrick Heron.

Coldstream's acceptance of 'given subject matter' as a problem to be investigated in his own practice influenced his modifications to the Slade curriculum. Whilst he retained the existing framework, based around the life and antique studios, he introduced changes in studio practice that subtly shifted the manner in which students worked. The antique studio was filled with plants, and students could choose either to work from the casts to produce an 'antique' drawing or from the plants to produce a 'still-life'. This innovation had the effect of promoting the background which the plants provided to the sculpture casts into a foreground worthy of detailed visual analysis in its own right. The antique studio was transformed from an environment of revered classical prototypes, which inculcated students in the academic tradition, to a site for observational practice using a type of subject matter that had to be analysed purely in visual terms on the two-dimensional pictorial surface without the academic associations of study from the antique.

The life room remained at the centre of Slade practice, but here too modes of observation became as important as methods of constructive drawing. Although older tutors who preserved a reverence for the Slade traditions of drawing descended from Tonks continued to teach at the School and maintained the connection to these practices, Carter and Coldstream introduced new methods of working from the figure. Carter encouraged the students to look intensely at the model and map it out on the paper by marking points where shifts in the positions of planes or the relationship of the figure to negative space could be clearly observed.[17] This method emphasised the importance of perception and the process of its transfer to paper without necessarily understanding what the outcome would be, rather than the use of pre-existing knowledge of anatomy or Old Master drawing to interpret observation and produce a drawing that had been mentally prepared in advance. Stephen Chaplin, who was a Slade student between 1952 and 1955, describes this method and its links to ideas of perception in detail:

> In this process marks were the result of registering points where one could be relatively sure, ie changes of direction, or the more easily definable locations presented by the human body eg. Tip of nose relative to corner of screen, nipple, navel, to edge of throne. This was a question of lengths, angles and direction, which could be checked off first with the pencil held up at arm's length and then registered with a dot. Thus it was not a question of either forming an initial outline, or imputing an unseen skeleton, or of masses and voids but of recording visual 'facts' on positions of planes in relation to each other … These facts were not the important skeletal elements of eg. Skull, clavicle, pelvis 'known' to the anatomist Tonks or to his pupil George Charlton. They were ways of defining *all that could be seen* hence the later elaboration in this context of a notion of *democracy of vision* … To obtain some idea of this teaching one has to recreate the synthesis between verbal monologue and drawing process. And what all the tutors said was the subject of long student conversation. Many of us found the process of looking or registering with pencil or with paint absorbing. That is to say it was not an easy method, but a framework for constant refinement of one's perception. On one memorable occasion Carter came to me as I sat drawing in the antique room. Standing behind me, he said: 'That's a better drawing! … I can't see what it's of'.[18]

One student influenced by Coldstream's painting methods was Euan Uglow, who had studied with him at Camberwell before coming to the Slade in 1950. Uglow developed a life room practice based on Coldstream's ethos of rigorous observation and his system of meticulous measurement. *Female Figure Standing by a Heater* (Figure 9.5), which won the first prize for figure painting in 1952, exemplifies this approach to the figure. The relative proportions of the figure are established through horizontal measuring marks. These marks record the process of observation involved in making the work, providing a set of coordinates from which Uglow could start the new work of observation

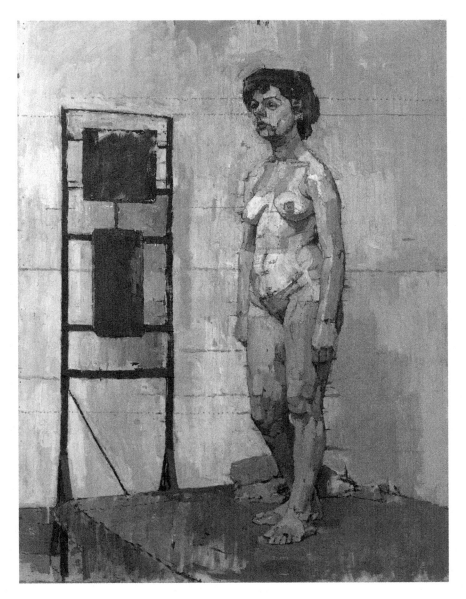

9.5 Euan Uglow, *Female Figure Standing by a Heater* (1952), oil on canvas, 101.6 × 76.2 cm, UCL Art Museum, University College London © the artist's estate.

presented by the model each day. The relationship of the figure to the position of the painter, and to the space of the life room and its apparatus, was also crucial to this work, both defining what was visible from the painter's line of sight and rendering this precisely and in proportion.[19]

However, these life room practices were most influential on students who had studied at Camberwell or had come to the Slade without previously attending other art schools, where many of the older students had already absorbed different methods of image-making. Students were also influenced by each other's work and staff guidance was tempered by a student sub-culture of exhibition-visiting and discussion.

The sculpture school also developed a different approach to drawing, derived from Sculpture Professor A.H. Gerrard's methods of making his students think in terms of solid forms rather than spaces. Gerrard taught life modelling by constructing an iron armature 'based on 3-dimensional thinking' and then taking exact measurements radiating out from the pelvis with callipers.[20] Drawings by students working in the sculpture school such as Martin Froy's nude built up in cubes and planes (Figure 9.6) showed this interest in the figure in three dimensions. Froy's work was also influenced by the teaching of art history at the Slade School, in particular Wittkower's lectures on Renaissance perspective.[21] Slade staff admired the way that Froy was alert to developments in the art world outside the School and was able to respond to these in his work, using them in an investigative way that went beyond an imitation of style.[22]

Froy's consistent application of his theoretical interest in art history and response to developments in contemporary art to life room practice was rare, and life room and portrait paintings were more likely to deal with the problems of objective painting. The main site for the intersection of art history and painting was the Summer Composition Competition which was retained and reinvigorated by Coldstream. The requirements of this painting prize sat uneasily with the systematic analysis of the subject in the purely visual terms required by the life, antique, portrait and still-life prizes, in which visual problems connected with the placing of model or objects were already in place and their resolution was an intrinsic part of the work. The placing of objects 'already understood' in imagined spaces was the central dynamic of the Summer Composition Competition. The Competition required imagination and compositional skills to produce a large-scale work, composed of disparate elements, yet completely resolved compositionally. This difference of approach recalls Coldstream's comment about the contrast between romantic and realist painters who 'start where we leave off'.[23]

Between 1892 and 1948, students had been expected to work independently during the summer vacation and were encouraged to plan their Summer Compositions by producing figure drawings and compositional sketches of figures in space, combining skills learnt in the perspective and life classes. However, in the 1950s, the dominant working practice at the School, derived from Coldstream, insisted that paintings should be worked through on the canvas rather than composed in advance and meant that little advice

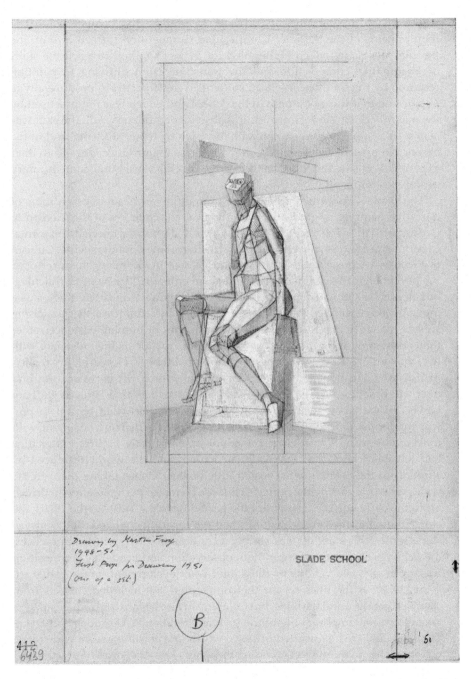

9.6 Martin Froy, *Seated Nude* (1950), pencil with white heightening on paper, 37.8 × 25.5 cm, UCL Art Museum, University College London © the artist.

was available to the students on how to prepare the compositions. The requirements of the Summer Composition Competition formed a fault line through the Slade, which highlighted the School's failure to teach the skills of imaginative composition and the transition from drawing to painting required by the set titles. In effect, students were expected to produce a type of painting that was not taught in the School and which was not practised by the majority of the staff. However, this absence of guidance from the staff was also seen as a positive liberal breadth of vision by many students, and in the absence of prescriptive methods, they were free to introduce ideas from their experience outside the School and to draw on Old Master and contemporary prototypes for inspiration.[24]

The Slade's continued interest in promoting an academic tradition of narrative painting might be seen as a logical continuation of the 'Return to Order' after the First World War, in which many artists rejected the formal experimentation and move towards abstraction of movements such as Cubism to explore the possibilities of figuration. Whilst in Germany this produced the psychologically charged forensic realism embodied by Neue Sachlichkeit artists such as Otto Dix and Christian Schad, in France and Italy there was a move by artists such as Pablo Picasso and Gino Severini towards classicising subject matter which focused on timeless themes of human existence rather than addressing the conditions of modern life, qualities which resonate with the conventions and traditions of history painting.[25] However, in reality, British art education had not experienced any such rift between pre- and post-war practices. Whilst former Slade students, including Percy Wyndham Lewis, Edward Wadsworth and David Bomberg, had been central to pre-war modernist developments in British art through their involvement with movements such as Vorticism, this involvement mostly occurred after they had left the School, and the Slade curriculum and the works produced by students at the School had revealed little of the debates taking place in the wider art world during the period of intense formal experimentation in British art in the early 1910s. Throughout the period from the 1910s to the 1940s, the curriculum and the prize categories had remained unchanged. But whilst in some senses this stability was simply a continuation of traditional practices, the School's emphasis on figuration, observation and academic composition was given renewed validity by these inter-war developments in figurative art.

In the 1950s the titles set for the competition still included subjects from classical literature and the Bible, but Coldstream also began to introduce subjects taken from contemporary literature, such as T.S. Eliot, W.H. Auden and Dylan Thomas. Coldstream awarded prizes to works that encompassed a wide range of approaches to the subject, dividing the works into categories of practice and judging them on the criteria relevant to each.[26] His endorsement of tradition at the Slade has often been seen as solely informed by a linear trajectory through the British tradition of realism from Camden Town to Euston Road,[27] but whilst

this trajectory reflects his own preoccupations, the Summer Composition Competition prizes awarded by him reveal the breadth of his definitions of committed painting, his understanding of the legitimate intellectual foundation of different practices and his respect for the individual approaches of the older students formed in response to influences outside the School.

In 1965 Coldstream said of the diversity of staff and student approaches:

> I encouraged the painters I thought the best. That's quite understandable. I think the Euston Road manner easily became a mannerism. When you go to a big art school it is obviously different from private studio practice. A modern art school is run on the understanding that all sorts of ideas and approaches, good of their kind, have to be encouraged.[28]

The two paintings that shared the first prize in 1950, the first year that Coldstream set and judged the competition, were Martin Froy's *Europa and the Bull* and Harold Cohen's *The Raising of Lazarus* (Figure 9.7). Both shared

9.7 Harold Cohen, *The Raising of Lazarus* (1950), oil on fibreboard, 122 × 150.2 cm, UCL Art Museum, University College London © the artist.

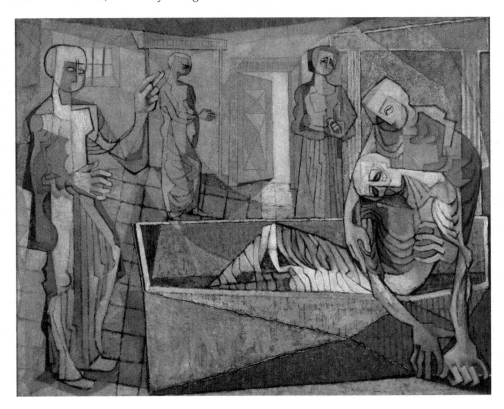

the stylistic influence of Cubism, but the combination of figures and space in Cohen's painting was consistent with the classic compositional strategies of traditional history painting. Townsend noted that both paintings were 'remarkable in their way, and both undoubtedly superior to the best "objective" pictures ... who are to share the second prize'.[29]

Despite Coldstream's lack of personal sympathy with the observational and compositional practices of the School of Paris, it may well have been Picasso who could provide the most compelling example for students of a figurative engagement with artistic tradition and large-scale composition that was still relevant in contemporary terms, both through his reinvention of traditional forms in classical paintings of the 1920s, in the reworking of iconic works by Gustave Courbet and Eugène Delacroix in the 1950s, and in his commitment to history painting through works such as *Guernica* (1937) and *Massacre in Korea* (1951).[30] Picasso's work would have been familiar to many students from a number of exhibitions held in post-war London, including the *Picasso and Matisse* exhibition at the Victoria and Albert Museum (1945), the inclusion of his iconic *Demoiselles D'Avignon* in Roland Penrose's exhibition *40,000 Years of Modern Art* at the Institute of Contemporary Art (1948), and the Arts Council exhibition *Picasso in Provence* (1951).[31] Townsend described the excitement of Slade students at Picasso's visit to London in November 1950 and wrote in his journal in January 1951 that 'a few students are keen investigators of Klee or Picasso, but these are almost old masters to them'.[32]

In 1951 two symbolist-influenced and imaginative interpretations of *The Expulsion from Eden* by Diana Cumming and Henry Inlander shared the first prize in the Summer Composition Competition, but closer to Coldstream's own preoccupations was the second-prize work, based on a poem by W.H. Auden. The composition of Michael Andrews' *August for the People* (Figure 9.8) is dominated by a fully clothed man who exudes social unease, a mood which is emphasised by juxtaposition with the relaxed holiday-makers in bathing suits who surround him. Auden's poem had triggered memories from Andrews' childhood holidays in Sheringham, Norfolk, and Andrews had drawn on these memories using the factual observational skills that he had learnt at the Slade in order to capture nuances of mood and human behaviour.[33] Townsend recorded Coldstream's admiration for the painting: 'this painting from real experience of everyday events, heightened by imagination, is just the sort of thing he would like to encourage'.[34] However, the award of first prizes to Cumming's and Inlander's paintings, which Townsend felt 'were far more successful as pictures; the vision carried them both through completely', shows the wide range of work encouraged at the Slade and the acceptance of a painting's success on its own terms, rather than according to preconceptions of what painting should be.[35]

In 1952 the first prize was shared by Diana Cumming's *Philostrates Imagines*, Philip Sutton's *Denial of St Peter* and Victor Willing's *Fighting Men*

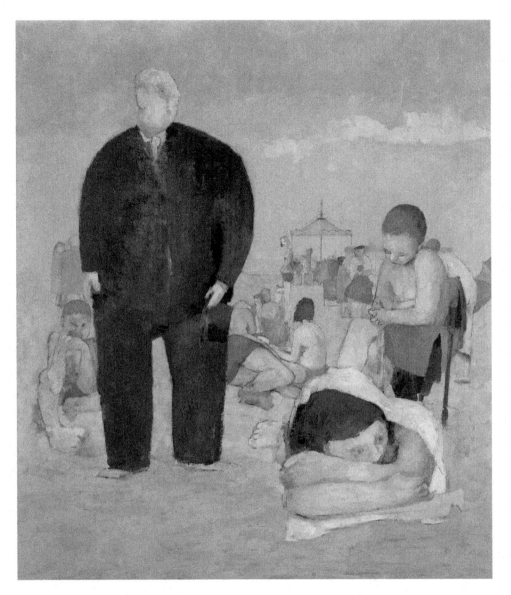

9.8 Michael Andrews, *August for the People* (1951), oil on board, 143.5 × 121.5 cm, UCL Art Museum, University College London © the Estate of Michael Andrews, courtesy of James Hyman, London.

(The Wasteland) (Figure 9.9). Townsend noted the difference in approaches of these three paintings and the need to award prizes to different categories of work:

The splitting of prizes seems to be the right principle for us to follow. We cannot
have Tonks' conviction that one kind of picture was the right and best for a
student to paint so that judgement was limited to finding the best of this sort.
Nowadays students are working in many quite opposed directions, we do
nothing to dissuade them and so must necessarily admit 'bests' of several kinds.
Diana Cumming … an eccentric poet, sui generis; Sutton an expressionist;
Willing a kind of Baconian, rather more tender and certainly more lyrical.[36]

According to Townsend, Coldstream's 1952 critique of the Summer
Composition Competition paintings was 'prefaced by some comments on
subject matter in painting'.[37] Coldstream's own notes on Cumming's and
Sutton's paintings demonstrate his interest in the interaction between subject
matter and execution and the material qualities of paint. He described in
detail the composition and palette of Cumming's work, while his comments
on Sutton concentrated on the visual effect of the work:

Predominant vermilion on deep blue ground; cold green and warm yellow
in flashes. Movement vitality. Effect of chaos without being chaotic. Delicacy

9.9 Victor Willing, *Fighting Men (The Wasteland)* (1952), oil on board, 149.9 × 180.4
cm, UCL Art Museum, University College London © the artist's estate.

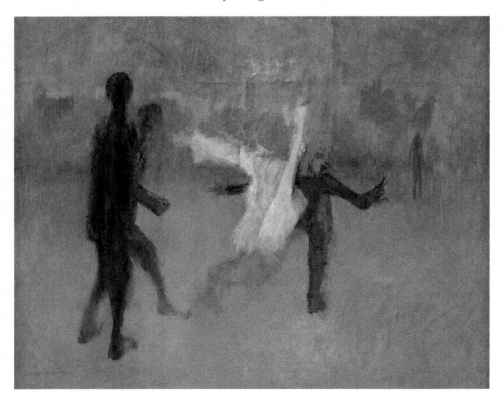

in drawing which is unexpected. Competence Conviction. Good sort of
Professionalism. Decoration and illustration values coincidental.[38]

No notes by Coldstream survive on Willing's *Fighting Men (The Wasteland)*, but
as Townsend observed, it demonstrated the influence of Francis Bacon's work.
The art critic David Sylvester lectured regularly at the Slade in the early 1950s
and had lectured on Bacon's work at the School, and Bacon himself sometimes
attended Sylvester's seminars, his Hanover Gallery shows also providing a
key point of reference for Slade students in the 1950s.[39] Martin Harrison has
seen Willing's painting as exemplary of the debate about photography that
was currently taking place at the Slade in which students such as Andrews and
Willing were participants, and has also argued that Willing's work exhibits both
current student interest in existentialism and the ability of the photograph to
isolate a violent or anxious incident.[40] This was a very different mode of vision
from the methodical objective painting taking place in the Slade life rooms in
the 1950s, but Sylvester considered Willing's painting to be a link between the
different approaches to realism of Coldstream and Bacon, describing it as a
synthesis between the 'Dionysian and the Apollonian'.[41]

Later trends in the Summer Composition Competition reflected the waning
of the Realist moment in the late 1950s with the influx of Abstract Expressionist
influences from America, a turn towards formalism and a focus on the creative
expression of the artist. Student works increasingly showed a move away from
the idea of a planned composition to a concentration on the manipulation of
paint and an exploration of its material qualities. Margaret Evans' *Interior with
Figures*, which won first prize in 1955, subordinated figures and interior to the
manipulation of vibrant patches of paint, and was admired by Townsend as 'the
nearest thing to an expression not just of a mood or ideas but of a personality
with a view of its own on the world'.[42] In the late 1950s a group of students
who were influenced by the late work of David Bomberg dominated the
Summer Composition Competition prizes.[43] Dennis Creffield's *St Paul*, which
won the first prize in 1959, and Mario Dubsky's *The Lament of Orpheus* (Figure
9.10), which won the first prize in 1960, both worked with an austere palette
and emphasised the tactile density of the paint surface. In 1960 Townsend
commented on this trend and the way that it grew out of life room teaching:

> [Dubsky] is the last of the thoroughgoing Bomberg followers – that is he is
> a disciple of Dorothy Mead and Creffield, and I think the strict orthodoxy
> will not be maintained much longer at the school … It shows a good deal the
> influence of [Andrew Forge's] teaching of life painting. He now takes all the
> students at the beginning of the second year for their first life pose, usually
> sets two models together for them, gets them to paint thickly, limited palette.[44]

Despite the wide variety of styles and diverse methods of working which
characterise the Summer Composition Competition works in the 1950s, the
rubric of composition painting remained constant and all the works shared the

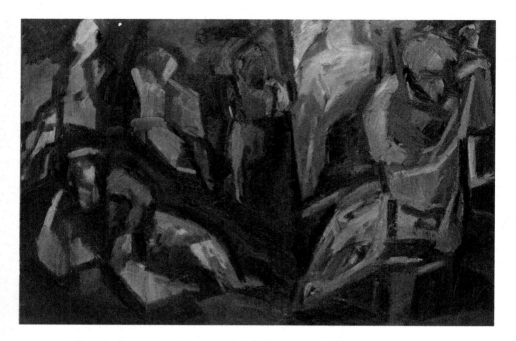

9.10 Mario Dubsky, *The Lament of Orpheus* (1960), oil on canvas, 157.5 × 231.2 cm, UCL Art Museum, University College London © the artist's estate.

starting point of an imaginative response to a literary title. This process was at odds with the Slade's central tenets of observation and realism, which were linked much more securely to life room practice. With much of the work for the Summer Composition Competition drawing on influences from outside the School and taking place outside its physical spaces and official discourses, it can be hard to locate this work within Slade pedagogy and recover why composition paintings remained relevant to staff and students. However, some indications of student intentions and staff reactions can be gleaned from student and staff diaries, and later statements by artists about their works. Paula Rego, who won first prize in 1954 for her painting *Under Milkwood*, emphasises how the Summer Composition Competition was valued by the students in encouraging the imaginative side of their work:

> I spent most of my time doing these pictures out of my head, which was encouraged. Not a restricting art school at all … And the subjects we were given for the summer comps – we had a set subject every year – were things like The Raising of Lazarus; you know, things to do from your head. They encouraged that.[45]

The paintings also allowed students to locate their work within an art-historical canon and explore theories that had been introduced in art history lectures

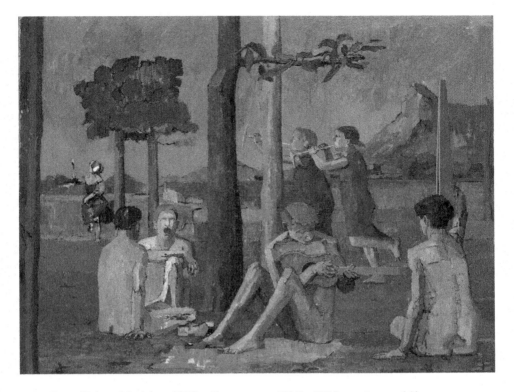

9.11 Euan Uglow, *Musicians* (1953), oil on canvas, 101.7 × 127.0 cm, Amgueddfa Genedlaethol Cymru – National Museum of Wales © the artist's estate.

and conversations with teaching staff. Uglow's *Musicians* (Figure 9.11) was painted at the Slade in 1953 for the Prix de Rome, a competition with similar requirements to the Summer Composition Competition. Catherine Lampert has stressed how Uglow was influenced by the teaching of perspective by Carter.[46] The artist's later comments are illuminating about the rationale behind *Musicians* and the influence of art history and theory on its conception:

> I was determined to try and paint a picture using all the old methods, like perspective, because perspective and proportion were very much buzz words, what with Sam [Carter] spending two years trying to write a criticism on John White's book on the Renaissance space. I was determined to paint this kind of picture, with a kind of imagery in mind, and try to prove it in terms of making drawings and trying to put it into space. I painted a picture where I knew how wide the cone was, how far away it was, how wide the trees were, the big mountain in the back, the Matterhorn.[47]

Uglow made many precise working drawings for the painting, including one in which the size of each element of the painting is indicated as if the artist

had stood in front of this imaginary landscape as he would have done in front of the life model. One drawing is inscribed 'Baptism' and, as Lampert has observed, Uglow's painting has some compositional similarities with Piero della Francesca's *Baptism of Christ*.[48] However, Uglow's account indicates that he was more interested in investigating the methods of Renaissance painters as analysed by art history than quoting compositional sources. This use of investigative observation endorses Coldstream's emphasis in the 1951–2 prospectus that students should 'inquire into the principles of drawing and use their own vision' and demonstrates how the seemingly separate practices of observation and composition enshrined in the life room and Summer Composition Competition respectively could be productively combined.

In trying to get a sense of the way that imaginative composition painting fitted into a Slade practice that was predominantly concerned with observational realism, it is also useful to draw on the critical language used by staff to judge the composition paintings. Most of these comments were verbal, but some of Coldstream's notes survive, and diarists like Townsend and Chaplin recorded the content of Coldstream's criticisms. Townsend stressed the importance of the Summer Composition Competition criticisms in establishing common goals and principles for the students: 'Bill criticised the summer pictures … it is the only occasion in the year when he talks to all the students in a way that could give them some idea of how he thinks and some direction; important he should do this'.[49] Chaplin emphasises the importance of Coldstream's critical performances to the students in giving a sense of who was worthy of the prizes and the vocabulary needed to elaborate this.[50]

Coldstream's thematic introductions had a similar function to the annual lectures of Edward Poynter, the first Slade Professor, in defining a direction and reflecting on current practice at the School.[51] Coldstream usually spoke for over an hour, beginning with an introduction addressing issues in contemporary painting relevant to the works on display, before going on to talk about the students' works in thematic groups. Detailed notes survive from his criticisms of 1958 and 1960, and these give an idea of the issues that were addressed. In 1958, when Wendy Yeo's *Townscape with Figures* won the first prize, he spoke at length on the 'different dangers of provincialism and modishness', addressing the conflict for students in balancing their own ideas with influences from outside. He counselled against the different dangers of an absorption in 'personal ideas of subjects' that was 'blind to opportunity' and the 'admiration of contemporary styles' or 'style with nothing to say'. He used Van Gogh as an example of the successful reconciliation of these two opposing tendencies in the way that he combined 'strong personal ideas and feeling for subject matter' with 'experience of other artists' methods past and contemporary'. He also stressed the interplay between ideas and the materiality of painting, quoting Mallarmé's advice to Degas that 'poems were

made up not of ideas but of words', but warning that 'it is also possible to have very able manipulation of paint with inadequate ideas behind it'.[52]

In 1960, when Bomberg-influenced painting was dominant, Coldstream was primarily concerned with the manipulation of paint and the 'physical existence of the picture in its own right'. He praised 'whole-hearted efforts with dealing with [the] serious business of painting' and noted a 'concern for [the] weight of paint, nearer modelling than covering', 'low tone [and] narrow range of colour', which he saw as a 'healthy approach – dealing with real things in terms of medium'. However, he cautioned against imposing a method which did not suit the artist's purpose, observing that 'language and vocabulary must suit what is said' and that 'technique in painting [is] not just [a] means to an end it dictates [the] end. Technique rules what sort of picture can be painted and what areas of thought or feeling can be included'. He advised against becoming a 'prisoner of method' and noted that it was 'important sometimes to forget painting and contemplate what is in front of you or your idea without preconception. You thus come by something with your painting that corresponds to an experience'.[53] He divided the paintings into categories, including 'efforts to deal with the subject through figure composition', 'eccentric paintings', 'treatment of subject as landscape', 'poetical illustration in terms of paint', 'abstract or near abstract' and 'more or less traditional figure compositions', in which latter category the winning painting by Mario Dubsky (Figure 9.10) was included.

The interplay between ideas, materiality and method in painting expressed in Coldstream's prize criticisms of 1958 and 1960 was a constant theme in the Summer Composition Competition, and although no notes by Coldstream survive for 1953 and Townsend's comments are limited to a list of the prize-winners, Chaplin remembers the Summer Composition Competition criticism of October 1953 starting with a condemnation of pictures 'composed wholly of the Idea and which were consequently a complete failure as a painting'.[54] For an imaginative painting to be a success in Slade terms, it also had to convince the staff of its 'honesty' and 'conviction', and that a rigorous working method suitable for the subject and compatible with the artist's intentions had been used to arrive at a pictorial solution. Staff disapproved of work that prioritised style and immediate visual effect over content and rigorous method.

During his later research as Slade archivist, Chaplin compiled a glossary of the positive and negative words used by staff c.1954, which reveal much about the value placed on observation over effect:

Hurrah: greatly compelling, expressive, expressive of form, unity, sustained interest, impressive, delicate, nice design, great perception of form, bloody good, good colour, honest, sincere.

Boo: crude, mannered, dry, disproportionate, insensitive, rotten, coarse angularity of the art school manner, appearances (not 'expression'),

generalised, preconceived, faceted, mannered, making a pleasing picture, painting after an effect.[55]

This list of terms indicates that observation, method and sincerity were valued above visual effect, yet begs the question of how sincerity and conviction were defined and identified. Were they part of the process or the result? Whilst answers to these questions are difficult to recover, the language used by staff suggests and defines the interface of Slade perceptual realism with other types of practice through an approved method and vocabulary. It is also helpful in locating the values that were consistent through the prize-giving between 1950 and 1960, despite the diversity of methods and styles. These are surprisingly consistent with the opposition between observation and style set out in Tonks' time, and indicate the ways in which the use of art-historical prototypes continued to be considered appropriate only in terms of investigating a method rather than copying a style. Art history remained influential at the Slade in this period, but rather than providing approved prototypes for imitation, it constituted an intellectual foundation for student work and suggested ways of investigating theories of perception and strategies of representation through studio practice. Coldstream's retention of signs of his struggle to represent the subject in his own finished paintings is emblematic of the honesty and sincerity in working practice that he valued in student work. But even working practices like those of Coldstream that posited an unmediated response to the subject were predicated on highly theorised concepts of vision derived from art history and confirm the continuing relevance of art history to art education in the 1950s.

Notes

I am grateful to UCL Library Special Collections, Stephen Chaplin and Charlotte Townsend-Gault for permission to quote from unpublished manuscript material.

1 A. Forge (ed.), *The Townsend Journals: An Artist's Record of His Times 1928–1951* (London: Tate Gallery Publications, 1976), p. 75.

2 C. St John Wilson, 'On William Coldstream's Method', in L. Gowing and D. Sylvester (eds), *The Paintings of William Coldstream 1908–1987* (London: Tate Gallery Publications, 1990), pp. 37–47.

3 Eugene Wolff's book was closely linked to Slade pedagogy. Wolff was Demonstrator of Anatomy at University College London and the book was based on the lectures that he delivered to Slade students. The book was illustrated by Slade staff member George Charlton, but Tonks was thanked in the preface for his 'useful criticism and advice with regard to the illustrations'. E. Wolff, *Anatomy for Artists* (London: H.K. Lewis & Co. Ltd., 1925), preface (unpaginated). See also Emma Chambers, *Henry Tonks: Art and Surgery* (London: UCL Art Collections, 2002), pp. 2–9 for a fuller discussion of the interplay between observation and knowledge, and the use of art-historical and anatomical sources in Tonks' drawings.

4 J. Fothergill (ed.), *The Slade: A Collection of Drawings and Some Pictures Done by Past and Present Students of the Slade School of Art 1893–1907* (London: Slade School of Fine Art, 1907), pp. 35–6.

5 See Emma Chambers, 'Redefining History Painting in the Academy: The Summer Composition Competition at the Slade School of Fine Art, 1898–1922', *Visual Culture in Britain*, 6(1) (2005), pp. 79–100 for a discussion of the early Summer Composition Competition paintings.

6 G. Charlton, 'The Slade School of Fine Art 1871–1946', *The Studio* (October 1946), p. 7.

7 University College London Library Special Collections: W. Townsend, *Journals 1919–1973* (unpublished, 13 July 1949).

8 Ibid., 29 August 1949.

9 University College London Department of the Fine Arts, 1951–2. *Slade School of Drawing, Painting and Sculpture.* (Slade Prospectus), p. 9.

10 See Deborah Cherry and Juliet Steyn, 'The Moment of Realism:1952–1956', *Artscribe* (June 1982), pp. 44–9 for a succinct account of this debate, including the competing claims for realism by those who wished to claim it for the left as an art of social responsibility and those who wished to rehabilitate the tradition and autonomy of European painting. James Hyman's *The Battle for Realism: Figurative Art in Britain During the Cold War 1945–1960* (New Haven, CT: Yale University Press, 2001) offers an extended analysis of the debates about competing realisms in the 1950s, but favouring the 'modernist realism' promoted by David Sylvester. Broadly speaking, the Slade was more in sympathy with Sylvester's ideas, whilst the Royal College of Art produced painters whose practice was more easily aligned with Berger's concept of realism. See Lynda Morris, 'The Beaux-Arts Years, 1948–1957', in Paul Huxley (ed.), *Exhibition Road: Painters at the Royal College of Art* (London: Royal College of Art, 1988), pp. 31–9; and Hyman, *The Battle for Realism*, p. 42.

11 Alfred Garrett, 'The New Realism in English Art', *The Studio*, CXLVII(735) (1954), pp. 161–9.

12 Quoted in P. Wright, *Painting the Visible World: Painters at the Euston Road School and at Camberwell School of Arts and Crafts 1930–1960* (London: Austin/Desmond Fine Arts, 1989), p. 2.

13 Townsend, *Journals*, 30 January 1950.

14 S. Chaplin, *A Slade Archive Reader* (unpublished, University College London Library Special Collections, 1998), 9.10, 9.14, 9.43, 9.75.

15 Ibid., 9.14a, 9.43.

16 Townsend, *Journals*, 9 June 1953.

17 Chaplin, *A Slade Archive Reader*, 9.49.

18 Ibid., 9.49, emphasis in original.

19 C. Lampert, *Euan Uglow: The Complete Paintings* (New Haven, CT: Yale University Press, 2007), p. 13.

20 B. Laughton, *William Coldstream* (New Haven, CT: Yale University Press for the Paul Mellon Centre for Studies in British Art, 2004), p. 163.

21 A. Forge, 'The Slade to the Present Day', *Motif*, 6 (1961), p. 48.

22 Townsend, *Journals*, 11 June 1951.

23 Forge, *The Townsend Journals*, p. 75.

24 Chaplin, *A Slade Archive Reader*, 9.57, 9.70.

25 See Linda Nochlin 'Return to Order', *Art in America* (September 1981), pp. 74–84; and Benjamin Buchloh, 'Ciphers of Regression: Notes on the Return of Representation in European Painting, *October*, 16 (1981), pp. 39–68. Buchloh argues that the 'Return to Order' was a politically conservative rejection of modernism which bolstered authoritarian politics. For more nuanced readings of debates on figuration, realism and nationalism in this period, see David Batchelor, '"This Liberty and this Order": Art in France after the First World War', in Briony Fer, David Batchelor and Paul Wood (eds), *Realism, Rationalism, Surrealism: Art Between the Wars* (New Haven, CT: Yale University Press, 1993), pp. 4–19; and Andrew Hemingway, 'The Realist Aesthetic in Painting', in Matthew Beaumont (ed.), *A Concise Companion to Realism* (Oxford: Wiley Blackwell, 2010), pp. 134–40.

26 Chaplin, *A Slade Archive Reader*, 9.57, 9.70. Slade Archive, *Summer Pictures 1946–1961*, University College London Library Special Collections, Box 3 c ii a.

27 See Hyman, *The Battle for Realism*, pp. 63–4.

28 Quoted in Wright, *Painting the Visible World*, p. 25.

29 Townsend, *Journals*, 17 October 1950.

30 See Leo Steinberg, 'The Algerian Women and Picasso at Large', in *Other Criteria: Confrontations with Twentieth-Century Art* (New York: Oxford University Press, 1972). John Minton at the Royal

College of Art also encouraged students to produce large-scale compositions derived from history painting at this period, and Lynda Morris has argued that his own *The Death of Nelson after Daniel Maclise* (1952) was an attempt to parallel Picasso's history paintings such as *Massacre in Korea* (1951). See Morris, 'The Beaux-Arts Years', p. 31.

31 See Chris Stephens and James Beechey (eds), *Picasso and Modern British Art* (London: Tate Publishing, 2012), pp. 184–5, 225–7.

32 Forge, *Townsend Journals*, pp. 91, 93.

33 W. Feaver, *Michael Andrews* (London: Tate Publishing, 2001), p. 11.

34 Townsend, *Journals*, 15 October 1951.

35 Ibid., 15 October 1951.

36 Ibid., 28 October 1952.

37 Ibid., 28 October 1952.

38 Slade Archive, *Summer Pictures 1946–1961*.

39 Chaplin, *A Slade Archive Reader*, 9.43.

40 M. Harrison, *Transition: The London Art Scene in the Fifties* (London: Merrell Publishers in Association with Barbican Art Galleries, 2002), p. 59.

41 From Sylvester's introduction to Willing's retrospective at the Whitechapel Art Gallery in 1982, quoted in Hyman, *The Battle for Realism*, p. 34.

42 Townsend, *Journals*, 25 October 1955.

43 Bomberg was an influential teacher at the Borough Polytechnic between 1947 and 1953, and his students Frank Auerbach and Leon Kossoff had one-man shows at the Beaux-Arts Gallery in 1956 and 1957 respectively. Andrew Forge, who brought Bomberg's influence into his teaching at the Slade, curated Bomberg's memorial exhibition for the Arts Council in 1958. See Morris, 'The Beaux-Arts Years', pp. 38–9.

44 Ibid., 26 October 1960.

45 J. McEwan, 'In Conversation with Paula Rego', in *Paula Rego* (London: Serpentine Gallery, 1988), p. 45.

46 Lampert, *Euan Uglow*, p. 21.

47 Ibid. Carter's research was published as a joint article with Wittkower: 'The Perspective of Piero della Francesca's "Flagellation"', *Journal of the Warburg and Courtauld Institutes*, XVI (1953), pp. 292–302.

48 Lampert, *Euan Uglow*, pp. 21–2.

49 Townsend, *Journals*, 1 November 1960.

50 Chaplin, *A Slade Archive Reader*, 9.41 and 9.70.

51 E. Poynter, *Ten Lectures on Art* (London: Chapman & Hall Ltd., 1879).

52 Slade Archive, *Summer Pictures*, 1958.

53 Ibid., 1960.

54 Chaplin, *A Slade Archive Reader*, 9.70.

55 Ibid., 9.72.

The Pedagogy of Capital: Art History and Art School Knowledge

Malcolm Quinn

The evolution of art and design education has in many ways followed a separate path from other sectors of further and higher education. Its emphasis on educational values differs from that of the main stream of academic institutions, and has in the past put it in partial isolation. The central problem facing us now is one of fostering a satisfactory relationship between art and design and the rest of the educational system while protecting those unique features, which are essential to the character and quality of art and design education. (Department of Education and Science National Advisory Council on Art Education, *The Structure of Art and Design Education in the Further Education Sector* (London: HMSO, 1970))

The art school is engaged in a continuous search for unity-identity which, by composition, cannot exist. (Raymond Durgnat, 'Art Schools: The Continuing Malaise', *Art and Artists*, 4(7) (1969), p. 8)

The first publicly funded art school in England, the Government School of Design, opened on 1 June 1837, in rooms in Somerset House that had been previously occupied by the Royal Academy. The School was the chimerical product of an experiment in 'the education of the eyes of the people'.[1] This was to be achieved through the construction of a cultural curriculum and a 'pedagogic itinerary' linking the government to the people of Britain through the art school and the museum.[2] The publicly funded art school was the product of anti-aristocratic *Kulturkampf*, the aim of which was to build an autonomous, rationalist and entrepreneurial brand of middle-class taste in Britain.[3] Minor aesthetic differences in mass-manufactured objects were to be the battleground of this struggle. This project for a British politics of aesthetics had been initiated by a group of Benthamites and 'Philosophical Radicals'.[4] This group had been formed in the Political Economy Club and the Board of Trade, and its representatives packed the Select Committee on Arts and

Manufactures of 1835–6.[5] In delivering the publicly funded art school as a new form of pedagogy under capital, the Select Committee mired it in intellectual problems and ethical dilemmas that have persisted into the present.[6] Nonetheless, the failure of the art school as a piece of nineteenth-century social and cultural engineering is framed by the larger intellectual problem of a virtuous capitalist pedagogy, a problem through which the vicissitudes of art history and complementary studies in the art school should also be read. The pedagogical project of the Select Committee on Arts and Manufactures of 1835–6 only came to fruition when Henry Cole established the Department of Practical Art under the aegis of the Board of Trade in 1852. It was already in retreat when Edward Poynter was appointed Director of Art and Principal of the National Art Training School in 1875, following Cole's retirement in 1873. The current narrative of the art school difference, which has survived the integration of British art schools within the university sector, continues to build on Poynter's differentiation of 'precept' (lecture-based instruction) and 'practice' (examples from studio practice): 'I have come to the conclusion that it is much easier to write about art than to practise it, and am led to the further conclusion that, as example is always better than precept, the more time I devote to painting in future and the less to public lecturing, the better it will be for my art and those interested in it'.[7] This was to be echoed later in the distinctions between 'non-studio' and 'studio' activities used in the combined Coldstream/Summerson Report of 1970. The development of a pedagogical opposition between theory and practice is what has determined discussion of 'art history and complementary studies' or 'contextual' studies in the art school since the Coldstream reforms, and has continued to be used within debates on practice-led research.[8]

There is an alternative reading of the art school distinction that places as much emphasis on the accord between art history and fine art proposed by Coldstream in 1960 as it does on the division between studio practice and complementary studies in the Coldstream/Summerson Report of 1970. In this reading, the Coldstream Reports are relevant not as unloved and often unimplemented bureaucratic curios from the 1960s, but because they proposed schemes for the self-management of colleges of art and design, more than 120 years after the first publicly funded art school had been established in Britain. The Coldstream Committees were set up to resolve problems of the over-specialisation and under-intellectualisation of courses in colleges of art. In 1959, the Minister of Education appointed Sir William Coldstream as Chair of a National Advisory Council on art education. Its recommendations were to be carried into effect by the National Council for Diplomas in Art and Design under Sir John Summerson, who granted diploma-awarding powers to fewer than half of the 72 colleges that applied under the new scheme.[9] The report called for 'some serious study of the history of art' with a mandatory 15 per cent of the total course devoted to 'the history of art and complementary

studies'.[10] As well as mandatory examinations in art history, the first report had advocated that all students on diploma courses should have some kind of fine art training. A decade later, the Coldstream/Summerson Report declared that art history no longer had to be studied and tested as an integral academic subject, and that the study of fine art would no longer be central to studies in the design field. Art history was stripped of its subject status in art schools in paragraph 38 of the Coldstream/Summerson Report, which is worth quoting in full:

> We see a need to develop the previous position. The conception of complementary studies and historical studies in terms of subjects has sometimes led to these studies becoming too easily separated from the students' main studies and to an unnecessary division between history of art and those other subjects collected under the term 'complementary studies'. We believe that these weaknesses can be overcome if the purpose of non-studio studies is thought of in terms of the educational objectives rather than the specific subjects to be taught. We see a prime objective of complementary studies as being to enable the student to understand relationships between his own activities and the culture within which he lives as it has evolved. Such studies should therefore offer him different ways of looking at art and design, and begin to build up a background against which he can view the experience of the studio. They should give him experience of alternative ways of collecting, ordering and evaluating information. Complementary studies should be an integral part of the student's art and design education, informing but not dictating to the creative aspects of his work.[11]

Ironically, the division made between studio practice and 'art history and complementary studies' in the Coldstream/Summerson Report relied on the same notions of virtuous pedagogy that had been employed to unite the study of art history and fine art in the first Coldstream Report. The first Coldstream Report had established a link between the study of art history and fine art by making them mandatory, thus designating them as the cardinal virtues of art education. They were the means by which pedagogical probity was to be managed within the art school system, creating a foundational myth for the discipline. In the 1960 Coldstream Report, art history and fine art practice were proposed as a single solution to the perceived problems of 'right action' or good practice in art school teaching. In 1970, this solution was refined by separating the spheres of studio and non-studio practice, with the studio as the nexus of right action and 'non-studio' subjects delivering the ethically neutral task of providing 'alternative ways of collecting, ordering and evaluating information'.

The proposed exclusion of art history as an integral, university-based subject in 1970 and its reconstitution within the resulting divide between studio practice and the 'educational objectives' of complementary studies is directly related to the founding distinction of the publicly funded art school that was introduced through government intervention in the 1830s. If the question

before the Select Committee on Arts and Manufactures in 1835 was how far public taste could be adapted to the demands of economic expediency, the belated bureaucratic interventions of the two Coldstream Reports struggled with the scattered remnants of this nineteenth-century experiment, splitting art school pedagogy between corrigibility at the individual level (represented by art history and fine art) and the optimisation of new assemblages of persons and objects (represented by complementary studies).

Complementary studies, unlike Courtauld Institute-style art history or studio-based teaching, was a pedagogical invention of the first Coldstream Committee designed to locate a number of courses within a common intellectual framework. Despite its doubly subordinate role as both 'non-studio' and 'non-subject', it negatively described the intellectual field of the publicly funded art school as something that was not a university and not an academy of art. Complementary studies was the intellectual residue or 'symptom' of the genealogical differences between the art school, the art academy and the university that were introduced as a government-sanctioned experiment in the 1830s.[12] Paradoxically, the service level and improvised knowledge of complementary studies, which lacked the elitist virtues of either academic art history or studio practice under the sign of fine art, was the only vehicle through which the publicly funded art school could have laid claim to its own history in the latter half of the twentieth century. It failed to do so largely because this would have required complementary studies to renounce its role as a service to studio practice and declare its anomalous institutional position.[13] However, the attempt to analyse the link between the problem of virtue and the agency of government within art school pedagogy is still relevant, not least because of recent attempts to introduce new, government-initiated but largely unanalysed epistemological inventions such as 'impact' and 'knowledge transfer' within British higher education, which return once again to practical problems in the production of virtuous 'general' knowledge.

The publicly funded art school in Britain was a unique pedagogical product of industrial capitalism. This product, which was aligned with government policy and museum practice in the 1830s, failed to assume cultural meaning within this alignment and has not developed wider intellectual relevance outside the terms set by the art academy and the university. The reasons for the lack of a purpose-built intellectual rationale for an art school can be traced through the dilemmas of pedagogy in commercial society expressed by Adam Smith, Jeremy Bentham and James Mill. While Jeremy Bentham offered models of systemic optimisation based on the exclusion of sentiments of sympathy and antipathy, Adam Smith made these same sentiments the basis of an approach in which the vices of commercial society were parlayed into individual virtues. While in 1782 Joshua Reynolds could write that he 'perfectly agreed' with the aesthetic sentiments of Adam Smith, the political economists at the Select Committee on Arts and Manufactures in 1836 established the

distinction between the School of Design and the Royal Academy of Arts on an opposition between public and private interests.[14] The ambition of the Select Committee of 1835–6 was to place the activity of looking at and understanding art under the purview of government, with members like William Ewart suggesting that a set of nationally agreed 'ruling principles' of art and design could reduce the privileges and authority of private art academies.[15] This raised the important question as to whether the mixed economy of virtues and cultural competencies, which were said to be demonstrated in 'cultivated' and 'uncultivated' attitudes towards art, could be reconciled within a general political economy of culture. In the parliamentary session of 14 July 1835, Ewart proposed that 'a Select Committee be appointed to inquire into the best means of extending a knowledge of the Fine Arts, and of the Principles of Design among the people – especially among the manufacturing population of the country; and also, to inquire into the constitution of the Royal Academy, and the effects produced by it'. Thomas Wyse, who was soon to be appointed to the Select Committee on Arts and Manufactures, remarked that the 'want of cultivation in the people at large was the general complaint that the middle classes of this country when they go into a gallery of paintings or sculpture, despised and sometimes destroyed the works of art exhibited, merely because they were not early accustomed to a cultivation of those arts'.[16] Attempts to produce a pedagogy appropriate to industrial capitalism reached deadlock in the 1860s in the revisionist utilitarianism of James Mill's son John Stuart Mill, their friend Henry Cole's failure to construct a viable post-utilitarian public pedagogy of taste and the turn to the aesthetic movement by Cole's successor Edward Poynter. John Stuart Mill's lecture on higher education at St Andrew's University in 1867, in which he claimed that 'Education makes a man a more intelligent shoemaker ... but not by teaching him how to make shoes', and Edward Poynter's *Ten Lectures on Art*, which raised the studio/non-studio distinction into a pedagogical principle in the 1860s, mark decisive points where the possibility of a particular kind of art school distinction was renounced.[17] As Stuart Macdonald has commented, 'all pretence to be teaching designing for trade for artisans [in publicly funded art schools] was dropped after 1864'.[18] Although Mill and Poynter's positions seem opposed in giving priority to theory and practice, respectively, both asserted the value of an ethics of character promoted by ruling pedagogical elites. This has also meant that the difference between the art school and the academy of art that was envisioned in 1835–6 has either been subsumed within genealogies of art education from the Renaissance to the present or presented as an aberration within these genealogies. According to Quentin Bell, the thought process that gave rise to the first publicly funded art school was that of a bureaucratic machine, developing inexorably towards Henry Cole's Gradgrindism and attended by 'scandal, confusion and disaster'.[19] For Bell, the attempt to reconcile arts and manufactures was misguided on its own terms, since 'a

state-supported art school has no place in a laissez-faire economy' in which manufacturers could not be relied upon to selflessly invest in art schools for the common good.[20] Bell commented that the Schools of Design under the conditions of free enterprise 'collided with private interests, either those of the teachers or those of industry' in 'a hidden contradiction within the system which could not be resolved without inflicting injury on someone'.[21]

Despite this, Bell insisted that 'the economy of the country made them [art schools] necessary'.[22] Although Mervyn Romans has challenged Bell's view, I have argued elsewhere that art schools were a 'political economic' necessity, supplying a unique introduction to 'capitalist citizenship' that traditional art academies and universities did not supply.[23] On 2 September 1835, Charles Toplis spoke to the Select Committee on Arts and Manufactures on behalf of the mechanics' institutes:

> The people, who felt the privation and saw the necessity of common
> elementary instruction, communed with each other on their common wants,
> and combined together to effectuate the object of their common desires. They
> associated themselves for the purposes of mutual improvement, and under
> the impressions of their particular necessities devised for themselves methods
> and matters of study which assorted with their avocations, their leisure and
> their pecuniary means.[24]

Already in 1776, Adam Smith had put forward a political economic view of education by arguing that if there were no endowed universities to distort the market for knowledge, 'no science would be taught for which there was not some demand', citing the home education of women, who were barred from the university system, as a good example of demand-led education put to a useful purpose.[25] It hardly needs to be stated that Smith's example of the domestic education of women nonetheless reproduces a hierarchy in which the ethical character of the male 'tutor' rules over the useful knowledge of the female pupil. Smith's discussion of the difference between economic and ethical purposes in industry was played out in the various volumes of *The Wealth of Nations*. His famous description of the pin factory in volume one of *The Wealth of Nations* sees the division of labour increasing the dexterity of the workman, his application to the task in hand, his ability to transfer from one trade to another and to sell his labour on the market.[26] However, in volume two of *The Wealth of Nations*, he also suggests that education provided by the government can ameliorate the alienating effects of the division of labour, which tends to make individuals 'as stupid and ignorant as it is possible for a human creature to become ... his dexterity at his own particular trade seems, in this manner, to be acquired at the expense of his intellectual, social and martial virtues'.[27] Whereas volume two of *The Wealth of Nations* locates public pedagogy within a normative account of virtue ethics, this virtuous pedagogy can only function outside the conditions of the workplace that are described in volume one. The mechanics' institutes and their associated

libraries were the first to occupy this 'negative space' of higher knowledge within industrial capital. The government's role in promoting public virtue in the free market was implicit in the structure of the School of Design from the very beginning and was made fully explicit when Henry Cole assumed control of the Government 'Department of Practical Art' in 1852. Cole, who never attended a university, had an intellectual and personal debt to utilitarianism. He had been introduced to Bentham's circle by Thomas Love Peacock and, in March 1836, James Mill had recommended Cole for a job in the Public Records Office.[28] Cole also undertook a 'discourse analysis' of the work of the Select Committee on Arts and Manufactures.[29] With direct reference to the Select Committee, Cole united the functions of the art school, the museum and government in his exhibition of 'Correct Principles of Taste' (the so-called 'Chamber of Horrors') at Marlborough House in 1852. In his exhibition of 'Principles of Taste', he attempted to resolve what Bell would later identify as the 'contradiction within the system' with a nexus of public institutions in which production and consumption within industrial capitalism could be understood and rationalised according to universal principles of design for manufacture. If there is an ethics and a pedagogy at work here, it is not an ethics based on the development of noble and cultivated character, but a quasi-utilitarian ethics that promoted capitalist citizenship through the use of government statements that rationalised the links between persons and objects. The very notion of 'laws and principles in Ornamental Art, as [a] ... branch of human science', as promoted by Cole and the Department of Practical Art, represents the shift in ethical prescription to the understanding of a 'science' of commodities, albeit one that avoided Bentham's pleasure-driven revaluation of taste,[30] in favour of government regulation of the aesthetic encounter.[31] Edward Poynter was later to criticise the pedagogical imperatives generated by this industrial ethic, preferring the values of the privileged cultivated class to which he belonged, as represented by the taste for Old Masters, for example: 'it may be said that an object of industrial art is *never* now produced which is satisfactory to the cultivated eye from every point of view'.[32] On the other hand, the attempts by Cole and other design reformers to construct citizenship through official statements on taste by drawing attention to 'mistakes in candlesticks' and other aberrations did not succeed in realising 'the education of the eyes of the people' that had been envisioned in the mid-1830s.[33] Cole was satirised by Charles Dickens as the mysterious 'Third Gentleman' who accompanies Mr Gradgrind in *Hard Times* (1854), where, among other things, the errors represented by wallpaper with realistic renderings of horses were discussed.[34] Nonetheless, if the difference between 'right' and 'wrong' was to be determined by the consistency of the use of signs, Cole had travelled a long way from Adam Smith's sentimental education without approaching the deontological tenets of modernism.

It is worth contrasting these developments with Edward Poynter's later position on public pedagogy. Poynter argued that in a world where 'the modern spirit' and 'the artistic spirit' became more opposed each day, and where the progression of manufactured bad taste among the middle classes had occluded the simple taste of the workman and the cultivated taste of the elite, the best option was to retreat from the field. He attacked the divorce of ornament and object that also troubled Cole, but from a completely different ethical standpoint, in which the pedagogy of the Slade School and that of the government schools of art could not occupy the same aesthetic universe. His lecture on 'The Influence of Art on Social Life' at the Liverpool meeting of the Social Science Congress in October 1876 demonstrated how his aesthetic movement sentiments perceived the sign of alienated labour in misapplied ornament. He declared that 'It is better to have no decoration at all than such as is purely mechanical' and was criticised for saying this by Cole.[35] He believed in the importance of individual character in aesthetic production over and above the need for mechanical design for manufacture. Nevertheless, he concluded that it was 'useless however to deplore and rail against this invasion of machinery; the best thing that can be done under the circumstances is to devote ourselves to the consideration of how far it will be possible to make it, under existing conditions, subservient to the principles of sound art'.[36]

More significantly, Poynter disassembled the pedagogical relationship between government, art schools and museums that had been proposed in the 1830s, declaring that the museum encouraged only the facile 'cribbing' of great art and that the government schools of art should now occupy a subservient position within a new hierarchy of art education in which drawing should be taught as a manual skill to children only. Here he remained within the rhetorical parameters of Adam Smith's original dilemma, declaring the problem insoluble other than by a fundamental reform of human character:

> the ideas of material progress and welfare in vogue with a large section of
> the community are in direct opposition to the very existence of an art the
> principles of which seem to us so obvious; to calculate therefore on any
> general artistic sentiment becoming a part of our national life would seem
> more hopeless now than it has ever been. Before this can happen, it is not
> too much to say that not only must our national characteristics be other then
> they are, but our beliefs in the efficacy of much that is thought essential to the
> progress, enlightenment, and happiness of mankind must be eradicated.[37]

Henry Cole has since become the arch villain in art school historiography. The gap between Cole's proposed public science of taste and institutionalised character building is nowadays occupied by Humanist academic studies of specific audiences for art, uniting social scientific methodology with an emphasis on cultural identity. Quentin Bell's version of events has had considerable influence on the transformation of Cole's approach into the

paragon of 'bureaucracy' within art educational discourse. When Bell first published *The Schools of Design* in 1963, art schools in Britain were dealing with the aftermath of the first Coldstream Report of 1960. Bell's book offered a narrative template for the dangers of bureaucratic meddling in art education, which he was to take further in his comments on the Coldstream reforms in an essay on 'The Fine Arts' published in 1964: 'the enormous advantage of the Dip.AD. ... is that its management will be in the hands of the colleges themselves and not of the Ministry of Education'.[38] The 'creativity versus bureaucracy' motif has become a permanent feature of art school discourse up to and well beyond the 'Hornsey Affair' of 1968; it is often aligned with differences between practice and theory.[39] On the other hand, the distinctions between the art academy and the art school first established by the agency of government in the nineteenth century have not assumed much importance in debates on art education, either during the decade of the Coldstream Reports or since. An exception to this was an oblique reference to the origins of publicly funded art education by Norbert Lynton in an article responding to the Coldstream/Summerson Report published in *Studio International* in November 1970. At this time, Lynton had given up his position as Head of Art History and General Studies at Chelsea School of Art to become Director of Exhibitions for the Arts Council of Great Britain. His article offers an intriguing, if undeveloped, explanation for the art school distinction: 'the existence of any sort of publicly-financed art education is a very remarkable thing ... it proves the survival of a superstition that came in with industrialization, a desire for some sort of insurance policy against the end of civilization'.[40]

The first thing to note about this passage is that Lynton untypically located the origins of publicly financed art education in industrial capitalism rather than within a story of art or, as Stuart Macdonald does, a narrative of art education stretching from the academies of the Renaissance to 1970. Here the art school distinction stems from the way it is marked by capital, which sets it apart from both the art academy and the university. Lynton's idea of 'superstition', since it is linked to an 'insurance policy against the end of civilization', suggests an apotropaic defence against the devaluing or vicious effects of commerce. Instead of the studio/non-studio distinction offered by the Coldstream Report, Lynton used a civilised/non-civilised distinction in which the art school is placed on one side and industrial capital on the other. His thoughts on this issue acknowledge the existence of the distinction between the art school, the academy of art and the university, and locate the art school difference within a debate on public ethics within the social arrangements of capital, but make no reference to the specific question of which ethical models are best employed as an insurance policy against 'the end of civilization'.

The pedagogical insurance policies that had been developed against this situation within publicly funded art schools, from Poynter's 'practice' to Coldstream's axis of virtue represented by art history and fine art, was earlier

displayed in Poynter's unwillingness to participate in public lectures, as he noted in the preface to his published lectures:

> My position as [Slade] Professor seemed to require a certain number of
> formal lectures, although practical instruction in art was the main object of
> my appointment: and these led to others being given outside for the benefit
> of a public which lies in wait for any one they can catch for an evening's
> instruction.[41]

For the Coldstream/Summerson Report, virtue was guaranteed by opposing studio practice to the non-studio non-discipline of complementary studies. A particularly 'superstitious' insurance policy proposed by the Coldstream/ Summerson Report was the designation of a neutralised class of non-studio-based non-specialists teaching complementary studies, whose:

> teaching, while constantly in touch with the values of the studio, is based
> on intellectual disciplines and processes which are distinct from those of
> the studio ... We are in no doubt that every student's course must include
> some serious and relevant studies in the history of art and design. How these
> different ingredients to the course are balanced is best left to the judgement of
> individual colleges.[42]

If the virtues of the studio could not be enhanced by an alignment with academic art history, they would be defended by the weakening of 'art history and complementary studies'. The changes made to art history and complementary studies in the Coldstream/Summerson Report resulted in a symbolic walkout from committee member Sir Nikolaus Pevsner, whose 'Note of Dissent' is included at the end of the Report. Pevsner objected on the grounds that complementary studies was a recipe for vague, undisciplined and ungrounded intellectualism. Norbert Lynton echoed his criticisms:

> This leaves it open to any school to reduce its art history work to almost
> nothing. Complementary studies are to be assessed (not art history specifically,
> nor it seems at any particular point in the course), and each school is to make
> its own arrangements with NCDAD about this ... It will take brilliance and
> monumental fortitude to stop the obligatory 'some serious studies in the
> history of art and design' deteriorating into coffee-table-book exercises or
> cliché-ridden and premature harangues on the contemporary art scene.[43]

In this respect, the Coldstream/Summerson Report adapted some elements of the radical model of art school pedagogy proposed during the occupation of Hornsey College of Art in May 1968, as set out in the manifesto 'On the Reasons for a Revolution', which was later published in *Leonardo* in 1969. According to Nick Wright, President of the Hornsey College of Art student union, there were three key features of this pedagogical model: first, the elimination of GCE entrance qualifications and examinations in art history and

general studies, which were seen to be derived from the stratified structure of formal academic education and were inappropriate to art schools; second, 'a diffused idea that art and design constituted a discrete activity within higher education and could legitimately be considered separately from academic or technical and scientific studies by virtue of the special character of art'; and, third, the embrace of design, the machine and the built environment.[44]

These utterly contradictory objectives combine an affirmation of the art school distinction 'by virtue of the special character of art' with notions of the non-assessed, unschooled and non-disciplinarity. In a moment of revolutionary rhetoric, they confusedly embraced both the end of civilisation and art as an insurance policy against it. In these circumstances, it was no surprise that the Coldstream/Summerson Report came up with the studio/ non-studio distinction as the best way to stabilise art school pedagogy, with an emphasis on the studio as the ultimate guarantee of the art school distinction. Interestingly, the constitution of a non-discipline such as complementary studies can be more readily understood not so much in terms of Adam Smith's description of the problem as through James Mill's variation of it in his essay on 'Education', published in the fifth edition of *Encyclopedia Britannica* in 1818 and reprinted in 1836 as one of a series of 'Pamphlets of the People'. This essay provides an associationist psychological framework with which to understand the pedagogical principles of the 'Philosophic Radicals' such as Poulett-Thomson, Grote and Bowring at the Select Committee of 1835, who had found positions in the Board of Trade through the conduit of the Political Economy Club, established by James Mill in 1821 as a vehicle for Benthamite ideas. It also provides clues to understanding Cole's decision to follow the lead set by the Select Committee in 1835 with his public pedagogical strategy of 1852.

In his essay on 'Education', James Mill sketches out a politicised notion of 'total education' across all sectors of society under the conditions of commerce. His critique was in line with Smith's principles, employing his division of labour principle and his condemnation of universities. Unlike Smith, however, Mill identified a collective code rather than individual probity as the source of virtue. He argued that the difference between 'vice' and 'virtue' was a question of reinforced associations, not the development of character:

> It is upon a knowledge of the sequences which take place in human feelings or thoughts, that the structure of education must be reared ... As the sequences among the letters or simple elements of speech may be made to assume all the differences between nonsense and the most sublime philosophy, so the sequences, in the feelings which constitute human thought, may assume all the differences between the extreme of madness and of wickedness, and the greatest attainable heights of wisdom and virtue.[45]

Here education does not take the form of an academic discipline, but is used to encourage individuals to establish a correct orientation to social objects

of desire. The aim is not to educate someone to be virtuous, but instead to help them to adopt the correct cultural sequence within a system for the distribution of social goods.[46]

James Mill's radical proposals for an education in 'the arts by which the different commodities useful or agreeable to man are provided' would eventually give way to the unholy alliance of an aesthetic elite and an aspirant mass of consumers within a skewed hierarchy of taste.[47] The 'ruling idea' of political economy proclaimed in 1835–6 did not become the idea of those who ruled. This development is certainly manifest in the revisionist utilitarianism of James Mill's son, John Stuart Mill, including his inaugural Address at St Andrews in 1867, in which there seems little to choose between Mill's revisionist utilitarianism and Poynter's elitist aestheticism, where he defined art as 'the endeavour after perfection in execution' so that:

> Art, when really cultivated, and not merely practised empirically, maintains, what it first gave the conception of, an ideal Beauty ... and by this idea it trains us never to be completely satisfied with imperfection in what we ourselves do and are: to idealize, as much as possible, every work we do, and most of all, our own characters and lives.[48]

John Stuart Mill's insistence on placing higher education above the demands of business and the professions is a contribution to the development of an ethical approach that united academic art history and fine art practice in the Coldstream Report of 1960. Nevertheless, the influence of James Mill's model of 'total education' may still be seen in the objectives of complementary studies, although without the coherence of the government, art school and museums that was attempted between 1832 and 1852. Rather than delivering a culturally or ethically codified structure that separated 'nonsense and the most sublime philosophy' and right from wrong, complementary studies included both of these elements within a mix of disciplinary fragments, which, of course, included parts of art history. However, in common with James Mill's associationist matrix, complementary studies was not framed as a subject, but as an orientation towards cultural networks and the structural relations between persons and objects. In an essay on 'Art Students and their Troubles' published in *Leonardo* in 1975, Peter Lloyd Jones noted that complementary studies became 'a lightning conductor for tensions building up during the rest of the week'. In his view, these tensions had been caused by the romantic view of art students promoted by Coldstream because: 'The system is geared to produce the odd Picasso out of a more or less random assortment of individuals of greatly differing abilities and interests ... you can't build a system simply for the exceptions'.[49]

This same point was emphasised by Raymond Durgnat in an article in which he pinpointed the role of complementary studies in distinguishing the 'continual, anguished, messy search' for a unified pedagogical identity in the art school from the 'dreamlike unreality' of the university:

> They [complementary studies departments] also crystallise dissatisfaction
> with the art school itself. Being (apparently) irrelevant and compulsory, a
> symbol of establishment authoritarianism, they intensify resentment, and
> offer a target of common attack. But once battle is joined, then a merely
> competent and alert department must, by virtue of its brief, facilitate students'
> apprehension of their own discontents.[50]

Complementary studies may have acted as a 'lightning conductor' and the
sole pedagogical function uniting various practices in art schools, but it had
nonetheless emerged as a paltry concession informed by the alien principles
of the art academy and the university, and divided from the work of the
politician and the museum curator.

Paradoxically for Coldstream, his very emphasis on 'the special character
of art', meant that it was difficult to recruit the particular characteristics of
academic art history to the special character of art within a unified axis of
virtue without thereby sacrificing the virtues of art history within a new
arrangement of 'art history and complementary studies'. An editorial in the
Burlington Magazine in 1962, commenting on the introduction of mandatory
art history in the first Coldstream Report, made the observation that although
art history might contribute to the promotion of 'order' in art schools, it would
do so at the expense of its own integrity as a subject, with typical art students
attracted to the biographical content of 'an artist's personal struggle' rather
than the broader issues traditionally pursued by the art-historical discipline.[51]
The editorial concluded with the warning that the Courtauld did not produce
graduates capable of teaching on such terms, especially given the fact that 'the
student will demand a considerable amount of individual attention'.[52] What
the Coldstream Report of 1960 had demanded was art history as a model
of pedagogical virtue in the art school, not an actual academic subject. The
final resolution of these intellectual and institutional difficulties into the bare
distinction between studio and non-studio in the Coldstream/Summerson
Report demonstrated the antagonism between virtuous and non-virtuous
pedagogy and the descent into 'superstitious' divides between studio and
non-studio.

Ultimately, the art school could not operate according to the liberal arts
ideals drawn from the art academy and the university without sacrificing
pedagogical unity. This impasse, which occurred because of Coldstream's
attempt to manage the virtues of art school education from within, can be
read in two ways. The first reading shows how the educational objectives of
'art history and complementary studies' were gradually given disciplinary
status as 'visual culture' as the art school was placed under the tutelage of the
university. The second reading is itself based on the deliberate 're-reading'
of the social function of art under the conditions of commercial society first
raised by the Select Committee on Arts and Manufactures of 1835–6, which
was itself conducted as an attack on the supposed privileges of the Royal

Academy. Lara Kriegel has claimed that the Committee's founder, William Ewart, sought to do nothing less than to reconfigure the relationship between art and the state.[53] Where Adam Smith's model of virtuous knowledge under capital was based on the problem of the continuity of moral sentiments within a political economic mode of thought, elements of the Select Committee of 1835–6 tried a different tack, sidelining existing institutional guarantees on the probity of art in order that a new, free trade model of public ethics could be developed. The Committee opened up the possibility of risking the loss of individual virtue guaranteed by art in order to deliver a new idea of public virtue based on the combination of language and political power in the service of goods. The immediate introduction of members of the Royal Academy into the management of the School of Design foreclosed this possibility, which was not taken up again until Henry Cole became General Superintendent of the Department of Practical Art.

For Adam Smith, useful and practical knowledge was the 'correct' educational product for a free market system, but could only be guaranteed to be virtuous within a protected environment. Whilst this isolated practical knowledge from both the non-market orientation of universities and the moral dangers of the free market, it necessitated a prioritisation of an ethics of character over practical knowledge. Smith's model does not enable the development of new pedagogical institutions within a free market situation, since it depends on 'the conviction that the end of ethics is normative intervention and the conviction that the proper means of ethics is the illustration of particulars embellished by rhetoric', which is the same humanistic orthodoxy present in Poynter's prioritisation of painterly practice over public lectures.[54]

While it is commonplace to assume that an art school is an institution in which virtue might be risked in a harmlessly bohemian sense – for example, by the presence of a naked life model – the real threat exists in the risk to virtue and the threat to 'civilization' that is bound up in the historical constitution of the publicly funded art school. As has been demonstrated, however, the art school has not escaped the imposition of virtues established by the art academy and the university. Furthermore, the reason why this intellectual development has not occurred is because the art school has historically internalised structures of 'superstition' and moral defence that are underwritten by the academy and the university. While the discipline of art history was unsuccessfully recruited to this defence, the educational targets of 'art history and complementary studies' refer to the public matrix of cultural utilitarianism proposed by Benthamites. Within this, there are no guarantees of academic quality or ethical consistency; virtue is risked in a situation where it is not easy to distinguish an ethics of free speech from the moral dangers inherent in the free trade in goods. A brilliant allegory of this dangerous condition of knowledge was proposed in Patrick Keiller's film *London* (1994) in the figure of the art history and complementary studies lecturer 'Robinson'.

Rather than being a defined character with a robust ethical constitution, Robinson is an assemblage of multiple and kaleidoscopic cultural elements – an amalgam of Keiller's own teaching experience, a literary genealogy running from Rimbaud through Céline to Chris Petit, and the cultural theory lectures of Ray Durgnat. Robinson 'lives on what he earns in one or two days a week teaching in The School of Fine Art and Architecture at "The University of Barking". Like many autodidacts, he is prone to misconceptions about his subjects, but as there is no one at the university to oversee him, his position is relatively secure'. Robinson has never assumed the tutelage offered by the university structure that now hosts 'The School of Fine Art and Architecture'. His own pedagogy, which establishes the narrative of the film, is resolutely and eccentrically based on principles of orientation, whether political, historical, geographical or psycho-geographical, and does not constitute a defined subject or discipline.

Ironically, as I have shown, this pedagogy of cultural orientation is not a twentieth-century aberration but a fundamental link connecting 'art history and complementary studies' to Benthamite frameworks for managing the new assemblages of persons and objects that were being created by commercial society. Nonetheless, the impossibility of any guarantees of public virtue is what positions the art school within a problem of capitalist pedagogy that links *The Wealth of Nations* to contemporary notions of research impact and knowledge transfer.

Notes

1 *Report from the Select Committee on Arts and their Connexion with Manufactures With the Minutes of Evidence, Appendix and Index,* House of Commons, 16 August 1836, p. 23 (William Ewart to James Morrison): 'Do you think that sufficient attention has been paid to what may be called the education of the eyes of the people by our own Government?'

2 Tony Bennett, 'The Multiplication of Culture's Utility', *Critical Inquiry,* 21(4) (1995), p. 867.

3 See Malcolm Quinn, 'The Disambiguation of the Royal Academy of Arts', *History of European Ideas,* 37(1) (2011), pp. 53–62; and Malcolm Quinn, 'The Political Economic Necessity of the Art School 1835–1852', *International Journal of Art and Design Education,* 30(1) (2011), pp. 62–70.

4 Mervyn Romans, 'An Analysis of the Political Complexion of the 1835/6 Select Committee on Arts and Manufactures', *Journal of Art and Design Education,* 26(2) (2007), p. 219.

5 S.E. Finer, 'The Transmission of Benthamite Ideas 1820–50', in Frederick Rosen (ed.), *Jeremy Bentham* (Aldershot: Ashgate, 2007), p. 564.

6 Celina Fox, 'Fine Arts and Design', in Gillian Sutherland et al., *Education in Britain* (Dublin: Irish Academic Press, 1977), p. 70: 'The Select Committees and Royal Commissions expose the high spots of disaster, of not only theoretical, but principally of administrative confusion. They do not form part of an open public policy, but more often seem like torchlit journeys into shadowy basement reserves, which otherwise would have lain hidden from view … The parliamentary papers constantly provoke the question: who was competent to make judgements concerning the arts on a national scale?'

7 Preface to Edward Poynter, *Ten Lectures on Art* (London: Chapman & Hall, 1879), pp. vii–viii.

8 Chris Rust, Judith Mottram and Nicholas Till, *AHRC Research Review Practice-Led Research in Art, Design and Architecture* (2007), available at: http://www.ahrb.ac.uk/images/Practice-Led_Review_Nov07.pdf.

9 Peter Lloyd Jones, 'Art Students and their Troubles', *Leonardo*, 8(1) (Winter 1975), p. 61.

10 See the reference to the first report in Department of Education and Science National Advisory
 Council on Art Education, *The Structure of Art and Design Education in the Further Education Sector*
 (London: HMSO, 1970), paragraph 34, p. 10. The report is reproduced online at http://dera.ioe.
 ac.uk/13935/1/Structure_of_art_and_design_education.pdf.

11 Ibid., paragraph 38, p. 11.

12 See Elizabeth Bonython and Anthony Burton, *The Great Exhibitor: The Life and Work of Henry Cole*
 (London: V&A Publications, 2003), p. 177, where the authors note that in 1856, Henry Cole was
 still describing the project of national art education set in motion in 1835–6 as an 'experiment'.

13 For an example of how this possibility emerged and was then suppressed during the 'Hornsey
 Affair', see Lisa Tickner, *Hornsey 1968: The Art School Revolution* (London: Francis Lincoln Ltd,
 2008), pp. 72–5.

14 Letter from Joshua Reynolds to Bennett Langton dated 12 September 1782, reproduced in John
 Ingamells and John Edgcumbe (eds), *The Letters of Sir Joshua Reynolds* (New Haven, CT: Yale
 University Press, 2000), pp. 110–11.

15 House of Commons, Report from Select Committee on Arts and Manufactures Together with the
 Minutes of Evidence and Appendix (London: House of Commons, 1835), pp. 81, 126.

16 Hansard, *Parliamentary Debates* (series 3), Vol. XXIX, cols. 553–62 (14 July 1835): http://hansard.
 millbanksystems.com/commons/1835/jul/14/arts-royal-academy#S3V0029P0_18350714_HOC_28.

17 F.A. Cavenagh (ed.), *James and John Stuart Mill on Education* (Cambridge: Cambridge University
 Press, 1931), p. 135.

18 Stuart Macdonald, *The History and Philosophy of Art Education* (London: University of London
 Press, 1970), p. 176.

19 Quentin Bell, *The Schools of Design* (London: Routledge & Kegan Paul, 1963), p. 1.

20 Ibid., p. 135.

21 Ibid.

22 Ibid.

23 Quinn, 'The Political Economic Necessity', pp. 62–70, a response to Mervyn Romans, '"Living
 in the Past" Some Revisionist Thoughts on the Historiography of Art and Design Education',
 International Journal of Art and Design Education, 23(3) (2004), pp. 271–2.

24 Select Committee on Arts and Manufactures (1835), p. 113.

25 Adam Smith, *The Wealth of Nations*, Edwin Cannan, (ed.) (London: Methuen, [1776] 1925,
 2 volumes), Vol. II, p. 266.

26 Ibid., Vol. I, pp. 9–10, 266.

27 Ibid., Vol. II, p. 267.

28 Bonython and Burton, *The Great Exhibitor*, p. 49.

29 H.C. [Henry Cole] 'Committees of the House of Commons – Administration by Large Numbers',
 London and Westminster Review, 5(9) (1837), pp. 209–25.

30 See Malcolm Quinn, 'The Invention of Facts: Bentham's Ethics and the Education of Public Taste'
 in *Revue d'études Benthamiennes*, available at: http://etudes-benthamiennes.revues.org/346.

31 Lucy Brown, *The Board of Trade and the Free Trade Movement 1832–40* (Oxford: Oxford University
 Press, 1958), p. 81. Cole's attempt to develop a science of taste in the 1850s should be seen in the
 context of the earlier activities of the Board of Trade in the 1830s, which included the attempt to
 use statistics as the basis of a 'science of the state'.

32 Poynter, *Ten Lectures on Art*, p. 273, emphasis in original.

33 Anon., 'A Couple of Mistakes in Candlesticks', *Journal of Design and Manufactures*, 5 (1851), p. 80.
 See also Adrian Rifkin, 'Success Disavowed: The Schools of Design in Mid-Nineteenth-Century
 Britain. (An Allegory)', *Journal of Design History*, 1(2) (1988), p. 90.

34 See Professor Sir Christopher Frayling's First Henry Cole lecture at the Victoria and Albert
 Museum on 30 October 2008. This lecture is available on video and as a transcript at: http://www.
 vam.ac.uk/school_stdnts/education_centre/Henry_Cole_Lectures/index.html.

35 Poynter, *Ten Lectures on Art*, p. 269n.

36 Ibid., p. 258.

37 Ibid., p. 254.

38 Quentin Bell, 'The Fine Arts', in J.H. Plumb (ed.), *The Crisis in the Humanities* (London: Pelican, 1964), p. 115.

39 Tickner, *Hornsey 1968*, p. 102.

40 Norbert Lynton, 'Coldstream 1970', *Studio International*, 180(927) (1970), p. 167.

41 Preface to Poynter, *Ten Lectures on Art*, p. vii.

42 Department of Education and Science, *The Structure of Art and Design Education*, paragraph 39, p. 11.

43 Lynton, 'Coldstream 1970', p. 168.

44 Nick Wright, 'What Happened at Hornsey in May 1968', http://www.1968andallthat.net/node/82.

45 James Mill, 'Education', in W.H. Burston (ed.), *James Mill on Education* (Cambridge: Cambridge University Press, 1969), p. 52.

46 Ibid., p. 61.

47 Ibid., p. 111.

48 John Stuart Mill quoted in Cavenagh, *James and John Stuart Mill on Education*, pp. 195–6.

49 Lloyd Jones, 'Art Students and their Troubles', p. 64.

50 Raymond Durgnat, 'Art Schools: The Continuing Malaise', *Art and Artists*, 4(7) (1969), p. 8.

51 Benedict Nicholson, 'Art History in Art Schools', *Burlington Magazine*, 716(104) (1962), p. 451.

52 Ibid., p. 452.

53 Lara Kriegel, *Grand Designs: Labor, Empire and the Museum in Victorian Culture* (Durham, NC: Duke University Press, 2007), p. 24.

54 Ryan Patrick Hanley, *Adam Smith and the Character of Virtue* (Cambridge: Cambridge University Press, 2009), p. 81.

Study the Masters? On the Ambivalent Status of Art History within the Contemporary Art School

Katerina Reed-Tsocha

> When Levine presented her photographs of [Walker] Evans's pictures, I interpreted the work as her saying 'study the masters; do not presume to reinvent photography; photography is bigger and richer than you think it is in your youthful pride and conceit' ... The fact that nobody seemed to notice that her work was an admonition is no excuse for ignoring it.[1]

Jeff Wall's reading of Sherie Levine's appropriations as acts of homage stands at odds with the widely accepted interpretation of her project in terms of a deconstructive exercise exposing the fallacies of modernism.[2] Instead, it establishes an unexpected continuum between Wall's understanding of Levine and his own photographic practice. 'I had always studied the masters and respected the art of the past', Wall has stated, yet as we shall see, even in his case, such declarations of respect possess a certain degree of ambivalence towards figures of authority.[3] Beginning a chapter on British art school education with references to Jeff Wall, a Canadian, may come across as somewhat unconventional; however, it forms a springboard for considering some larger questions of direct relevance. There is a singular conceptual continuity between Wall's statements on the importance of art history and the impact of his own British education on his practice, especially during his doctoral research at the Courtauld Institute in the early 1970s under the supervision of T.J. Clark. Wall's studies of Édouard Manet, both visual and textual, reflect his close engagement with Clark's ideas and provided one main channel for art-historical input that enriched his work. I would like to propose that the two closely related aspects of Wall's practice, the visual and the textual, provide a viable model for the PhD in Fine Art, as it is understood in the UK. My claim is not that this is *the only* viable model, but rather that it is an interesting one worthy of further analysis. These reflections are based on observations on the recently introduced doctoral programme at the Ruskin

School of Drawing and Fine Art at the University of Oxford. One of the distinctive characteristics of the Ruskin School is that rather than being an autonomous art school, it is part of a major research university. This situation not only increases access to research resources in general but also encourages academic research itself as a possibility for artists. This fact has a significant impact on the way in which most doctoral projects currently underway are conceptualised. The third part of this chapter will address this topic in detail.

This relationship of art history to fine art educational practice is not isolated to the postgraduate realm within current academic curricula. I will discuss aspects of the undergraduate curriculum of the Ruskin, as this has developed in recent years, in the context of the larger question of the role of art history within a contemporary art school. This is where Wall's unconventional, and uncommon, admonition to learn from the Old Masters becomes particularly pertinent. How would Wall's recommendations for artists to 'study the masters' be received by students in the post-YBA, post-conceptual, post-postmodernist environment of contemporary art schools in the UK? The answer is not difficult to guess. Art history is widely perceived by art students as a dead discipline, academic, irrelevant; a field forever contaminated by unnecessary classifications and detached observations. This dominant stance lacks flexibility and could even be seen as reminiscent of the kind of stereotyping and problematic construction of 'otherness' that post-colonial studies have alerted us to – an unusual claim perhaps, but one that I am willing to pose here. The broader question of the role of art history includes that of the role of the art historian within the art school. One might think that in order to adjust productively to the creative and freer environment of the art school, art historians need to undergo a personality change. Is that true? Moreover, if art history is perceived as inextricably linked to the outdated study of the Masters and the appeal to their authority, a pantheon of 'new Masters' fuels the discourse of the studios. They can be described as 'textual masters'. They go in and out of fashion and support statements that barely conceal an appeal to authority: in the 1980s and early 1990s, the unquestionable supremacy belonged to Jean Baudrillard and the discourse of the simulacrum, alongside poststructuralism, Michel Foucault, Roland Barthes and the death of the author. Now Nicholas Bourriaud's *Relational Aesthetics* (1998) has become the somewhat unexpected, and still not sufficiently contested, turn-of-the-millennium landmark; Foucault's biopolitics retain their authority in the context of discussions of bio art, superseding the earlier fascination with the function of the author and related poststructuralist attacks; Chantal Mouffe, Boris Groys and Jacques Rancière, among others, are contemporary thinkers who form the basis of fashionable references in art crits and studio talk. Rather intriguingly, there appears to be an openness to the more broadly conceived term 'art theory' that art history no longer enjoys.[4]

In addressing the larger question of the function of art history (and art historians) within the practice-oriented context of a contemporary art school, I

will take as a starting point the experience of the course 'Art in the Expanding Field: The Transition to Postmodernism' that recently formed part of the undergraduate curriculum of the Ruskin School.[5] This course replaced an earlier one that provided a linear historical survey of the history of art. Instead, 'Art in the Expanding Field' aimed to analyse the implementation of critical frameworks derived from art-historical writings associated with the journal *October*, and more specifically the volume *Art since 1900* (2004).[6] (Although some divergence from the original terminology would be already apparent in the choice of the broader term 'expanding' rather than 'expanded' in the name of the course.)[7] The extent to which such a heavily academicised framework can be relevant to fine art students, even after all necessary adjustments, is a valid question. The objective, however, was to cultivate a critical stance towards one of the dominant paradigms of how practice can be theorised in contemporary terms and to scrutinise ways in which art history, as an academic discipline, is capable of making or breaking the reputations of artists through their insertion into well-crafted progressive narratives, as well as the applicability of critical terms carrying significant evaluative weight (one obvious example being the term 'post-medium condition' as employed by Rosalind Krauss).[8] The idea was to mobilise institutional analysis as a critical mode to alert art students to ways in which their own practice could be theorised sometime in the future with reference to established paradigms. This raised the question of how such paradigms were established in the first place within the critical discourse that supports them and how intellectual trends of criticism may become dominant for a period of time. One further objective was to encourage a shift away from glossy journalistic criticism that is both easier to read and easier to admire. The challenge was the same old one: how to make it all interesting and immediately relevant. One way of responding to this was to encourage longer excursions into the contemporary practices under discussion, on these occasions leaving critical frameworks aside. Another way was to introduce the artists' own voice, paying close attention to critical writings and interviews, and also to instances of diverging from or going along with dominant art criticism. In the latter case, Sherrie Levine's espousal of poststructuralist rhetoric made a good case study.[9]

From a teaching point of view, the course presented an additional, and intriguing, challenge because it was offered as a second-year option to students in Art History. In this respect, it was important to take into account the expectations and rationale of the BA in Art History. Aside from providing art-historical knowledge of contemporary developments in artistic practices and a critical understanding of key theoretical terms with numerous implicit methodological references that would tie in with the historiographical interests of art history students, the course had a further objective: to help cultivate a distinctive understanding of artistic practices from a perspective internal to the fine art discipline in a way that is characteristic of art school thinking and

the direct ways in which artists approach art as opposed to the more detached attitude of art historians who are more 'constrained' by the academic side of their discipline. To a certain extent, the success of this mission had to rely on the interaction of the mixed audience of fine art and art history students during the discussion that followed the lectures.

The responses of this mixed audience confirmed a divergence of attitudes. Whereas art history students engaged more readily with the theoretical aspects of the overall framework, its consistency, historical precedents and the theoretical ideas that inform it, fine art students, struggling with the pressure to make art that responds to the most recent trends, regarded academic frameworks with suspicion, ultimately diverting their attention to well-established trend setters, namely, art magazines and art fairs. And yet there was one intriguing discovery: art students responded well to a very different aspect of the lectures related to the Concept of the Master. What became evident was a strong 'engineering' interest in the way the lecture itself is constructed; in other words, the craftsmanship involved in the development of argumentation and how its elements hang together. This led to numerous stimulating discussions of craftsmanship itself and ways in which it applies beyond its more contested manifestations in artistic practices – an example of the vibrant intellectual environment and creative thinking that is so characteristic of an art school.

All this raises the question of the current role of art historians within the art school. It could be argued that their role is that of mediators providing 'translation' from one culture or discipline to another, offering access to relevant literature and cultivating critical thinking. As we saw above, the art-historical lecture seems to be at its most effective if it is able to offer a model of good practice that is interesting in its own right, and anything that may be perceived as an 'academic' style of teaching or, more generally, approach is unlikely to prove productive. An often-repeated line that I at least have encountered on numerous occasions both at undergraduate and postgraduate level is the emphatic and often derisive statement from students that 'we are not art historians'. The implications of this are worth considering. In the 'Ruskin debates' that were motivated by this statement, several rhetorical questions were polemically posed by the students, many focusing on the role of art historians as the temple guardians of the deified great Masters. The following questions convey the flavour of these debates:

- When we say that we are not art historians, which constructed identity are we normalising? What is art history?
- Given how difficult it is to define one's identity as an art historian within the discipline, can it be easier to do so from the outside?
- Who is an art historian and who is not? Is it a question of changing roles rather than identities, and do these roles not overlap? Do they

not stand in a reciprocal and mutually informing relationship with each other? What about the long-standing tradition of art criticism, and even philosophical art criticism, that fits in naturally within art-historical writing?

- What is an art historian? The 'other'? The dubious ally? The pedantic academic? The student of the ways of 'dead white males'? Is vitality and creativity the exclusive privilege of an art school?
- In rejecting art history, could we be accused of: fear of colonisation?; reverse projection of stereotypes and ideologies?; intellectual insecurity even?

The point was to highlight the danger of simplistically assuming that art history is one-dimensional without differentiating between all the strands that compose its complex intellectual identity, in particular following the intense methodological cross-fertilisation of the discipline since the 1970s with theoretical frameworks derived from literary theory, linguistics, philosophy and anthropology. And yet, within the incredibly pluralistic and fertile environment of an art school, it is somehow easier to acknowledge an interest in geography, anthropology or psychology than in art history.

All this would seem to imply that in the textual aspects of their practice, artists steer clear of art-historical material, which, of course, is not the case. The statement 'we are not art historians' comes across as a disclaimer, an unwillingness to be bound by methodological constraints that apply to this 'other discipline'. This raises serious questions concerning interdisciplinarity, which become even more pertinent at postgraduate level. Is the disclaimer sufficient to validate borrowing freely and eclectically from other discourses in the name of artistic creativity? Is there a danger of this resulting in lightweight quasi-creative writing? Similar considerations apply to all disciplinary borrowings: frequent citations of French philosophy, eclectic use of scientific terms, the importation of ideas from sociology and political theory. There are no prefabricated methodological guidelines as to how this imported intellectual material can be used. Nevertheless, such interdisciplinary excursions have to be constrained by the methodological framework of the discourses from which they borrow. Extensive citations of the work of social historians of art, to take one example, can be used intelligently only if they reflect an awareness of the methodological interests of the social history of art, its potential and its limitations.

The rejection of the 'hopelessly academic' discipline of art history has often appeared in tandem with enthusiasm for the variously constructed notion of theory. Where art history is seen as imposing suspicious and constraining categorisations, theory is celebrated as liberatingly creative, politically progressive and open-ended. The 1980s have come to be seen as the decade of theory, the era of theoretically motivated practice. A number

of voices expressed scepticism towards this phenomenon ranging from mild to extreme. For example, Yves-Alain Bois complained of widespread theoreticism, 'the obligation to be theoretical', as a more general phenomenon across universities, but did not restrict it to artists.[10] More specific, and more outspoken, Robert C. Morgan described what he dubbed 'a careerist's gamble' as follows: 'One way of succeeding within the context of the game was to be adopted by a writer or a magazine – preferably both – with the right art world credentials, who would quote Benjamin, Adorno, and the five famous French post-structuralists and thus … reify or legitimate one's position in the mainstream'.[11] In the aftermath of the death of the author, or the artist, it turned out that the real Masters whose authority prevailed were theorists.

These objections are useful to bear in mind in seeking the right balance between studio and art-historical/theoretical teaching in art schools as well as in the search for the most productive way to deliver the latter. A first observation to be made in this context is that there is no need to reintroduce outdated boundaries. The diversity of ideas that constitute the intellectual atmosphere of the art school turns it into an ideal environment for interdisciplinarity and for a freer exploration unconstrained by territorial wars between disciplines. Art schools are capable of providing stimulating intellectual environments in which the exchange of ideas thrives, free of the policing of disciplinary borders and other pedantic concerns. There seems to be something distinctive about art school seminars – or, at least, this was our experience of the Ruskin seminars, which provided artists with a forum different from the discourse of the studio and yet operating across a continuum with the vitality and internal understanding of art that is so characteristic of art students. The 'academic' identity of the Ruskin as the Fine Art Department of the University implied that it was possible to make the most of the creation of such an interdisciplinary research forum. It was here rather than at the level of academic regulations and institutional guidelines that the real integration of the art school with the University and the real enrichment of the University with the intellectual and imaginative input of the art school seemed to be taking place. In some sense, this rich environment signalled the final distancing from the reverential attachment to the Masters that characterised the outdated tradition of the Écoles des Beaux-Arts, not as an act of rebellion but as a confident move into new territories of intellectual exploration.

At this point, I interrupt the pedagogical discussion with an art-historical interlude. My motivation for so doing is twofold: to avoid further general remarks and illustrate the ambivalent status of art history within the art-historical practice of artists through a case study; and to return to the concept of the master by retrieving one of the few remaining contemporary references to this endangered species. Rather unconventionally, as I explained in the introduction, my case study will be based on Jeff Wall's practice in both artistic and textual terms. As has already been noted, as a Canadian, Wall may

not at first glance seem an obvious part of the British art school scene. And yet his work remains extremely popular and influential among art students in the UK. The pervasive impact of a British educational institution on Wall's ideas and practice in the period 1970–1973 when he conducted art-historical research under the supervision of T.J. Clark at the Courtauld Institute is of great importance. I will not try to reconstruct the exact historical details of this impact; rather, the discussion that follows will highlight the influence of Clark's ideas on Wall's practice. Wall's studies under Clark served as an important case study within one of the art-historical lectures given as part of the 'Art in the Expanding Field' course.

Jeff Wall's declaration that 'I had always studied the masters and respected the art of the past' represents a clear proclamation of respect.[12] Nevertheless, his engagement with the masters does not lack ambivalence. He confesses his scepticism, which developed during the 1960s under the pressure of the widespread assumption that the art of the past was 'obsolete'. This ambivalence turned out to be productive, leading to a complete re-evaluation of the work he believed it necessary to study. He eventually decided to 'study the masters whose work, either in photography or in other art forms, didn't violate the criteria of photography but either respected them explicitly or had some affinity with them'.[13] An initial list included 'traditional painters like Manet, Cézanne, and Velasquez, more recent artists like Pollock and Carl Andre … cinematographers such as Néstor Almendos, Sven Nykvist, or Conrad Hall, and film directors and writers like Luis Bunuel, Rainer Werner Fassbinder, Robert Bresson, Terrence Malick, and Jean Eustache'.[14] Respect for tradition came along with the awareness that due to the dominance of photography and video, it was no longer possible to paint like the great Masters. Seeking a different model, Wall discovered the artistic use of large-scale lightbox transparencies as a medium for representing modern life pictorially, producing a contemporary technological equivalent of Charles Baudelaire's conception of the 'painting of modern life'. Wall has written on the restoration of the concept of the picture as a central category of contemporary art around 1974 and the return to pictorialism after the demise of photoconceptualism.[15] In his historical account, he puts forth the claim that photography could not follow linguistic conceptualism all the way and had to turn away from conceptual art, from all its reductions and negations. In this sense, photoconceptualism marked the end of the old regime of conceptualism and created the conditions for a renewed understanding of pictorialism. This is the context for Wall's own critical attitude and his sustained engagement with the pictorial modes of the past. He goes so far as to make the uncompromising statement that: 'The only way to continue in the spirit of the Avant-Garde is to experiment with your relation to tradition'.[16] In a later interview, he elaborated on the notion of tradition, invoking the concept of aesthetic experience. Tradition, he clarified, is not an institution to be respected. Describing it as 'something dynamic

and perpetually renewed', he defines tradition in terms of the continuity of aesthetic pleasure (not in terms of continuity of taste, but as the potential of works of art to generate pleasure dynamically).[17] The Kantian underpinnings of this view have been channelled into Wall's thinking primarily through the writings of Thierry de Duve. The question that preoccupies Wall is whether or not the art of the great masters has been superseded, has become a thing of the past, as he says characteristically. Recalling a visit to the Prado, an important catalyst for his thinking according to numerous references in interviews, he explains how, seeing the works of Goya, Velazquez and the other Masters 'strengthened [his] intuition that this kind of art was not a thing of the past. It was contemporary art, there was nothing essentially historical about it. *Las Meninas* was there, a picture still speaking to us ... That connected me with the Kantian idea of aesthetic experience. It showed me that an intense aesthetic experience is always a moment of intense contemporaneity, a moment of the Now, regardless of whether it occurs in front of a picture 300 years old'.[18]

Wall's refusal to regard the art of the great masters as a 'thing of the past' is cast in distinctively Hegelian terms.[19] In other words, Wall refuses to acknowledge the end of modernism or a point of radical rupture between modernism and postmodernism. He is then able to stride between the two with characteristic facility. Not only can his use of art-historical references be seen as a continuation of the project of modernism, but he also unashamedly espouses modernist ideas such as the notion of the medium.[20] He attacks digital photography on the grounds that it allows no sense of the limitations of the medium, and thus removes the age-old challenge posed to the artist of overcoming these in his or her practice. At the same time, through his use of lightboxes and critical appropriation of the tactics of advertising, he clearly transgresses the modernist specificity of the medium and embarks on what he has described as a 'polemical intervention' on the nature of photography. The commitment to modernism and a postmodernist reflexivity are both evident, for example, in his re-making of Édouard Manet's emblematic *A Bar at the Folies-Bergère* (Figure 11.1: 1882).

What is the status of Wall's new takes on classical masterpieces and on the appearance of the latter within his works? The diversity of intention and pictorial complexity of the outcomes yields no single answer. Wall's strategy never becomes formulaic. Peter Galassi has described Wall's 're-enactments', as he calls them (not entirely accurately, for the references are often oblique and well hidden), as gambles, involving an element of risk that establishes Wall's singularity in a way that it would be difficult for other artists to follow him 'into his singular aesthetic and intellectual labyrinth'.[21] Whether they may be described as re-enactments, re-stagings or re-makings, the mentality behind them is most definitely not one of appropriation.[22] Wall works with sources in the manner of Manet, radicalising them and enlisting them in the painting of modern life.[23] In so doing, he provides masterpieces

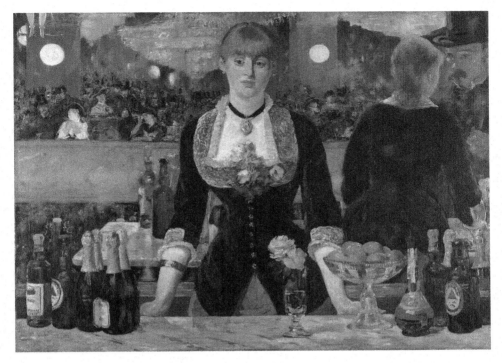

11.1 Édouard Manet, *A Bar at the Folies-Bergère* (1881–2), oil on canvas, 96 × 130 cm © The Samuel Courtauld Trust, the Courtauld Gallery, London.

with a largely unpredictable afterlife. At the same time, he retains some distance from modernist seriousness by describing some of these works as 'philosophical comedies': *Dead Troops Talk (A Vision after an Ambush of a Red Army Patrol near Moqor, Afghanistan, Winter 1986)* (1992), *The Giant* (1992), *The Vampires Picnic* (1991), *'Abundance'* (1985) and, more relevantly in terms of re-makings, *The Thinker* (1985) fall into this category.[24] The title of *The Thinker* is directly derived from Auguste Rodin, but the art-historical reference in terms of content is to Albrecht Dürer's engraving of *The Peasant's Column* (1524–5), a proposal for an unrealised monument that is one of the illustrations in Dürer's manual for artists, *The Instruction in Measurement* (1525). On top of the monument – or rather, anti-monument – which was intended to commemorate a bloody peasant uprising sits a peasant stabbed in the back. The 'victory' column is erected out of a butter churn, a pitcher and a wheat sheaf. Wall turns the peasant into a worker in worn-out dark suit and battered brown boots sitting on a column made out of a tree trunk, curbstone and a cement building block overlooking an industrial landscape outside Vancouver, and proposes a monument 'dedicated to disillusion and failure'. Thinly disguised is a further reference to Dürer's *Melencolia I* (1514), the stabbed peasant is

sitting in the same brooding position, absorbed in fruitless contemplation, as the strange winged creature of the celebrated iconographical case study. This absorption perhaps links the references to Dürer and the strangely appropriated title from Rodin in a perversely ironic way. Not everyone is convinced by this early work. Peter Galassi, for example, describes it as 'an admirably audacious experiment that failed to ignite; its raw materials remain oddly inert, untouched by pictorial alchemy'.[25] The comment reminds us of Thierry de Duve's objection regarding the excess of theoretical references in *Diatribe* (1985). Returning to *The Thinker* from this perspective and following art-historical associations makes one wonder about the prominently shown brown boots and potential allusions to notorious art-historical controversy over Martin Heidegger's reading of the transformative powers and utopian gestures of Van Gogh's *Peasant Boots*.

In proclaiming with characteristic ambivalence that 'Today, I think, each artist has become his own academy', Wall makes an anti-authoritative statement while at the same time retaining, and respecting, the authority of tradition and of an historical institution. Peter Galassi interprets this comment in order to refer to the redeployment of past achievement as a resource for future innovation, but its scope may be wider than that.[26] I see it more as a confident defence of intellectual self-sufficiency, promoting the ideal of the accomplished contemporary artist who has at his or her disposal all the tools of the trade, including the theoretical sophistication and in-depth knowledge of past art. Whether or not this multifarious identity includes that of the artist-writer, the producer of theoretical discourse which may supplement the practice (rendering the critic redundant) or exist in parallel (as Wall's own essay production does), the fact remains that according to this conception the artist comes across to some extent as a new Leonardo, a Renaissance man.

Wall is often sceptically described as an art-historian's photographer and his work is seen as prone to accusations of academicism and over-intellectualisation. While the task he sets for himself is enormous, these accusations also reflect certain well-entrenched ideological wars within art schools. Hovering over his re-makings is, admittedly, the potentially perceived problem of too much art history, of artistic practice degenerating into an art-historical quiz; asking which artistic masterpiece lies behind each picture. But that would be to miss the point. Wall's references are deeply internalised and his interests on each occasion are varied and multidirectional. His is a productive engagement with art history, arguably of great pedagogical potential in illustrating productive and rich modes of interaction with art-historical material.

After giving the lecture on this topic, it was particularly interesting to see which points attracted the most attention among a fine art student audience. There was a strong interest in debating the implications of the modernist idea of the 'resistance of the medium' in relation to one's own practice. This led to

a wider discussion of the nature of conceptualism and a questioning, by some, of what was perceived as an excessively theoretical, and perhaps facile, art form. The larger patterns of transition from modernism to postmodernism, and the realisation of the inevitable lack of clarity in this shift that the lecture implicitly put forward, were also discussed in detail. Closely related to the first point was the second major response, this time to de Duve's critical position regarding the excess of theoretical references in Wall's work. In this case, the debate shifted away from conceptualism to ways in which art-historical knowledge could be productively assimilated within artistic practices without turning art into illustration. How can art retain its vitality and its self-motivation? When is art-historical knowledge too much? How can one counter the danger of turning artistic practice into an academic project? These were some of the main questions asked. The concept of the Master, by contrast, received no attention whatsoever, despite frequent references implanted in order to test reactions.

The danger of academicisation not only preoccupied the undergraduate audience of these lectures but also became a major focus of discussions at the Ruskin postgraduate seminar in research methodology. It is not difficult to hear in the background distant echoes of old debates on the academicisation of artistic practice, going back to the introduction of complementary studies in UK art schools and beyond. In this case, however, we were concerned with more recent objections to the establishment of doctoral degrees in fine art allegedly turning artists into frustrated academics and sacrificing the spontaneity and unconscious creativity of practice to the high altar of academic accomplishment. Bearing this in mind, Wall might provide a masterclass with his textual practice for students and the thesis component of their practice-led PhDs.[27]

In terms of the nature of writing involved in the practice-led PhD, the main options, which have been explored by different programmes in the UK, appear to be as follows: (a) creative writing; (b) reflections on practice; and (c) academic writing. The first two often represent the kind of writing involved in a number of MFA programmes. At the Ruskin, at least in the first phase of the development of the DPhil programme, both these kinds of writing were encouraged, but, crucially, they were regarded as part of the studio output. It was acknowledged that studio work may involve an element of textual practice, which could be quite substantial and the nature of which falls under the broad heading of creative writing, and that the conceptualisation of the project may rely on a written exploration of various aspects of the practice, which may extend well beyond the merely explanatory and may generate highly accomplished pieces of writing. From the perspective of the Ruskin programme, the assumption has been that neither of these can be channelled into the thesis. However, the precise definition of the nature of the thesis itself remains open-ended. Aside from stipulating that it should fit into the overall

research project, providing some form of contextualisation for the practice and specifying its length as 40,000 words, there are no further specifications. Experience has shown that the distinctive, internal understanding of artistic practices possessed by artists can help to generate excellent pieces of art criticism. This would indicate that the context of practices that share common objectives or somehow operate in a similar vein to one's own is an obvious choice in terms of a thesis topic – although this kind of sustained and lengthy engagement with the work of others could prove counterproductive in different ways. Defining one's practice against that of others, becoming too analytical about matters that are close to one's own creative activity, or too critical of strands of practice that may have close affinities to one's own, heightening an awareness of dead ends to be avoided – all these are some of the potential difficulties that may arise from extensive theoretical engagement with closely related artistic practices and could conceivably inhibit practice by making it excessively self-conscious.

Another obvious context is that of ideas. In this case, the thesis would address broad ideological and intellectual contexts, which are of relevance to the practice. In this capacity, it would most likely interact with historical, philosophical or literary disciplines and with certain social sciences, such as ethnography, anthropology and cultural geography, to name but a few. A whole set of challenging methodological issues arise in relation to these patterns of interaction. For within these disciplines, discussions of topics that may come across initially as of general interest quickly become highly specialised. How can it be ensured that rigorous writing is produced when interacting with a discipline in which one has no formal training? What standards are to be applied? And how is the topic to be approached methodologically? The guiding principle is that this is determined empirically and on a case-by-case basis, with specialised supervision playing a key role in circumnavigating some of the most difficult-to-resolve issues. In all cases, one is constrained by the critical standards applicable to the existing discourse: it is not possible to engage, for example, with analytic philosophy without using sustained argumentation or to address a problem formulated within the social history of art without drawing upon that particular methodological framework, if only in order to transcend it.

The prevailing objection to all the above is that the doctorate in fine art relies upon – and inevitably leads to – excessive academicisation of artistic practice. There is an element of truth in this. But even if aspects of the project may be dominated by academic work, the practice itself should build strong defences against any potential academicisation. The imminent dangers are the reduction of the PhD to a form of illustration of theoretical ideas and also the loss of intrinsic interest and ultimately autonomy. There is a fine balance to be achieved: the practice is complemented by the 'academic' component (the term 'academic' being used here for want of a better word, since 'theory'

imposes a dichotomy between theory and practice that remains deeply problematic), while at the same time emphatically asserting its independence.

The long and diverse tradition of artists' writings provides an interesting field of comparison. A number of prominent examples come to mind: Robert Smithson, Daniel Buren, Donald Judd, Robert Morris, Joseph Kosuth, Art & Language, Gerhard Richter and Jeff Wall, to mention but a few, all have engaged in a strong textual practice.[28] And it is within this context that the writing practice of Jeff Wall can be considered as providing one possible model. Over an extensive period of time, Wall developed a strong textual practice, writing a significant number of essays, which complemented his studio work while at the same time operating on a level parallel to it. He has explained that his writing arose largely out of the texts for his lectures during the period when he was teaching, and has also discussed the relationship between the textual and the studio component of his artistic practice.[29] He has explicitly rejected his characterisation as an art historian, describing his involvement in art history as motivated by the problems he encountered in the studio.[30] Having considered the possibility of engaging in a textual practice – first inspired by creative writing, taking Breton's *Nadja* (1928) as his model, and then in a linguistic conceptualist vein – he opted instead for essay writing, contributing to the tradition of artist-writers, such as Robert Smithson and Robert Morris, and very importantly Dan Graham, endorsing a theoretical, i.e. writing, practice as a parallel and self-standing strand of production.[31] Its seriousness of engagement refers to the avant-garde tradition of artistic writing.[32] At the same time, it is characterised by sustained argumentation as opposed to the usual mode of poetic licence usually employed by artists in their statements. Where it differs from most academic writing is that whereas the latter is often determined by disciplinary constraints, Wall's writing reflects what may be described (no doubt controversially) as an artist's perspective, an internal understanding of art. Describing this writing as art historical sounds restrictive, and yet it engages with the discourse of art history on equal grounds.

As independent as Wall would like this strand to be, the fact remains that his engagement with art history permeates his work. Nowhere is this more evident than in *Picture for Women* (Figure 11.2: 1979), his re-making of Manet's *A Bar at the Follies-Bergère*, which is saturated with Manet scholarship to such an extent that it can be described as an academic case study. Feminist art history, the discourse of the gaze, accounts of reflexivity, the theory of modernism, the writings of T.J. Clark and others are all reflected in Wall's art-historical study.[33] Crucially, however, despite its implicit 'academic' content and explicit art-historical reference, Wall's re-making results in an intriguing picture. The woman's direct gaze becomes a focal point that attracts the viewer's attention like a magnet. There is something mysterious about the picture and its composition, a puzzle of representation that is waiting to be unlocked in a manner that also recalls the art-historical scholarship on *Las*

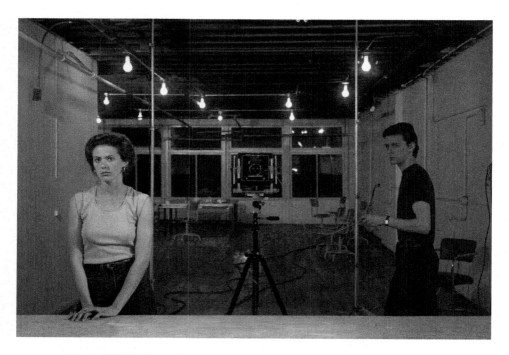

11.2 Jeff Wall, *Picture for Women* (1979) transparency in lightbox, 142.5 × 204.5 cm, courtesy of the artist.

Meninas. If *Picture for Women* remains visually interesting and intellectually intriguing, balancing out art-historical reference and visual content is an extremely difficult task. *Diatribe* (1985) is a positioning of social history within a landscape by Nicolas Poussin. A picture of two unemployed mothers, it aims to make proletarian motherhood visible, as the artist described it.[34] Compositionally, the wasteland they traverse evokes *Landscape with Diogenes* (c.1647), and the animated conversation between the two figures, as Wall explained, refers to the peripatetic tradition of philosophising. These references, however, remain esoteric. There is no obvious pictorial justification for why their conversation should be a philosophical one, and the reference to the artist-philosopher seems exaggerated. At this point, we come full circle to the objection that remains most forceful in considering doctoral research projects that are motivated by art history. It is captured in the following critical point made by Thierry de Duve: '*Diatribe* is far from being Wall's most convincing work perhaps because it is ruled by theoretical intentions that are too complex, too knowing and deliberate, because it leaves too little room for surprises that come from the unconscious, whatever the artist may say'.[35]

There are no manuals or graduate handbooks that can help circumnavigate this kind of problem, but perhaps a more positive assessment of the situation

is possible using the idea of 'research in progress', of research projects that continuously evolve to include both success and partial failure, the latter retained for its heuristic significance. Incidentally, this is also one of the most positive aspects of the contested term 'research project' as applied to artistic practice: it highlights the element of continuous search, the experimental nature of the artistic process as a process of conceptualisation. In this context, an instance of 'artistic failure' is as productive as any successful work, for it supplies an intermediate provisional step as a means to an end, and because of the conceptual conclusions it is capable of generating if used rightly.

To return to the proposed model for the textual component of doctoral projects, what is particularly interesting in the case of Wall's writing practice is his understanding of this as a parallel activity – and it is this mode of existing in parallel, while at the same time being part of an organic whole, that applies precisely to one conception at least of the written thesis component of the PhD in fine art. Interestingly, most of Wall's writings engage with ideas within the wider context of artistic practices and do not indulge in subjective reflections or creative literary modes, even though their length is that of an essay rather than an extensive thesis. Regarding Wall's texts as precedents lends support to the written aspects of doctoral projects in certain respects and perhaps not in others. The best recommendation is to keep matters open-ended, retaining as much flexibility as possible in the definition of the thesis, bearing in mind that for every artistic project, there are numerous alternative thesis topics that can be pursued productively, and that in the best of cases, they may even stimulate the artistic practice, although, crucially, the patterns are likely to be implicit and complex.

This final section completes the discussion of the ambivalent status of art history within the contemporary art school, both in terms of undergraduate teaching and in terms of imported content to artistic practice at the postgraduate level. It is worth remembering that ambivalence can also be productive. In any case, the objective of the art-historical presence cannot conceivably be to offer ready-made authoritative frameworks (the Masters' voice), but rather to cultivate critical thinking: the ability to both analyse and criticise these frameworks on the basis of sustained argument.

Notes

1 Jeff Wall, 'Frames of Reference', in *Jeff Wall: Selected Essays and Interviews* (New York: Museum of Modern Art, 2007), pp. 173–4.

2 For a deconstructive reading, see Rosalind Krauss, 'The Originality of the Avant-Garde', in *The Originality of the Avant-Garde and Other Modernist Myths* (Cambridge, MA: MIT Press, 1986); Douglas Crimp, 'The Photographic Activity of Postmodernism' and 'Appropriating Appropriation', in *On the Museum's Ruins* (Cambridge, MA: MIT Press, 1993).

3 Wall, 'Frames of Reference', p. 173.

4 Widely read books among art students include, for example, Chantal Mouffe, *On the Political* (London: Routledge, 2005); Boris Groys, *Art and Power* (Cambridge, MA: MIT Press, 2008); Paul Virilio, *Art and Fear* (London: Continuum, 2010); Jacques Rancière, *The Politics of Aesthetics* (London: Continuum, 2004); Jacques Ranciere, *Aesthetics and its Discontents* (Cambridge: Polity Press, 2009); Jacques Ranciere, *The Future of the Image* (London: Verso, 2007); and Pierre Bourdieu, *The Rules of Art* (London: Polity, 1996).

5 I taught three substantially modified versions of this lecture series during the academic years 2008–11.

6 Hal Foster, Rosalind Krauss, Yves-Alain Bois and Benjamin Buchloh (eds), *Art since 1900* (London: Thames & Hudson, 2004).

7 'Expanding field' was used as a broader term that retained an implicit reference to Rosalind Krauss' 'Sculpture in the Expanded Field', in Rosalind Krauss, *Passages in Modern Sculpture* (Cambridge, MA: MIT Press, 1981) without coinciding with her technical use of the term 'expanded field'.

8 On the post-medium condition, see Rosalind Krauss, *A Voyage on the North Sea: Art in the Age of the Post-Medium Condition* (London: Thames & Hudson, 2000).

9 See Sherie Levine, 'Statement', in Charles Harrison and Paul Wood (eds), *Art in Theory 1900–1990* (Oxford: Blackwell, 1990), p. 1065.

10 Bois describes theoreticism as the indiscriminate appeal to theory as a set of ready-made tools and miracle solutions. See Yves-Alain Bois, 'Resisting Blackmail', in *Painting as a Model* (Cambridge, MA: MIT Press, 1998), pp. xii–xiii.

11 Robert C. Morgan, 'After the Deluge: The Return of the Inner-Directed Artists', *Arts Magazine* (March 1992), p. 50.

12 Wall, 'Frames of Reference', p. 173.

13 Ibid., pp. 175–6.

14 Ibid.

15 'Marks of Indifference: Aspects of Photography in, or as, Conceptual Art', in *Jeff Wall: Selected Essays and Interviews*, pp. 143–68.

16 Lee Robbins, 'Lightbox, Camera, Action', *ArtNews*, 94 (1995), pp. 220–23.

17 Thierry de Duve, Arielle Pelenc, Boris Groys and Jean-Francois Chevrier (eds), *Jeff Wall* (London: Phaidon, 2002), p. 321.

18 'Interview with Jean-Francois Chevrier', in *Jeff Wall: Selected Essays and Interviews*, p. 325.

19 In Hegel's systematic thought, art as a form of awareness of the Absolute Spirit is superseded by religion and philosophy. Hegel believed that this had already happened in his own times, hence the famous quote 'Art, considered in its highest vocation, is and remains for us a thing of the past'. See *Hegel's Aesthetics: Lectures on Fine Art* (1820–1829), trans. T.M. Knox (Oxford: Oxford University Press 1975, 2 volumes), Vol. I, p. 11.

20 'I don't think I've broken with Modernism': see Jeff Wall, 'Post-60s Photography and its Modernist Context: A Conversation between Jeff Wall and John Roberts', in *Jeff Wall: Selected Essays and Interviews*, p. 333.

21 Peter Galassi, 'Unorthodox', in *Jeff Wall* (New York: Museum of Modern Art, 2007), pp. 40–41.

22 'In *The Destroyed Room* I was interested in a "remaking" of an existing image, a sort of mannerist attitude toward it. The Delacroix painting seemed very modern to me. I see a lot so-called "old art" that way. Why shouldn't we be able to relate to it as contemporary?', in 'A Democratic, a Bourgeois tradition of Art: A Conversation with Jeff Wall by Anne-Marie Bonnet and Rainer Metzger', in *Jeff Wall: Selected Essays and Interviews*, p. 246.

23 Cf. T.J. Clark's analysis of *Olympia*'s sources in Titian's *Venus d'Urbino* and Giorgione's *Sleeping Venus* in 'Olympia's Choice', in *The Painting of Modern Life: Paris in the Art of Manet and his Followers* (London: Thames & Hudson, 1999).

24 See 'Arielle Poulenc in Correspondence with Jeff Wall', in *Jeff Wall: Selected Essays and Interviews*, p. 260.

25 Galassi, 'Unorthodox', p. 42.

26 Ibid., p. 40. Galassi provides a historical overview of the collapse of academies in the second half of the nineteenth century, the rise of artistic radicalism with Manet and his contemporaries, and their eventual establishments as 'the Old Masters of a new academy without walls'.

27 The literature on the practice-led PhD is growing rapidly. See indicatively Annette W. Balkema and Henk Slager (eds), *Artistic Research* (Amsterdam and New York: Rodopi, 2004); Katy Mcleod and Lin Holdridge (eds), *Thinking through Art: Critical Reflections on Emerging Research* (London: Routledge, 2005); Lesley Duxbury, Elizabeth M. Grierson and Dianne Waite (eds), *Thinking through Practice: Art as Research in the Academy* (Melbourne: Royal Melbourne Institute of Technology Publishing, 2007); Hazel Smith and Roger Dean, *Practice-led Research, Research-led Practice in the Creative Arts* (Edinburgh: University of Edinburgh Press, 2009); Estelle Barrett and Barbara Bolt (eds), *Practice as Research: Approaches to Creative Arts Enquiry* (London: I.B. Tauris, 2010). See also the special issue of *Working Papers in Art and Design*, 1(1) (November 2000).

28 See Jack Flam (ed.), *Robert Smithson: The Collected Writings* (Berkeley, CA: University of California Press, 1996); Robert Morris, *Continuous Project Altered Daily: The Complete Writings of Robert Morris* (Cambridge, MA: MIT Press, 1991); Joseph Kosuth, 'Art After Philosophy' (1969), in *Art After Philosophy and After* (Cambridge, MA: MIT Press, 1993); Hans-Ulrich Obrist (ed.), *Gerhard Richter: The Daily Practice of Painting* (London: Thames & Hudson, 1995); Wall, *Selected Essays and Interviews*.

29 Mainly at Simon Fraser University from 1976 to 1987, having started as an assistant professor at the Nova Scotia College of Art & Design in Halifax, and less regularly at the University of British Columbia since 1987.

30 Jeff Wall, 'Writing on Art: Interview between Jeff Wall and Jean-Francois Chevrier', in *Jeff Wall: Selected Essays and Interviews*, p. 319.

31 Jeff Wall, 'Partially Reflective Mirror Writing', in Alexander Alberro (ed.), *Two Way Mirror Power: Selected Writings by Dan Graham on His Art* (Cambridge, MA: MIT Press, 1999); see 'Writing on Art: Interview between Jeff Wall and Jean-Francois Chevrier', in *Jeff Wall: Selected Essays and Interviews*, pp. 313–17.

32 Wall, 'Post-60s Photography and its Modernist Context', pp. 331–45.

33 Wall acknowledges this, also referring to *The Destroyed Room* (1978), his re-making of Delacroix's *The Death of Sardanapalus*, as another work that has arisen directly out of his teaching. Manet remains a pivotal reference for Wall. Cf. also his essay 'Unity and Fragmentation in Manet', in *Jeff Wall: Selected Essays and Interviews*, pp. 77–84.

34 Quoted in Thierry de Duve, 'The Mainstream and the Crooked Path', in de Duve et al. (eds), *Jeff Wall*, p. 40.

35 De Duve, 'The Mainstream and the Crooked Path', p. 41.

'Without a Master': Learning Art through an Open Curriculum

Joanne Lee

Having been involved in contemporary art and the higher education sector for the last 20 years – as an artist/writer and as a student, lecturer and course leader – I have witnessed just how persistently my discipline has been engaged with debates around pedagogical tradition and innovation, and indeed how ideas of education now pervade the production and curation of contemporary art.[1] In the last few years alone, a host of books on the subject have been published (with 2009 being a particular high-water mark) and were you to read even a few of these, you would quickly acknowledge the diversity of approaches practised within the contemporary field.[2] In England it seems that, despite the existence of government-approved subject 'benchmarks', it is hard to find agreement upon what should be taught or how the teaching might be approached; perhaps the only consensus is that there is no consensus.[3] This chapter will summarise key developments in the history of English art education through which such uncertainty has been amplified, as well as identifying examples of the educational projects where art practice has itself made critical propositions about pedagogy. In such instances there has often been a concern with the power relationships at play within teaching and learning, and with questions of critical mastery: given the focus of the current volume on the role of art history for artist-teachers, I will consider the often-vexed relationship between art practice and historical and critical studies within these debates. I want to conclude by showing how the Fine Art course at Nottingham Trent University has sought to respond to these questions, informed by reflections upon the utility of Jacques Rancière's suggestion that learning can take place 'without a master'.[4]

The major reforms of English art education in the 1960s laid the groundwork for what subsequently became today's undergraduate courses in Fine Art. Charged to develop and formalise an agreed curriculum for art

and design, the government committees led by Sir William Coldstream and Sir John Summerson debated with key figures in the world of art, industry and higher education. Their discussions resulted in the introduction of the Diploma in Art and Design (Dip AD), a qualification devised to be equivalent to the standard undergraduate university degree, thanks in no small part to the required inclusion of a written dissertation in art history. The government papers of the era acknowledge the limited number of academics qualified to teach this new art history component, as there were then only a few courses teaching the subject as either a major or minor study at university; indeed, committee members seem to have regarded the role of teaching art history to art students as something of a job-creation scheme for the graduates of these courses, the effects of which they hoped might be to further develop art history as a discipline itself. [5]

For me, the most interesting aspect of these reforms is that, just as a nationwide curriculum for art and design was agreed, something of a 'wild card' was introduced in the form of the 'complementary studies' element of each course. This aspect, aimed at broadening the students' education, might include whatever the institution saw fit – psychology, sociology, economics – and was not to be examined or assessed.[6] The provision of such complementary subjects, which were initially peripheral to the core curriculum, increasingly came to inflect art and its education, such that these days, the very heterogeneity of the academic discipline owes a great deal to their impact.

The Dip AD developed into a Bachelor of Arts degree and Fine Art education increasingly came to be provided within polytechnics rather than autonomous art schools. Under the aegis of the Council for National Academic Awards (polytechnics being unable to award their own degrees), the necessity of establishing parity of esteem across awards given by universities, polytechnics and colleges began to affect methods of teaching and learning, as art schools found themselves sharing physical and conceptual space with those from other disciplines. Polytechnics were also often at the vanguard of modularisation, which saw the Fine Art curriculum split into discrete aspects, whose relationship was not always made clear to students or much understood by some staff.[7]

In 1992, the transformation of the polytechnics into new universities, each with their own degree-awarding powers, brought Fine Art courses into a yet more explicit relationship to the wider academic culture from which much of the subject had hitherto maintained its distance.[8] Meanwhile, the Research Assessment Exercise (and its successor, the Research Excellence Framework), whose demands have clearly shaped many new academic appointments, has had the effect of creating Fine Art staff teams who have been encouraged to focus increasingly upon academic research rather than professional art practice. (The effect of this – both positive and negative – upon student

experience and aspirations could form the subject of a chapter in itself.) Right now, if the Bologna Declaration is accepted, we will see models of education and accreditation (largely following the English model) standardised across Europe: it is clear how compliant with university culture English art education has become and how far we are now removed from the art schools of Europe.[9] In England we have seen a gradual erosion of the remaining independent art school sector: many schools have joined together because of the need to create economies in the scale of provision, and a great deal have been incorporated into new or existing universities.[10]

In this shifting educational landscape, it seems that change has gained momentum, such that there is relatively swift and seemingly perpetual reinvention of what should be taught, and how it might best be done. In part this is driven by a 'customer-focused' approach concerned, in England at least, with the impact of student fees upon recruitment and the need to make courses commercially viable; some have preferred to develop named routes, continuing the tradition of degree courses focusing on a single medium, such as painting, or perhaps 'innovating' new titles, which they hope will prove attractive in the increasingly competitive market, whilst others have emphasised broad-based, interdisciplinary study, popular amongst students who do not want to specialise at that stage.[11] As I suggested earlier, despite government initiatives requiring subject areas to develop benchmark statements describing their curricula and approaches to teaching and learning, it seems that there is still apparently little agreement as to what exactly should be taught. A 2004 article in *The Guardian* reported: 'A survey this week shows colleges and university arts departments in Britain agree on very little when it comes to the curriculum for future artists, except, bizarrely, black and white photography and silkscreen printing'.[12] That same year, Paul Shakeshaft of Anglia Polytechnic University asserted in a letter to the *Times Higher* that Fine Art courses are 'comparatively formless', and asked: 'Is there any other degree regime less specific in its objectives, curriculum or criteria?'[13]

Across the last decade or so, the debate about art education from school to university has been marked by a repeated concern with the perceived 'difficulty' of teaching the subject. *The Impossibility of Art Education* (1999) focused upon conceptual and political difficulties within the context of the National Curriculum for schools,[14] whilst the series of short case studies in *Why We Make Art and Why It Is Taught* (2010) demonstrate that family histories and experiences outside the classroom were seemingly as important as any aspect of formal teaching in developing artistic inclinations and practices.[15] In John Reardon's book of interviews with artists who teach, opinion is divided between those who feel that art can be taught and those who do not, believing instead that what they are providing is an environment or set of conditions within which students may learn to make art or become artists.[16] James Elkins, in his assertively titled book *Why Art Cannot Be Taught* (2001),

admits to being pessimistic about what happens in art schools and claims that whilst 'interesting and valuable things happen in studio art instruction … I don't think it involves teaching art'.[17] John Baldessari, meanwhile, who was involved with both Cal Arts and UCLA, makes a similar view plain in an interview with students of Frankfurt's Städelschule. He says: 'I don't think art can be taught. I really don't. But I do think that one of the advantages of an art school is that the student gets to meet artists, other artists who are practising'.[18]

Even setting aside such major philosophical or conceptual issues, practical questions emerge as regards curricula and teaching methods now that contemporary art itself is an increasingly diverse field, within which a huge and sometimes contradictory range of ideas, media and histories are being explored.[19] The contemporary art scene appears to be so preoccupied with ideas of mobility, itinerancy and the ephemeral – as is manifest in the current culture of projects, residencies, workshops, biennials, art fairs, festivals and the like – that the very discipline itself seems in flux.[20] In this climate, how might we agree what kinds of skills and knowledge are needed by students?

This current volume asks about the importance of art history for art education: just how can the subject be brought to students in such a way as to be relevant to those engaged in such diverse practices and approaches? Given the very limited teaching time available within the average critical studies module and the rather meagre amount of credit points awarded for such study, it is hard to see how a survey course could be anything other than perfunctory in its coverage; even a course focusing instead upon certain very particular themes would find it difficult to map the territory satisfactorily. And yet, with the increasing heterogeneity of contemporary art and the hybridisation of cultural forms, there is an argument for dealing with the still broader conceptions of visual culture, cultural studies and so forth, though here the scale of the field even more clearly exceeds the timetable. In terms of equipping students with useful knowledge that would aid their development, one can recognise a plethora of other options, from aesthetics and philosophy through reception theory and the like, or one might take a more radical tack and suggest an exploration of contemporary science and its intersection with art in order to allow a clearer understanding of the increasingly technologised world. Maybe a study of economics might equip students with the skills to deal more effectively with funding structures or the art market; or, perhaps as a counter to perceived capitalist excess, should we now focus instead upon ideas of sustainability and resourcefulness? The only thing that seems clear is that there is a grab bag of histories and theories, all of which *could* offer something relevant, useful or challenging to the contemporary art student. Faced with such practicalities, what on earth do students need to know?

Such questions are increasingly emerging through art projects, the development of which seems to suggest a sense of dissatisfaction in the

art world with art education 'as it is' and a desire for art/artists to propose solutions. One key example was the cancelled *Manifesta 6*, which sought as part of its agenda to create an independent art school in Cyprus and which transmogrified into *unitednationsplaza*, an 'exhibition as school'. Initiated by Anton Vidokle and running in Berlin between 2006 and 2007, it developed out of the tradition of Free Universities and involved over 100 artists, writers and theorists in its seminars and events.[21] It continued in a new manifestation in Mexico City, as well as the year-long *Night School* project at New York's New Museum, which began in January 2008.[22] Vidokle provided the informative appendix, 'An Incomplete Chronology of Independent Art Schools', at the end of his essay 'Exhibition as School in a Divided City', which set out the rationale behind the *Manifesta* project, and it is clear that the range and diversity of the listed independent/experimental art schools and collaborative educational projects demonstrates a recurrent preoccupation with pedagogy that is rarely seen in other disciplines.[23] Even within the 'formal' higher educational sector, a host of 'cells', think-tanks and symposia have debated the seemingly temporal, mobile and global future of art/art education: Edinburgh College of Art's Future Academy project has appeared in Tokyo, Mumbai, Melbourne and elsewhere, and the Städelschule's *Gasthof* project, which invited students from outside the institution to come and stay as if in a guesthouse, involved cooking and similar shared activities.[24] Whilst there is a recognition of historical precedents (as in Vidokle's list of independent schools), there is, it seems, a paucity of specifically art-historical reference points; the discursive focus of such projects is frequently upon philosophical and political approaches instead. The Masters here are not old ones, but the new Masters of contemporary 'theory', from a variety of disciplines.

One such philosophical 'heavyweight' is Jacques Rancière, and it has been his book *The Ignorant Schoolmaster* ([1987] 1991) that recurs again and again in recent debates about art education. In it, he argues that learning can and should take place without a Master, and his radical aim is to articulate the conditions for 'intellectual emancipation'. This curious work tells the story of one Joseph Jacotot and his nineteenth-century pedagogical experiments, but, as its translator Kristin Ross points out in her introduction, readers often experience a real sense of uncertainty concerning the identity of the book's narrator: 'The reader ... is not quite sure where the voice of Jacotot stops and Rancière begins. Rancière slips into Jacotot's text, winding around or worming in; his commentary contextualizes, rehearses, reiterates, dramatizes, elaborates, *continues* Jacotot'.[25] For Ross, the uncertainty caused by this ventriloquism is productive: being unclear as to who exactly is speaking, the effect is of science-fiction time-travel, serving to bring Jacotot's revolutionary ideas once more right into the present, *our* present, via Rancière's own philosophical relation to the ideas and events of 1968, from which context the book emerged.

The Ignorant Schoolmaster opens by introducing Jacotot. An esteemed figure in post-revolutionary France, he had been an artilleryman, an instructor in the Bureau of Gunpowder, secretary to the Minister of War, substitute for the Director of the École Polytechnique, had risen to become a deputy in the French government and had also been a lecturer in rhetoric, analysis, languages, mathematics and law, amongst several other subjects. His success was disrupted, however, with the restoration of the Bourbons, after which he was forced into exile in Belgium. In receipt of a half-pay professorship in French literature at the University of Louvain (Leuven), he found himself in the challenging situation of having a host of students who wanted to study with him, but with whom he had no common language: he spoke French and they Flemish. Rather fortuitously, however, a bilingual edition of Fénelon's 1699 work *Télémaque* had recently been published in Brussels, and with this 'thing in common' Jacotot 'taught' his students French – or, more precisely, he gave them this book with instructions (via an interpreter) to learn and repeat the French text over and over until they could recite it. As a result, without any further instruction and without a teacher's explication, they managed to learn the language, such that subsequently they were able to write essays (in French) expressing their opinions of the book and its ideas. It was later reported by his contemporaries that Jacotot had wondered: 'How could these young people, deprived of explanation, understand and resolve the difficulties of a language entirely new to them? ... And how surprised he was to discover that the students, left to themselves, managed this difficult step as well as many French could have done'.[26]

Jacotot/Rancière recognised that young children find out about the world around them by noticing things and asking questions of/about those things. Similarly, the Flemish students had attended to the comparison of the French and Flemish texts and were able to learn the new language as a result of considering and questioning what they had noticed, extrapolating verb conjugations, sentence structures and so forth from the repetitions, patterns, similarities and differences they could see. As Rancière comments: 'Let's call the act that makes an intelligence proceed under the absolute constraint of a will *attention*'.[27] He continues: 'It makes no difference whether the act is directed at the form of a letter to be recognised, a sentence to be memorised, a relation to be found between two mathematical entities, or the elements of a speech to be composed'.[28] *The Ignorant Schoolmaster* asserts: 'Whoever looks always finds. He doesn't necessarily find what he was looking for, and even less what he was supposed to find, but he finds something new to relate to the thing that he already knows'.[29] Learning is thus all about making connections between that which is already known and that which one is encountering for the first time. Rancière goes on to suggest that we use our attention and 'artistic research' (he uses this term even when speaking of broader conceptions of learning) in relation to that which we wish to know.[30] He advises that we

should then attempt to recount how we feel about what we have found, and in expressing this to others allow them to feel it also, 'despite the inevitable arbitrariness of language'.[31]

Jacotot/Rancière even went so far as to suggest that it is possible for someone who was ignorant of a subject or language to 'teach' another person that subject – Jacotot ran classes in piano and painting, two subjects of which he was 'notably incompetent'.[32] For him, 'explication is the myth of pedagogy', because he realised that people had long been able to learn things without the intervention of a teacher to explain them – indeed, one might go further and say people learn *most* things in their life without direct explanation.[33] The book gives the example of an illiterate mother teaching her child to read: whilst the mother does not herself know the words, she knows how to see 'in his eyes, in the child's features, when he is doing work, when he is pointing to the words in a sentence, if he is attentive to what he is doing'.[34] In other words, she knows whether or not the child points to the same word on the page and says the same thing each time: she knows whether he is fooling about and trying to pull the proverbial wool over her eyes! According to Rancière's formulation: 'The ignorant one himself will do *less* and *more* at the same time. He will not verify what the student has found; he will verify that the student has searched. He will judge whether or not he has paid attention'.[35] So, whilst there is a 'subject' being learnt (in this case 'how to read'), the teacher 'merely' confirms the student's attention rather than the content of that learning. For Jacotot/Rancière, if 'Masters' explicate the content of a book to their students, there is always an innate power relationship at work. The system, in effect, is self-perpetuating: there is a promise that tomorrow, if you, the student, listen well to your Master's explications, you will understand more, you will take another step along the road to knowledge, but you will always remain behind the Master's superior position.

Whilst some of Rancière's thinking may seem to be at odds with academia in its apparent removal of subject expertise from the equation (to which I will return shortly), other aspects clearly echo approaches widespread throughout higher education (and not just within that relating to art). He observes, for example, that it is the students' desire to learn that is crucial: Jacotot asks himself if 'wanting was all that was necessary for doing' and Rancière's book seems to answer this in the affirmative.[36] Many students arrive in colleges and universities with such a desire, but I have often seen how students' interest is lost or compromised upon encountering a subject in higher education. As psychotherapist and essayist Adam Phillips suggests (following Freud), education is not always enlivening.[37] In order to address such issues, universities are increasingly focused upon student retention and engagement, and it is now common for students to be placed at the heart of decisions about their own learning, encouraged to make choices about what and how to study, with the intention that this will let them maintain the

interest that brought them to higher education in the first place.[38] Such choice most commonly involves selecting particular modules from those offered by a course/department, but more rarely it is about students substantially self-determining their own study (typical of many, though not all, contemporary Fine Art courses).

So, in order to determine what art students need to study, what would happen were we to support them in making their own choices? It is said that when students devise their own projects, they are more inclined to learn more deeply and independently; in art education, this happens through doing, which mobilises both practical and conceptual skills; they often have to liaise with other people as collaborators or audience; the learning itself takes place through practically testing things out and through a mix of critical and intellectual consideration alongside play or intuition.[39] There are also, as one might imagine, some major challenges. A certain level of maturity would seem to be necessary: it is hard for students at the beginning of their studies to know what might be important for them to learn and there is surely a tendency for people to avoid difficult or challenging aspects. Then there is the question of how is it possible to support the diversity of 'subjects' or approaches that may result from such self-determination: surely it is inefficient/expensive in terms of time and resources to tailor education so individually? Or perhaps the opposite may also be proposed: needing no experts – and thus apparently requiring no research upon which to base expertise – perhaps it is pure expediency on the part of universities to centre learning on the student? Additionally, there are risks that an individual focus may diminish sociability. Students may become isolated in their own work due to an absence of a sense of collective enterprise involved in studying the same topic simultaneously with others and that, as a result, they are thus unable to develop their participation in communities of practice associated with the field. Moreover, such individualism could allow students to retreat into what are essentially solipsistic and self-indulgent practices with little relation to the critical aims of university education or the disciplinary concerns.

I think that this is to mistake the reality of what can happen when students pursue a rigorously applied 'open' curriculum in Fine Art, as is the case of the undergraduate course at Nottingham Trent University where I teach and from which the subsequent examples are taken.[40] An open curriculum is not 'no curriculum' or some sort of 'anything goes' free-for-all, students are not left to their own devices to do simply as they please, and whilst they begin from their current point of interest, the asking of certain types of questions – through the giving of specific tasks or assignments – helps beginners to identify what they need to learn and challenges solipsistic tendencies. In terms of a specifically art-historical dimension, such questioning might prompt students to ask how their particular idea/practice has previously been considered and understood, and by whom, as well as identifying if such issues remain currently active in the discipline

and why this may or may not be the case. This could relate to the specificity of a particular fine art medium (painting, photography, live work, etc.) or to social, political, cultural or philosophical intersections with art. Whatever their individual starting point, students are repeatedly asked to position themselves in relation to the contexts of contemporary art and its precursors – these are researched, tried out and tested through sustained making, through the critical documentation of that process and through a series of written pieces.[41]

Those who believe students are ill-equipped to make appropriate choices would do well to remember that all students arrive at university with previous experience and knowledge of various sorts – they are far from empty vessels – and this needs to be revealed and shared amongst the larger cohort. Such exchange occurs informally in the studio environment, but also within more structured workshops or discursive fora; the collective knowledge available amongst a group of students is a valuable resource.[42] Their knowledge may well differ from what staff expected, which in turn challenges the conceptions of academics as to what it might be important to learn right now. It is certainly true that some students exercising choice will try to avoid aspects they find difficult, but according to research in the US, the majority of people who have experienced an 'open curriculum' display a sort of 'fearlessness' about encountering new ideas and problems, and dealing with unexpected or challenging material.[43] Of course, there *are* problems to overcome. Some students find identifying and pursuing their own interests very difficult: many have become accustomed to being 'taught to the test' and they would honestly prefer to be told what to do rather than undertake the difficult work of thinking for themselves. Such students do not want to be 'intellectually emancipated', they simply want to get a good degree, which means being told exactly how to succeed at a rather superficial level.[44] Here it is important to open up dialogue about the reasons why this may be the case.

The concern that a kind of dubious individualism is promulgated on Fine Art courses may be countered by the numerous instances through which students are challenged by other ideas, responses and perspectives. For example, techniques are used to explore the critical space between what an artist intends and the reception of his or her actual work: in some seminars the students are required not to speak about the work presented, but rather to listen to the dialogue it produces amongst the group – a mix of their peers (including students from other year groups) and members of the staff team. Here they have to process diverse and often unexpected views, their consideration of which is evidenced within material submitted at assessment. In such sessions, it isn't just about the presenting student gaining feedback upon what he or she has made, but also about the critical work being done by those who speak, and by those who witness the encounters.[45]

Several other types of encounter are generated. Visiting artists, writers, curators and cultural practitioners of various sorts present aspects of their

work in a programme which is also open to the public: here students and staff witness together the diverse approaches taken to making and thinking about art, and dialogue is enabled between students and the broader professional community. The curriculum also stages encounters where students are able to witness staff performing criticality in just the same way as they themselves have been asked to do. So, for example, there are regular sessions at which staff visibly put pressure upon their own practice, interrogating it through specific historical, critical or professional contexts.[46] It is here that art history can most explicitly inform work with students, although rather than presenting a thematic or survey course, they attempt to reveal how such concerns remain live and of utility in different ways for different artists/practices.

In the open curriculum, lecturers are not presented as gatekeepers of knowledge, but mediate and extend what the students can learn by offering support or prompts to help them progress further; fellow students are also partners in this.[47] Such an approach is at odds with the apparent role of a university lecturer, who is usually employed *because* of his or her subject knowledge – but the situation does not need to be considered in such binary terms. Staff expertise is not absent, but it emerges in dialogue with students, where their own knowledge is also at play. In an open curriculum, staff and students work alongside one another to explore, with interest, our existing knowledge/s and together we try to ask questions of the new things we encounter. Kiyoshi Okutsu, Professor of Aesthetics at Japan's Yamaguchi University, formulates these principles well: 'At university ... it is not a matter of someone who has knowledge conveying it to someone who does not. When I teach, I try to work together with students to jointly get to know something'.[48] In this approach there are no Masters (old or otherwise), but rather a community of practice with its members in dialogue with one another, discussing historical, critical, professional and epistemological questions.[49] An open curriculum enables a critical debate about what is to be learnt and about the state of knowledge in the contemporary field.

Underlying the whole debate is the always contentious issue of what education should be *for*.[50] With the Browne Review's emphasis upon universities as engines of economic prosperity, some now believe that education is increasingly instrumentalised to produce a flexible and itinerant workforce – the so-called 'precariat' of people in short-term jobs, without recourse to stable occupational identities or careers, social protection or protective regulations.[51] This is a real and significant danger, which Fine Art education addresses frankly, not least because of the long history of economic precarity within our discipline: conversations about the utility of their degree study, as well as the social and political priorities with which contemporary practice has to contend, are threaded through the course from the very beginning. The Nottingham open curriculum is far from apolitical: a tradition of activism has emerged in graduates as a result, as has a culture where

students realise that their future frequently requires collective endeavour, hence the proliferation of artist-run spaces and studio groups.[52]

These days, an education in Fine Art is rarely a narrow professional training because the discipline itself increasingly involves hybrid creative forms, student aspirations are so diverse and the future for which courses try to prepare them is so uncertain.[53] As Gordon Brown (the former Dean of MIT rather than the erstwhile British Prime Minister) contends, 'we are not preparing students for the world of today, or the world that teachers have grown up in; we are preparing students for a world that we can barely imagine'.[54] At its best, the open curriculum of a Fine Art course is an intensely social space where learning takes place between participants. Together we negotiate the shifting necessities of a world that is in flux and formulate future options – through the interrelationship of individual and community, the creative and the critical. Anton Vidokle offers a neat summation: 'The actual activities that typically take place in an art school – experimentation, scholarship, research, discussion, criticism, collaboration, friendship – contribute to a continuous process of seeking out and redefining the potential in practice and theory'.[55]

I cannot think of a better goal in art education and I remain convinced that it can and must be achieved without a Master.

Notes

1 Paul O'Neill and Mick Wilson's editorial 'Introduction', in Paul O'Neill and Mick Wilson (eds), *Curating and the Educational Turn* (London: Open Editions 2010) offers a useful list of such projects: Daniel Buren and Pontus Hultén's *Institut des Hautes Etudes en Arts Plastiques*, 1996; the 'Platforms' of *Documenta 11* in 2002; the educational leitmotif of *Documenta 12* in 2007; the unrealised *Manifesta 6* experimental art school as exhibition and the associated volume, *Notes for an Artschool*; the subsequent *unitednationsplaza* and *Night School* projects; *protoacademy*; *Cork Caucus*; *Be(com)ing Dutch: Eindhoven Caucus*; *Future Academy*; *The Paraeducation Department*; 'Copenhagen Free University'; *A.C.A.D.E.M.Y.*; *Hidden Curriculum*; Tania Brueghera's *Arte de Conducta* in Havana; *ArtSchool Palestine*; *Brown Mountain College*; *Manoa Free University*; and *School of Missing Studies*, Belgrade. They go on to note (at p. 13) a range of sometimes short-lived institutional models in galleries and museums: Maria Lind's work at Kunsverein München; Catherine David at Witte de With in Rotterdam; Maria Hlavajova at BAK in Utrecht; Nicolas Bourriaud and Jérôme Sans at Palais de Tokyo, Paris; Vasif Kortun at Platform Garanti Contemporary Art in Istanbul; and Charles Esche's museum model at Rooseum in Malmö.

2 An indicative reading list might include such examples as: Heike Belzer and Daniel Birnbaum (eds), *Kunst lehren/Teaching Art: Städelschule Frankfurt/Main* (Cologne: Verlag der Buchhandlung Walther König, 2007); Brad Buckley and John Comonos (eds), *Rethinking the Contemporary Art School: The Artist, the PhD and the Academy* (Halifax: Press of the Nova Scotia College of Art and Design 2009); G. James Daichendt, *Artist-Teacher: A Philosophy for Creating and Teaching* (Bristol: Intellect, 2010); James Elkins, *Why Art Cannot Be Taught* (Champaign, IL: University of Illinois Press, 2001); Steven Henry Madoff (ed.), *Art School (Propositions for the 21st Century)* (Cambridge, MA: MIT Press, 2009); John Reardon and David Mollin (eds), *Ch-ch-ch-changes: Artists Talk about Teaching: Interviews by John Reardon* (London: Ridinghouse, 2009).

3 The Quality Assurance Agency for Higher Education acknowledges something of this reality in its *Subject Benchmark Statement* for Art and Design, remarking on the 'richness and diversity of art and design higher education'. See http://www.qaa.ac.uk/Publications/InformationAndGuidance/Documents/ADHA08.pdf (2008), p. 1.

4 Jacques Rancière, *The Ignorant Schoolmaster: Five Lessons in Intellectual Emancipation,* translated by Kristin Ross (Stanford, CA: Stanford University Press, 1991). The work was originally published

in French in 1987. Rancière's proposition resonates through many of the recent publications and events I have listed in the first footnotes to this chapter. Whilst much of his work has drawn upon the political significance of aesthetic and philosophical theories from Kant and Schiller et al., *The Ignorant Schoolmaster*, with its ideas of equality and self-emancipation, owes more to the critical pedagogy of Freire, Illich and their ilk. Rancière has become one of contemporary art's pre-eminent theorists, appearing at academic conferences and art fairs alike; indeed, so ubiquitous did he become for a time that in 2005, Artforum's online diary *Scene and Herd* was able to cast him as the 'art-world darling du jour'. See 'Mum's the Bird', 26 October 2005 (available at: http://artforum.com/diary/id=9695). His reputation has been built through such works as *The Politics of Aesthetics: The Distribution of the Sensible*, *The Future of the Image*, *The Emancipated Spectator* and *The Aesthetic Unconscious*, and he has been set to work in the contemporary art academy's re-thinking of what might constitute 'research': the journal *Art and Research* devoted an issue to Rancière 'With and Around Jacques Rancière', *Art and Research, Studio 55: Centre for Research in Fine Art Practice*, 2(1) (Summer 2008) (available at: http://www.artandresearch.org.uk/v2n1/v2n1editorial.html). Tirdad Zolghadr (one of the key participants in *unitednationsplaza*) characterises matters nicely in a wickedly funny description of art seminars: 'You sit in a circle because it's less formal, someone quotes Barthes, someone criticizes "relational aesthetics" and then you all agree on reading Rancière's *Ignorant Schoolmaster* by next week'. See O'Neill and Wilson, *Curating and the Educational Turn*, pp. 162–3.

5 'The teaching of the history of art will need teachers qualified in the subject. First rate teachers are rare but we believe that the supply will increase with the growth of the subject in the universities. The introduction of courses in art schools … will indeed create a new demand and thus promote supply'. First Report, William Coldstream/Ministry of Education, *First Report of the National Advisory Council on Art Education* (London: Her Majesty's Stationery Office, 1960), paragraph 25.

6 Notes prepared for its Chairman Nicolas Pevsner, the National Council for Diplomas in Art and Design History of Art Panel, offer the following comment: 'Hence quite a variety of subjects are possible, and we do not want to limit them in any way. Psychology might be suitable, or sociology, or more factually – economics. But one college suggested regional studies, i.e. the geology, geography, history, archaeology, architecture, economics, etc. of their own region, and that also seems an excellent scheme'. See National Council for Diplomas in Art and Design History of Art Panel (6/63), Sixth Meeting 22 May 1963, Appendix – Paper: Agenda Item 4, pp. 4–6, held in the National Archives at Kew.

7 Some staff found modularisation to have destroyed the unity of arts education and many found its structures perplexing. Olivier Richon, currently teaching at the Royal College of Art, recalls this era critically: 'The teaching became fragmented and turned into distinct teachable modules with aims and objectives, and that basically doesn't work with art' (Reardon and Mollin (eds), *Ch-ch-ch-changes*, p. 304). Michael Corris, also interviewed in Reardon and Mollin, describes how many of his then colleagues at Oxford Brookes University found the modular system to be 'so complex that, like Einstein's Theory of Relativity … only a handful of individuals at the university understood how it worked' (p. 91). It is interesting that within Fine Art, modularisation was so frequently viewed as problematic, given that its founding principles seem consistent with the development of complementary studies. Theoretically at least, it allowed people to assemble a degree programme that fit their own interests, though within many universities the reality of its implementation in practice meant that students were often subject to complex pre-/post-/co-requisites, which still defined absolutely the material to be studied, but now divided aspects that were essentially related or made awkward conjunctions out of disparate material. Modularisation was built upon the intellectual traditions of Scottish generalism, which recognised how, as art historian Murdo Macdonald puts it, 'one area of thought or expertise benefits from illumination by another and it is therefore culturally and educationally desirable to be able to place such areas in relation to one another'. See Murdo Macdonald, 'Sir Patrick Geddes and the Scottish Generalist Tradition', *2009 Sir Patrick Geddes Commemorative Lecture* (Royal Town Planning Institute in Scotland and the Saltire Society, available at: http://www.kosmoid.net/planning/geddeslectures). The echoes of these laudable aspirations can be heard in a 1994 report dealing in part with modularisation, which asserts that: 'The creation of small units of knowledge and the almost infinite number of ways in which they can be assembled encourages analysis of the scope and nature of knowledge in any discipline, its relationship to other disciplines and sub-disciplines'. See Gareth Williams and Heather Fry, *Longer Term Prospects for British Higher Education: A Report to the Committee of Vice Chancellors and Principals* (London: University of London Institute of Education, 1994). Perhaps the real problem with modularisation was that many degree pathways actively sought to retain control over the student's study and that, as a result, compromises were made which offered neither real choice (in terms of a substantial opportunity to study modules from the wider school/university) nor a coherent approach to the discipline itself. The upshot, as so often in higher education, was something of a dog's breakfast.

8 Even whilst the Council for National Academic Awards (CNAA) had sought to ensure parity, art and design frequently ploughed its own furrow. It was indicative that this began right from the moment that students wished to apply for such courses, for they had to do so via the Art and

Design Admissions Registry (rather than the Universities Central Council on Admissions or the Polytechnics Central Admissions Service).

9 The detail of the declaration is available online (see: http://www.ehea.info/Uploads/Declarations/ BOLOGNA_DECLARATION1.pdf). For many art schools/academies in Europe, the coming standardisation of teaching and qualification through the Bologna Process is seen as entirely inadequate for artistic education. A great many of the contributors to Paul O'Neill and Mick Wilson's *Curating and the Educational Turn* denounce the anticipated changes.

10 For example, the formerly independent colleges of Central St Martins (itself an amalgamation of two once-separate art schools), Chelsea, Camberwell, Wimbledon, the London College of Communication and the London College of Fashion now form a federation as University of the Arts London; and via intermediary mergers into the Surrey Institute of Art & Design and the Kent Institute of Art & Design, colleges at Canterbury, Epsom, Farnham, Maidstone and Rochester finally became the University of the Creative Arts. A few independent colleges remain: as well as the Royal College of Art, there are the Arts University College at Bournemouth, Cleveland College of Art and Design, University College Falmouth, Hereford College of Arts, Leeds College of Art, Norwich University College of the Arts, Plymouth College of Art and Ravensbourne.

11 With the new fees regime in place in England from 2012, in non-STEM subjects the full cost of education now falls upon students themselves. The impact of 'consumer choice' upon the degree courses offered in art and design is therefore only likely to increase, as the recent Browne Review makes clear in its assertion that 'students are best placed to make the judgment about what they want to get from participating in higher education': *Securing a Sustainable Future for Higher Education: An Independent Review of Higher Education Funding and Student Finance*. See http://www.bis.gov.uk/assets/biscore/corporate/docs/s/10-1208-securing-sustainable-higher-education-browne-report.pdf, p. 25.

12 See http://www.guardian.co.uk/education/2004/apr/27/newuniversities19922012.highereducation. The survey reported in this article was derived from research at the Laboratory, Ruskin School of Art, University of Oxford. Its findings are presented and discussed in Paul Bonaventura and Stephen Farthing (eds), *A Curriculum for Artists* (Oxford: Laboratory, Ruskin School of Drawing & Fine Art, University of Oxford/New York: New York Academy of Art, 2004).

13 See http://www.timeshighereducation.co.uk/story.asp?storyCode=188089§ioncode=26.

14 Geoff Cox, Howard Hollands and Victoria de Rijke (eds), *The Impossibility of Art Education*, (London: Camerawords, 1999).

15 Richard Hickman, 'Section Two: Conversations and Reflections – Some Mini Case-Studies', in *Why We Make Art and Why it is Taught* (Bristol: Intellect, 2010), pp. 69–103.

16 Reardon and Mollin (eds), *Ch-ch-ch-changes*.

17 James Elkins, *Why Art Cannot Be Taught: A Handbook for Art Students* (Champaign, IL: University of Illinois Press, 2001), pp. 1–2.

18 See Belzer and Birnbaum, *Kunst lehren/Teaching Art*, p. 122.

19 Alex Farquharson demonstrates this range rather neatly when he lists artist Carsten Holler's diverse activities: 'zoologist, botanist, paediatrician, physiologist, psychologist, occupational therapist, pharmacist, optician, architect, vehicle designer, evolutionary theorist and political activist'. See 'Before and After Science', *frieze*, 85 (2004), p. 93.

20 In 2011, for example, Pirate Camp Set Up its Artists' Itinerant Campsite at the Venice Biennale (http://www.pirate-camp.org) and a series of On The Road events across Europe focused on cultural mobility (http://www.on-air-mobility.org/timetable/on-the-road), whilst the Artists in Transit project tried to explore what mobility really meant for artists today (http://blog.igbk.de/about) and the Identity and Itinerancy symposium at National Galleries of Scotland considered the rootless, peripatetic nature of art practice (http://www.axisweb.org/dlForum.aspx?ESSAYID=18150).

21 See http://www.unitednationsplaza.org.

22 See http://museumashub.org/node/48.

23 See http://manifesta.org/wordpress/wp-content/uploads/2010/07/NotesForAnArtSchool.pdf.

24 See http://www.metronomepress.com/documenta12.html and the catalogue Dirk Fleischmann and Jochen Volz (ed.), *Gasthof 2002* (Frankfurt am Main: Staatliche Hochschule für Bildende Künste – Städelschule, 2003).

25 Kristin Ross, 'Translator's Introduction', in Rancière, *The Ignorant Schoolmaster*, p. xxii, emphasis in original. I have chosen as a result to name both protagonists in the formulation Jacotot/Rancière wherever the uncertainty persists.

26 Rancière, *The Ignorant Schoolmaster*, p. 2.

27 Ibid., p. 25, emphasis in original.

28 Ibid.

29 Ibid., p. 33. There is an interesting echo of this in Carol Gray and Ian Pirie's findings that artist researchers are characteristically eclectic borrowers who seek what they need from a heterogeneous range of sources and critical perspectives. See their '"Artistic" Research Procedure: Research at the Edge of Chaos?', *Proceedings of 'Design Interfaces' Conference* (Salford: The European Academy of Design, University of Salford, 1995).

30 Rancière, *The Ignorant Schoolmaster*, p. 70.

31 Ibid.

32 Ibid., pp. 14–15.

33 Ibid., p. 6.

34 Ibid., p. 31.

35 Ibid, emphasis in original.

36 Ibid., p. 2.

37 Adam Phillips, *The Beast in the Nursery* (London: Faber & Faber, 1999), p. 23.

38 So-called 'student-centred' learning is now the claim of many universities and colleges (though whether it actually exists in practice within all the courses/institutions who aspire to it remains debatable). The theory has it that this approach facilitates a more active and deeper learning than would be the case in teacher-led, transmissive methods of education and that, as a result, students develop an increased sense of responsibility, accountability and autonomy for their studies, as well as building interdependent and mutually respectful relationships with their teacher; teacher and learner are both enabled to reflect upon the teaching and learning process itself. For a summary of the key aspects of student-centred learning, see Susan J. Lea, David Stephenson and Juliette Troy, 'Higher Education Students' Attitudes to Student Centred Learning: Beyond "Educational Bulimia"', *Studies in Higher Education*, 28(3) (2003), p. 322. Student-centred learning emerged from progressivist educational applications of John Dewey's pragmatist philosophy: here learning is believed to take place through social interactions via which ideas gain enduring meanings and through doing/testing. See John Dewey, *Experience and Education* (Indianapolis: Kappa Delta Pi, 1938). It was also informed by Malcolm Knowles' ideas of 'andragogy', which recognised that how and why adults learn is different than is the case for children; developing out of a Humanist tradition, Knowles' work suggested that adult learners seek self-actualisation, wanting their learning to be socially relevant and with the potential for immediate application. See Malcolm S. Knowles, *The Modern Practice of Adult Education: Andragogy versus Pedagogy* (Englewood Cliffs: Prentice Hall, 1970). Knowles was influenced by Carl Rogers' experience from client-centred psychotherapy, which was also applied to education via his 1969 book, *Freedom to Learn: A View of What Education Might Become* (Columbus: C.E. Merrill Publishing Co., 1969).

39 Research in the US has found that students exercising choice through open curricula become more active learners, developing unusual levels of individual motivation and a demonstrable passion for their learning. See a Teagle Foundation 'Working Group' White Paper, *The Values of the Open Curriculum: An Alternative Tradition in Liberal Education* (June 2006), available at: http://www.teaglefoundation.org/teagle/media/library/documents/learning/2006_brownwg_whitepaper.pdf?ext=.pdf.

Such approaches are also said to allow for different 'learning styles' and to cater for 'multiple intelligences'. On learning styles, see Heather Fry, Steve Ketteridge and Stephanie Marshall, *Handbook for Teaching and Learning in Higher Education* (London: Routledge, 2008), pp. 18–21, where learners are defined as Activists, Reflectors, Theorists and Pragmatists. Meanwhile, Howard Gardner's *Frames of Mind: The Theory of Multiple Intelligences* (New York: Basic Books, 1985) proposed that each person has a unique cognitive profile involving eight primary intelligences: Spatial, Linguistic, Logical-mathematical, Bodily-kinesthetic, Musical, Interpersonal, Intrapersonal and Naturalistic. I retain some scepticism towards the terminology and application of learning styles or multiple intelligences, both of which have become something of an educational industry, generating countless books and training packages. However, I do want to acknowledge that such

perspectives recognise the diversity of students and that they may learn differently from one another.

40 This is a broad-based Fine Art course. Here the students are variously involved in painting, sculpture, print and installation, they make live work, films or photography and they deal with process, materials or form, or perhaps pursue conceptual or curatorial practices without the production of 'artefacts': there are no media-specific pathways. The course has around 270 students across three years, the majority of whom have had a year's foundation study between school and university, as well as mature students who arrive with a variety of prior learning experiences.

41 All students pursue a single 120-credit module in each year, through which they attend to practice, theory and professional skills. Students are assessed holistically at the end of each module and discrete assignments do not accrue aggregated marks, though feedback is given upon particular aspects. Written and oral exercises mobilise different 'voices' and critical/professional languages: this happens through proposals, event/exhibition reviews, historical/critical reflections, artists' talks, artists' statements and so on, as well as practices of notebook/sketchbook/journal-keeping and blogging.

42 Students work alongside one another in studios and technical workshops throughout Fine Art education: this space-in-common is a vital aspect of their study and yet is one continually under threat from institutions for whom space is, of course, a cost. Nicholas de Ville has recognised what he considered to be an important oral tradition of knowledge taking place in studios as practice is pursued. See 'The Theory/Practice Intermundium', *Drawing Fire: The Journal of the National Association of Fine Art Education*, 2(3) (Autumn 1998).

43 Teagle Foundation White Paper, *The Values of the Open Curriculum*, p. 8 .

44 Colin Bryson of Nottingham Business School writes: 'The need to get a "good degree" makes assessment the main driver for students – there is too much focus on the narrow purpose of attaining a grade, the magical 2:1. The key purpose of assessment – learning – gets lost'. See http://www.timeshighereducation.co.uk/story.asp?storycode=401576.

45 In these 'Show and Listen' seminars, we try to create the conditions within which 'dialogue' and 'encounter' may take place, using Martin Buber's conceptions of these terms. In Buber's thinking, it is neither the individual nor the collective that is important, but rather the 'sphere of the between': it is through the meeting with others that one is enabled to meet with oneself. Such seminars are not simply about offering opinions, they also recognise the role of active or attentive silence within which critical work is being done. See Martin Buber, *Between Man and Man* (London: Kegan Paul, 1947).

46 These 'Presenting Contexts' and 'Interrogating Contexts' sessions are an attempt to realise Gilles Deleuze's assertion that: 'We learn nothing from those who say "Do as I do". Our only teachers are those who tell us to "do with me" and are able to emit signs to be developed in heterogeneity rather than propose gestures for us to reproduce'. See Giles Deleuze, *Difference & Repetition* (London: Continuum, 2004), p. 26.

47 Here we are working with social constructivist models, including Lev Vygotsky's theory of the zone of proximal development, as defined: 'The distance between the actual developmental level as determined by independent problem solving and the level of potential problem solving as determined through problem solving under adult guidance or in collaboration with more able peers': Lev S. Vygotsky, *Mind in Society: The Development of Higher Psychological Processes* (Cambridge, MA: Harvard University Press, 1978). Others have added the concept of the teacher providing cognitive support as a kind of 'scaffolding'. See Jerome Bruner, 'The Role of Dialogue in Language Acquisition', in Anne Sinclair, Robert Jarvella and Willem. J.M. Levelt (eds), *The Child's Conception of Language* (Berlin, Heidelberg, New York: Springer-Verlag, 1978), pp. 241–56. For a summary of social constructivism's place within theories of learning, see Orison Carlile and Anne Jordan, 'It Works in Practice But Will it Work in Theory? The Theoretical Underpinnings of Pedagogy', in Sarah Moore, Geraldine O'Neill and Barry McMullin (eds), *Emerging Issues in the Practice of University Learning and Teaching* (Dublin: All Ireland Society for Higher Education, 2005).

48 Kiyoshi Okutsu, 'Metronome Think Tank Tokyo', in Clémentine Deliss (ed.), *Metronome No. 11 What is to Be Done? Tokyo* (Paris: Metronome Press, 2007), p. 245. This echoes Paulo Freire's critique of the banking model of education, where students are 'receiving objects' within which teachers deposit knowledge: Paulo Freire, *The Pedagogy of the Oppressed* (New York: Herder & Herder, 1970), p. 77.

49 The unwillingness to act as gatekeepers of knowledge is informed by academic research in Fine Art where epistemological debates continue about the species of knowledge offered by practice-based/practice-led research. 'Compared with the established epistemologies of the humanities, the

social sciences and the natural sciences, the discourse surrounding practice-based and practice-led research in art and design is relatively young and includes a range of diverse approaches. What practice-based and practice-led research in the arts is or is not is highly controversial': Lindsay Brown and Cornelia Sollfrank, 'Who is Afraid of Artistic Research?', *Art and Research: A Journal of Ideas, Contexts and Methods*, 2(2) (Spring 2009). This is also made visible in the 2012 iteration of *Documenta* (13), whose 'Maybe Education and Public Programs' set out an agenda in which: '"Maybe" reflects the fact that knowledges are difficult to express and hard to pin down, and that art and artistic research often avoid any form of stable meaning. "Maybe" refers, in positive terms, to the lack of certainty, and of any general statement presenting the whole. It is rather a marker for an active reconsideration of ways of presenting knowledge in the context of art'. See http://d13. documenta.de/#programs. The Nottingham Trent University visual arts research cluster entitled 'Still Unresolved' specifically explores the relationship between states of contingency, uncertainty, irresolution and open-endedness within contemporary art practice: see http://www.ntu.ac.uk/ research/document_uploads/Open-Research-Book.pdf, pp. 68–71.

50 For Peter M. Senge: 'When education is driven by incessant pressures to perform on standardized tests, get good grades, and get into the right college, in order to get a good job and make lots of money, then education reinforces the consumerism and economic orthodoxy that drive the present global business system'. Peter Senge, 'Education for an Interdependent World: Developing Systems Citizens', in Andy Hargreaves, Ann Lieberman, Michael Fullan and David Hopkins (eds), *Second International Handbook of Educational Change* (Dordrecht: Springer, 2010, 2 volumes), Vol. II, p. 135.

51 Guy Standing, *The Precariat: The New Dangerous Class* (London: Bloomsbury Academic, 2011).

52 It may be that aspects of art education leave the university system; existing student debt and the tough economic climate is already seeing graduates exploring alternatives to stadying Masters degrees: many artists' groups are formulating so-called 'associate' schemes which can allow artists access to resources necessary for them to make their work, as well as to the critical dialogue and social support they may once have sought in an MA/MFA. This trend was discussed by artists from Spike Island's Associates (Bristol), Eastside Project's Extra Special People (Birmingham), S1 Artspace Studio Members (Sheffield) and Stand Assembly Studio Members (Nottingham) as part of 'Temporary Association', an event held at 1 Thoresby Street, Nottingham on 19 April 2011.

53 Some want to work as artists (and that category alone encompasses a host of media and contexts ranging from commercial galleries to socially engaged practice), but many realise that they prefer other contexts for their creativity – they become designers, filmmakers or musicians, for example; graduates go on to curate, or focus upon further academic study/research in related fields; others become schoolteachers, workshop leaders or art therapists – and some will go on to careers and lives which do not directly involve the subject, but make use of the generic skills offered by any degree-level education.

54 Quoted in Senge, 'Education for an Interdependent World', p. 134.

55 Anton Vidokle, 'Education to School: *unitednationsplaza*', in O'Neill and Wilson (eds), *Curating and the Educational Turn*.

Bibliography

Archives

Archives de l'École Nationale Supérieure des Beaux-Arts, Paris.
University College London Archive (London): Calendar and Session Book, 1896–7 and 1898–99.
Keating Papers, Private Collection (KPPC) catalogued by Éimear O'Connor.
National Archives, Ireland.
National Archives Kew (London): National Council for Diplomas in Art and Design History of Art Panel.
National Library of Scotland (Edinburgh): Joseph Noel Paton letters.
National Library of Wales (NLW) (Aberystwyth): HRC2/1, 4, 5, 8–9, 12; HRC3/1-3; HRC7/3; HRC8/1.
Royal Academy of Arts archives (London): Northcote correspondence.
Royal Scottish Academy, RSA Archives (RSAA) (Edinburgh): artist files: William Borthwick Johnstone.
Slade Archive, *Summer Pictures 1946–1961*, University College London Library Special Collections, UCL Archives: *Report of the Council*, 28 February 1872.
University of Glasgow, GB 0247 MS Whistler P202: Letter from [E[lizabeth] R[obins] Pennell] to Pavillon Madeleine, 4 October 1899.

Published Works

Adfyfr (a.k.a. Thomas John Hughes), *Neglected Wales (reprinted by permission from the* Daily News) (London: National and Liberal Printing & Publishing Association Ltd, 1887).
Simon Alderson, 'Ut Pictura Poesis and its Discontents in Late Seventeenth- and Early Eighteenth-Century England and France', *Word and Image*, 11(3) (1995).
Frances Ames-Lewis and Paul Joannides (eds), *Reactions to the Master: Michelangelo's Effect on Art and Artists in the Sixteenth Century* (Aldershot: Ashgate, 2003).
Benedict Anderson, *Imagined Communities: Reflections on the Origin and Spread of Nationalism* (London: Verso, 1983).
Anon., 'Foreign Art', *Art Union*, Vol. I (September 1839).
Anon., 'German Artists and Critics', *Art Union*, Vol. I (September 1839).
Anon., 'The German School: Pierre Cornelius', *Art Union*, Vol. I (November 1839)

Anon., 'The German School', *Art Union*, Vol. II (September 1840).

Anon., 'Foreign Publications Concerning Art. De l'Art en Allemagne, par H. Fortoul, Paris, 2 tomes, 8vo., 1842. On Art in Germany, by H. Fortoul. Rolandi, London, 2 Vols. 8vo, 1842', *Art Union* (May 1842).

Anon., 'The Frescoes of Schnorr', *Art Union* (August 1843).

Anon., 'The Art Schools of London', *Art Union* (January 1848)Anon., 'The Arts in Germany', *Athenaeum* (7 Sept. 1833).

Anon., 'Foreign Correspondence', *Athenaeum* (15 February 1834).

Anon., 'Foreign Correspondence', *Athenaeum* (6 December 1834).

Anon., 'Foreign Correspondence', *Athenaeum* (13 December 1834).

Anon., 'Foreign Correspondence. History of Modern German Art', *Athenaeum* (17 September 1836).

Anon., 'Foreign Correspondence. The Arts at Munich', *Athenaeum* (10 April 1841).

Anon., 'Review: *Münchner Jahrbücher für bildende Kunst* (Leipzig, 1839–40)', *The Dublin Review* (August 1841).

Anon., 'Art. VI.-1. De l'Art Moderne en Allemagne. Par M. le Comte A. de Raczynski. Paris 1836. Tome 1. 4to., 2. Die neuere Deutsche Kunst. Berlin. 1836. 1ster Band. 4to.', *Foreign Quarterly Review* (October 1836).

Anon., 'History of Modern Art in Germany; A Review of "Histoire de l'Art Moderne en Allemagne" par le Comte A. Raczynski', *Foreign quarterly review* (Jul. 1840).

Anon., 'Art. VIII.-Histoire de l'Art moderne en Allemagne, par le Comte A. Raczynski. Tom III. 4to. pp. 582. Paris', *Foreign Quarterly Review* (January 1842).

Anon., Review: München, seine Kunstschätze, seine Umgebungen, und sein öffentliches Leben (1841)', *Kunst und Künstler in München*, 1840.

Anon., 'Fine Arts: Modern Historical Painters at Rome', *Literary Chronicle* (9 October 1824)

Anon., 'From Italy, November 1818', *Literary Gazette* (19 December 1818).

Anon., 'Review of New Books. The Tyrol', *Literary Gazette* (6 April 1833).

Anon., 'Description of Certain Frescos, Painted by Some German Students Not at Rome', *London Magazine* (August 1820).

Anon., 'Art. V. – Histoire de l'Art moderne en Allemagne. Par le Comte A. Raczynski. 3 vols. 4to. Paris, 1836–1841', *Monthly review* (September 1844).

Anon., 'Illustrations of Italian Poets, Painted in Fresco', *Parthenon* (October 1825).

Anon., 'Art. I.-1. Histoire de l'art Moderne en Allemagne. Par le Comte A. Raczynski. Berlin, 2 vols. 4to. 1841., 2. Die Düsseldorfer Mahler Schule. Von J. J. Scotti. Düsseldorf. 1842, 3. Report from the Select Committee on Fine Arts. London 1844', *Quarterly Review* (March 1846).

Anon., 'Review: München, seine Kunstschätze, seine Umgebungen, und sein öffentliches Leben (1841)', *The New Quarterly Review, or Home, Foreign and Colonial Journal* (July 1844; October 1844).

Anon., 'Review: *Munich, ou Aperçu de l'Histoire des Beaux-Arts en Allemagne, et surtout en Bavière*, 1844, Karl Schnaase's *Geschichte der bildenden Künste* (1843) and Franz Kugler's *Handbuch der Kunstgeschichte* (1842)', *New Quarterly Review, or Home, Foreign and Colonial Journal* (October 1844).

Anon., *Catalogue of Views in Greece, Italy, Sicily, and the Ionian Islands painted in water colours by Hugh William Williams ... now exhibiting in the Calton Convening-Room, Waterloo Place, 1822* (Edinburgh: 1822).

Anon., *Catalogue of a collection of drawings of pictures by the Italian, Spanish, Flemish, Dutch and French Schools executed by J. F. Lewis, the property of the Royal Scottish Academy, with notes on the styles of the artists, as illustrated by their works – intended chiefly for the students of the academy* (Edinburgh: 1853).

Anon., *Centenary Exhibition of the Royal Scottish Academy of Paintings, Sculpture, and Architecture 1826–1926* (Edinburgh: Royal Scottish Academy, [1926]).

Anon., 'A Couple of Mistakes in Candlesticks', *Journal of Design and Manufactures*, 5 (1851).

Anon., *Daily Telegraph*, 3 May 1920.

Anon., 'Deputations to Ministers. A National Museum for Wales', *The Times*, 21 April 1904.

Anon., *Drawing Practices, Mediums and Methods 1500–1950*, Exhibition Catalogue, Strang Print Room, UCL, 10 May–16 June 2000.

Anon., 'Fine Art. Royal Scottish Academy. Collection of Copies and Studies from the Old Masters', *The Scotsman*, 16 November 1853.

Anon., 'Fine Arts. Royal Scottish Academy. Second Notice', *The Scotsman*, 23 November 1853.

Anon., 'Hogarth Club', *The Times*, 28 February 1884.

Anon., 'The King and Queen at Cardiff: National Museum of Wales Opened', *The Times*, 22 April 1927.

Anon., 'Lightbox, Camera, Action', *ArtNews*, 94 (1995).

Anon., 'Minor Topics of the Month', *The Art Journal* (August 1853).

Anon., 'National Museum of Wales. An Appeal for £100,000', *The Times*, 4 February 1926.

Anon., 'National Museum for Wales', *The Times*, 24 June 1904.

Anon., 'National Museum of Wales', *The Times*, 10 January 1927.

Anon., 'Proposed National Museum for Wales', *The Times*, 9 January 1902.

Anon., 'Royal Scottish Academy's Exhibition. Second Notice', *The Scotsman*, 19 February 1853.

Anon., 'The Royal Scottish Academy', *The Art Journal*, VI (January 1854).

Anon., 'The Royal Visit to Cardiff. The King on Welsh Enterprise. Ceremony at the National Museum', *The Times*, 27 June 1912.

Anon., 'The Theory/Practice Intermundium', *Drawing Fire: The Journal of the National Association of Fine Art Education*, 2(3) (Autumn 1998).

Anon., *The Thirty-Sixth Annual Report of the Royal Scottish Academy* (Edinburgh, 1863).

Anon., *The Twenty-Sixth Annual Report of the Royal Scottish Academy* (Edinburgh, 1853).

Anon., 'Welsh National Museum. Seward v. Lord Mayor And Corporation Of Cardiff', *The Times*, 2 February 1911.

Bruce Arnold, *Orpen: Mirror to an Age* (London: Cape, 1981).

Bruce Arnold, William Orpen: 1878–1931 (Dublin: Town House in Association with the National Gallery of Ireland, 1991).

Ruth Artmonsky, *Slade Alumni 1900–1914 William Roberts & Others* (London: Artmonsky Arts, 2001).

Francis Bacon, *The Advancement of Learning and New Atlantis* (Oxford: Clarendon Press, 1974).

A.L. Baldry, *Sir Joshua Reynolds* (London: George Newnes Ltd., 1903).

G. Baldwin Brown, *William Hogarth* (London, Walter Scott Co., Ltd., 1905).

Annette W. Balkema and Henk Slager (eds), *Artistic Research* (Amsterdam and New York: Rodopi, 2004).

Giuseppe Marco Antonio Baretti, *A Guide through the Royal Academy* (London: Cadell, 1781).

Paul Barlow, 'Fear and Loathing of the Academic, or Just What is it that Makes the Avant-Garde So Different, So Appealing?', in R. Denis and C. Trodd (eds), *Art and the Academy in the Nineteenth Century* (Manchester: Manchester University Press, 2000).

Emma Barker, Nick Webb and Kim Woods (eds), *The Changing Status of the Artist* (New Haven, CT: Yale University Press, 1999).

John Barrell, *The Political Theory of Painting from Reynolds to Hazlitt: 'The Body of the Public'* (New Haven, CT: Yale University Press, 1986).

Estelle Barrett and Barbara Bolt (eds), *Practice as Research: Approaches to Creative Arts Enquiry* (London: I.B. Tauris, 2010).

Tim Barringer and Elizabeth Prettejohn (eds), *Frederic Leighton Antiquity, Renaissance, Modernity* (New Haven, CT: Yale University Press, 1999).

Roland Barthes, 'The Death of the Author', in *Image Music Text* (London: Fontana Press, 1977).

David Batchelor, '"This Liberty and this Order": Art in France after the First World War', in Briony Fer, David Batchelor and Paul Wood (eds), *Realism, Rationalism, Surrealism: Art Between the Wars* (New Haven, CT: Yale University Press, 1993).

Timothy Baycroft and Mark Hewitson (eds), *What is a Nation? Europe 1789–1914* (Oxford: Oxford University Press, 2006).

Henry William Beechy, *The Literary Works of Sir Joshua Reynolds* (London: Bell, 1878).

Quentin Bell, 'The Fine Arts', in J.H. Plumb (ed.), *The Crisis in the Humanities* (London: Pelican, 1964).

Quentin Bell, *The Schools of Design* (London: Routledge & Kegan Paul, 1963).

William de Belleroche, *Brangwyn talks* (London: Chapman & Hall, 1946).

Heike Belzer and Daniel Birnbaum (eds), *Kunst lehren/Teaching Art: Städelschule Frankfurt/Main* (Cologne: Verlag der Buchhandlung Walther König, 2007).

Tony Bennett, 'The Multiplication of Culture's Utility', *Critical Inquiry*, 21(4) (1995).

Janetta Rebold Benton, *Art of the Middle Ages* (London: Thames & Hudson, 2002).

Andy Bielenberg (ed.), *The Shannon Scheme and the Electrification of the Irish Free State: An Inspirational Milestone* (Dublin: Lilliput Press, 2002).

Ilaria Bignamini, 'George Vertue, Art Historian and Art Institutions in London, 1689–1768: A Study of Clubs and Academies', *Volume of the Walpole Society*, 54 (1988)

Johannes Bilstein, 'Nichts den Lehrern schulden. Über Künstler als Prototypen der Selbstkonstitution', *Neue Sammlung*, 38 (1998).

David Bindman, *Ape to Apollo: Aesthetics and the Idea of Race in the 18th Century* (Ithaca, NY: Cornell University Press, 2002).

Lloyd F. Bitzer, 'Introduction', in George Campbell, *The Philosophy of Rhetoric*, (Carbondale, IL: Southern Illinois University Press, 1988).

Roland Blythe, *First Friends: Paul and Bunty, John and Christine – and Carrington* (Huddersfield: Fleece Press, 1997).

T.S.R. Boase, 'The Decoration of the New Palace of Westminster, 1841–1863', *Journal of the Warburg and Courtauld Institutes*, 17(3/4) (1954).

Yves-Alain Bois, 'Resisting Blackmail', in *Painting as a Model* (Cambridge, MA: MIT Press, 1998).

Paul Bonaventura and Stephen Farthing (eds), *A Curriculum for Artists* (Oxford: The Laboratory, Ruskin School of Drawing & Fine Art, University of Oxford/New York: New York Academy of Art, 2004).

Elizabeth Bonython and Anthony Burton, *The Great Exhibitor: The Life and Work of Henry Cole* (London: V&A Publications, 2003).

Abbé du Bos, *Critical Reflections on Poetry, Painting and Music. With an Inquiry of the Rise and Progress of the Theatrical Entertainment of the Ancients, transl. by Thomas Nugent* (London: Nourse, 1748, 3 volumes).

Pierre Bourdieu, *The Rules of Art* (London: Polity, 1996).

Giuliano Briganti, *Italian Mannerism* (London: Thames & Hudson, 1961).

Lindsay Brown and Cornelia Sollfrank, 'Who is Afraid of Artistic Research?', *Art & Research: A Journal of Ideas, Contexts and Methods*, 2(2) (Spring 2009).

Lucy Brown, *The Board of Trade and the Free Trade Movement 1832–40* (Oxford: Oxford University Press, 1958).

Jerome Bruner, 'The Role of Dialogue in Language Acquisition', in Anne Sinclair, Robert Jarvella and Willem. J.M. Levelt (eds), *The Child's Conception of Language* (Berlin, Heidelberg, New York: Springer-Verlag, 1978).

Martin Buber, *Between Man and Man* (London: Kegan Paul, 1947).

Benjamin Buchloh, 'Ciphers of Regression: Notes on the Return of Representation in European Painting, *October*, 16 (Spring 1981).

Brad Buckley and John Comonos (eds), *Rethinking the Contemporary Art School: The Artist, the PhD and the Academy* (Halifax: Press of the Nova Scotia College of Art and Design, 2009).

Helen Buckley, 'Seán Keating, Artist Extraordinary', *The Limerick Leader*, 26 February 1972.

Edmund Burke, *A Philosophical Enquiry into the Origin of our Ideas of the Sublime and Beautiful* (Oxford: Oxford University Press, 1990).

Séan Burke, *The Death and Return of the Author: Criticism and Subjectivity in Barthes, Foucault, and Derrida* (Edinburgh: Edinburgh University Press, 1998).

John Burnet, *Practical Hints on Colour in Painting Illustrated by Examples of the Works of the Venetian, Flemish and Dutch Schools* (London: James Carpenter & Son, 1827).

John Burnet, *The Discourses of Sir Joshua Reynolds* (London: James Carpenter, 1842).

Anthony Burton, 'Putting South Kensington to Work: The Department of Science and Art', Franz Bosbach, et al. (ed.), *Prinz Albert und die Entwicklung der Bildung in England und Deutschland im 19. Jahrhundert* (Berlin: Saur, 2000).

Werner Busch, 'Die Akademie zwischen autonomer Zeichnung und Handwerksdesign – zur Auffassung der Linie und der Zeichen im 18. Jahrhundert', in Herbert Beck, Peter C. Bol and Eva Maek-Gérard (eds), *Ideal und Wirklichkeit in der bildenden Kunst im späten 18. Jahrhundert* (Berlin: Gebr. Mann Verlag, 1984).

Werner Busch, *Das sentimentalische Bild: die Krise der Kunst im 18. Jahrhundert und die Geburt der Moderne* (Munich: Beck, 1993).

Frank Büttner, 'Bildungsideen und bildende Kunst um 1800', in Reinhart Koselleck (ed.), *Bildungsbürgertum im 19. Jahrhundert. Teil II* (Stuttgart: Klett-Cotta, 1990).

Frank Büttner, 'Der Streit um die Neudeutsche religios-patriotische Kunst', in Wolfgang V. Frühwald, Franz Heiduk and Helmut Koopmann (eds), *Aurora. Jahrbuch der Eichendorff-Gesellschaft*, Vol. XLIII (Frankfurt am Main: Freies deutsches Hochstift, 1983).

Frank Büttner, 'Overbecks Ansichten von der Ausbildung zum Künstler. Anmerkungen zu zwei Texten Friedrich Overbecks', in Andreas Blühm and Gerhard Gerkens (eds), *Johann Friedrich Overbeck, 1789–1869. Zur zweihundertsten Wiederkehr seines Geburtstages* (Lübeck: Museum für Kunst und Kulturgeschichte, Behnhaus, 1989).

Frank Büttner, *Peter Cornelius. Fresken und Freskenprojekte* (Stuttgart: Franz Steiner, 1999, 2 volumes).

Frank Büttner, 'Peter Cornelius in Düsseldorf', in Wend von Kalnein (ed.), *Die Düsseldorfer Malerschule* (Mainz: Von Zabern, 1979).

Frank Büttner and Karl Schlögel, ,Die Akademie und das Renommee Münchens als Kunststadt', *Zeitenblicke: Online-Journal Geschichtswissenschaften* (2006), available at: http://www.zeitenblicke.de/2006/2/Buettner/index_html.

Werner Busch, *Nachahmung als bürgerliches Kunstprinzip, Ikonographische Zitate bei Hogarth und in seiner Nachfolge* (Hildesheim: Olms, 1977).

Canterbury College of Art, *British Artists in Italy: Rome and Abbey Scholars 1920–1980* (Canterbury: Kent County Council, Education Committee, 1985).

Orison Carlile and Anne Jordan, 'It Works in Practice But Will it Work in Theory? The Theoretical Underpinnings of Pedagogy', in Sarah Moore, Geraldine O'Neill and Barry McMullin (eds), *Emerging Issues in the Practice of University Learning and Teaching* (Dublin: All Ireland Society for Higher Education, 2005).

F.A. Cavenagh (ed.), *James and John Stuart Mill on Education* (Cambridge: Cambridge University Press, 1931).

Emma Chambers, *Henry Tonks: Art and Surgery*, exhibition catalogue (London: UCL Art Collections, 2002).

Emma Chambers, 'Redefining History Painting in the Academy: The Summer Composition Competition at the Slade School of Fine Art, 1898–1922', *Visual Culture in Britain*, 6(1) (2005).

Emma Chambers, *Student Stars at the Slade 1894–1899, Augustus John and William Orpen* (London: University College of London Art Collection, 2005).

Mary Chamot, *Modern Painting in England* (London, Country Life Ltd., 1937).

Mary Chamot, Dennis Farr and Martin Butlin, *The Modern British Paintings, Drawings and Sculpture*, Vol. I, Artists A–L (Tate Gallery Catalogues, 1964).

S. Chaplin, *A Slade Archive Reader* (unpublished, University College London Library Special Collections, 1998).

G. Charlton, 'The Slade School of Fine Art 1871–1946', *The Studio* (October 1946).

Deborah Cherry, 'The Hogarth Club: 1858–1861', *Burlington Magazine*, 122(925) (1980).

Deborah Cherry and Juliet Steyn, 'The Moment of Realism: 1952–1956', *Artscribe* (June 1982).

T.J. Clark, *The Painting of Modern Life: Paris in the Art of Manet and his Followers* (London: Thames & Hudson, 1999).

George Cleghorn, *Ancient and Modern Art, Historical and Critical*, 2nd edn (Edinburgh and London: William Blackwook and Sons, 1848, 2 volumes).

First Report William Coldstream/Ministry of Education, *First Report of the National Advisory Council on Art Education*, Ministry of Education (London: Her Majesty's Stationery Office, 1960).

H.C. [Henry Cole] 'Committees of the House of Commons – Administration by Large Numbers', *London and Westminster Review*, 5(9) (1837).

Linda Colley, *Britons: Forging the Nation, 170—1837* (New Haven, CT: Yale University Press [1992], 1994).

Charles Henry Cope, *Reminiscences of Charles West Cope* (London: Richard Bentley & Son, 1891).

David Peters Corbett and Lara Perry (eds), *English Art 1860–1914: Modernities and Identities* (Manchester: Manchester University Press, 2000).

Elizabeth Cowling (ed.), *Picasso: Challenging the Past* (London: Yale University Press, 2009).

Geoff Cox, Howard Hollands and Victoria de Rijke (eds), *The Impossibility of Art Education* (London: Camerawords, 1999).

Douglas Crimp, *On the Museum's Ruins* (Cambridge, MA: MIT Press, 1993).

Cultor, 'Schools of Art in England', *Art Union* (August 1848).

Allan Cunningham, *The Lives of Most Eminent British Painters, Sculptors, and Architects* (London: John Murray, 1830, 6 volumes).

Raymond C. Curry, *The Wild West Show: A Story of the Cornwallis-West Family* (Christchurch: Natula, 2009).

G. James Daichendt, *Artist-Teacher: A Philosophy for Creating and Teaching* (Bristol: Intellect, 2010).

Charlotte Aull Davies, *Welsh Nationalism in the Twentieth Century: The Ethnic Option and the Modern State* (New York: Praeger, 1989).

Graham Day and Gareth Rees (eds), *Regions, Nations and European Integration: Remaking the Celtic Periphery* (Cardiff: University of Wales Press, 1991).

Katy Deepwell, *Women Artists between the Wars: 'A Fair Field and No Favour'* (Manchester: Manchester University Press, 2010).

Giles Deleuze, *Difference & Repetition* (London: Continuum, 2004).

Department of Education and Science National Advisory Council on Art Education, *The Structure of Art and Design Education in the Further Education Sector* (London: HMSO, 1970).

Roger de Piles, *The Principles of Painting* (London: Osborne, 1743).

John Dewey, *Experience and Education* (Indianapolis, IN: Kappa Delta Pi, 1938).

Hans Dickel, *Deutsche Zeichenlehrbücher des Barock. Eine Studie zur Geschichte der Künstlerausbildung* (Hildesheim: Olms, 1987).

Austin Dobson, *Hogarth* (London: S. Low, Marston, 1894).

Magdalena Droste, *Das Fresko als Idee. Zur Geschichte öffentlicher Kunst im 19. Jahrhundert* (Münster: Lit. Kunstgeschichte: Form und Interesse, 1980, 2 volumes).

Raymond Durgnat, 'Art Schools: the Continuing Malaise', *Art and Artists*, 4(7) (1969).

Paul Duro, *The Academy and the Limits of Painting in Seventeenth-Century France* (Cambridge: Cambridge University Press, 1997).

Thierry de Duve, Arielle Pelenc, Boris Groys and Jean-Francois Chevrier (eds), *Jeff Wall* (London: Phaidon, 2002).

Lesley Duxbury, Elizabeth M. Grierson and Dianne Waite (eds), *Thinking through Practice: Art as Research in the Academy* (Melbourne: Royal Melbourne Institute of Technology Publishing, 2007).

William Dyce and Charles Heath Wilson, *Letter to Lord Meadowbank and the Committee of the Honourable Board of Trustees for the Encouragement of Arts and Manufactures, on the best means of ameliorating the arts and manufactures of Scotland in point of taste* (Edinburgh: Thomas Constable, 1837).

Charles Lock Eastlake, *Contributions to the Literature of the Fine Arts* (London: John Murray, 1848).

James Elkins, *Why Art Cannot Be Taught* (Champaign, IL: University of Illinois Press, 2001).

James Engell, *The Creative Imagination. Enlightenment to Romanticism* (Cambridge, MA: Harvard University Press, 1981).

Lindsay Errington, *Master Class: Robert Scott Lauder and his Pupils* ([Aberdeen]: National Galleries of Scotland, 1983).

Michelle Facos and Sharon L. Hirsh (eds), *Art Culture and National Identity in Fin-de-siecle Europe* (Cambridge: Cambridge University Press, 2003).

Brian Fallon, *Irish Art 1830–1990* (Belfast: Appletree Press, 1994).

Dennis Farr, *English Art, 1870–1940* (Oxford: Clarendon Press, 1978).

Dennis Farr, 'Obituary: Mary Chamot', *The Independent* (17 May 1993).

W. Feaver, *Michael Andrews* (London: Tate Publishing, 2001).

Karl Ludwig Fernow, *Carstens, Leben und Werke* (Hannover: Carl Rümpler, 1867).

S.E. Finer, 'The Transmission of Benthamite Ideas 1820–50', in Frederick Rosen (ed.), *Jeremy Bentham* (Aldershot: Ashgate, 2007).

Jack Flam (ed.), *Robert Smithson: The Collected Writings* (Berkeley, CA: University of California Press, 1996).

Dirk Fleischmann and Jochen Volz (ed.), *Gasthof 2002* (Frankfurt am Main: Staatliche Hochschule für Bildende Künste – Städelschule, 2003).

John Fleming, 'Art Dealing in the Risorgimento II', *Burlington Magazine*, 121(917) (1979).

Geo Foggo, 'On Anatomy and Expression', *Arnold's Library of the Fine Arts*, 1(5) (1833).

A. Forge, 'The Slade to the Present Day', *Motif*, 6 (1961).

A. Forge (ed.), *The Townsend Journals: An Artist's Record of His Times 1928–1951* (London: Tate Gallery Publications, 1976).

Hal Foster, Rosalind Krauss, Yves-Alain Bois and Benjamin Buchloh (eds), *Art Since 1900* (London: Thames & Hudson, 2004).

John Fothergill (ed.), *The Slade: A Collection of Drawings and Some Pictures Done by Past and Present Students of the London Slade School of Art 1893–1907* (London: Slade School of Fine Art, 1907).

Celina Fox, 'Fine Arts and Design', in Gillian Sutherland et al., *Education in Britain* (Dublin: Irish Academic Press, 1977).

Mitchell Benjamin Frank, *German Romantic Painting Redefined. Nazarene Tradition and the Narratives of Romanticism* (Aldershot: Ashgate, 2001).

Christopher Frayling, *Henry Cole and the Chamber of Horrors: The Curious Origins of the V&A* (London: V&A Publishing, 2010).

Paulo Freire, *The Pedagogy of the Oppressed* (New York: Herder and Herder, 1970).

Walter Friedlaender, *Mannerism and Anti-Mannerism in Italian Painting*; introduction by Donald Posner (New York: Schocken Books, 1965).

Anke Fröhlich, *Landschaftsmalerei in Sachsen in der zweiten Hälfte des 18. Jahrhunderts. Landschaftsmaler, -zeichner und -radierer in Dresden, Leipzig, Meißen und Görlitz von 1720 bis 1800* (Weimar: Verlag und Datenbank für Geisteswissenschaften, 2002).

Heather Fry, Steve Ketteridge and Stephanie Marshall, *Handbook for Teaching and Learning in Higher Education* (London: Routledge, 2008).

Roger Fry, *Reflections on British Painting* (London: Faber & Faber, 1934).

Gordon Fyfe, *Art, Power and Modernity: English Art Institutions, 1750–1950* (Leicester: Leicester University Press, 2000).

Klaus Gallwitz (ed.), *Die Nazarener in Rom: ein deutscher Künstlerbund der Romantik* (Munich: Prestel, 1981).

Howard Gardner, *Frames of Mind: The Theory of Multiple Intelligences* (New York: Basic Books, 1985).

David Garnett (ed.), *Carrington: Letters and Extracts from Her Diaries* (London: Cape, 1970).

Alfred Garratt, 'The New Realism in English Art', *The Studio*, CXLVII(735) (1954).

Clifford Geertz, 'The Politics of Meaning', in *The Interpretation of Cultures* (New York: Basic Books, 1973).

Robert Gildea, *Barricades and Borders: Europe 1800–1914* (Oxford: Oxford University Press, 1987).

Victor Ginsburgh and Sheila Weyers, 'De Piles, Drawing and Color. An Essay in Quantitative Art History', *Artibus et Historiae*, 23(45) (2002).

Carl Goldstein, *Teaching Art: Academies and Schools of Art from Vasari to Albers* (Cambridge: Cambridge University Press, 1996).

Esme Gordon, *The Royal Scottish Academy of Painting, Sculpture and Architecture: 1826–1976* (Edinburgh: Skilton, 1976).

Joseph von Görres, *Gesammelte Schriften*, Vol. VIII, Abt. 2, 2 (Munich: Literarisch-artistische Anstalt, 1874).

Lionel Gossman, 'Unwilling Moderns: The Nazarene Painters of the Nineteenth Century', *Nineteenth-Century Art Worldwide*, 2 March 2003, available at: http://www.19thc-artworldwide.org/index.php/autumn03/273-unwilling-moderns-the-nazarene-painters-of-the-nineteenth-century.

Algernon Graves, *The Royal Academy of Arts: A Complete Dictionary of Contributors and their Work from its Foundation in 1769 to 1904* (London: Henry Graves and Co., 1905, 8 volumes).

Carol Gray and Ian Pirie, '"Artistic" Research Procedure: Research at the Edge of Chaos?', in *Proceedings of 'Design Interfaces' Conference* (Salford: European Academy of Design, University of Salford, 1995).

Christopher Green (ed.), *Art Made Modern: Roger Fry's Vision of Art* (London: Courtauld Gallery, Courtauld Institute of Art, in association with Merrell Holberton, Publishers, 1999).

Boris Groys, *Art and Power* (Cambridge, MA: MIT Press, 2008).

Jean H. Hagstrum, *The Sister Arts: The Tradition of Literary Pictorialism and English Poetry from Dryden to Gray* (Chicago, IL: Chicago University Press, 1958).

James Hamilton, *Turner: A Life* (London: Hodder & Stoughton, 1996).

Ryan Patrick Hanley, *Adam Smith and the Character of Virtue* (Cambridge: Cambridge University Press, 2009).

Matthew Hargraves, *Candidates for Fame. The Society of Artists of Great Britain 1760–1791* (New Haven, CT: Yale University Press, 2005).

June E. Hargrove (ed.), *The French Academy: Classicism and its Antagonists* (Newark, NJ: University of Delaware Press, 1990).

Charles Harrison, *English Art and Modernism 1900–1939* (London: Yale University Press, 1994).

Martin Harrison, *Transition: The London Art Scene in the Fifties* (London: Merrell Publishers in Association with Barbican Art Galleries, 2002).

George Harvey, *Notes on the Early History of the Royal Scottish Academy* (Edinburgh: Edmonston & Douglas, 1873).

Francis Haskell, *The Ephemeral Museum, Old Master Paintings and the Rise of the Art Exhibition* (New Haven, CT: Yale University Press, 2000).

Arnold Hauser, *Mannerism: The Crisis of the Renaissance and the Origin of Modern Art* (Cambridge, MA; London: Belknap Press of Harvard University Press, 1986; London: Routledge & Kegan Paul, 1965).

William Hazlitt, *Conversations of James Northcote, Esq., R.A.* (London: Colburn & Bentley, 1830).

David Boyd Haycock, *A Crisis of Brilliance* (London: Old Street Publishing, 2009).

Benjamin Haydon, *On Academies of Art (more particularly the Royal Academy) and their pernicious effect on the genius of Europe* (London 1839).

Michael Hechter, *Internal Colonialism: The Celtic Fringe in British National Development, 1536–1966* (London: Routledge & Kegan Paul 1975).

Hegel's Aesthetics: Lectures on Fine Art (1820–9), trans. T.M. Knox (Oxford: Oxford University Press, 1975, 2 volumes).

Andrew Hemingway, 'The Realist Aesthetic in Painting', in Matthew Beaumont (ed.), *A Concise Companion to Realism* (Oxford: Wiley Blackwell, 2010).

Martin Hewitt (ed.), *The Victorian World* (London and New York: Routledge, 2012).

Richard Hickman, 'Section Two: Conversations and Reflections – Some Mini Case-Studies', in *Why We Make Art and Why It Is Taught* (Bristol: Intellect, 2010).

Jane Hill, *The Art of Dora Carrington* (London: Herbert Press, 1994).

Frederick Whiley Hilles, *The Literary Career of Sir Joshua Reynolds* (Hamden, CT: Archon Books, [1936] 1967).

Charles Lewis Hind, *The Art of Stanhope A. Forbes, R.A.* (London: Virtue & Co., 1911).

Charles Lewis Hind, *Constable* (London: T.C. & E.C. Jack [1909]).

Charles Lewis Hind, *Days with Velasquez* (London: A&C Black, 1906).

Charles Lewis Hind, *Hercules Brabazon Brabazon, 1821–1906: His Art and Life* (London: G. Allen & Company, Ltd., 1912).

Charles Lewis Hind, *Landscape Painting from Giotto to the Present Day* (London: Chapman & Hall, 1923–4).

Charles Lewis Hind, *The Post Impressionists* (London: Methuen & Co., Ltd., 1911).

Charles Lewis Hind, *Romney* (London: T.C. & E.C. Jack, [1907]).

Charles Lewis Hind, *Turner's Golden Visions* (London: T.C. & E.C. Jack, 1910).

Charles Lewis Hind, *Watteau* (London: T.C. & E.C. Jack, [1910]).

Charles Lewis Hind, *William Hogarth, 1697–1764* (London: T.C. & E.C. Jack, 1910).

Hermione Hobhouse, *The Crystal Palace and the Great Exhibition: Art Science and Productive Industry: A History of the Royal Commission for the Exhibition of 1851* (New York: Continuum, 2002).

Eric Hobsbawn and Terence Ranger (eds), *The Invention of Tradition* (Cambridge: Cambridge University Press, 1983).

Konrad Hoffmann, 'Antikenrezeption und Zivilisationsprozeß im erotischen Bilderkreis der frühen Neuzeit', *Antike und Abendland*, 24 (1978).

Joseph Hone, *The Life of Henry Tonks* (London: William Heinemann Ltd., 1939).

Holger Hoock, 'Old Masters and the English School. The Royal Academy and the Notion of a National Gallery at the Turn of the Nineteenth Century', *Journal of the History of Collections*, 16(1) (2004).

Holger Hoock, *The King's Artists: The Royal Academy of Arts and the Politics of British Culture, 1760–1840* (Oxford: Oxford University Press, 2003).

A.D. Horgan, *Johnson on Language* (Basingstoke: Macmillan, 1994).

Libby Horner and Gillian Naylor (eds), *Frank Brangwyn 1867–1956* (Leeds: Leeds Museums & Galleries, 2007).

House of Commons, *Report from Select Committee on Arts and Manufactures together with the minutes of evidence and appendix* (London: House of Commons, 1835).

House of Commons, *Report from the Select Committee on Arts and their Connexion with Manufactures with the Minutes of Evidence, Appendix and Index* (London: House of Commons, 1836).

House of Commons, *Report from the Select Committee on Fine Arts; together with the minutes of evidence, appendix, and index, Session 1* (1841).

House of Commons, *Royal Commission Report on the Present Condition of the RA* (1863)

David Howarth, *The Invention of Spain: Cultural Relations between Britain and Spain 1770–1870* (Manchester: Manchester University Press, 2007).

Anna Mary Howitt, *An Art-Student in Munich* (London: Longman, Brown, Green and Longmans, 1853, 2 volumes).

Derek Hudson, *Sir Joshua Reynolds: A Personal Study* (London: Geoffrey Bles, 1958).

Sidney C. Hutchinson, *The History of the Royal Academy 1768–1986* (London: Robert Royce Ltd., 1986).

Sidney C. Hutchinson, 'The Royal Academy Schools, 1768–1830', *Volume of the Walpole Society*, 38 (1962).

James Hyman, *The Battle for Realism: Figurative Art in Britain During the Cold War 1945–1960* (New Haven, CT: Yale University Press, 2001).

John Ingamells and John Edgcumbe (eds), *The Letters of Sir Joshua Reynolds* (New Haven, CT: Yale University Press, 2000).

Alexander W. Inglis, 'Minutes of Evidence', Board of Manufactures Committee, *Report by Departmental Committee to Enquire into the Administration of the Board of Manufactures* (Edinburgh: HMSO, 1903).

John Ireland and John Nichols, F.S.A., *Hogarth's Works: With Life and Anecdotal Descriptions of his Pictures* (London: Chatto & Windus, 1883, 3 volumes).

Anna Brownell Murphy Jameson, *Visits and Sketches at Home and Abroad, with tales and miscellanies now first collected and a new edition of the Diary of an ennuyée; in four volumes.* (London: Saunders & Otley, 1834, 4 volumes).

Hans Robert Jauss, 'Tradition, Innovation, and Aesthetic Experience', *Journal of Aesthetics and Art Criticism*, 46(3) (1988).

John Cordy Jefferson, 'Female Artists and Art-Schools of England', in *Art Pictorial and Industrial* (London: Sampson Low, Martson Low, and Searle, 1870).

David Fraser Jenkins and Chris Stephens (eds), *Gwen John and Augustus John* (London: Tate Publishing, 2004).

David Jeremiah, 'Lessons from Objects', *Journal of Art & Design Education*, 3(2) (1984).

Augustus John, 'A Note on Drawing', in Lillian Browse (ed.), *Augustus John: Drawing* (London: Faber & Faber, 1941).

Augustus John, *Finishing Touches* (London: Jonathan Cape Ltd, 1966).

J. Johnson and A. Greutzner, *The Dictionary of British Artists, 1880–1940* (Woodbridge: Antique Collectors' Club, 1976).

Samuel Johnson, *Lives of the Most Eminent English Poets* (London: Bathurst et al., 1781, 4 volumes).

Samuel Johnson, 'Progress of Arts and Language', *The Idler*, 63 (June 1759), in Samuel Johnson, *The Idler* (London: Newberry, 1761, 2 volumes).

Aled Jones and Bill Jones, 'The Welsh World and the British Empire, c.1851–1939: An Exploration', *Journal of Imperial and Commonwealth History*, 31(2) (2003).

Peter Lloyd Jones, 'Art Students and their Troubles', *Leonardo*, 8(1) (Winter 1975).

Rica Jones, 'The Artist's Training and Techniques', in Tate Gallery, *Manners & Morals: Hogarth and British Painting 1700–1760* (London: Tate Gallery Publications, 1987).

Birgit Jooss, 'Die verhängnisvolle Verquickung von produzierendem und lehrendem Künstler', in Léon V. Krempel and Anthea Niklaus (eds), *Cornelius, Prometheus, der Vordenker* (Munich: Haus der Kunst, 2004).

Martin Kallich, *The Association of Ideas and Critical Theory in Eighteenth-Century England. A History of a Psychological Method in English Criticism* (The Hague: Mouton, 1970).

Alfred Kamphausen, *Asmus Jacob Carstens* (Neumünster: Wachholt, 1941).

Immanuel Kant, *Kritik der Urteilskraft* (Hamburg: Meiner, [1790] 2001).

Willie Kealy, 'Work and Personality Evoke Many Tributes – Keating – a Portrait of the Artist', *Irish Press* (22 December 1977).

Seán Keating, 'A Tribute to William Orpen', *Ireland Today*, II (1937).

Martin Kemp, 'True to their Natures: Sir Joshua Reynolds and Dr. William Hunter at the Royal Academy of Arts', *Notes and Records of the Royal Society of London*, 46(1) (1992).

Wolfgang Kemp, *… einen wahrhaft bildenden Zeichenunterricht überall einzuführen." Zeichnen und Zeichenunterricht der Laien 1500–1870* (Frankfurt am Main: Syndikat Autoren- und Verlags-Gesellschaft, 1979).

D.V. Kent, *Cosimo de' Medici and the Florentine Renaissance: The Patron's Oeuvre* (New Haven, CT: Yale University Press, 2000).

Dermot Keogh and Andrew McCarthy, *Limerick Boycott 1904: Anti-Semitism in Ireland* (Cork: Mercier Press, 2005).

Thomas Kirchner, 'Das Modell Akademie. Die Gründung der Akademie der Künste und mechanischen Wissenschaften', in Akademie der Künste, Berlin, *Die Kunst hat nie ein Mensch allein besessen: 1696–1996 Dreihundert Jahre Akademie der Künste, Hochschule der Künste Berlin* (Berlin: Henschel, 1996).

Thomas Kirchner, 'Der europäische Kontext. Die akademische Bewegung im 18. Jahrhundert – Wien und Stockholm', in Akademie der Künste, Berlin, *Die Kunst hat nie ein Mensch allein besessen: 1696–1996 Dreihundert Jahre Akademie der Künste, Hochschule der Künste Berlin* (Berlin: Henschel 1996).

Samuel Kirkup, 'Description of Certain Frescos, Painted by Some German Students Not at Rome', *London Magazine* (August 1820).

Samuel Kirkup, 'From Italy, November 1818', *Literary Gazette* (19 December 1818).

Samuel Kirkup, 'Modern Historical Painters at Rome', Fine Arts, *The Literary Chronicle* (9 October 1824).

Samuel Kirkup, *Annals of the Fine Arts* (1816–20, 5 volumes).

Malcolm S. Knowles, *The Modern Practice of Adult Education: Andragogy versus Pedagogy* (Englewood Cliffs, NJ: Prentice Hall, 1970).

P.G. Konody and Sidney Dark, *Sir William Orpen, Artist and Man* (London: Seeley Service, 1932).

Reinhart Koselleck, 'Fortschritt', in *Geschichtliche Grundbegriffe* (Stuttgart: Klett-Cotta, 1975, 8 volumes).

Joseph Kosuth, 'Art After Philosophy' (1969), in *Art After Philosophy and After* (Cambridge, MA: MIT Press, 1993).

Rosalind Krauss, 'The Originality of the Avant-Garde', in *The Originality of the Avant-Garde and Other Modernist Myths* (Cambridge, MA: MIT Press, 1986).

Rosalind Krauss, 'Sculpture in the Expanded Field', in *Passages in Modern Sculpture* (Cambridge, MA: MIT Press, 1981).

Rosalind Krauss, *A Voyage on the North Sea: Art in the Age of the Post-Medium Condition* (London: Thames & Hudson, 2000).

Lara Kriegel, *Grand Designs: Labor, Empire and the Museum in Victorian Culture* (Durham, NC: Duke University Press, 2007).

Wilhelm von Kügelgen, *Jugenderinnerungen eines alten Mannes*. Neuausgabe nach der kritischen Ausgabe von Johannes Werner (Leipzig 1924: Leipzig: Koehler & Amelang, 1989)

Ernst Kris and Otto Kurz, *Legend, Myth and Magic in the Image of the Artist: A Historical Experiment* (New Haven, CT: Yale University Press, 1979).

Bernd Krysmanski, 'William Hogarths Kritik an der Balance des Peintres: Roger de Piles, Jonathan Richardson, Mark Akenside und Joseph Spence im Fadenkreuz der englischen Satire', in Joachim Möller (ed.), *Sister Arts: Englische Literatur im Grenzland der Kunstgebiete* (Marburg: Jonas, 2001).

C. Lampert, *Euan Uglow: The Complete Paintings* (New Haven, CT: Yale University Press, 2007).

Hugh P. Lane to Standish O'Grady, 'Royal Hibernian Academy of Arts, Lower Abbey Street, Dublin. Winter Exhibition – Old Masters', *All Ireland Review* (15 November 1902).

Cecily Langdale and David Fraser Jenkins, *Gwen John: An Interior Life* (Oxford: Phaidon Press, 1985).

Bruce Laughton, 'Introduction', in *A Centenary Exhibition: The Slade, 1871–1971* (London: Royal Academy of Arts, 1971).

B. Laughton, *William Coldstream* (New Haven, CT: Yale University Press for the Paul Mellon Centre for Studies in British Art, 2004).

Susan J. Lea, David Stephenson and Juliette Troy, 'Higher Education Students' Attitudes to Student Centred Learning: Beyond "Educational Bulimia"', *Studies in Higher Education*, 28(3) (2003).

Jo Alice Leeds, 'Copying and Invention as Sources of Form in Art', *Art Education*, 37(2) (1984).

Frederic Leighton, *Addresses Delivered to the Students of the Royal Academy* (London: Kegan Paul, Trench, Trübner & Co., 1897).

Robin Lenman, *Artists and Society in Germany 1850–1914* (Manchester: Manchester University Press, 1997).

G.D. Leslie, *The Inner Life of The Royal Academy: With an Account of its Schools and Exhibitions Principally in the Reign of Queen Victoria* (London: John Murray, 1914).

Sherie Levine, 'Statement', in Charles Harrison and Paul Wood (eds), *Art in Theory 1900–1990* (Oxford: Blackwell, 1990).

M-G. Michael Lewis, *John Frederick Lewis RA 1805–1876* (Leigh-on-Sea: F. Lewis Publishers, 1978).

Günter Leypoldt, 'A Neoclassical Dilemma in Sir Joshua Reynolds' Reflections on Art', *British Journal of Aesthetics*, 39(4) (1999).

Rhodri Windsor Liscombe, '"The Diffusion of Knowledge and Taste": John Flaxman and the Improvement of the Study facilities at the Royal Academy', *Walpole Society*, 53 (1987).

Ceridwen Lloyd-Morgan, *Gwen John Papers at the National Library of Wales* (Aberystwyth: NLW, 1988).

Frederick P. Lock, *Edmund Burke* (Oxford: Clarendon Press, 1998, 2 volumes).

John Locke, *An Essay Concerning Human Understanding* (London: Penguin, 1997).

Maria H. Loh, 'New and Improved: Repetition as Originality in Italian Baroque Practice and Theory', *The Art Bulletin*, 86(3) (2004).

Peter Lord, *Clarence Whaite and the Welsh Art World: The Betwys-y-coed Artists' Colony 1844–1914* (Llandudno: Coast and Country Publications, [1998] 2009).

Norbert Lynton, 'Coldstream 1970', *Studio International*, 180(927) (1970).

Murdo Macdonald, 'Celticism and Internationalism in the Circle of Patrick Geddes', *Visual Culture in Britain*, 6(2) (2005).

Stuart Macdonald, *The History and Philosophy of Art Education* (London: University of London Press, 1970).

Neil MacGregor, *A Victim of Anonymity: The Master of the Saint Bartholomew Altarpiece* (London: Thames & Hudson, 1993).

Steven Henry Madoff (ed.), *Art School (Propositions for the 21st Century)* (Cambridge, MA: MIT Press, 2009).

Denis Mahon, *Studies in Seicento Art and Theory* (Westport, CT: Greenwood Press, 1971).

John L. Mahoney, 'Reynolds' Discourses on Art: The Delicate Balance of Neoclassic Aesthetics', *British Journal for Aesthetics*, 18 (1978).

Ekkehard Mai, *Die deutschen Kunstakademien im 19. Jahrhundert. Künstlerausbildung zwischen Tradition und Avantgarde* (Cologne: Böhlau, 2010).

André Malraux, *Psychologie de l'art: la création artistique* (Geneva: Skira, 1947–8).

André Malraux, *The Voices of Silence*, trans. Stuart Gilbert (Princeton, NJ: Princeton University Press, [1953] 1978).

David Mannings, 'An Art-Historical Approach to Reynolds' Discourses', *British Journal of Aesthetics*, 16(4) (1976).

David Mannings, *Sir Joshua Reynolds: A Complete Catalogue of His Paintings. The Subject Pictures Catalogued by Martin Postle* (New Haven, CT: Yale University Press, 2000).

Elizabeth Mansfield, *Art History and its Institutions: Foundations of a Discipline* (London and New York: Routledge, 2002).

Signor Mariannecci, *SS Paul and Peter Raising the King's Son, in the Brancacci Chapel, Florence*, chromolithograph (Arundel Society, 1863).

Andrew Martindale, *The Rise of the Artist in the Middle Ages and Early Renaissance* (London: Thames & Hudson, 1972).

H.C.G. Matthew and Brian Harrison (eds), *Oxford Dictionary of National Biography* (Oxford: Oxford University Press, 2004).

Kerry McCarthy, 'Portrait of the Artist as an Angry Old Man', *Irish Independent*, 6 June 1973.

Kenneth McConkey, 'Sir William Orpen: His Contemporaries, Critics and Biographies', in *Orpen and the Edwardian Era* (London: Pyms Gallery, 1987).

J. McEwan, 'In Conversation with Paula Rego', in *Paula Rego* (London: Serpentine Gallery, 1988).

W.D. McKay and Frank Rinder, *The Royal Scottish Academy, 1826–1916* (Glasgow: James Maclehose and Sons, 1917).

Penny McKeon, 'The Sense of Art History in Art Education', *Journal of Aesthetic Education*, 36(2) (2002).

Katy Mcleod and Lin Holdridge (eds), *Thinking through Art: Critical Reflections on Emerging Research* (London: Routledge, 2005).

Fionnuala McManamon, 'James Barry: A History Painter in Paris in the 1760s', in Tom Dunne and William L. Pressly (eds), *James Barry, 1741–1806: History Painter* (Aldershot: Ashgate, 2010).

James Mill, 'Education', in W.H. Burston (ed.), *James Mill on Education* (Cambridge: Cambridge University Press, 1969).

Charles Mitchell, 'Three Phases of Reynolds' Method', *Burlington Magazine for Connoisseurs*, 80(467) (1942).

Alexander Monro, *Scottish Art and National Encouragement containing a view of the existing controversies and transactions during the last twenty-seven years, relative to art in Scotland* (Edinburgh: 1846).

H. Cliff Morgan, 'The Schools of the Royal Academy', *British Journal of Educational Studies*, 21(1) (1973).

Prys Morgan, 'The Creation of the National Museum and National Library', in John Osmond (ed.), *Myths, Memories and Futures: the National Library and National Museum in the Story of Wales* (Cardiff: Institute of Welsh Affairs, 2007).

Robert C. Morgan, 'After the Deluge: The Return of the Inner-Directed Artists', *Arts Magazine* (March 1992).

Edward Morris, *French Art in Nineteenth-Century Britain* (New Haven, CT: Yale University Press 2005).

Lynda Morris, 'The Beaux-Arts Years, 1948–1957', in Paul Huxley (ed.), *Exhibition Road: Painters at the Royal College of Art*, exhibition catalogue (London: Royal College of Art, 1988).

Robert Morris, *Continuous Project Altered Daily: The Complete Writings of Robert Morris* (Cambridge, MA: MIT Press, 1991).

Chantal Mouffe, *On the Political* (London: Routledge, 2005).

John Mulcahy and Arthur Gibney, 'Arthur Gibney on the Future of the RHA', *Irish Arts Review*, 19(1) (2002).

Jeffrey M. Muller, 'Rubens's Theory and Practice on the Imitation of Art', *Art Bulletin*, 64(2) (1982).

Linda Murray, *The High Renaissance and Mannerism: Italy, the North and Spain 1500–1600* (London: Thames & Hudson, [1967] 1977).

Paul Nash, *Outline: An Autobiography and Other Writings* (London: Faber, 1949).

National Museum of Wales, *Works of Art Given to the National Museum of Wales (Cardiff) by Sir William Goscombe John, R.A.* (Cardiff: National Museum of Wales, 1943).

J.B. Nichols (ed.), *Anecdotes of William Hogarth, written by himself: With Essays on his Life and Genius, and Criticisms on his Works, selected from Walpole, Gilpin, J. Ireland, Lamb, Phillips, and Others. To which are added a catalogue of his prints; account of their variations, and principal copies; lists of paintings, drawings, &c.* (London: J.R. Nichols And Son, 1833).

Benedict Nicholson, 'Art History in Art Schools', *Burlington Magazine*, 716(104) (1962).

Linda Nochlin, 'Return to Order', *Art in America* (September 1981).

James Northcote, *The Life of Sir Joshua Reynolds* (London: Henry Colburn, 1819, 2 volumes).

James Northcote, R.A., *Memoirs of Sir Joshua Reynolds* (London: Colburn, 1813).

John J.R. O'Beirne, 'A Coming Irish Artist, The Work of John Keating', *The Rosary*, 21 (1917).

Hans-Ulrich Obrist (ed.), *Gerhard Richter: The Daily Practice of Painting* (London: Thames & Hudson, 1995).

Robert O'Byrne, *Hugh Lane 1875–1915* (Dublin: Lilliput Press, 2000).

Éimear O'Connor, *Seán Keating in Context: Responses to Culture and Politics in Post-Civil War Ireland* (Dublin: Carysfort Press, 2009).

Éimear O'Connor, *Seán Keating: Art, Politics and Building the Irish Nation* (Dublin: Irish Academic Press, 2013).

Éimear O'Connor, 'Seán Keating: Contemporary Contexts', catalogue essay for the eponymous exhibition at the Crawford Art Gallery Cork, (Cork, 2012).

Éimear O'Connor, 'Seán Keating and the ESB: Enlightenment and Legacy,' catalogue essay for the eponymous exhibition (Dublin: RHA Gallery Dublin, 2012).

Kiyoshi Okutsu 'Metronome Think Tank Tokyo', in Clémentine Deliss (ed.), *Metronome No. 11 What is to be Done? Tokyo* (Paris: Metronome Press, 2007).

Henry O'Neil, *Lectures on Painting Delivered at the Royal Academy* (London: Bradbury, Evans, & Co., 1866).

Paul O'Neill and Mick Wilson (eds), *Curating and the Educational Turn* (London: Open Editions, 2010).

Leonée Ormond and Richard Ormond, *Lord Leighton* (New Haven, CT: Yale University Press, 1975).

Richard Ormond, *Leighton's Frescoes in the Victoria and Albert Museum* (London: Victoria and Albert Museum 1975).

Sir William Orpen, *Stories of Old Ireland & Myself* (London: Williams and Norgate, Ltd., 1924).

Erwin Panofsky, *Idea. Ein Beitrag zur Begriffsgeschichte der älteren Kunsttheorie* (Berlin: Verlag Bruno Hessling, 1960).

Rozsika Parker and Griselda Pollock (eds), *Old Mistresses: Women, Art and Ideology* (London: Routledge & Kegan Paul, 1981).

Nicholas Penny (ed.), *Reynolds* (London: Royal Academy of Arts, 1986).

Gill Perry and Colin Cunningham (eds), *Academies, Museums and Canons of Art* (New Haven, CT: Yale University Press, 1999).

Nikolaus Pevsner, *Academies of Art: Past and Present* (Cambridge: Cambridge University Press, 1940).

Ulrich Pfisterer, 'Kampf der Malerschulen – Guido Renis *Lotta dei Putti* und die Caravaggisten', in *Pluralisierung und Autorität in der Frühen Neuzeit. 15.–17. Jahrhundert* (Mitteilungen des Sonderforschungsbereiches 573, Vol. II, Munich: LMU, 2008).

Alan Butt Philip, *The Welsh Question: Nationalism in Welsh Politics, 1945–1970* (Cardiff: University of Wales Press, 1975).

Adam Phillips, *The Beast in the Nursery* (London: Faber & Faber, 1999).

Edward Pinnington, *George Paul Chalmers and the Art of His Time* (Glasgow: T. & R. Annan & Sons, 1896).

Pliny, *Natural History Books XXXIII–XXXVI with an English translation by H. Rackham* (Cambridge, MA: Harvard University Press, 1952).

Griselda Pollock, *Avant-garde Gambits 1888–1893: Gender and the Colour of Art History* (London: Pandora Books, 1992).

Griselda Pollock, 'Beholding Art History: Vision, Place and Power', in Stephen Melville and Bill Readings (eds), *Vision and Textuality* (Basingstoke: Macmillan, 1995).

Matthew C. Potter, 'A Glorious Revolution in British Art?', in C. Keeley and K. Boardman (eds), *1848: The Year the World Turned?* (Newcastle: Cambridge Scholars Press, 2007).

Matthew C. Potter, *The Inspirational Genius of Germany: British Art and Germanism, 1850–1939* (Manchester: Manchester University Press, 2012).

Alan Powers, 'Decorative Painting in the Early Twentieth Century: A Context for Winifred Knights', in *Winifred Knights 1899–1947* (The Fine Art Society Plc and Paul Liss in association with the British School at Rome, 1995).

A. Powers, 'Honesty of Purpose', *Country Life* (27 February 1986).

Edward Poynter, *Ten Lectures on Art* (London: Chapman & Hall, 1879).

Sarah Prescott, '"Gray's Pale Spectre": Evan Evans, Thomas Gray, and the Rise of Welsh Bardic Nationalism', *Modern Philology*, 104(1) (2006).

William L. Pressly, *The Life and Art of James Barry* (New Haven, CT: Yale University Press, 1981).

Renate Prochno, *Joshua Reynolds* (Weinheim: VCH, Acta Humaniora, 1990).

Saskia Pütz, *Künstlerautobiographie. Die Konstruktion von Künstlerschaft am Beispiel von Ludwig Richter* (Berlin: Gebr. Mann., 2011).

Malcolm Quinn, 'The Political Economic Necessity of the Art School 1835–1852', *International Journal of Art and Design Education*, 30(1) (2011).

Malcolm Quinn, 'The Disambiguation of the Royal Academy of Arts', *History of European Ideas*, 37(1) (2011).

Malcolm Quinn, 'The Invention of Facts: Bentham's Ethics and the Education of Public Taste', *Revue d'études Benthamiennes*, September 2011, available at: http://etudes-benthamiennes.revues.org/346.

Jacques Rancière, *Aesthetics and its Discontents* (Cambridge: Polity Press, 2009).

Jacques Rancière, *The Future of the Image* (London: Verso, 2007).

Jacques Rancière, *The Ignorant Schoolmaster: Five Lessons in Intellectual Emancipation*, trans. Kristin Ross (Stanford, CA: Stanford University Press, 1991).

Jacques Rancière, *The Politics of Aesthetics* (London: Continuum, 2004).

John Reardon and David Mollin (eds), *Ch-ch-ch-changes: Artists Talk about Teaching. Interviews by John Reardon* (London: Ridinghouse, 2009).

Richard Redgrave and Samuel Redgrave, *A Century of British Artists* (London: Phaidon, 1947).

Joachim Rees, 'Die unerwünschten Nereiden. Rubens' Medici-Zyklus und die Allegoriekritik im 18. Jahrhundert', *Wallraf-Richartz-Jahrbuch*, 54 (1993).

J. Reynolds, *The works of Sir Joshua Reynolds, knight ... containing his Discourses, Idlers, A journey to Flanders and Holland, and his commentary on Du Fresnoy's art of painting* (London: T. Cadell, Jr. and W. Davies, 1798, 3 volumes).

Michael Reynolds, 'The Slade: The Story of an Art School, 1871–1971' (University of London, Slade School of Fine Art Archives, unpublished).

Aileen Ribeiro, *Dress Worn at Masquerades in England, 1730 to 1790, and its Relation to Fancy Dress in Portraiture* (New York: Garland, 1984).

Ludwig Richter, *Lebenserinnerungen eines deutschen Malers* (Frankfurt am Main: Verlag von Johannes Alt, 1885).

Ernst Rietschel, *Jugenderinnerungen* (Leipzig: Evangelische Verlagsanstalt, 2002).

Liz Rideal, *Mirror Mirror: Self-Portraits by Women Artists*, (London: National Portrait Gallery, 2001).

Adrian Rifkin, 'Success Disavowed: The Schools of Design in Mid-Nineteenth-Century Britain. (An Allegory)', *Journal of Design History*, 1(2) (1988).

Gordon Roderick, 'Technical Instruction Committees in South Wales, United Kingdom, 1889–1903 (Part 2)', *The Vocational Aspect of Education*, 45(2) (1993).

Sue Roe, *Gwen John* (London: Vintage, 2002).

Carl Rogers, *Freedom to Learn: A View of What Education Might Become* (Columbus, OH: C. E. Merrill, 1969).

Mervyn Romans, 'An Analysis of the Political Complexion of the 1835/6 Select Committee on Arts and Manufactures', *Journal of Art and Design Education*, 2(2) (2007).

Mervyn Romans, '"Living in the Past": Some Revisionist Thoughts on the Historiography of Art and Design Education', *International Journal of Art and Design Education*, 23(3) (2004).

Sonia Rouve, 'Teaching Art History: A Methodological Reappraisal', in Dick Field and John Newick (eds), *The Study of Education and Art* (London: Routledge & Kegan Paul, 1973).

Royal Academy, *Frederic Leighton 1830–1896* (London: Royal Academy of Arts, 1996).

Royal Birmingham Society of Artists, *The Sixty-Third Autumn Exhibition, at the Rooms of the Society 1889* (Birmingham: Hudson and Son, [1889]).

Royal Cambrian Academy of Art, *A Centenary Celebration: Paintings Selected from the Annual Exhibitions of The Royal Cambrian Academy of Art Held in Wales 1882–1982* (Llandudno: Mostyn Art Gallery & Royal Cambrian Academy of Art, 1982).

Royal Scottish Academy, *Art Property in the Possession of the Royal Scottish Academy* (Edinburgh, 1883).

Eric Rowan (ed.), *Art in Wales, 2000 BC–AD 1850: An Illustrated History* (Cardiff: Welsh Arts Council, 1978).

Eric Rowan and Carolyn Stewart, *An Elusive Tradition: Art and Society in Wales 1870–1950* (Cardiff: University of Wales Press, 2002).

Wolfgang Ruppert, *Der moderne Künstler. Zur Sozial- und Kulturgeschichte der kreativen Individualität in der kulturellen Moderne im 19. und frühen 20. Jahrhundert* (Frankfurt am Main: Suhrkamp, 1998).

Chris Rust, Judith Mottram and Nicholas Till, *AHRC Research Review Practice-Led Research in Art, Design and Architecture* (2007).

George Augustus Sala, *William Hogarth: Painter, Engraver, and Philosopher* (London: Smith, Elder and Co., 1866).

M. Sargant-Florence (ed.), *Papers of the Society of Mural Decorators and Painters in Tempera*, Vol. III. 1925–1935 (Brighton: Dolphin Press, 1936).

Dawna Schuld, 'Conspicious Imitation: Reproductive Prints and Artistic Literacy in Eighteenth-Century England', in Rebecca Zorach/Elizabeth Rodini (eds), *Paper Museums. The Reproductive Print in Europe, 1500–1800* (Chicago, IL: David and Alfred Smart Museum of Art, University of Chicago, 2005).

Peter Senge, 'Education for an Interdependent World: Developing Systems Citizens', in Andy Hargreaves, Ann Lieberman, Michael Fullan and David Hopkins (eds), *Second International Handbook of Educational Change* (Dordrecht: Springer, 2010, 2 volumes).

Anthony Ashley Cooper Shaftesbury, *Characteristics of Men, Manners, Opinions and Times*, Lawrence E. Klein (ed.) (Cambridge: Cambridge University Press, 1999).

John Sitter, *Arguments of Augustan Wit* (Cambridge: Cambridge University Press, 2007).

John Skehan, 'Palette and Palate', *Word* (April 1965).

Helen Smailes, *Robert Herdman 1829–1888* (Edinburgh: National Galleries of Scotland, 1988).

Alastair Smart, *Allan Ramsay, 1713–1784* (Edinburgh: Trustees of the National Galleries of Scotland, 1992).

Sam Smiles (ed.), *Sir Joshua Reynolds: The Acquisition of Genius* (Bristol: Sansom & Company, 2009).

Sam Smiles and Stephanie Pratt, *Two-Way traffic: British and Italian Art 1880–1980*, exhibition catalogue (University of Plymouth, 1996).

Adam Smith, *The Wealth of Nations*, Edwin Cannan (ed.) (London: Methuen, [1776] 1925, 2 volumes).

Alison Smith, *The Victorian Nude: Sexuality, Morality, and Art* (Manchester: Manchester University Press, 1996).

Graham Smith, 'A Medici Source for Michelangelo's Doni Tondo', *Zeitschrift für Kunstgeschichte*, 38 (1975).

Hazel Smith and Roger Dean, *Practice-led Research, Research-led Practice in the Creative Arts* (Edinburgh: University of Edinburgh Press, 2009).

Joanna Soden, *Paintings from the Diploma Collection of the Royal Scottish Academy* (Edinburgh, 1992).

Joanna Soden, 'Tradition, Evolution, Opportunism. The Role of the Royal Scottish Academy in Art Education 1826–1910' (PhD thesis, University of Aberdeen, 2006).

David H. Solkin, *Richard Wilson: The Landscape of Reaction* (London: Tate Gallery, 1982).

David Solkin (ed.), *Turner and the Masters* (London: Tate Publishing, 2009).

N. Neal Solly, *Memoir of the Life of David Cox* (London: Chapman and Hall, 1873).

Guy Standing, *The Precariat: The New Dangerous Class* (London: Bloomsbury, 2011).

Jean Starobinski, 'Fabel und Mythologie im 17. und 18. Jahrhundert', in *Das Rettende in der Gefahr, Kunstgriffe der Aufklärung* (Frankfurt am Main: Fischer Wissenschaft, 1992).

V. Steenblock, 'Tradition', in Joachim Ritter/Rudolf Eisler (eds), *Historisches Wörterbuch der Philosophie* (Darmstadt: Wiss. Buchges., 1995, 13 volumes).

Leo Steinberg, 'The Algerian Women and Picasso at Large', in *Other Criteria: Confrontations with Twentieth-Century Art* (New York: Oxford University Press, 1972).

Chris Stephens and James Beechey (eds), *Picasso and Modern British Art* (London: Tate Publishing, 2012).

Michael Alexander Stewart, 'Abstraction and Representation in Locke, Berkeley and Hume', in G.A.J. Rogers and Sylvana Tomaselli (eds), *The Philosophical Canon in the 17th and 18th Centuries: Essays in Honour of John W. Yolton* (Rochester, NY: University of Rochester Press, 1996).

C. St John Wilson, 'On William Coldstream's Method', in L. Gowing and D. Sylvester (eds), *The Paintings of William Coldstream 1908–1987* (London: Tate Gallery Publications, 1990).

Denys Sutton (ed.), *Letters of Roger Fry* (London: Chatto & Windus, 1972).

John Sweetman, 'John Frederick Lewis and the Royal Scottish Academy I; The Spanish Connection', *Burlington Magazine*, CXVII (2005).

John Sweetman, 'John Frederick Lewis and the Royal Scottish Academy II; Italy, the Netherlands and France', *Burlington Magazine*, CXLVIII (2006).

Tom Taylor (ed.), *The Life of Benjamin Robert Haydon, from his Autobiography and Journals* (New York: Harper, 1853, 3 volumes).

A Teagle Foundation 'Working Group' White Paper, *The Values of the Open Curriculum: An Alternative Tradition in Liberal Education* (June 2006).

Mikuláš Teich and Roy Porter (eds), *The National Question in Europe in Historical Context* (Cambridge: Cambridge University Press, 1993).

Ned Thomas, *The Welsh Extremist: A Culture in Crisis* (London: Gollancz, 1971).

Colin Thomson, *Pictures for Scotland. The National Gallery of Scotland and its Collection: A Study of the Changing Attitude to Painting since the 1820s* (Edinburgh: National Galleries of Scotland, 1972).

Lisa Tickner, *Hornsey 1968: The Art School Revolution* (London: Frances Lincoln, 2008).

Gary Tinterow and Genevieve Lacambre, *Manet/Velazquez: The French Taste for Spanish Painting* (New Haven, CT: Yale University Press, 2003).

Dabney Townsend, 'Lockean Aesthetics', *Journal of Aesthetics and Art Criticism*, 49(4) (Autumn 1991).

Colin Trodd, *Visions of Blake: William Blake in the Art World 1830–1930* (Liverpool: Liverpool University Press, 2012).

John Turpin, *A School of Art in Dublin since the Eighteenth Century: A History of the National College of Art and Design* (Dublin: Gill & Macmillan, 1995).

Robert Upstone (ed.), *William Orpen: Politics, Sex and Death* (London: Tate Publishing, 2005).

William Vaughan, *German Romanticism and English Art* (New Haven, CT: Yale University Press, 1979).

Paul Virilio, *Art and Fear* (London: Continuum, 2010).

Lev S. Vygotsky, *Mind in Society: the Development of Higher Psychological Processes* (Cambridge, MA: Harvard University Press, 1978).

G. F. Waagen, 'Thoughts on the New Building to be Erected for the National Gallery of England, and on the Arrangement, Preservation, and Enlargement of the Collection', *Art Journal*, 5 (1853).

Jeff Wall, 'Partially Reflective Mirror Writing', in Alexander Alberro (ed.), *Two-Way Mirror Power: Selected Writings by Dan Graham on His Art* (Cambridge, MA: MIT Press, 1999).

Jeff Wall, *Selected Essays and Interviews* (New York: Museum of Modern Art, 2007).

Horace Walpole, *Anecdotes of painting in England; with some account of the principal artists; and incidental notes on other arts; collected by the late Mr. George Vertue [...]* (Strawberry Hill/Twickenham, 1765–71 [1765–80], 4 volumes).

Robert R. Wark (ed.), Sir Joshua Reynolds, *Discourses on Art* (New Haven, CT: Yale University Press, 1997).

Simon Watney, *English Post-Impressionism: 1930–1939* (London: Studio Vista, 1980).

Daniel Webb, *Remarks on the Beauties of Poetry* (London: Dodsley, 1762).

Evelyn Welch, *Art and Society in Italy* (Oxford: Oxford University Press, 1997).

Richard Wendorf, *Sir Joshua Reynolds: The Painter in Society* (London: National Portrait Gallery, 1996).

Geffrey Whitney, *A Choice of Emblems* (Leyden: Plantyn, 1586).

Iris Wien, *Joshua Reynolds. Mythos und Metapher* (Munich: Fink, 2009).

Andrew Gibbon Williams, *William Roberts: An English Cubist* (Aldershot: Lund Humphries, 2004).

G.A. Williams, 'When was Wales?' (1979), in Stuart Woolf (ed.), *Nationalism in Europe, 1815 to the Present* (New York: Routledge, 1996).

Gareth Williams and Heather Fry, *Longer Term Prospects for British Higher Education: A Report to the Committee of Vice Chancellors and Principals* (London: University of London Institute of Education, 1994).

C.A.P. Willsdon, *Mural Painting in Britain 1840–1940: Image and Meaning* (Oxford: Oxford University Press, 2000).

J. Wilson, *The plan and new descriptive catalogue of the European Museum: King Street, St. James Square: instituted the 23d April, 1789, for the promotion of the fine arts and the encouragement of British artists* (London: Smeeton, 1808).

Andrew Wilton (ed.), *Grand Tour: The Lure of Italy in the Eighteenth Century* (London: Tate Gallery Publishing, 1996).

Edgar Wind, 'Humanitätsidee und heroisiertes Porträt in der englischen Kultur des 18. Jahrhunderts', *Vorträge der Bibliothek Warburg* (1930/1931).

Edgar Wind, 'The Mænad under the Cross. Comments on an Observation by Reynolds', *Journal of the Warburg and Courtauld Institutes*, I (1937/38).

Edgar Wind, 'Borrowed Attitudes in Reynolds and Hogarth', *JWCI*, II (1938/39).

Emma L. Winter, 'German Fresco Painting and the New Houses of Parliament at Westminster, 1834–1851', *Historical Journal*, 47(2) (2004).

Rudolf Wittkover, 'Imitation, Eclecticism, and Genius', in Earl. R. Wasserman (ed.), *Aspects of the Eighteenth Century* (Baltimore, MD: Johns Hopkins University Press, 1965).

Edward L. Widmar, *Young America: The Flowering of Democracy in New York City* (Oxford: Oxford University Press, 1999).

Charles Heath Wilson, 'Observations on some of the Decorative Arts in Germany and France, and on the causes of the superiority of these, as contrasted with the same Arts in Great Britain. With suggestions for the improvement of Decorative Art', *Edinburgh New Philosophical Journal* (July–October 1843).

E. Wolff, *Anatomy for Artists* (London: H.K. Lewis & Co. Ltd, 1925).

P. Wright, *Painting the Visible World: Painters at the Euston Road School and at Camberwell School of Arts and Crafts 1930–1960* (London: Austin/Desmond Fine Arts, 1989).

Nick Wright, 'What Happened at Hornsey in May 1968', see http://www.1968and allthat.net/node/82.

Patricia Zakreski, *Representing Female Artistic Labour, 1848–1890: Refining Work for the Middle-Class Woman* (Aldershot: Ashgate, 2006).

Oliver Zimmer, *Nationalism in Europe, 1890–1940* (Basingstoke: Palgrave Macmillan, 2003).

Index

Steer, Philip Wilson, 131–3, 138, 196
still life, 65, 200
studio, 1, 20, 23, 30, 56, 60, 77, 82, 84,
 86, 94, 96–7, 105, 118–19, 130–31,
 155, 161, 162, 170–74, 177, 183, 190,
 197, 203, 212, 216–19, 223–5, 227,
 234, 238, 243, 245, 254, 259, 261
Summer Composition Competition, *see*
 Slade School of Art
Sylvester, David, 196–7, 207

taste, 10, 14, 16, 19, 30–31, 34, 36–7, 39,
 42, 51, 56–7, 59, 69, 93, 98, 112, 118,
 128, 148, 150, 157, 159, 215, 218–19,
 221–2, 226, 240
Tate Gallery, London (est. 1897), 134,
 137
technical instruction, 6–7, 20, 24, 30,
 33, 47–8, 65, 70, 72, 75–6, 86, 87, 89,
 91, 95, 115–16, 122, 132–3, 139–40,
 150, 158, 211, 225, 259
tempera, 139–41
textual Masters, 234
theory, *see* art theory
Tintoretto, 137, 194
Titian, 9, 18, 58, 64, 68, 72, 74–5, 118, 137
Tonks, Henry, 129, 131–35, 138–42
 Demonstration Drawing (c.1908), 190,
 191
Townsend, William, 189, 195, 197,
 204–7, 210–11
tradition, 3, 4, 7, 14–15, 18, 23, 29–30,
 34–42, 47, 49, 52, 54–5, 59, 89, 92,
 96, 116, 129–33, 135–6, 139, 145,
 149, 155, 160–63, 169, 171, 175,
 177–8, 181–2, 184, 190, 195–8, 202,
 204, 211, 220, 237–40, 242, 245–6,
 251, 253, 255
Trustees' Academy, Edinburgh (est.
 1760), 16–17, 65–7, 70, 74–5, 77

Uffizi, Florence (est. 1765), 64
Uglow, Euan, 198–9, 209–10

Female Figure Standing by a Heater
 (1952), 198, **199**
Musicians (1953), **209**
universities, 6, 20, 83, 110, 123, 129, 157,
 180, 197, 216–221, 223, 225–9, 234,
 238, 252–3, 257–60; *see also* liberal
 arts
University College London, 129, 131, 137
utilitarianism, 18–19, 54, 219, 221, 226,
 228
ut pictura poesis, 35, 39

van Dyck, Anthony, 36, 65, 75, 136
van Gogh, Vincent, 21, 137, 210, 242
Vasari, Giorgio, 6–8, 22, 112
 Lives of the most eminent Painters,
 Sculptors and Architects (1550), 7
Vatican, Rome, 51, 61, 121–2; *see also*
 Sistine Chapel
Velazquez, Diego, 72–4, 107, 109, 136,
 162, 240, 239
 Las Meninas (1656), 240, 245–6
vernacularism, 5, 145, 155
Viennese Academy, *see* Academy of
 Fine Arts, Vienna
Veronese, Paolo, 9, 68, 74–5

Waagen, Gustav Friedrich, 70, 95
Walpole, Horace, 31, 35–6, 39, 41
watercolour, 2, 63–4, 68, 70, 72–7, 135
Wall, Jeff, 23, 233–4, 238–47
 Diatribe (1985), 246
 Picture for Women (1979), 245, **246**
Waugh, Edna, 135–6
West, Benjamin, 14, 89, 106
West, William Cornwallis, 149, 157
Westminster Fresco Competition, 5,
 83, 96, 97; *see also* fresco
Whaite, Henry Clarence, 152–4, 157–8
Whistler, James Abbott McNeill, 59–61,
 162
Whistler, Rex, 194
 Trial Scene from 'The Merchant of
 Venice' (1925), **194**

Lightning Source UK Ltd.
Milton Keynes UK
UKOW05n0420121216
289730UK00017B/195/P